Vygotsky and Creativity

Critical Pedagogical Perspectives

Greg S. Goodman, *General Editor*

Vol. 5

PETER LANG
New York • Washington, D.C./Baltimore • Bern
Frankfurt • Berlin • Brussels • Vienna • Oxford

Vygotsky and Creativity

A Cultural-historical Approach to Play, Meaning Making, and the Arts

EDITED BY M. Cathrene Connery,
Vera P. John-Steiner, & Ana Marjanovic-Shane

PETER LANG
New York • Washington, D.C./Baltimore • Bern
Frankfurt • Berlin • Brussels • Vienna • Oxford

Library of Congress Cataloging-in-Publication Data

Vygotsky and creativity: A cultural-historical approach to play,
meaning making, and the arts / [edited by] M. Cathrene Connery,
Vera P. John-Steiner, Ana Marjanovic-Shane.
p. cm. — (Educational psychology: critical pedagogical perspectives; 5)
Includes bibliographical references and index.
1. Creative thinking. 2. Play—Psychological aspects.
3. Art—Psychological aspects. 4. Creative ability—Psychological aspects.
5. Vygotskii, L. S. (Lev Semenovich), 1896–1934. I. Connery, M. Cathrene.
II. John-Steiner, Vera. III. Marjanovic-Shane, Ana.
LB1062.D35 370.15'7—dc22 2009039771
ISBN 978-1-4331-0706-1 (hardcover)
ISBN 978-1-4331-0705-4 (paperback)
ISSN 1943-8109

Bibliographic information published by **Die Deutsche Nationalbibliothek**.
Die Deutsche Nationalbibliothek lists this publication in the "Deutsche
Nationalbibliografie"; detailed bibliographic data is available
on the Internet at http://dnb.d-nb.de/.

Cover image by M. Cathrene Connery

The paper in this book meets the guidelines for permanence and durability
of the Committee on Production Guidelines for Book Longevity
of the Council of Library Resources.

Printed in the United States of America

To my children and grandchildren, who build knowledge, love, and dance with joy, and ask wonderful questions. V.J.S.

To Paul, because of his encouragements, to Giga and Elie because of the inspiration they gave to me, and to Mama Sanda, my most important collaborator. A.M.S.

To James and Paula and my mentors, Phyllis, Pat, and Stefanie, with much love. M.C.C.

Table of Contents

Acknowledgments ... ix

Part One: Theoretical Foundations

1. Dancing with the Muses: An Cultural-historical Approach
 To Play, Meaning Making and Creativity..................................... 3
 Vera John-Steiner, M. Cathrene Connery, and Ana Marjanovic–Shane

2. The Historical Significance of Vygotsky's Psychology of Art 17
 M. Cathrene Connery

3. Without Creating ZPDs There Is No Creativity............................ 27
 Lois Holzman

4. From Yes and No to Me and You:
 A Playful Change in Relationships and Meanings 41
 Ana Marjanovic–Shane

Part Two: Domains of Artistic Expression

5. Crossing Scripts and Swapping Riffs:
 Preschoolers Make Musical Meaning... 63
 Patricia St. John

6. The Social Construction of a Visual Language:
 On Becoming a Painter ... 83
 M. Cathrene Connery

7. Dance Dialogues: Creating and Teaching
 in the Zone of Proximal Development... 107
 Barry Oreck and Jessica Nicoll

8. The Inscription of Self in Graphic Texts in School 125
 Peter Smagorinsky

9. Commitment and Creativity: Transforming Experience into Art 141
 Seana Moran

Part Three: Connections Between Creative Expression, Learning, and Development

10. A Synthetic-Analytic Method for the Study of Perezhivanie:
 Vygotsky's Literary Analysis Applied to Playworlds 163
 Beth Ferholt

11. Keeping Ideas and Language in Play:
 Teaching Drawing, Writing, and Aesthetics in a Secondary Literacy
 Class .. 181
 Michelle Zoss

12. Creating Developmental Moments:
 Teaching and Learning as Creative Activities .. 199
 Carrie Lobman

13. A Cultural-historical Approach to Creative Education 215
 Ana Marjanovic–Shane, M. Cathrene Connery, & Vera John-Steiner

Notes .. 233
Contributors .. 237
Index .. 241

Acknowledgments

THe succesful creation of any book requires multiple forms of expertise, talent, and commitment. We are deeply grateful to the many individuals who joined our dance to share essential gifts that brought this work into existence. Our profound appreciation is extended to the following people: Greg Goodman, our kind and wise editor; Sophie Appel and the patient production crew at Peter Lang; and our extraordinary colleagues and friends, Valerie Clement and Bonita Ferguson. We also appreciate Ithaca College's Education Department for funding the assistance of Marta Eva and Holly Wegner. Much thanks to these graduate students for providing such a high quality of support despite a demanding summer school schedule. We also wish to acknowledge the creative collaboration we have experienced working together as a source of inspiration, growth, compassion, and development. We are grateful for the opportunity to truly engage in the creative process by elaborating our thinking, cheering each other on, providing encouragement, and nurturing confidence and trust.

Part One
Theoretical Foundations

Dancing with the Muses:
A Cultural-historical Approach to Play, Meaning Making and Creativity

Vera John-Steiner
M. Cathrene Connery
Ana Marjanovic–Shane

Strings sing at the touch of a violinist's bow. Light and shadow cast across a stage like rivers of silk, while bodies sway to the heartbeat of a wild drum. Sunflowers burst into bloom on canvas, as clay rises on the wheel into a cylindrical dome. We have long been fascinated with the ability of the arts to transform the material into the seemingly ethereal. As children and adults, we have all been inspired to play, act, and dream on paper, in poetry, or through performance within our personal and professional lives. Across time and space, politics and religion, we are united in our collective need to dance with the muses as both artists and audience members.

So why have the arts been neglected by so many scholars of human development? Is it a consequence of the rationalistic bias of our educational system? Is it because development in literacy and mathematics is more accessible and more open to measurement than growth in dramatic play, music, or drawing? In this book, we make the argument that thought, emotion, play, and creativity as well as the creation of relationships are an integrated whole. When some aspects of this totality are broken apart, learning and development are diminished.

We bring to this issue a background in Vygotskian scholarship as well as that of practicing artists and educators. The ideas of the ground–breaking Russian psychologist, L.S. Vygotsky, are becoming increasingly influential in their emphasis on the social sources of development and the central role of tools and artifacts, such as the computer, in learning. Vygotsky's theory con-

trasts sharply with the more dominant approaches of constructivists, (i.e., those of Piaget), who envisioned development as a universally shared process independent of the particular historic and cultural environment. Vygotsky's strong emphasis on culture and social interaction is particularly relevant to our contemporary multicultural society and has been effectively applied to studies of literacy, concept formation and bilingualism. Ironically, although his first publication was devoted to the arts, cultural historical scholars dedicated to his thinking have paid little attention to analyses of play, meaning making, and creativity.

As individual editors, each of us has drawn on Vygotsky's framework to investigate our own interests in play, meaning making, and creativity. Through these explorations, we encountered colleagues from a diverse array of disciplines who shared our fascination and curiosity. Using cultural-historical theory, an approach founded on Vygotsky's theories and developed further in the former Soviet Union, the United States, and other countries, we collectively sought to articulate a response to these essential processes in the life of the mind. Our informal, formal, political, and creative efforts led us to the development of this book.

The purpose of this introductory chapter is threefold. First, we seek to introduce the reader to Vygotsky as a teacher, researcher, scholar and fellow creative spirit. Second, we provide a background of his ideas by summarizing essential concepts from the collection of loosely associated theories that constitute cultural-historical theory. Third, we contextualize a discussion on play, meaning making, and creativity within this view to present an enriched understanding of the arts.

L. S. Vygotsky: A Life of Creative Activity

L. S. Vygotsky was born in 1896 in Orsha, Russia, a small town, which is now part of Belarus. The young boy grew up in Gomel. He was a member of a large, highly educated, Jewish family. By the time he reached adolescence, Vygotsky developed strong intellectual interests in many disciplines including philosophy and history and shared his mother's love of poetry. He finished gymnasium with great distinction and subsequently attended Moscow University where he studied law. He supplemented this course of study with classes at the Shanjavsky People's University, continuing his interest in history and philosophy. As an adolescent he composed several drafts of an analysis of Shakespeare's *Hamlet*, which later became the basis of his doctoral dissertation. During these years he also broadened his knowledge of linguistics and psy-

chology. Vygotsky was influenced by William James and Sigmund Freud and, throughout his life, he conducted a thorough study of European and American psychological theories.

After completing his university studies, Vygotsky returned to Gomel, where he taught in state schools. He also participated in the town's cultural life. During these years, he mostly published literary reviews and became interested in educational psychology. Vygotsky's interest in literature and drama established his reputation as a brilliant lecturer. Unfortunately, Gomel suffered the hardships of civil war and attacks made by different armies and local bandits. Nevertheless, Vygotsky began his first psychological investigations while teaching at Gomel's Teacher's College. During this time, Vygotsky's family was first struck by tuberculosis and his younger brother died of the illness. While taking care of his brother, Vygotsky himself also became ill with TB. After his marriage in 1924 to Roza Smekhova, he left Gomel for Moscow at the invitation of a senior faculty member and psychologist, Alexander Luria. Vygotsky's collaboration with Luria and Leont'ev would prove to be a highly creative endeavor.

Once in the capital, Vygotsky joined the Institute of Experimental Psychology where "from very early in his professional life he had seen the development of the science of man as his cause, a cause he took extremely seriously and to which he dedicated all of his energy" (van der Veer & Valsiner, 1991). His first publication was *The Psychology of Art* (Vygotsky, 1925/1971) described by Cathrene Connery in this text. Vygotsky went on to publish 15 articles a year including lectures, reviews, and forewords to works of foreign authors. His second book was published in English as *Educational Psychology* (1992). In the late 1920s, his interests expanded to children with atypical development including blind, deaf, and retarded children. Publications on this topic were assembled in Volume 2 of his collected works. Vygotsky's theoretical analyses were first summarized in "The Historical Meaning of Crisis in Psychology" (1927) which first appeared in English in Volume 3 of his collected works.

Increasingly, Vygotsky became interested in how human activity is mediated by artifacts, a topic that he first developed in "Tool and Symbol in Child Development." This manuscript forms the first section of the volume *Mind in Society* (1978) co-edited by Michael Cole, Vera John-Steiner, Sylvia Scribner, and Ellen Souberman. Throughout his life, Vygotsky relied on a dialectical Marxist approach to the development and investigation of the human sciences. His most widely read work is *Thought and Language*, first published in English in 1962. In this book, he brings together his cultural-historical ideas with a focus on the interrelationship of thinking and speaking. The impact of

this volume has grown substantially over the years and has been published and re-edited several times. Vygotsky's ideas were shaped by his extraordinary scholarship, his deeply original mind, and his ability to work interdependently with colleagues and friends. His legacy might have been lost were it not for Luria's determined efforts to bring Vygotsky's work to a world audience after his untimely death from tuberculosis at the age of 38.

Essential Concepts of Cultural-historical Theory

Vygotsky's conceptual framework provides a rich, unique, and pragmatic contribution to theories of human psychology. His notions regarding the social sources of development, mediation, perezhivanie, the zone of proximal development, and methodology collectively describe the transformative development of individuals and societies. The following discussion highlights the significance of these concepts in order to nurture a cultural-historical understanding of play, meaning making, and creativity.

Social Sources of Development

The common theme that runs across Vygotsky's diverse writings is that of the social origins of psychological processes. Human beings are irrevocably interdependent. As infants, we are dependent on caregivers for survival and learning. In the course of development, young learners rely on the vast pool of transmitted experience shared by family members, teachers and peers. In his oft–quoted "genetic law", Vygotsky emphasized the primacy of social interaction by proposing that any process in the child's cultural development appears twice: Functions appear first on the social, then on the psychological plane or first between people, and then within the child as an intrapsychological process.

Imagination, as a psychological function that is located in the core of learning and development, also originates within social interaction and the cultural-historical moment of a child's development. Vygotsky wrote that "imagination operates not freely, but directed by someone else's experience, as if according to someone else's instructions " (Vygotsky, 1930/2004, p. 17). In this manner, imagination "becomes the means by which a person's experience is broadened, because he can imagine what he has not seen, can conceptualize something from another person's narration and description of what he himself has never directly experienced" (Vygotsky, 1930/2004, p. 17).

Vygotsky's genetic law of development is also observable in the development of speech. He proposed that language functions as a means of communi-

cation and cognition. Young children appropriate and make their own the speech that surrounds them. The internalization of dialogic interaction results in the development of language and thought. The semiotic means a child uses during internalization becomes the basis of her inner speech and verbal thinking.

The condensed nature of inner speech was described by Vygotsky in his well-known metaphor stating "a thought may be compared to a cloud shedding a shower of words....Precisely because a thought does not have its automatic counterpart in words, the transition to thought from word leads through meaning" (Vygotsky, 1987, p. 251). Contemporary students of language acquisition emphasize the interactional sources of language learning and language use (Tomasello, 2008). The communicative or interactional use of language, in fact, depends on the imagination of others. In this manner, learning from another can and should become an "experience based on imagination" (Vygotsky, 1930/2004, p. 17) in order for authentic learning to take place. Toward this end, Carrie Lobman illustrates the importance of teachers' imagination in the chapter she has contributed to this book.

Mediation

The critical role of mediation in Vygotsky's theory is most fully analyzed by James Wertsch who noted:

> In his view, a hallmark of human consciousness is that it is associated with the use of tools, especially 'psychological tools' or 'signs'. Instead of acting in a direct, unmediated way in the social and physical world, our contact with the world is indirect or mediated by signs....It is because humans internalize forms of mediation provided by particular cultural, historical, and institutional forces that their mental functioning is sociohistorically situated (Wertsch, 2007, p. 178).

In this quote, Wertsch highlights another important aspect of Vygotsky's thinking: psychological tools develop within the diverse cultural and historical settings of humankind. One needs only to evoke the computer to realize how profoundly our memory, planning, writing and editing processes have changed in our reliance on this relatively new technological and cognitive tool.

Most scholars within the cultural historical tradition emphasize language as central to thought and pay limited attention to symbolic systems and other semiotic means. While we recognize the critical role of language, we prefer a pluralistic theory that John-Steiner (1995) named "cognitive pluralism." Some examples of these diverse semiotic means include mathematical symbol systems, maps, artistic sketches, sign language, imagery, and musical notes. These systems of representation are imbedded in social practice in that, "ecology,

history, culture and family organization play roles in patterning experience and events in the creation of knowledge" (John-Steiner, 1995, p. 5).

In the chapters that follow, the authors describe a variety of meditating tools. Patricia St. John documents children's reliance on musical instruments in her chapter. Peter Smagorinsky writes of students' construction of masks and their impact on writing activities. Cathrene Connery highlights the appropriation of physical and psychological tools in painting. Reliance on mediating tools is a developmental process which Vygotsky emphasized "*is neither simply invented nor passed down from adults*; rather it arises from something which is not originally a sign operation and becomes one only after a series of *qualitative* transformations" (Vygotsky, 1978, p. 46, italics in the original).

Perezhivanie

While Vygotsky's work is strongly cognitively oriented, he also included affective considerations in his theory of human development and consciousness. One of these is *perezhivanie*, which some have translated as "lived emotional experience." Social interaction among children and adults is perceived through the lens of previous experience; meditational means are appropriated and represented by individuals in their own characteristic ways. Michelle Zoss highlights how teaching and learning are enriched when classrooms provide opportunities for students to express ways of perceiving their experience. Ana Marjanovic-Shane illustrates how interaction and instruction is enhanced when built on trusting relationships in play, including vivid and metaphoric descriptions of experience that produce emotional engagement.

The term perezhivanie is an important one in theatre director Stanislavsky's teaching of actors. He asked them to re-live previously relevant or profound experiences when preparing to engage with a new role. Vygotsky was influenced by this work and appropriated the concept for his own thinking about emotional experience. It is only recently that his essay, "The Problem of the Environment" in which he developed his understanding of lived experience, was published in English. Diverse authors in the cultural-historical theoretical community, now familiar with this concept, increasingly refer to perezhivanie as they recognize its significant role in parenting, teaching and communicating among partners. Beth Ferholt presents a novel means of studying perezhivanie through the unique use of film.

Emotional aspects of experience are also crucial for imagination. Vygotsky agreed that "all forms of creative imagination include affective elements" (Vygotsky, 1930/2004, p. 19). In his exploration of children's imagination and creativity, Vygotsky often spoke of the circular path of imagination from lived

experiences, through the imagination that combines and recombines elements of these experiences, to the embodiments of imagination in the material form of an artistic product (image, music, dance, story, etc). According to Vygotsky, for such a circle to be completed, both intellectual and emotional factors are essential (Vygotsky, 1930/2004, p. 21). Barry Oreck and Jessica Nicoll describe how young dancers engage on this path as they develop a personal vocabulary of movement.

Zone of Proximal Development (ZPD)

The most widely discussed concept in Vygotsky's writings is that of the ZPD. Vygotsky wrote "We propose that an essential feature of learning is that it creates the zone of proximal development; that is, learning awakens a variety of internal developmental processes that are able to operate only when the child is interacting with people in his environment and in cooperation with his peers. Once these processes are internalized, they become part of the child's independent developmental achievement" (Vygotsky, 1978, p. 90). The appeal of this notion of assisted performance that precedes a learner's ability to independently solve tasks has widespread educational implications. Learners differ in how efficiently they use assistance and this difference was of significance to Vygotsky's argument. To understand the full meaning of the ZPD is to recognize that it is not a recipe for teaching skills. As Lois Holzman emphasizes, the ZPD is a relational process that embraces the full unity of the social and personal aspects of development in which new functions are realized that are not yet mature.

Currently, researchers have broadened this concept to include peer-based reciprocal assistance including "all aspect[s] of the learner-acting, thinking and feeling" (Wells, 1999, p. 331) and mutual zones of proximal development for collaborative partners (John-Steiner, 2000). In this broader view of the ZPD, scholars have come to identify that the co-construction of new ideas includes the sharing of risks, constructive criticism, and the creation of a safety zone. Partners can live, however temporarily, in each other's heads. They draw on their mutuality as well as on their differences and background knowledge, working style and temperament. As Mahn & John-Steiner (2002) reflect: "Innovative works of literature, drama and science are nourished by sustained support—as are teaching and learning across the lifespan" (p. 52). The complex relationship between writers and the literary establishment is the focus of Seana Moran's chapter in this book.

Vygotsky's Method

A central theme in Vygotsky's writings is that of movement. He argued that the nature of phenomena is revealed during the process of change. In following this principle, he wrote:

> To study something historically means to study it in the process of change; that is the dialectical method's basic demand. To encompass in research the process of a given thing's development in all its phases and changes—from birth to death—fundamentally means to discover its nature, its essence, for 'it is only in movement that a body shows what it is' (Vygotsky, 1978, pp. 64–65).

Vygotsky created situations in which a new solution process was provoked by the way in which the experimenter and the participant interacted. For example, in *Thought and Language* he described how children, when getting ready to draw, lacked a color they needed. This arrangement was planned by the experimenter to study the children's response to task difficulties. The young artists met the challenge by talking to themselves, articulating, "Where is the pencil? I need a blue pencil. Never mind, I'll draw with the red one and wet it with water; it will become dark and look like blue" (1986, p. 30).

While this example is given in Vygotsky's discussion of the role of private or egocentric speech, it also illustrates his "experimental-developmental" method in that the approach "artificially evokes or creates a process of psychological development" (ibid., p. 61). Additional examples of this experimental method occur when the researcher, teacher or parent provides the learner with a psychological tool such as a number line when dealing with mathematical operations or the introduction of signs such as words or task cards to assist in concept formation. The developmental aspects of this method focus on the study of a process from its beginning through its various changes until competence is reached. As Vygotsky wrote:

> We believe that child development is a complex dialectical process characterized by periodicity, unevenness in the development of different functions, metamorphosis or qualitative transformation of one form into another, intertwining of internal and external factors, and an adaptive processes which overcomes impediments that the child encounters (1978, p. 73).

A Cultural-historical Perspective on Play, Meaning Making, and Creativity

Within this framework, we emphasize that play, meaning making, and creativity constitute distinct and interdependent processes in individual and collective experience.

Play

Play is a dynamic and complex activity, which, according to Vygotsky (1933/1976), represents an interactive social form of embodied imagination. Play simultaneously requires and leads to complex symbolic constructions, behavioral mastery, collaborative protocols, emotional arousal and control, and the production of group cultural lore. Vygotsky noted "play is.....the leading source of development in pre-school years" (1933/1976, p. 537). In early childhood, play appears as the motives of the growing child shift towards the realization of personal desires. Because these desires are unattainable in reality, the child seeks to realize them through the imagination. For Vygotsky, play represents the first appearance of imagination in development—as imagination in action.

Vygotsky distinguishes play from other activities based on two essential characteristics: first, children create imaginary situations in play. Second, play is always based on rules. In fact, for Vygotsky, the imaginary situation already contains rules of behavior so that "there is no such thing as play without rules" (ibid., p. 541). As they explore the rules of social behavior and relationships, children develop through the meaning making of imaginary situations created in pretend play. Vygotsky discovered that children are able to follow the rules in play before they can adhere to those of everyday, real-life situations. Development calls for the capacity to be able to act in a situation "which is only conceived on an imagined level" and is independent of immediate reality for two reasons: first, in order for learning to occur, children must be able to interpret the meaning and sense of a situation (or objects) irrespective of their perceptual appearance. In other words, learners need to be able to evaluate events and things based on their relevant values, rules and expectations. Second, the use of imagined meanings and rules leads to the development of will and voluntary *actions* independent of immediate *reactions* to physical stimuli (ibid., pp. 545–550). Based on these insights, Vygotsky claimed that play represents a specialized form of the zone of proximal development asserting, "Action in the imaginative sphere, in an imaginary situation, the creation of voluntary intentions and the formation of real-life plans and volitional motives—all appear in play and make it the highest level of pre-school development" (ibid., p. 552). Vygotsky's work on play and its developmental significance have influenced many researchers and educators around the world, leading to innovations in an assortment of programs highlighted in our concluding chapter.

Meaning Making

Play is just one expression of meaning making or semiosis that occurs across the life span. Meaning making is the construction of knowledge into understanding with others within and across a variety of contexts and codes (Vygotsky, 1986). Commonly referred to as learning, comprehending, or understanding, meaning making developed from our need to organize life experience as individuals, communities, and members of the human species.

Vygotsky did not consider meaning to be a private collage of concepts residing within a person's head. His thoughts on meaning making are refreshing in that he brings together traditionally held opposites. For example, instead of isolating forms of thinking into separate, discrete skills, Vygotsky viewed meaning making as a complex synthesis of interdependent processes. He also paired emotion and thought together as equitable processes that occur simultaneously. While meaning making occurs inside the social relationship of the ZPD, meaning is processed through the individual prism of perezhivanie. Similarly, the early meaning making efforts of children and novices often intertwine internal and external states. Ironically, the developmental task of today's learners involves the discovery and recreation of concrete and conceptual tools inherited from past generations. Through the appropriation and application of these cultural tools, learners become a medium for and makers of meaning and history (Vygotsky, 1978, 1986).

Meaning making derives both content and significance from communications in the ZPD. The ZPD acts as a bridge to provide access between meaning makers and learning resources in a variety of forms and manners. Young children and novices are socialized into thought communities because in appropriating thought and signs together, meaning making is born. From the womb to the tomb, cultural knowledge and social practices from ever-widening circles are internalized through interactional exchanges, joint activities, and scaffolded experiences. In this manner, we gradually nurture a larger depth and greater breadth of understandings.

Creativity

Within Vygotsky's developmental framework, creativity as a process includes children's play, imagination, and fantasy. It is a transformative activity where emotion, meaning, and cognitive symbols are synthesized. He focuses on everyday or mundane creative activities as well as the construction of creative artifacts or products which can have a lasting impact across generations emphasizing, "No accurate cognition of reality is possible without a certain

element of imagination, a certain flight from the immediate, concrete, solitary impressions in which this reality is presented..." (Vygotsky, 1987, p. 349).

While early play provides the beginnings of the 'construction of the new' so basic to creative processes, Vygotsky also emphasized the importance of de-sire–driven fantasy, which emerges more powerfully during adolescence. That is also a period when young people become more reflective and critical, thereby combining fantasy and cognition. Such a connection is basic to sus-tained exploration including the pursuit of diverse styles in the arts and modes of inquiry in the sciences. During adolescence the tension between social and individual processes is resolved in new ways, giving rise to works that, while frequently imitative, also provide the sources for future, more original, direc-tions. Emotional support from family, teachers, and friends is crucial when young creative individuals are making difficult choices; they are engaged in transforming artistic knowledge acquired through apprenticeships into their first independent endeavors.

In *Notebooks of the Mind*, John-Steiner (1997;1985) wrote about this pas-sage as recalled by composers. Igor Stravinsky, as a young man, was taught by the Russian composer Rimsky-Korsakov: "Once a week I took my work to him and he criticized and corrected it, giving me all the necessary explanations, and at the same time he made me analyze the form and structure of classical works. A year and a half later I began the composition of a symphony. As soon as I finished one part of a movement I used to show it to him, so that my whole work, including the instrumentation, was under his control" (1985, p. 147). In this passage, Stravinsky exemplifies how becoming a composer involves a deep engagement with a mentor and the practice of the ZPD. While Stravinsky uses the term "control," the passage shows the power of scaffolding in the achieve-ment of mastery and then the move into innovation.

Early in his career, Vygotsky wrote in *The Psychology of Art* that art "intro-duces the effects of passion, violates inner equilibrium, changes will in a new sense, and stirs feelings, emotions, passions and vices without which society would remain in an inert and emotionless state" (1925/1971, p. 249). Tradi-tionally, creativity has been studied as an individual process, a result of predis-position, talent, apprenticeship, and recognition of prevalent trends. In contrast, Vygotsky saw a dialectical relationship between the individual and her/his world. In one of his essays on *Imagination and Creativity in Childhood*, he wrote, "every inventor, even a genius, is always the outgrowth of his time and environment. His creativity stems from those needs that were created be-fore him, and rests upon those possibilities that, again, exist outside of him" (Vygotsky quoted in van der Veer and Valsiner, 1991, p. xi). This theme per-vades the three sections of this book. The first section, entitled "Theoretical

Foundations" will further elaborate a sociocultural approach to play, meaning making, and creativity. The second section, "Domains of Artistic Expression" will describe how Vygotsky's legacy has been implemented in studies of literature, dance and the visual arts. The final section and conclusion, "Connections between Creative Expression, Learning, and Development" will elaborate how educational practices might embody the principles of play, imagination, and art to foster greater human growth and understanding.

The view of creativity as part of social life is presented in a variety of ways in the subsequent chapters. Some authors focus on improvisation as a joint activity between dancers and choreographers. Other scholars see it as collaboration between teachers, researchers and students. In performances based on such joint activities, the traditional dichotomy between everyday or "mundane" creativity and transformative creativity, which profoundly changes a human domain of knowledge in the arts or sciences, is attenuated. In the creativity literature, a distinction is frequently made between "c" or the novel solutions or approaches we invent in daily life and "C" attributed to the deep engagement of creative individuals in their lifelong pursuit in expanding our human legacy. In Vygotsky's view, "creativity exists not only where it creates great historical works, but also everywhere human imagination combines, changes, and creates anything new" (Vygotsky, 1998, p. 90). The activity of improvisation becomes ephemeral if it is not linked to the enduring discipline of building on past work while also being governed by a broad vision and a passion for one's task. In focusing on children and adolescents, Vygotsky highlighted the developmental processes that lead to the construction of the new. Play, fantasy, conceptual understanding, and creative imagination are all imbedded in the cultural and social processes that make human life possible. In *The Psychology of Art*, he first formulated his important principle that creative work is profoundly social:

> Art is the social within us, and even if its action is performed by a single individual it does not mean that its essence is individual...art is the social technique of emotion, a tool of society which brings the most intimate and personal aspects of our being into the circle of social life...it would be more correct to say that emotion becomes personal when every one of us experiences a work of art: it becomes personal without ceasing to be social... (Vygotsky, 1925/1971, p. 249).

In this book, the contributors expand this cultural historical framework and show how creativity, in all its manifestations, is woven together with learning, teaching, discovery, and transformational change.

References

John-Steiner, V. (1985). *Notebooks of the mind: Explorations of thinking* (1st ed.). Albuquerque: University of New Mexico Press.

John-Steiner, V. (1995). Cognitive pluralism: A sociocultural approach. *Mind, Culture and Activity, 2,* 2–11.

John-Steiner, V. (2000). *Creative collaboration.* Oxford, UK; New York: Oxford University Press.

Mahn, H., & John-Steiner, V. (2002). The gift of confidence: A Vygotskian view of emotions. In C. G. Wells & G. Claxton (Eds.), *Learning for life in the 21st century.* Oxford, UK: Blackwell, pp. 46–58.

Tomasello, M. (2008). *Origins of human communication.* Cambridge, MA: MIT Press.

van der Veer, R., & Valsiner, J. (1991). *Understanding Vygotsky: A quest for synthesis.* Oxford, UK; Cambridge, MA: Blackwell.

Vygotsky, L. S. (1925/1971). *The psychology of art.* Cambridge, MA: MIT Press.

Vygotsky, L. S. (1927/1997). The historical meaning of the crisis in psychology: A methodological investigation. In R. W. Rieber & J. Wollock (Eds.), *The collected works of L.S. Vygotsky* (Vol. 3, pp. 233–343). New York: Plenum Press.

Vygotsky, L. S. (1930/2004). Imagination and creativity in childhood. *Journal of Russian and Eastern European Psychology, 42*(1), 7–97.

Vygotsky, L. S. (1933/1976). Play and its role in the mental development of the child. In J. S. Bruner, A. Jolly, & K. Sylva (Eds.), *Play–Its role in development and evolution* (pp. 537–554). New York: Penguin Books Ltd.

Vygotsky, L. S. (1934/1986). *Thought and language* (A. Kozulin, Trans. rev. ed.). Cambridge, MA: MIT Press.

Vygotsky, L. S. (1962). *Thought and language.* Cambridge, MA: MIT Press.

Vygotsky, L. S. (1978). *Mind in society: The development of higher psychological processes.* Cambridge, MA: Harvard University Press.

Vygotsky, L. S. (1987). Imagination and its development in childhood (N. Minick, Trans.). In R. W. Rieber & A. S. Carton (Eds.), *The collected works of L.S. Vygotsky* (Vol. 1, pp. 339–350). New York: Plenum Press.

Vygotsky, L. S. (1990). Imagination and creativity in childhood. *Soviet Psychology, 28*(10), 84–96.

Wells, C. G. (1999). *Dialogic inquiry: Towards a sociocultural practice and theory of education.* Cambridge, UK; New York: Cambridge University Press.

Wertsch, J. V. (2007). Mediation. In H. Daniels, M. Cole, & J. V. Wertsch (Eds.), *The Cambridge companion to Vygotsky.* New York: Cambridge University Press, pp. 178–192.

The Historical Significance
of Vygotsky's Psychology of Art

M. Cathrene Connery

W Hat is art? What is the relationship between the artist, viewer and creative object or event? What is the function and value of art in individual and collective life? As a young scholar, L.S. Vygotsky deliberated the answers to these essential questions. His family life and education were enriched by a passion for literature, drama, and painting. Between Vygotsky's nineteenth and twenty-fifth birthdays, he developed a series of preliminary, yet profound answers to his inquiries. At the age of twenty-nine, his initial analyses were incorporated into his doctoral dissertation and first major work entitled *The Psychology of Art* (1925).

This text establishes emotion and creativity as cornerstones of Vygotsky's thinking, topics to which he returned intermittently throughout his life. Indeed, through his examination of aesthetics, history, and criticism of human creation, Vygotsky developed some methods of analysis which led him to transform existing approaches and develop the dialectical syntheses of intellect /emotion; thought / sign; and individual / society.

While a few critics have regarded the *Psychology of Art* as the product of immature scholarship, this seminal work offers a window into Vygotsky's formative views on the creative process, providing contemporary theorists, researchers and practitioners with the foundational concepts upon which a more articulated theory can be developed. Toward this end, this chapter highlights the historical significance of Vygotsky's formative work as well as his perspectives on the triadic relationship between the artist, audience, and creative product. The chapter will also present his reflections on the psychobiological origins of art, the experience of catharsis through the creative process and aesthetic response, as well as the transformative value of art.

Vygotsky's doctoral dissertation included a meticulous critique spanning Freudian theory, German idealist philosophy, Wundt's psychology and the aesthetics of Russian formalism. Vygotsky deliberately deconstructed and criticized these ideologies of his time, ingeniously uniting individual and collective trends in aesthetics that had traditionally been posed in opposition to each other. Scholars had previously viewed the psychological and sociological dimensions of art to be like the two ends of a rope. By juxtaposing and then bringing these two endpoints together in a circular fashion, Vygotsky pointed out the dialectical relationship between these concepts creating a novel philosophical system. His methodological application of dialectics distinguishes his work from his contemporaries.

In addition, Vygotsky dismissed previous notions regarding the transmission of creative products as central to their function. In breaking with scholarly tradition, the *Psychology of Art* places emotion at the heart of creative processes. His theory of catharsis, elaborated below, and his opposition to simple dichotomies motivated him to work toward a theory more fully realized in his later works that still provides a model for contemporary scholars. Vygotsky's approach prompts reconsideration of psychological processes such as learning, meaning making, and communicating as cultural-historical practices rooted in emotion. In the *Psychology of Art*, Vygotsky had not fully formulated the productive integration of these processes and how they develop and change historically and culturally, but he progressed toward a theory more fully realized in his later works.

The Triadic Relationship between Artist, Audience and Artistic Product

Who is the artist? In contrast to Western notions of an isolated individual working within a solitary venue, Vygotsky viewed the artist as a social person collectively engaged in the cognitive-affective processes of creation with other community members. During the creative process, the artist appropriates the legacy of her selected genre including the implicit ideologies of its cultural-historical canon. This creative heritage interacts with the artist's unique problem-solving process and is further transformed by the productive forces, economic conditions, and sociopolitical constructs that impact the artist's psychological processes.

Who is the audience? Vygotsky identified those persons who experience aesthetic outcomes and obtain novel understandings from creative products as spectators, viewers, and readers. The individual or group that constructs new knowledge through symbolic connection does so from both the *primary* cultural circle in which the piece was conceived and constructed, as well as the

secondary cultural context in which the creative product is experienced. Vygotsky also viewed the aesthetic response as both intra-personal (within an individual) and inter-personal (between individuals) processes. He characterized the roles of the spectator, reader, and viewer as active and dynamic.

What is the creative product? According to Vygotsky, the creative product is not a stand-alone idea or object imposed on a physical form, rather, it includes the original elements that exist *prior* to the complete realization of the creative product or event. He contended that an artist's actual work involves the cognitive-affective processes of the painter, dancer, flutist, or poet as well as the resultant artifact or event. The young scholar viewed abstract and concrete components as a dialectic residing *within* a product itself. In other words, the artist infuses significance inside a creative artifact or event, resulting in the physical and psychological synthesis of content.

Content takes on an allegorical resemblance or symbolic manifestation through form. The young psychologist did not consider form to be a static shape or impression imposed on letters, wood, clay or character. Instead, form results from a synergistic interaction between the artist's work (cognitive-affective processes) and content (abstract and physical properties) inherent in the piece itself. In this manner, Vygotsky referred to form as an action or *verb*, "[an] artistic arrangement of the given material, made with the purpose of generating a specific aesthetic effect" (p. 53).

Interestingly, Vygotsky distinguishes between the artistic product and art per se. Vygotsky affirmed that, together with language, myth, custom, religion, laws, and ethical standards, art exists as the physical manifestation of an idea in motion. Despite the diversity of artistic genres, all creative objects and events organize sign, symbol, and pattern into an outer form, an inner form, and a core element. For example, the outer form of a sculpture consists of its material, such as bronze, while the outer form of a song is established by its melody. The inner form of a creative product incorporates the image, sensation, or idea encapsulated by the outer form. The inner form of the same piece of sculpture might appear as a blind-folded woman standing with a sword in one hand and a set of scales in another. The inner form of an African–American spiritual might relate the journey of Moses and his people to the Promised Land.

In contrast to these empirical dimensions, the core element of a piece of art reflects the significance of the object or event hidden within the inner form: the allegorical representation of Justice constitutes the symbolic meaning of the sculpture; the core of the song relates the hopeful escape of slaves on the Underground Railroad.

Art condenses reality and the phenomena of life in ways that humans are not capable of experiencing in their daily lives. In this manner, Vygotsky attested that art includes "something above and beyond its normal, conventional content" that allows artist and audience to journey beyond "feelings of fear and pain" (p. 243). For example, when viewing the previously mentioned sculpture, an individual might experience a powerful sense of relief and assurance while simultaneously experiencing the elusive ideal of justice manifested within the concrete, authoritarian solidity of the metal placed in the context of a violent world. The rhythmic patterning of sound in the spiritual performance discussed earlier in this chapter might reach a crescendo where chorus and congregation momentarily experience a sense of sweet release of embracing their Maker at the height of the song. Vygotsky ascertained such profound, emotional states are rooted in a complex, transformative psychological process developed by early humans.

The Psychobiological Origins of Art

Why did art-making evolve as a unique activity of the human species? The Greeks first proposed that art originated as a by-product of economic activity. While Vygotsky acknowledged the relationship between art and trade or financial interchange, in contrast, he argued that art originated from an internal psychobiological source. His theory postulates that revolutionary advances in the cerebral cortex of early humans initiated the replacement of instinct with consciousness. As a result of this new psychological functioning, human beings came to rely on the use of multi-modal signs to assist in controlling the often unstable and threatening environment that surrounded them. As symbolic constructions created by the mind, these signs are differentiated from random movements, gestures, and sounds and result in integrated patterns. Patterns, when systematized, become rhythms.

Vygotsky ascertained it was not coincidental that ancient peoples viewed rhythmic pattern as an archway into the mystical world. The alluring qualities of rhythm in dance, drumbeat, and chant were employed to evoke and induce apparitions from the spirit world in order to make requests, prayers, and voice grievances. In this manner, the systematic application of rhythmic sign was believed to potentially correct or even redirect the future. Many traditional communities believe that tonal rhythm soothes the heart and can potentially cure the body/mind. Modern science is supporting these assertions. Whether birthed of dance, decoration, or drum, the use of rhythmic pattern originated as a form of visual, verbal, or kinesthetic discourse. Diverse communities em-

ploy these multimodal, rhythmic signs to communicate, heal, and connect with powers greater than their own.

Vygotsky exemplified his theory of the psychobiological origins of art using music. The application of aural rhythmic pattern in songs evolved as a response to arduous labor. Patterned rhythms assist humans engaged in strenuous work through a song's capacity to organize, support, and regulate physical movement, thereby providing relief and relaxation from continuous effort. He observed that the lyrics of work songs characteristically express the voice of the work as well as that of the workers themselves. Universal themes regarding the nature and length of the activity, the hopes and dreams of the laborers, and their position to authority weave their way across continents, cultures, and tunes.

Vygotsky pointed to dance as a second example of the psychobiological origin of art. He maintained systematic, rhythmic use of kinesthetic pattern directly correlates with the need to continuously re-establish homeostasis with one's environment. The exercise of visual, aural, and kinesthetic rhythms have traditionally aided human beings during times of great joy and distress or as an accompaniment to profound life rituals or passages. Thus, he proposed that the foundations of art are rooted in the human need to manage and release intense physical, mental, or emotional strain.

An Alternative View of Catharsis

What was Vygotsky's view on catharsis? In order to achieve his own definition, he examined several traditions, outlining the genesis of the term. The Greeks first referred to catharsis as the physical purging of excrement from the intestines. Aristotle extended this meaning to a form of emotional purification achieved through vicarious experience. In time, Grecian culture came to view drama and music as artistic products with the potential of favorably inducing moral purgation. While the concept of catharsis later assumed Christian connotations of purity through the use of self-flagellation and torture, Vygotsky noted the triadic association between emotion, healing or cleansing, and the arts to be firmly rooted in antiquity. In the *Psychology of Art*, the young scholar additionally presented Freud's view of catharsis as the abreaction of unconscious, pan-sexual conflicts dormant since youth. Freudian theory posited catharsis as a central feature of psychoanalysis whereby the analyst seeks to facilitate the relief of intense emotions by linking his patient's affective states with childhood memories.

In a meticulous critique of these schools of thought, Vygotsky rejected ca-
tharsis as a psychological event derived from a negative malaise of the body or
mind. Instead, he defined the cathartic process as a natural, innate, and
healthy psychological need of all individuals and the societies which they in-
habit. Questioning the notion of the unconscious mind, Vygotsky argued that
all thought and emotion are consciously experienced to a lesser or greater de-
gree. His writings suggest that affective and intellectual knowledge subsist at
various locations along a continuum of consciousness, subject to movement
from one state of realization to another.

The transformative potential of emotions is a central feature of Vygotsky's
alternative view of catharsis. He considered feelings to be the "pluses and mi-
nuses" or "discharges and expenditures of unused energy" (p. 246). Character-
izing the nervous system as a constantly active battlefield or relentless funnel,
Vygotsky advised, "The world pours into man...thousands of calls, desires,
stimuli, etc. enter but only an infinitesimal part of them is realized and flows
out through the narrow opening. It is obvious that the unrealized part of
life...must somehow be utilized and lived" (p. 247). He noted that "a need
arises from time to time to discharge the unused energy and give it free reign
in order to re-establish our equilibrium with the rest of the world" (p. 246).
Employing the metaphor of a tea kettle, Vygotsky asserted that our psyches
occasionally require the release of "steam pressure" or emotion, when it "ex-
ceeds the strength of the vessel. Apparently, art is a psychological means for
striking a balance with the environment at critical points of our behavior" (p.
247).

While Vygotsky recognized that contemporary artistic endeavors appear to
be detached from their work-related origins, he asserted art retains its early
psychobiological roots today as a means by which catharsis might be achieved
by individuals and societies. The young psychologist observed that the artist,
per se, independently "introduces into the work of art the element which was
formerly generated by labor: the feelings of pain, torment, and hardship
(which require relief) are now aroused by art itself, but their nature remains
the same" (p. 245). In other words, the psychobiological origins of the ancient
pyramid builder's song laid the foundation for the hip-hop listener and sym-
phony audience to experience relief and relaxation when engaged with music.
Art has endured as a means to consolidate the vast amount of phenomena
encountered in the rigors of everyday living, providing a vessel to achieve cog-
nitive-affective balance. The biological basis of art confirms its relevance as a
requisite tool in the struggle for existence, affording "the possibility of releas-
ing into art powerful passions which cannot find expression in normal, every-
day life" (p. 246).

Catharsis and the Artistic or Aesthetic Response

How does the cathartic function of art occur in individual and collective life? Vygotsky observed that artists and audiences alike can achieve the transcendent resolution of emotion by engaging in the reciprocal processes of creative production and aesthetic response.

Catharsis originates with the artist's need or desire to engage in the creative process. As a community member and cultural-inheritor of the genre, the artist relies on an intense association between feeling, imagination, and sign systems. The representation of meaning through symbolic means aligns with the artist's understanding of the relational capabilities of her medium and the perceptual capacities of the human brain. The artist draws on a conglomerate of symbolic patterns and rhythms afforded by the content, genre, and material to purposely summon an aesthetic response on the part of the audience by means of the resultant artifact or event.

Vygotsky identifies three parts to this artistic or aesthetic response: "the contrast discovered by us in the structure of artistic form and that of artistic content" creates the rhythmic pattern which enables catharsis to occur (p. 215). The first two components include conflicting art elements. Vygotsky pointed to the contrast between material and form in sculpture. He noted, "It is remarkable that the artist forces the stone to take on the shape of plants to sprout branches, to bear leaves, to blossom" (p. 237).

When juxtaposed, the physical, concrete or outer form of a creative product clashes with its psychological, abstract, inner core or significance to create the third component Vygotsky identified as rhythm. In architecture, Vygotsky observed, "the lightness and transparency that the Gothic architect manages to draw up from the heavy, inert stone is the best corroboration of this idea" (p. 237). The contrast between a cathedral's "material massiveness" and "triumphant vertical" creates a rhythm "which makes the viewer feel the whole edifice striving upward with tremendous force" (p. 237).

In catharsis, the artist or viewer interacts with the rhythmic patterns of the creative product or event in a "process of breaking up and associating what has been read [or viewed] with the emotions previously stored in the mind" (p. 81). The dialectic that occurs between internal and external texts is realized in material, relational, and psychological transformations. Such r/evolutions potentially lead the artist and/or audience to emotional release.

For example, the effect and content of a creative work often contrast to form the beat of the cathartic rhythm as evidenced in comedy, drama, and tragedy. These two contrasting elements develop into two separate trajectories, ultimately meeting at a single point of emotional culmination. Vygotsky ex-

plained that "the spectator or reader's feelings of anger, horror, regret, or grief as they witness the struggle of the plot are transformed into hope, enthusiasm, and happiness at the moment of the protagonist's destruction" (p. 232). The cathartic dynamic results in "the creative act of overcoming feeling, resolving it, conquering it" (p. 248) and is achieved as "painful and unpleasant affects are discharged and transformed into their opposites...[as] a complex transformation of feelings" (p. 214). Vygotsky was so captured by these transformative properties that he observed "art's true nature as transubstantiation" (p. 243).

The Social Technique of Emotion

The following formulation provides the most important bridge between Vygotsky's work on art and his later work on the unification of the social and individual spheres of experience. He explained that the aesthetic response does not generate immediate action. Rather, like an earthquake revealing concealed strata below the crust, art "opens the way for the emergence of powerful hidden forces within us" (p. 253). In addition to achieving intense emotional release, catharsis produces novel forms of understanding characterized by the integration of intellect and affect. When encountering Michelangelo's *Pietá* for the first time, a viewer might experience a sudden, novel, and pristine sense of the physical mortality of the man named Jesus Christ.

Vygotsky ascertained that everyday emotions evolve into artistic feelings through heightened activity of the imagination of the artist and the audience. Catharsis produces the *emotional knowledge* of an embodied image or concept. For example, most people can identify the emotion of fear as a common, recognizable, and fleeting affective state. Munch's painting, *The Scream*, provides a distinct "secondary" form of expression that dramatically captures the cognitive-affective notion of fear. In this manner, "art is the social technique of emotion, a tool of society which brings the most intimate and personal aspects of our being into the circle of social life" (p. 249). In other words, the artist infuses their internal, private, individual feelings into a work of art. Their emotion is "objectivized, materialized, and projected outside of us" (p. 249) within an external, public, and social event. The reciprocal processes of aesthetic creation and response allow us to personalize the universal and universalize the personal, potentially inspiring us to organize our future behavior.

The Transformative Value of Art

Vygotsky's conclusion in the *Psychology of Art* emphasizes that the cathartic potential of art offers a host of evolutionary benefits to individuals and commu-

nities alike. The aesthetic response relieves, exposes and refreshes the individual and collective psyche like opening a window after the rain. In calling dormant, sequestered, or dispossessed emotions forward to the present, a terrific energy is relinquished, re-establishing emotional flow. This discharge of untapped energy "introduces order and harmony into the psychic household of our feelings" (p. 248) at independent and communal levels. As perceptual reality, emotion, and knowledge are transformed into higher forms of consciousness, art provides the vehicle by which artist / audience is able to mediate beyond their individual realities to collectively experience a more profound comprehension of truth as it relates to the human species (Leont'iev, 1971 in Vygotsky, 1971).

Creative ingenuity is not bound to the past; artists serve our culture as agents who actively construct the tools by which we draft blueprints for the future. Herein lies the human potential for cultural, conceptual or evolutionary change: Facilitating action, art is the muse who awakens us from our affective slumber, inspiring individuals, groups, communities, and cultures to conquer the past and advance undeterred into the future.

Reference

Vygotsky, L. S. (1925/1971). *The psychology of art.* Cambridge, MA: MIT Press.

Without Creating ZPDs
There Is No Creativity

Lois Holzman

When discussing the essential role of play in early child development, Vygotsky remarked, "In play a child always behaves beyond his average age, above his daily behavior; in play it is as though he were a head taller than himself" (Vygotsky, 1978, p. 102). In this chapter I will explore that marvelous metaphor "a head taller" in the context of investigating the mundane creativity that is and produces human development and learning. In other words, my focus here is on the *collective activity of creating*. I am interested in how social units create environments in which they qualitatively transform themselves and their environments. I propose an understanding of creativity as socially imitative and completive activity. I have come to this understanding from immersion in a quarter-century of intervention research that actualizes the "head taller" experience for people across the life span by allowing, inviting, and guiding them to create zones of proximal development (ZPDs). This research, serving only as a backdrop for the present discussion, is discussed in other writings, the most recent being *Vygotsky at Work and Play* (Holzman, 2009).

A ZPD Is a ZPD—Or Is It?

Even though Vygotsky's ZPD is essential to his understanding of *the relationship between development and learning and play*, it has become, in our time, more narrowly associated with learning and the school-like acquisition of knowledge and skills. Part of what I want to do in this discussion is restore the complexity, radicalness, and practicality of Vygotsky's discovery of the ZPD.

The ZPD is important in Vygotsky's rejection of the popular belief that learning follows and is dependent upon development and in his related criticism of traditional teaching: "Instruction would be completely unnecessary if it merely utilized what had already matured in the developmental process, if it were not itself a source of development" (Vygotsky, 1987, p. 212). Rejecting the view that learning depends on and follows development, Vygotsky put forth a new relationship between these two activities: "The only instruction which is useful in childhood is that which moves ahead of development, that which leads it"(p. 211) pushing it further and to elicit new formations. In other words, for Vygotsky *learning leads development*. In previous works, I refer to this discovery as not merely a new relationship but as a new *kind* of relationship (at least for psychology) the dialectical unity learning-leading-development. I do this to capture the way Vygotsky sees learning and development as a totality and change as qualitative transformation of the whole (Holzman, 1997; F. Newman & Holzman, 1993).

The question of how learning leads development depends, at least in part, on how we understand what the ZPD is. As the most popularized concept stemming from Vygotsky's writings, the ZPD has been given multiple interpretations by educational researchers, psychologists, and others. Different meanings can be traced, in part, to different translations of his writings (Glick, 2004) and from the numerous contexts in which Vygotsky wrote about the ZPD. In briefly reviewing some of these contexts, understandings, and implications that follow from them, I will bring together Vygotsky's comments from diverse sources and provide the backdrop for the view I am putting forth.

Individual

A common understanding of the ZPD is that it is a characteristic or property of an individual child. This understanding stems from passages like the following:

> The psychologist must not limit his analysis to functions that have matured. He must consider those that are in the process of maturing. If he is to fully evaluate the state of the child's development, the psychologist must consider not only the actual level of development but *the zone of proximal development* (Vygotsky, 1987, pp. 208–9).

To some educational researchers this translates into the ZPD being or producing a measure of a child's potential, and they have devised alternative means of measuring and evaluating individual children (for example, Allal & Pelgrims, 2000; Lantolf, 2000; Lidz & Gindis, 2003; D. Newman, Griffin, & Cole, 1989; Tharp & Gallimore, 1988).

Dyadic

In other passages, however, the ZPD plays a key role in Vygotsky's argument that learning and development are fundamentally social and form a unity. Joint activity and collaboration in children's daily lives are also implicated, as in the following passage:

> What we call the Zone of Proximal Development...is the distance between the actual developmental level as determined by independent problem solving, and the level of potential development as determined through problem solving under guidance or in collaboration with more capable peers (Vygotsky, 1978, p. 86).

Perhaps it was the phrase "more capable" that led to the conceptualization of the ZPD as a form of aid termed prosthesis by Shotter (1989) and Wertsch (1991) and scaffolding by Wood, Bruner and Ross (1976). This conceptualization has become so popular that the typical college textbook equates the ZPD with scaffolding and (incorrectly) attributes both terms to Vygotsky (for example, Berk & Winsler, 1995; MacNaughton & Williams, 1998; Rodgers & Rodgers, 2004). Moreover, despite Vygotsky's mention of "peers" in the passage above, most empirical research with this perspective takes "the aid" to be a single, more capable individual, most often an adult (termed "expert" in contrast to the "novice" child).

In keeping with this dyadic interpretation of the ZPD, it is common for "social level" and "interpsychological" to be reduced to a two-person unit in the following oft-quoted passage:

> Every function in the child's cultural development appears twice: first on the social level and later, on the individual level; first *between* people (*interpsychological*), and then *inside* the child (*intrapsychological*). This applies equally to all voluntary attention, to logical memory, and to the formation of concepts. All the higher mental functions originate as actual relations between people (Vygotsky, 1978, p. 57).

Collective

At other times Vygotsky emphasized more clearly that the socialness of learning-leading-development is collective, that the ZPD is not exclusively or even primarily a dyadic relationship, and that what is key to the ZPD is that people are doing something together. For example, "Learning awakens a variety of internal developmental processes that are able to operate only when the child is interacting with people in his environment and in cooperation with his peers" (Vygotsky, 1978, p. 90).

The necessity of collective activity that Vygotsky attributes to the learning-development relationship is at the forefront of his approach to special educa-

tion. His writings on this subject (collected and published in English as *Fundamentals of Defectology*, 1997) argue that children with abnormalities such as retardation, blindness or deafness can indeed develop. They should not be written off or remediated, nor should these children be segregated and placed in schools with only children like themselves. Vygotsky made the point that qualitative transformation (as opposed to rote learning) is a collective accomplishment, a "collective form of 'working together'" he called it in an essay entitled, "The Collective as a Factor in the Development of the Abnormal Child" (Vygotsky, 2004, p. 202). In this same essay he characterized the social, or interpsychological, level of development (Vygotsky, 2004, p. 4) as "a function of collective behavior, as a form of cooperation or cooperative activity" (p. 202).

I like that phrase, "a collective form of working together." It seems a good fit with my experience as researcher, teacher, and trainer. I read Vygotsky here as saying that the *ZPD is actively and socially created*. This is beyond and perhaps other than the popular conception of the ZPD as an entity existing in psychological-cultural-social space and time. For me, the ZPD is more usefully understood as a process rather than as a spatio-temporal entity and as an activity rather than a zone, space or distance. Furthermore, I offer the *ZPD activity* as the simultaneous creating of the zone (environment) and what is created (learning-leading-development).

Creativity

The concept of ZPD activity provides a new way to understand human development that puts creativity center stage. Not creativity as typically understood, however. For in both everyday and psychological discourse, creativity is taken to be an attribute of individuals. Further, creative individuals are understood to produce special things, original, novel, unique, and perhaps extraordinary or extraordinarily significant items, relative to others who are "not creative." The kind of creativity I am talking about in relation to ZPD activity is not an attribute of individuals but of social units (e.g., dyads, groups, collectives, and so on), and it is not special or extraordinary but ordinary and everyday. (Yet, while mundane, it is also magical!)

How do social units create ZPDs? For one thing, we must be capable of doing what we do not know how to do, either individually or collectively. Human beings learn and develop without knowing how or that we know. In other words, *we become epistemologists without employing epistemology*. Vygotsky recognized this seeming paradox of human life, at least in its early childhood

version. He understood that developmental activity does not require knowing how, as when he identified "the child's potential to move from what he is able to do to what he is not" (Vygotsky, 1987, p. 212) as the central characteristic and creative activity of learning leading development.

Further, he understood that for young children, knowing how to do a particular thing does not require knowing that they are doing this particular thing. As he put it, "...before a child has acquired grammatical and written language, he knows how to do things but does not know that he knows...In play a child spontaneously makes use of his ability to separate meaning from an object without knowing that he is doing it, just as he does not know he is speaking in prose but talks without paying attention to the words" (Vygotsky, 1978, p. 99). This thread of Vygotsky's thought has, to my way of thinking, been neglected, not only in the study of early childhood but also in its implications for understanding and fostering development throughout the life span. If children do not need to know, why do the rest of us (Holzman, 1997; F. Newman & Holzman, 1997)? This question has been debated vigorously by postmodernists, of course, but very little by cultural historical activity theorists, a situation I have tried to remedy (see, for example, Holzman, 2006a).

Inspired by Vygotsky's insights on how very young children and children with disabilities go beyond themselves and participate in ZPD activity (creating environments for learning–leading development and simultaneously learning leading–development), my work has been to expand this creative methodology through collaboration with others in building "ZPD-creating-head taller" therapeutic, educational, and organizational practices and simultaneously studying the practices we have built. Development, from this perspective, is the practice of a *methodology of becoming* in which people shape and reshape their relationships to themselves, each other, and to the material and psychological tools and objects of their world.

Imitation

Thus far, I have suggested that from a developmental and educational perspective it is useful to understand ZPDs as actively created, that the creators are social units rather than individuals, and that the creative ZPD activity is a non-epistemological methodology of becoming. What is this methodology? In other words, what does being a head taller look like?

The answer requires taking a new look at imitation. Along with not knowing, imitation has been overlooked by socio-cultural researchers in my opinion. And as with not knowing, I suggest that imitation is necessary for

creativity in general and for creating ZPDs in particular. In relation to ZPDs, I take my cue from Vygotsky: "A full understanding of the concept of the zone of proximal development must result in a reevaluation of the role of imitation in learning" (1978, p. 87).

As part of his re-evaluation, Vygotsky discounted an essentially mechanistic view of imitation that was "rooted in traditional psychology, as well as in everyday consciousness" (Vygotsky, 1987, p. 209). He was also wary of the individualistically biased inferences drawn from such a view, as for example, that "the child can imitate anything" and that "what I can do by imitating says nothing about my own mind" (1987, p. 209). In its stead, Vygotsky posited that imitation is a social-relational activity essential to development noting, "Development based on collaboration and imitation is the source of all specifically human characteristics of consciousness that develop in a child" (1987, p. 210).

Children do not imitate anything and everything as a parrot does, but rather what is "beyond them" developmentally speaking and yet present in their environment and relationships. In other words, imitation is fundamentally creative, by which I mean that it helps to create the ZPD. The kind of language play that typifies conversations between very young children and their caregivers can perhaps provide clarity on this point. Here is one of Vygotsky's many descriptions of early childhood language development. It is a difficult passage, one that I have to re-discover the meaning of each time I read it:

> We have a child who has only just begun to speak and he pronounces single words... But is it fully developed speech, which the child is only able to master at the end of this period of development, already present in the child's environment? It is, indeed. The child speaks in one word phrases, but his mother talks to him in language which is already grammatically and syntactically formed and which has a large vocabulary... Let us agree to call this developed form, which is supposed to make its appearance at the end of the child's development, the final or ideal form. And let us call the child's form of speech the primary or rudimentary form. The greatest characteristic feature of child development is that this development is achieved under particular conditions of interaction with the environment, where this...form which is going to appear only at the end of the process of development is not only already there in the environment...but actually interacts and exerts a real influence on the primary form, on the first steps of the child's development. *Something which is only supposed to take shape at the very end of development, somehow influences the very first steps in this development* (Vygotsky, 1994, p. 348).

Both developed and rudimentary language are present in the environment, Vygotsky tells us. In that case, what is environment? If both forms of

language are present, then environment cannot be something fixed in space and time nor separate from child and mother. Rather, it seems that environment must be both what is the specific socio-cultural-historical conditions in which child and mother are located, and what is coming into existence, the changed environment being created by their language activity. In other words, this environment is as much activity as it is context. In their speaking together, very young children and their caregivers are continuously reshaping the "rudimentary" and "developed" forms of language. It is this activity, I suggest, that is and creates the ZPD, and through which the child develops as a speaker, meaning maker, and language user.

Completion

Along with imitation there is another activity taking place in the creating of the language-learning ZPD: completion. This idea is based in Vygotsky's understanding of the relationship between thinking and speaking, in which he challenged the expressionist view of language (that our language expresses our thoughts and feelings). Speaking, he said, is not the outward expression of thinking but part of a unified, transformative process. Two passages from *Thinking and Speech* are especially clear in characterizing his alternative understanding:

> The relationship of thought to word is not a thing but a process, a movement from thought to word and from word to thought... Thought is not expressed but completed in the word. We can, therefore, speak of the establishment (i.e., the unity of being and nonbeing) of thought in the word. Any thought strives to unify, to establish a relationship between one thing and another. Any thought has movement. It unfolds (Vygotsky, 1987, p. 250).

The structure of speech is not simply the mirror image of the structure of thought. It cannot, therefore, be placed on thought like clothes off a rack. Speech does not merely serve as the expression of developed thought. Thought is restructured as it is transformed into speech. It is not expressed, but completed in the word (Vygotsky, 1987, p. 251).

Instead of positing a separation into two realms: the private one of thinking and the social one of speaking. There is just one: speaking/thinking, a dialectical unity in which speaking *completes* thinking. Vygotsky was delineating the thinking-speaking process for individuals, but his conceptualization can be expanded in the following way. If speaking is the completing of thinking, if the process is continuously creative in socio-cultural space, then the "completer" does not have to be the one who is doing the thinking. Others can

complete for us (Newman and Holzman, 1993; Holzman, 2009). Think about it. Would children be able to engage in language play/conversation before they knew language if thinking/speaking were not a continuously socially completive activity in which others were completing for them?

The ongoing activity of completion can be seen in the conversations that very young children and their speaking caregivers create, as in caregivers' typical responses to the single words and phrases of toddlers (e.g., Child: "Cookie!" Adult: "Want a cookie?" [getting a cookie and giving it to child] Child: "Mama cookie." Adult: "Yes, Mommy's giving you a cookie."). Like the child's imitations, completion is also a dominant activity of creating the language-learning ZPD. Together, imitation and completion comprise much of the language play that transforms the total environment, a process out of which a new speaker emerges.

The current culture too often loses sight of what I have presented: not its detail but its general common sense notions. Children do not learn language nor are they taught language in the structured, systematic, cognitive, acquisitional, and transmittal sense typical of later institutionalized learning and teaching. They develop as speakers, language makers, and language users as an inseparable part of joining and transforming the social life of their family, community, and culture. When babies begin to babble, they are speaking before they know how to speak or that they speak, by virtue of the speakers around them accepting them into the community of speakers and creating conversation with them. Mothers, fathers, grandparents, siblings, and others do not have a curriculum, give them a grammar book and dictionary to study, nor remain silent around them. Rather, they relate to infants and babies as capable of doing things that are beyond them. They relate to them as fellow speakers, feelers, thinkers, and makers of meaning. In other words, as fellow creators. This is what makes it possible for very young children to be as though a head taller.

Play

It is time to return to play, the activity to which Vygotsky attributed the "head taller" experience. His writing on play concerned young children's free play of fantasy and pretense, and the more structured and rule-governed playing of games that becomes frequent in later childhood.

All play, Vygotsky believed, creates an imaginary situation and all imaginary situations contain rules. It is the relationship between the two that changes with different kinds of play. In the game play of later childhood, rules

are overt, often formulated in advance, and dominate over the imaginary situation. The elements of pretend are very much in the background and rules are instrumentally necessary to the playing (Vygotsky, 1978). Think of basketball, video games, and board games.

In the earlier play of very young children, the rich meaning making environment of free and pretend play, the imaginary situation dominates over rules. The rules do not even exist until the playing begins, because they come into existence at the same time and through the creation of the imaginary situation. In Vygotsky's words, they are "not rules that are formulated in advance and that change during the course of the game, but ones that stem from an imaginary situation" (1978, p. 95). That is, they are rules created *in the activity of playing*.

When a young child takes a pencil and makes horse-like movements with it, in creating this imaginary situation s/he is simultaneously creating the "rules" (keep jumping, make whinnying sounds, don't write on the paper) of the play. When children are playing Mommy and baby, the new meaning that the imaginary situation creates also creates the "rules" of the play (for example, how Mommy and baby relate to each other "in character"). In these examples, at the same time as new meaning is being created with pencil, self, and peer, the "old" meanings of horse, pencil, Mommy, and baby are suspended from these objects and people. Both the old and the new meanings are present in the environment. This is analogous to creating language-learning ZPDs just discussed, in which environment is both the specific socio-cultural-historical conditions under which children play, and the changed environment being created by their play activity. Here, as in that case, environment is as much activity as it is context.

It is these elements of free or pretend play that, for Vygotsky, distinguish the play ZPD from that of learning-instruction ZPD:

> Though the play-development relationship can be compared to the instruction-development relationship, play provides a much wider background for changes in needs and consciousness. Action in the imaginative sphere, in an imaginary situation, the creation of voluntary intentions, and the formation of real-life plans and volitional motives—all appear in play and make it the highest level of preschool development (Vygotsky, 1978, pp. 102–3).

In making this distinction, to my way of thinking Vygotsky makes too sharp a break between playing and learning-instruction. Can't play be the highest level of preschool development and still be developmentally important across the life span? I think so. I think that Vygotsky overlooked some continuity between the two ZPDs, in part because he was so concerned with learn-

ing in formalized school contexts. This continuity, which I have come to believe has significance for later childhood and beyond, relates to the characteristics of creativity in ZPD activity that I have been discussing.

Learning Playfully Outside of School

It is a feature of our western culture (and most other cultures) that we relate to very young children as creative. I mean that both in the sense of creativity I have introduced here: their participation in creating ZPDs and in the more conventional sense of appreciating their individual products (scribbles, phrases, songs, dances, and so on). And we gradually stop doing so as they get older. We bifurcate learning and playing, trivializing play in the process, and have created institutionalized structures to maintain that bifurcation and trivialization. We introduce the concept of work. In nearly all schools the elements of ZPD-creating, freedom from knowing, creative imitation, and completion, are absent.

We also relate to the imitative activity of very young children as creative in both the mundane and the appreciative senses and we gradually stop doing that as they get older. Imitating becomes copying. What once gave delight is to be avoided. A child of three or four years is likely to be told she is clever or smart (or at least cute) for creatively imitating. In nearly all schools, a child of seven or eight is likely to be told she is cheating and shouldn't copy.

In the extreme, schooling transforms not knowing into a deficit; creative imitation into individualized accomplishments, rote learning and testing, and completion into correction and competition.

This is the current situation. This is what schools do and do not do. I am as concerned as the next person about it, but I am equally concerned with bringing informal learning to the forefront of dialogue and debate among educators, researchers, policy makers, and the public. This is because that is where creativity still lives. Putting on a play or concert and playing basketball as a team require the members to create a collective form of working together. Unfortunately, doing well in school does not. My reading of the literature on informal educational or learning programs, along with my own intervention research, shows that these programs (in particular, those involving the arts or sports) are more often than not learning-leading-development environments, methodologically analogous to early childhood ZPDs in a manner appropriate to school-aged children and adolescents. Whether deliberately or not, they continue to relate to young people as creative in both mundane and appreciative senses.

These kinds of cultural informal learning programs share important fea-
tures, most notably, those that foster activities that create ZPDs: freedom from
knowing and socially imitative and completive activity. First, kids come to
them to learn how to do something they do not know how to do. Maybe they
want to perform in a play, make music videos, play the flute, dance, or play
basketball. They bring with them some expectation that they *will* learn. They
are related to by skilled informal educational instructors, often practitioners
themselves, as capable of learning, regardless of how much they know coming
into the program. Thus, while there are, of course, differences in skills and
experience that young people bring to informal learning programs, the playing
field is more level than in school. Really good programs, in fact, use such het-
erogeneity for everyone's advantage (Gordon, Bowman, & Mejia, 2003;
Holzman, 2006b, 2009).

Second, in these programs it's OK to imitate and complete; in fact, it's es-
sential. The presumption is that one becomes an actor, music producer, musi-
cian, dancer, and athlete by doing what others do and building on it. From
the fundamentals through advanced techniques and forms, creatively imitating
instructors and peers, and being completed by them, is what is expected and
reinforced.

I have come to view informal learning programs that have these features as
learning environments created by, and allowing for, *learning playfully*. They are,
in this sense, a synthesis of Vygotsky's ZPDs of learning–instruction and of
play, not as spatio-temporal zones but as mundane creative activity. For, as in
the free or pretend play of early childhood, the players (both students and in-
structors) are more directly the producers of their environment-activity, in
charge of generating and coordinating the perceptual, cognitive, and emo-
tional elements of their learning and playing. Most psychologists and educa-
tors value play for how it facilitates the learning of social roles, with socio-
cultural researchers taking play to be an instrumental tool that mediates be-
tween the individual and the culture and, thereby, a particular culture is ap-
propriated (as in the work of Nicolopoulou & Cole, 1993; Rogoff, 1990;
Rogoff & Lave, 1984; Wertsch, 1985). Through acting out roles (play-acting),
children try out the roles they will soon take on in "real life." I am sympathetic
to this understanding, and yet I think there is more that play contributes to
development than this. Being a head taller is an ensemble performance, not
"an act." After all, we don't say the babbling baby is acting out a role.

I see play as both appropriating culture and creating culture, a performing
of who we are becoming (Newman and Holzman, 1993; Holzman, 1997,
2009). I see creative imitation as a type of performance. When they are playing
with language very young children are simultaneously performing, *becoming-*

themselves. In the theatrical sense of the word, performing is a way of taking "who we are" and creating something new, in this case a newly emerging speaker, on the stage a newly emerging character, in an outside of school program a skilled dancer or athlete, through incorporating "the other."

In his essay on the development of personality and world view in children, Vygotsky wrote that the preschool child "can be somebody else just as easily as he can be himself" (Vygotsky, 1997, p. 249). Vygotsky attributed this to the child's lack of recognition that s/he is an "I" and went on to discuss how personality and play transform through later childhood. I take Vygotsky to be saying that performing as someone else is an essential source of development at the time of life before "I."

Early childhood is the time before "I" and the time before "I know." We can never completely replicate the type of lived activity out of which learning-leading-development occurs and "I" and "I know" are created. Nor should we want to. But outside of school programs, to the extent that they are spaces and stages for creativity (mundane and otherwise), appear to support young people's learning-leading-development through revitalizing play and performance. Such programs are precisely the kind of support schools need for as long as schools continue to discourage creativity.

References

Allal, L., & Pelgrims, A. (2000). Assessment of—or in—the zone of proximal development. *Learning and Instruction, 10*(2), 137-152.

Berk, L. E., & Winsler, A. (1995). *Scaffolding children's learning: Vygotsky and early childhood education.* Washington, DC: National Association for the Education of Young Children.

Glick, J. (2004). The history of the development of higher mental function. In R. W. Rieber & D. K. Robinson (Eds.), *The essential Vygotsky.* New York: Kluwer Academic/Plenum Publishers, pp. 345-357.

Gordon, E. W., Bowman, C. B., & Mejia, B. X. (2003). *Changing the script for youth development: An evaluation of the all stars talent show network and the Joseph A. Forgione Development School for Youth.* New York: Institute for Urban and Minority Educations, Teachers College, Columbia University, pp.23-44.

Holzman, L. (1997). *Schools for growth: Radical alternatives to current educational models.* Mahwah, NJ: Lawrence Erlbaum Associates.

Holzman, L. (2006a). Activating postmodernism. *Theory & Psychology, 16*(1), 109-123.

Holzman, L. (2006b). Lev Vygotsky and the new performative psychology: Implications for business and organizations. In D. M. Hosking & S. McNamee (Eds.), *Organizational behaviour: Social constructionist approaches.* Oslo, Norway: CBS Press, pp. 254-268.].

Holzman, L. (2009). *Vygotsky at work and play.* New York: Routledge.

Lantolf, J. P. (2000). *Sociocultural theory and second language learning.* Oxford, UK; New York: Oxford University Press.

Lidz, C. S., & Gindis, B. (2003). Dynamic assessment of the evolving cognitive functions in children. In A. Kozulin, B. Gindis, V. S. Ageyev, & S. M. Miller (Eds.), Vygotsky's educational theory in cultural context (pp. 99–116). New York: Cambridge University Press.

MacNaughton, G., & Williams, G. (1998). Techniques for teaching young children: Choices in theory and practice. French Forests, Australia: Longman.

Newman, D., Griffin, P., & Cole, M. (1989). The construction zone: Working for cognitive change in school. Cambridge, UK: Cambridge University Press.

Newman, F., & Holzman, L. (1993). Lev Vygotsky: Revolutionary scientist. London; New York: Routledge.

Newman, F., & Holzman, L. (1997). The end of knowing: A new developmental way of learning. London; New York: Routledge.

Nicolopoulou, A., & Cole, M. (1993). The generation and transmission of shared knowledge in the culture of collaborative learning: The Fifth Dimension, its play world, and its institutional contexts. In E. A. Forman, N. Minick, & C. A. Stone (Eds.), Contexts for learning: Sociocultural dynamics in children's development (pp. 283–314). New York: Oxford University Press.

Rodgers, A., & Rodgers, E. M. (2004). Scaffolding literacy instruction. Strategies for K-4 classrooms. Portsmouth, NH: Heinemann.

Rogoff, B. (1990). Apprenticeship in thinking: Cognitive development in social context. New York: Oxford University Press.

Rogoff, B., & Lave, J. (1984). Everyday cognition: Its development in social context. Cambridge, MA: Harvard University Press.

Shotter, J. (1989). Vygotsky's psychology: Joint activity in the zone of proximal development. New Ideas in Psychology, 7, 185–204.

Tharp, R. G., & Gallimore, R. (1988). Rousing minds to life: Teaching, learning, and schooling in social context. Cambridge, UK; New York: Cambridge University Press.

Vygotsky, L. S. (1978). Mind in society: The development of higher psychological processes. Cambridge, MA: Harvard University Press.

Vygotsky, L. S. (1987). The collected works of L.S. Vygotsky (Vol. 1). New York: Plenum Press.

Vygotsky, L. S. (1994). The problem of the environment. In R. van der Veer & J. Valsiner (Eds.), The Vygotsky reader (pp. 338–354). Oxford: Blackwell Publishers.

Vygotsky, L. S. (1997). The historical meaning of the crisis in psychology: A methodological investigation. In R. W. Rieber & J. Wollock (Eds.), The collected works of L.S. Vygotsky (Vol. 3, pp. 233–343). New York: Plenum Press.

Vygotsky, L. S. (2004). The collective as a factor in the development of the abnormal child. In R. W. Rieber & D. K. Robinson (Eds.), The essential Vygotsky (pp. 201–219). New York: Kluwer Academic/Plenum Publishers.

Wertsch, J. V. (1985). Vygotsky and the social formation of mind. Cambridge, MA: Harvard University Press.

Wertsch, J. V. (1991). Voices of the mind: A sociocultural approach to mediated action. Cambridge, MA: Harvard University Press.

Wood, D. J., Bruner, J. S., & Ross, G. (1976). The role of tutoring in problem solving. Journal of Child Psychology and Psychiatry, 17(2), 89–100.

From Yes and No to Me and You:
A Playful Change in Relationships and Meanings

Ana Marjanovic–Shane

I want to suggest a point in metaphor which is independent of the question of its cognitivity and which has nothing to do with its aesthetical character. I think of this point as the achievement of intimacy. There is a unique way in which the maker and the appreciator of a metaphor are drawn closer to one another (Cohen, 1980).

This chapter examines the process of meaning making as an ontological process of transforming relationships and the role of play and playfulness in that process. The main assumption is that playful acts have a potential to change relationships between the players, giving them new points of reference and enabling them to experience themselves and others as co-authors of the situations. More importantly, these changes facilitate a change of roles, as players become co-constructors of the meaning of the situation and their relationship. It is important to understand how the roles and relationships between the players change and what those changes in relating to others may imply for creating dialogues and jointly constructing ways of seeing the world.

For that purpose, I look at play from a slightly different point of view than the currently dominant perspectives in the majority of the current texts on human development (El'konin, 1981; Garvey, 1976; Holzman, 2009; McMahon, Lytle, & Sutton-Smith, 2005; Paley, 1992, 2004b; Sutton-Smith, 1976a, 1976b, 1979, 1985, 1986; Sutton-Smith & Kelly-Byrne, 1984; Sutton-Smith & Pellegrini, 1995; Vygotsky, 1930/2004a, 1933/1976, 1971, 1978, 1986; Vygotsky & Luria, 1994). Namely, in the contemporary Western child and human development literature, it became customary to see play as a provenance of individual development and a dominant activity in childhood. This orientation, in Sutton-Smith's (1997) opinion, belongs to the "progress rhetoric of play" (Sutton-Smith, 1997, p. 36), in which play is conceived as being important, even central for the development of the symbolic function.

Play is, therefore, indispensable in cognitive and language development. Because of looking at play activity in terms of its value for development of other psychological and/or social functions, rather than seeing it as having a value of its own, the progress rhetoric of play contains a strong *instrumental* bias. Furthermore, the "progress rhetoric of play" focuses mostly on the form of play known as "pretend play," "make-believe," or "dramatic play" out of the whole range of different kinds of play practiced by children and adults[1]. This type of play usually involves children (and rarely adults) creating imaginary situations in which children play roles that they construct based on their own experiences (Bretherton, 1984; Garvey, 1990; Paley, 1984, 1992, 2004a, 2004b; Vygotsky, 1930/2004b, 1933/1976). The literature on play often describes children's exploration of imaginary situations through which they learn about important human relationships, activities and situations. Through these processes of playful exploration, children develop and grow. The instrumental progress rhetoric of children's play is best seen in the concept of the zone of proximal development of the higher mental functions such as memory, will, cognition, emotions, and morality (Vygotsky, 1933/1976, 1978, 1986; Vygotsky & Luria, 1994). In Vygotsky's words, "a child's greatest achievements are possible in play, achievements that tomorrow will become her basic level of real action and morality" (Vygotsky, 1978, p. 100). The zone of proximal development that is created in play refers usually to the development of an individual child. The connection is made between, on one hand, the imaginary situation constructed in play including the rules that the child explores and the roles that the child develops, and, on the other hand, the child's own future development. For instance, Vygotsky assumed that in play a child can voluntarily guide her/his behavior and can conceptualize the rules of imaginary situations that s/he still cannot yet do in reality. He noted, "What passes unnoticed by the child in the real life becomes a rule of behavior in play" (Vygotsky, 1978, p. 95)[2].

In this chapter, however, I examine another aspect of play: the meanings that play can create for the community of players in an immediate situation and the value of playing per se. I look at the meanings and significance of playing for the interpersonal relationships between the participants and the views, opinions and feelings that the participants construct about the immediate situation, events in which they participate, and themselves. In other words, I examine the "ontology of being a player" rather than the "epistemology of creating other forms of competence [through play]" (Sutton-Smith, 1997, p. 106). I understand play as a special kind of an interpersonal act, an act in the sense

of a Serbian (and Russian) term "postupak"[3]. It is examined as a deed that transpires between the players (of any age, often including adults) as the authors of play, rather than the characters in the imaginary situation of play. Participants in play are seen as the collaborators in creating and directing their actual relationships, judgments, values and even rules. I explore the nature of change in the relationships between players and ask what difference can playing make in the way the players relate to each other.

Emotions

Of special interest in this analysis are transformations of the emotions that infuse the whole process of establishing connections and building relationships in meaning making. I analyze tensions and contradictions that build up, and the moments of their transformation and possible resolutions. I assume that the introduction of play into an ongoing interaction may lead to a change in the emotional quality of the relationship. I examine whether the emotional dynamic in a playful situation differs for those who play and for whose who are excluded from play (for any reason). Play and similar forms of interaction that involve imagination and creative constructions (art) may lead to emotional transformations that are constitutive in building reflexive experience of one-self. The phenomenon of catharsis as defined by Vygotsky (1971) will be examined as a type of emotional experience (in the sense of the Russian concept of *perezhivanie*), that might be important not only in the creation and perception of art, but also in the transformation of the relationships to others and to self. The epistemological and cognitive aspects of play are examined here in regard to their function in developing and transforming relationships.

Methodological Issues

One of the goals of this analysis is to create initial steps toward building a cultural historical theory of the role of imagination and play in making meaning. I use ethnographic data and the procedures of grounded theory (Glaser & Strauss, 1967) in making these initial steps. The event presented was videotaped in an after–school program and is a part of a corpus of "research data" . However, the question of what represents the "data" is an important and pervasive methodological problem, especially when it comes to studies of meaning construction. The very object of this study including the live construction of relationships, the dynamics of the participants' feelings, possible reasons they had to act as they did, and the significance of each act that occurred, cannot

be found in the bare video record any more than they might be found in the textual transcripts. In fact, the "data" that need to be used in the analysis first had to be reconstituted. In this chapter, the videos and the transcripts of videos are not treated as "the data", but rather as *the evidence* that serves to reconstruct the data. In Vygotsky's words, a social scientist "finds himself faced with the necessity of actually creating the object of his study" (Vygotsky, 1971, p. 23). Thus, to preserve the dynamics, the feelings and the meanings as objects of this study, I created a story to reconstruct the pulse of the actual people, as the "transition" from an actual lived event to the magnetic tape and finally to paper. In the next section, I present the story based on the video footage of the event and the interviews with some of the participants[4].

When Yes Is No and No Is Yes: The Story

For several years, children of diverse ages in the East Coast Latin American Community Center (ECLACC) participate in the "Lego-Logo" program under guidance and leadership of Mr. Steve. The program has been started with help from the nearby state university. They build robots and smart devices from Lego blocks and use computers for programming the robots to perform series of precise actions moving on a large board. The ECLACC Lego-Logo program is enrolled in a national competition that prescribes rules and tasks the robots must accomplish. Many children at ECLACC apparently enjoy participating in this activity in which they volunteer. The room is often crowded with children of all ages. Mr. Steve is a teacher who leads this activity and the head of the computer center at ECLACC (see Matusov, 2009, for more description of this program).

In the episode that is in focus in this chapter, the main protagonists are: Mr. Steve; 9–10 year-old friends who will be named Pedro and Manuel; three 11–13 year-old girls named Lily, Julia and Mimi; an older boy called Robert; and several other children of different ages also present in the room. A professor from the nearby university and Mr. Steve are filming the activities in the room for an educational research project. Mr. Steve, who collaborates in the research, has just set up his own camera to record the activities in the room. He wants to show the video to the children and discuss how they can work better with each other. The professor is setting up another camera. In the center of the room stands a big board prepared for the robots to perform their activities. The board leaves a narrow walking space to numerous computers that line the walls on each side of the room. This is the first day of videotaping

the activities. The event related here happens about five minutes into the tap-ing session.

Lily is in the Lego-Logo room for the first time. She is in the company of another girl, Julia. Lily seems to be a quiet and a shy girl. She and Julia are standing on one side of the big board waiting for Mr. Steve to answer their question about an assignment he gave them earlier: a paper with a scheme of a robot. However, Mr. Steve went to the far side of the board to finish preparing the Lego-Logo materials.

Pedro and Manuel are jumping, waving arms in all directions, fooling around and making funny faces directly in front of the camera lens. Pedro approaches the camera and stares into it from a very close range, and then he moves away and looks at it from afar. He is smiling and curious as if he ex-pects something surprising to happen with the camera.

While Pedro jumps and waves at the camera, Mr. Steve is engaged in set-ting up materials for the Lego-Logo activity in the back of the room. Then Mr. Steve starts to walk along the side of the board towards Pedro. As he walks, he is talking across the board to Mimi, Pedro's teenage cousin. She is also walking towards Pedro on the opposite side of the board from Mr. Steve.

Totally absorbed by his own performance for the camera, Pedro starts to wave his arms up and down and around like a windmill. In that moment, Mr. Steve and Mimi, Pedro's cousin, collide with him right in front of the camera. By accident, Pedro's outstretched and waving hand briefly touches Mimi's breast. For a moment, Pedro looks startled. Annoyed, Mimi exclaims in a voice that sounds like a warning or a protest, "Yo-ough!"

Pedro grabs her by the arms and starts to push her away. She warns him, "Watch your hands!" and pulls out of his grip. But he replies, "Watch your mouth!" and gives her the final little shove on the arm that sends her away. His expression changes into a smug smile.

At that same moment, Mr. Steve exclaimed, "Hey! That's recording!" warning Pedro about his behavior in front of the camera.

Probably attracted by the raised voices, Julia and Lily turn their heads and see Pedro pushing Mimi away. They look rather annoyed and displeased. Julia particularly gives Pedro a long stare with her mouth curled, slightly biting her lower lip as though in disgust.

However, Pedro is not looking in their direction and is not aware of their stare. It seems to have finally dawned on him what Mr. Steve had said. He walks to the camera again, gives it a probing and a pensive look, and then again moves a bit away sizing it up. He looks curious, puzzled, and somewhat taken aback. He is not aware of any disproval when he turns to Julia and Lily and asks simply, "Is that really recording us right now?"

Julia answers in a raised, scornful, and slightly irritated voice, "Yes, it is!" Lily echoes her. Julia's tone is sharp and degrading. It sounds to me almost like a threat, "Better watch out what you are doing, little boy!"

Pedro looks quite put off, standing with an uneasy grin and slightly rocking on his feet. He replies in defiance, "No, its not!" But this attack probably helps him realize that his collision with Mimi was perhaps seen and even recorded on camera.

Lily retorts back to Pedro, yelling a bit louder, "Yes, it is!"

Pedro again insists, "No, it's not!"

Julia, then, yells very loudly, leaning over to Pedro and pronouncing every word slowly and separately almost as if talking to a moron, "YES! IT! IS!" Lily nods to Julia's every word, continuing to watch what will Pedro do.

Pedro stands there with an uneasy grin! He seems to be getting more and more tense and upset. He bends over the board, takes one more good look of the camera, and then quickly runs to Mr. Steve exclaiming as if pleading for help, "Mr. Steve! Right? It's not recording right now!" He grabs Mr. Steve's left arm, but Mr. Steve does not respond right away as he was now engaged in setting up the Lego robots with other children. Pedro pulls Mr. Steve toward himself trying to get in his line of vision. He urgently repeats, vigorously shaking his head, "Mr. Steve! Right? It's not recording now!"

Mr. Steve replies to Pedro and also to all the children around the board, nodding his head in a matter of fact serious tone, "Yes, it *is* recording." He looks across the board to Lily and catches her smiling, approving look. He says to her: "See that little light?" as he points his finger to the camera which has a blinking red light on its front. Lily nods and smiles again. They exchange understanding looks.

All that time Pedro is holding Mr. Steve by the arm, repeating in louder and what sounds increasingly urgent tones, still shaking his head, "Right? It's not recording!" as if he did not hear Mr. Steve's words at all. He starts jumping up and down, still holding Mr. Steve's arm and repeating louder and louder, "Right? It's not recording, Mr. Steve!"

But Mr. Steve's attention is now on Lily. When she confirms that she sees the little red light, he says, "Yeah!" and she nods. Mr. Steve leans over the board, raising his right hand in a "give-me-five" sign to Lily. She responds and claps her hand to his. With a smile on his face, he exclaims, "That's my girl!" He moves a bit closer to her and asks: "What's your name?" She replies in a pretty low voice. Mr. Steve asks her to repeat. When she does, he smiles and chuckles, "*I* knew that!"

However, Pedro is not letting go, still trying to get Mr. Steve's attention. He grabs him with both hands. It looks like he is desperately trying to make

Mr. Steve look at him. He is shaking his head and repeating,"Right? It's not recording?"

Mr. Steve finally looks at Pedro. He gives him a hug, a few vigorous pats on the hair and a big smile. Then he stops and gets out of Pedro's grip. He slightly tilts his head with a very brief expression that might mean, "Hm! What am I going to do with you, silly?" He turns straight to Pedro, looks him directly in the eyes, gives him a *new* big smile and starts to nod his head up and down in a non-verbal "*Yes*" while at the same time, rhythmically pronouncing to each nod of his head, "*No-it's-not-recording.*" And he laughs loudly and whole-heartedly.

Pedro first takes Mr. Steve's words seriously. He turns to Lily and Julia and says, in what sounds like a satisfied, maybe even a slightly triumphant tone, "What did I tell you!! Aaah? ... Uuum? ... Julia!"

Mr. Steve continues to nod and to laugh. He turns away from Pedro to-ward Lily, leans over the board and calls, "Hey!" catching her attention. When she raises her head, he looks her directly in the eyes, smiling in apparent an-ticipation of sharing a good joke with her. He starts again nodding his head in a non-verbal "*Yes*" to his rhythmic chant, "*No-it's-not-recording!*" He starts to laugh loudly and Lily laughs, too, to the point that she has to bend down from laughter.

But, Pedro is not laughing. He looks serious. He had moved a bit away from Mr. Steve and is watching his exchange with Lily from a distance. He is not pulled into the game. He probably does not see it as a game at all.

Other children in the room are now attracted and watch Mr. Steve. Someone shouts from the side, "Yes it is!" Mr. Steve accepts this cue. Still facing Lily, he switches from nodding his head up and down to shaking it left and right in a non-verbal "*No*" very deliberately and widely, as he starts chant-ing in the rhythm of his head,"*Oh, Yes! Yes! It-is-recording!*" He laughs more and makes Lily laugh even harder.

Mr. Steve catches Pedro's glance again and, again, turns directly to him as he continues to chant, "*Yes-it-is!*" and shake his head left and right in a non-verbal "*No*" . One more time, Pedro insists, "No, it's not!" He does not sound playful but serious and insisting. Although, this time he is less loud and his voice trails off.

Mr. Steve suddenly turns to the professor and addresses him. "I told her..." he says to the professor, pointing to Lily.

And then Mr. Steve replays the whole yes-no game for the professor: He turns to Lily again and leans over the board to her. When she looks at him, he

starts to nod his head up and down again in a non-verbal "*Yes*" and to chant, "*No-it's-not-recording.*"

In the meantime, Pedro approaches the camera yet again. He comes really close to stare into it. He repeats, almost together with Mr. Steve, "It's not... re-COR-ding!" but he does not sound playful at all. He turns to Lily and Mr. Steve and leans over the board toward them. When Mr. Steve switches his chant to, "*Yes-it-is-recording*" and begins to shake his head left and right, Pedro again exclaims, "Noooo! It's not!"

Pedro's older cousin, Robert, had watched this whole scene from the beginning. At one point, he also approached the camera to see for himself whether it was recording. Robert now moves behind Pedro and gently holds his head for a moment. He looks at Pedro with a warm smile like one looks at a little child who is ignorant, yet adorable.

Mr. Steve walks away from Lily, looking at the professor. He laughs loudly, "Ha, ha, ha, ha!" The professor smiles a bit and replies, "That's confusing!" He does not sound enthusiastic. He does not laugh. He is not pulled into the play. As he later reported to me[5], he tried to save Pedro's face. But Mr. Steve laughed and clapped his hands, "Uh-oh! That'll get somebody!" he exclaimed, sounding very pleased with his play. Pedro turned away and the whole situation faded away.

Play as a Challenge: Analysis and Discussion

If we study acts of creating meaning as acts of building and transforming relations and relationships, our question then is about the nature of these relations and relationships that have formed and/or changed. What is the significance of Mr. Steve's playfulness? How does his playfulness make a difference in changing the relationships between the participants and the relations that participants make of the situation? Why did he decide on playfulness? What could have been potential alternatives in his reaction to Pedro and Lily and his communication with the professor? Would these alternatives be better? Better for what? To answer these questions, I look at the unfolding of the events in this episode from different points of view and through different magnifying lenses.

Growing Tensions

Mr. Steve's playful response happened at the point in time when the concerns of different participants became increasingly contradictory to each other and tensions between them intensified. Even the various concerns of Mr. Steve

alone were starting to contradict each other. For instance, he needed to take care of setting up the materials for the activity, including working with Lily as a shy, new participant of the activity, and Pedro's growing and distracting anxieties.

To better see the changes that Mr. Steve's play introduced into the situation, I will first present what appeared to be the perspectives of the key participants: Mr. Steve, Lily, Pedro and the professor. I have constructed Lily's and Pedro's perspectives based on the observable evidence in the video recording and information about them provided to me in the interviews with Mr. Steve and the professor.

Lily's Perspective. Lily was new to the Lego Logo activity but appeared to be eager to join and participate. She watched Mr. Steve attentively and reacted to his remarks. Being new to a situation probably means taking a measure of many things happening in it and making judgments about what is going on. In other words, Lily was probably sensitive to how the whole situation felt, making up her mind to stay and continue or to leave. Lily and Julia saw Pedro pushing Mimi away. They did not see the whole event from the beginning. Judging by their expressions, they might have thought that he was aggressive, inappropriate and rude. In their exchange with Pedro about whether the camera was recording or not, Julia openly expressed derision and scorn toward him. Lily chimed in using a similarly scornful tone later on. When Julia went to another part of the room, Lily stayed and watched Pedro's attempts to have Mr. Steve agree that the camera was not recording. She seemed to have been waiting to see how Mr. Steve would react to Pedro. She also seemed to be eager for more of Mr. Steve's attention. It looked like she was sizing up the whole Lego-Logo room including the ways of behaving and activities that take place there.

Pedro's perspective. Pedro and his friend Manuel looked intrigued by the camera. It was the first day of taping and they were exploring what happens when they jump in front of it. They could see themselves in the little digital display of the camera that was turned toward the room. It was like a mirror in front of which they could make faces, jump and watch their own reflections. Pedro seemed to be totally engaged in experimenting with different moves in front of the camera. He was not aware that Mimi and Mr. Steve were approaching and his collision with Mimi was accidental. When his hand briefly touched her breast, Pedro looked startled but apparently not displeased. When Mimi protested, he grabbed her arms and gave her a push away with a slight smile on his face. However, when he understood Mr. Steve's warning that he might have been recorded on camera, he looked like he became seriously concerned about it. His concerns were probably amplified by Julia's and

Lily's unfriendly, almost hostile response to his question. He looked like he became increasingly self-conscious perhaps even embarrassed. When he ran to Mr. Steve and asked him to confirm that camera was not recording, it sounded like a cry for help. It seemed like it became very important for him that he was not recorded on camera, but one can only guess what might have been the reason.

Mr. Steve's perspective. Mr. Steve had a complex situation in which he had to coordinate several tasks: He was making sure that all the materials were ready and in place for the Lego–Logo Activity. He was busy with some older children in the back of the room and searching for Lego pieces and previously made robots. He was aware there was a new girl in the room, and he seemed to be especially attentive to her. His intent was to include her in the activities and make her feel welcome. In addition, this was the first day of video taping with his professor whom he had known very well for a number of years. Yet, the taping seemed to have added a layer of complexity to the busy Lego–Logo room. When Mr. Steve saw Pedro "fooling around" in front of the camera and he and Mimi bumped into Pedro, instead of simply telling the children to calm down, he warned Pedro, and others in the room, that they were being recorded. When a moment later Pedro started to "plead" with him to say that the camera was not recording, Mr. Steve was faced with yet another challenge— Pedro was not listening to him and was obviously denying the information just presented to him, that camera was indeed recording.

The multiple tensions at that moment were strong and complex. Such tense and complex situations are difficult and there is no recipe for how to resolve them. Every different *postupak* would lead to a different outcome. Mr. Steve responded by creating play. In analyzing the characteristics and meanings of play as an interactive postupak, a deed that changes interpersonal relationships in this particular situation, and possibly other ones, I will highlight three main findings:

1. Playing together may produce multiple overlapping meanings;

2. Playing is mutually voluntary, i.e. a person must want to play and must be invited (or at least not clearly rejected) by the others;

3. Joining the community of players makes a difference in the quality of the relationships between the players and based on that may lead to a difference in understanding of the situation, self and others.

In the next section I discuss the complex and multiple meanings of Mr. Steve's play especially in contrast to other possible, non-play, responses.

Many Meanings of Play

I argue that Mr. Steve's playful sequence apparently had several addressees and achieved several transformations in the relationships between the participants and in the way they related to the whole situation.

I first explore Mr. Steve's play as an offer to Lily meant to increase her positive feeling about the situation and to gain her trust and build a relationship with her. I also discuss Mr. Steve's play as a means to increase the affectionate bonds in the whole community for all the participants. Further, Mr. Steve's play is discussed as a good-humored teasing of Pedro. Finally, the episode can also be seen as a playful offer to the professor, confirming the trust and friendship between Mr. Steve himself and the professor in a situation in which Mr. Steve was not only a colleague but also in the focus of the research.

A playful offer to Lily. I argue that when Mr. Steve turned to Lily, his play became an offer to her to join the fun. They laughed together at the funny juxtaposition of the YES and NO and possibly at Pedro. For her, Mr. Steve's Yes and No fusion could have had yet another dimension: it could have looked like a playful parody of her and Julia's previous altercation with Pedro. The interchange transformed into a paradox of saying one thing and doing another, thereby uniting the opposites into an impossible and a fantastic comedy. At the moment, when Mr. Steve made a playful offer to Lily, it did not seem to be laughter at Pedro, but laughter at many things that may be funny. It may have been a laughter at any tense antagonism over which people might flare up, an antagonism that Mr. Steve now transformed into a funny, hilarious and silly oxymoron. Indeed, the situation that Mr. Steve transformed with his play might have contained even more tensions and potential arguments than were visible in the video recording. In the later interview, Mr. Steve described the relations between several sets of siblings and mutual cousins in this group of children. Pedro was a member of one of these sets. Mr. Steve referred to possible arguments and tensions he knew about. He described how he "personally come[s] to this scene here, knowing that Y. (Pedro's sister) is there... [and] Y. and M. are not friendly to other children at times.... And this comes...into play with me knowing that she (Y.) was gonna be here and all these things... are going to come up" (Villanueva, 2009).

In the interview Mr. Steve hinted that he might invite children to see themselves as funny by showing them how funny he can be. "They see... the funny things that they do.... Not only the things they do, but they see the funny things that I do...and all the grown ups...whether it be scratching...or, you know...acting like me! A, ha, ha, ha, ha!" His exchange with Lily looked like a carnivalesque jest inviting her and everyone else to laugh at the whole

world, transforming the world into both a laughable and a delightfully free and friendly place.

In addition to facing a potentially explosive situation, Lily *was* a new kid who Mr. Steve wanted to include into the activity and make feel welcome. He asserted, "She was new. Very smart, very attentive, very interested in learning. Very shy! [She was there for the] first time! *I have to make them feel comfortable one way or another. Then everybody gets to...feel each other.*"

This specific quality of an all-embracing ridicule or laughter that is "not an individual reaction to some isolated "comic" event [or a person]" , was described by Bakhtin (1984) as a universal carnivalesque laughter by everyone at the whole world. "The entire world is seen in its droll aspect." The world is perceived and experienced in its comical mode, in its laughable relativity and, most importantly, in its deep ambivalence. It is a laughter that "is gay, triumphant, and at the same time mocking, deriding. It asserts and denies, it buries and revives..." (Bakhtin, 1984, p. 11-12). Similarly, the laughter associated with play might transform relationships since it simultaneously invites participants to laugh and to laugh at themselves. By inviting one to laugh together, one includes others into a close, almost conspiratorial relationship in which a special bond of joint trust and understanding between the players is forged. Mr. Steve's offer to Lily quickly became an open offer for everyone to laugh together. Several other children joined in his joke, giving him hints when to reverse his chant and gesture combination. And almost everybody laughed together.

The only child that did not join and laugh was Pedro. He stayed out of play, insisting that the camera was not recording in spite of Mr. Steve's several attempts to include him into the laughter. In the next section, I discuss what the situation might have meant to Pedro and what Mr. Steve's actions might have meant for Pedro.

Teasing Pedro. After Mr. Steve paused, gave Pedro a hug, big smile and pat on the hair, he then stood in front of Pedro with a significant look on his face and started to nod his head in a non-verbal "Yes" to his rhythmical chanting, "No-its-not-recording". It was the beginning of his affectionate, playful and teasing response to Pedro. He meant his response to be a challenge to Pedro. "It was a wakeup call!" said Mr. Steve in a later interview with me. "I teased his intelligence a little bit!" Mr. Steve believed that Pedro really knew that the camera was recording, because he could see the little red light, stating:

> So I give him what he wants! The same confusion that he wants to give me...It's a tease, I believe, for him to realize that, when I first told him that, 'Yes, it was recording' , he still came back to me...[with his denial] and that now I am playing with

his intelligence. [I am] saying, 'Yes' [while shaking the head in a non-verbal denial] or 'No' [while nodding in affirmation]! What's he gonna do with *that*? Ha, ha, ha! And eventually he stops.

I argue that this type of affectionate and playful teasing of children needs to be seen in the larger context of culturally appropriate practices in socializing children's anxieties and fears. Playful teasing of children by adults in some communities and cultures has been found to have several overlapping purposes. For instance, teasing can be simultaneously used to control a child's behavior, to have fun together with a child, and to emphasize the bonding relationships existing between the participants in the interaction (Eisenberg, 1986,p. 182–183). Adults in some Hispanic communities[6] seem to involve young children from a very early age on, in teasing interchanges in order to increase their affectionate bonds by using humor and jokes (Eisenberg, 1986; Miller, 1986). An important reason for teasing children is to defuse their fears and anxieties. Eisenberg described teasing very young children about their fears, by exposing them to the feared situations in playful and exaggerated ways (Eisenberg, 1986, p. 187).

In my opinion, this type of playful teasing that serves, among other things, to diffuse children's possible fears and anxieties may be compared to the ubiquitous play of "Peek-a-boo" . In this seemingly universal game, the play makes fun of children's possible fears of being lost or separated from the caregiver. "Peek-a-boo" has the same quality of fusion of reality and the surreal, and of claiming that "yes is no and no is yes" about the fact that "you" are here and are not here at the same time, in a completely ridiculous and fun way.

Another, very important function that teasing can have is to defuse tensions that build up around disputes and arguments. Miller (1986) observed, "To tease is to convert a dispute into a mock dispute" (p. 209). Teasing often has an ambiguous quality of being both an argument with the one who is teased and at the same time a form of play that invites the teased one to join in and laugh at her/his own behavior and feelings. This seemingly unresolved duality is the hallmark of the activity of creating an imaginary situation.

An imaginary situation constructed in play can be viewed as a "chronotope" . Bakhtin used the term "chronotope" to describe not merely a physical point in space-time continuum but also a system of values, beliefs, roles, and positions within which people operate socially and psychologically. Bakhtin referred to this as "valorized" space-time. A chronotope is, therefore, a meaningful unity of social and individual values and relationships in a point (or a period) of time and in real space.

A chronotope constructed within play is often created as a reflection of one or more actual chronotopes. The representation of the reality in a play chronotope may be "serious" or "joking" as suggested by Wolfenstein (1954) as quoted in Bergen (2002). Therefore, a play chronotope potentially may represent a comment on reality. Such a comment is an act of giving special meaning to a topic of discourse by subverting it to a metaphoric perspective (Marjanovic-Shane, 1996).

Mr. Steve's playful and mocking imitation of Pedro's behavior may represent a transformation of a potential dispute with Pedro from an actual event into the realm of play. Mr. Steve could have, alternatively, just told Pedro to stop behaving silly or he could have told him explicitly that he was wrong or ignorant and that he should pay better attention. However, his playful response presented a challenge to Pedro. It was an invitation and a new opportunity for Pedro to change his behavior and the way he felt about the whole situation.

Mr. Steve understood that Pedro might have been embarrassed by his behavior in front of the camera. "He doesn't wanna be caught...doing things that he...knows that he does!" Mr. Steve expressed after watching the episode on tape. Mr. Steve added a potential explanation of how Pedro might have felt. He suggested, "Oh...me, I know I wouldn't wanna...jump, or be out of line! But I do it all the time! Ha, ha, ha! I don't care, but they [the children] do." By creating play, Mr. Steve could also be telling Pedro that there was no real reason to be afraid and frantic, that things might not always appear how they seem to be.

However, Pedro did not join the play, although Mr. Steve extended his offer to him several times. We can only speculate about the reasons why Pedro did not join in. As Mr. Steve said later in the interview, Pedro might have been too embarrassed to have his behavior caught on tape. He might have felt hurt by Mr. Steve's teasing instead of helping him, or both. He seemed stuck in his anxiety. He was alone in the room full of laughing kids, insisting that the camera was not recording even after the opposite was clear to everyone else.

A playful offer to the professor. Finally, Mr. Steve also addressed his play to the professor. He turned to the professor directly, inviting him to see how he played with Lily and other children in the room. He repeated the whole play sequence for the professor, since he was not quite sure whether the professor, as an audience, had seen it at all. One could suppose that offering Pedro a chance to play together and offering the professor to play together were both aimed at creating a closeness and equality between the collaborators in the community of players. However, at the same time, these offers came

from different interpersonal positions in those two relationships. Allowing Pedro to play might have empowered Pedro and helped him to overcome his fears. Offering the professor the chance to play, might have empowered Mr. Steve himself in a situation in which he was the one who was being observed and the professor the one who was observing and possibly judging.

The professor also did not join Mr. Steve's play. He did not feel comfortable with Mr. Steve's teasing Pedro[7]. By not joining in the play, he was trying to express solidarity with Pedro, trying to save his face.

Play and the Relationship of Co-authoring and Collaboration

As mentioned above, play chronotopes mirror all other "real"[8] chronotopes, but can mirror them in a special ways. Moreover, when people start to create play chronotopes, they also create a community of players who are involved in the joint construction of these playful imaginary chronotopes. The question I ask here is about the nature of the relationships that are created between the participants when they form a community of players.

Playing Is Mutually Voluntary

The first characteristic of the relationships between the participants in the community of players is that they are mutually voluntary members. Nobody can be "made" to play unless they voluntarily join the play. They can only be invited to play but not coerced. On the other hand, a person who is not invited to play can not join play! In the episode in this chapter, we see Pedro who stays out of the community of players, not joining in the common laugter, regardless of the multiple overt and implicit invitations by Mr. Steve. He may be staying out of play for different and complex reasons, which cannot be completely determined based on the video recording and the interview with Mr. Steve and the professor. He may have been too anxious about his behavior being recorded; he also may have felt that he was a butt of Mr. Steve's teasing and not actually invited into the play.[9] However, regardless of the reason, a person needs to want to join the play and to feel invited. Not joining in play also means not changing one's understanding of the situation and not changing the nature of the relationship with others. Pedro, indeed seemed stuck in his anxiety, alone in a room full of laughter, insisting that the camera was not recording. I argue that play will stop when it stops being perceived as voluntary for its participants.

Changing Quality of the Relationships

I argue that the relationships between the members of the community of play-
ers are relationships of collaboration in creating a fictive world (chronotope)
in which values, rules, expectations and possibilities are simultaneously being
co-constructed and constructing the relationships between the "heroes" in the
fictive world played by the participants. Because of these bonds, the members
cannot collaborate without simultaneously taking risks and trusting each
other. It seems to me that, because they are formed around the activity of con-
structing play, the relationships between them do not belong to any of the
"reality" chronotopes. However, and somewhat paradoxically, these relation-
ships do not belong to the realm of the imagined or play chronotope, either. I
argue that these new relationships are constructed on the border between the
reality and the play chronotope. They are relationships of simultaneously co-
authoring an imaginary world and co-authoring each other. In other words, a
new quality is forged in the relationship between the participants. To each
other, the participants become a ME and a YOU (Marjanovic-Shane, 1989;
Marjanovic-Shane & Beljanski-Ristić, 2008). The act that creates the play
frame is simultaneously an act of invitation to others to become co-authors, to
collaborate in creating a new chronotope. As an act, and as a *postupak*, it does
not belong to any "reality" chronotope, nor does it have any value within it.
The relation it creates between the ME and the YOU is not a mere relation; it
is a relationship. It does not have a tangible "object" or "objective" of the ac-
tivity systems in the reality chronotopes. In the words of Martin Buber, "The
life of a human being does not exist merely in the sphere of goal-directed
verbs. It does not consist merely of activities that have something for their ob-
ject" (Buber & Kaufmann, 1970, p. 54). The ME and the YOU enter into re-
lationship as authors, or better, as co-authors. This relationship is freely and
voluntarily formed. It is a relationship of dialogic listening. The imaginary
chronotope cannot be created and cannot exist without voluntary engage-
ment, full participation and equality of the co-authors. It re-establishes human
contact out of the binds of "reality" chronotopes with their hierarchies and
roles the subjects are given by the structure of the activity and the situation
rather than their "free choice" . The imagined world that is jointly built by the
ME and the YOU and that exists only *between*[10] them is what they offer to each
other. It is a gift that they keep giving each other and that, in turn, imparts
their relationship with a new quality: it gives them life as individuals-in-
relationship.

The acts of the members of the community of players (a ME and a YOU)
in relation to the imagined world are generative and aesthetic (Bakhtin et al.,

1990). They build it, organize it and arrange it. Every act of building the imag-
ined world has an aesthetic value of forming, shaping and "finalizing" it
(Bakhtin et al., 1990). The ME and the YOU create it for each other, making
it, with each turn, more shaped, more formed and more significant to each
other. Their postupaks toward each other are dialogic. Each move that builds
the imagined world is a gesture of a ME directed to a YOU. It is a gesture that
accepts, completes, extends, and transforms each other's visions. The ME and
the YOU become and exist through the dialogue about the world they are cre-
ating together. And that world—the play chronotope—is woven out of their
comments to each other about the other "realities" of their lives.

Concluding Remarks

Playing together can bring about transformations in the relationships in the
community of players; it can strengthen the bond, the feeling of mutual com-
pletion between the ME and the YOU. This is a new emotion, the energy of
becoming the ME and the YOU. It is the feeling of experiencing mutual un-
derstanding in the dialogic bond. It is a feeling of "completion" (Holzman,
2009) between the ME and the YOU. Furthermore, this feeling is also a feel-
ing of transformation and overcoming by "sincere emotions" (Vygotsky, 1971)
that exist in the relations between the participants in a hierarchical
chronotope of a goal–directed activity system. The feelings of fulfilling (or not)
an obligation to another, the feeling of being helped and having friends, or
emotions of battling with an opponent, the feelings of achievement of a goal
or failure to achieve it—are all emotions that arise from the relations within
goal- directed "reality" chronotopes. These feelings have immediacy of the
postupaks as they position the participants to each other and bind them with
values and norms derived by impersonal chronotopical forces of the division
of labor in object–oriented activities. But the new feeling, the new emotion of
understanding each other as collaborators in building a fictive world, is an
emotion that overcomes them all, giving the relationship between a ME and a
YOU a new depth and significance.

Writing from a slightly different perspective to describe the emotions
aroused in appreciation of art, Vygotsky claimed that "it is not enough to ex-
perience sincerely the feelings of the author; it is not enough to understand
the structure of the work of art; one must also creatively overcome one's own
feelings, and find one's own catharsis; only then will the effect of art be com-
plete" (Vygotsky, 1971, p. 248). In other words, one creates a new persona in
becoming a co-author to the author's ME. To understand a playful offer or a

work of art means to be transformed into a dialogic listener, into a YOU for someone's ME. Thus, the creative overcoming of one's own feelings, in play and other creative activities, releases new energy that creates and sustains dialogic relationships. That is, the completion of a ME: in a YOU, with YOU, and by YOU—and together becoming co-creators and co-authors of understanding.

References

Bakhtin, M. M. (1984). *Rabelais and his world* (1st Midland book ed.). Bloomington: Indiana University Press.

Bakhtin, M. M., Holquist, M., & Liapunov, V. (1990). *Art and answerability: Early philosophical essays* (1st ed.). Austin: University of Texas Press.

Bergen, D. (2002). Finding the humor in children's play. In J. L. Roopnarine (Ed.), *Conceptual, social-cognitive, and contextual issues in the fields of play* (pp. 209–220). Westport, CT: Ablex.

Bretherton, I. (1984). Representing the social world in symbolic play: Reality and fantasy. In I. Bretherton (Ed.), *Symbolic play*. Orlando, FL: Academic Press.

Buber, M., & Kaufmann, W. A. (1970). *I and thou*. New York: Scribner.

Cohen, T. (1980). Metaphor and the cultivation of intimacy. In S. Sacks (Ed.), *On metaphor* (pp. 1–10). Chicago: University of Chicago Press.

Eisenberg, A. R. (1986). Teasing: Verbal play in two Mexicano homes. In B. B. Schieffelin & E. Ochs (Eds.), *Language socialization across cultures* (pp. 182–198). New York: Cambridge University Press.

El'konin, D. B. (1981). *Psihologija dečje igre* [Psychology of child play] (B. M. Marija Marković, Trans. First ed., Vol. 4). Beograd: Zavod za udžbenike i nastavna sredstva.

Garvey, C. (1976). Some properties of social play. In J. S. Bruner, A. Jolly, & K. Sylva (Eds.), *Play: Its role in development and evolution* (pp. 570–583). New York: Penguin Books.

Garvey, C. (1990). *Play* (Enl. ed.). Cambridge, MA: Harvard University Press.

Glaser, B. G., & Strauss, A. L. (1967). *The discovery of grounded theory: Strategies for qualitative research*. Chicago: Aldine.

Holzman, L. (2009). *Vygotsky at work and play*. New York: Routledge.

Marjanovic-Shane, A. (1989). "You are a pig": For real or just pretend?—Different orientations in play and metaphor. *Play & Culture, 2*(3), 225–234.

Marjanovic-Shane, A. (1996). *Metaphor—A propositional comment and an invitation to intimacy*. Paper presented at the The Second Conference of ISCRAT. Retrieved June 1,2009 from http://www.speakeasy.org/~anamshane/intima.pdf..

Marjanovic-Shane, A., & Beljanski-Ristić, L. (2008). From play to art—From experience to insight. *Mind, Culture, and Activity, 15*(2), 93–114.

Matusov, E. (2009). *Journey into dialogic pedagogy*. New York: Nova Science.

McMahon, F. F., Lytle, D. E., & Sutton-Smith, B. (2005). *Play: An interdisciplinary synthesis*. Lanham, MD: University Press of America.

Miller, P. (1986). Teasing as language socialization and verbal play in a white working class community. In B. B. Schieffelin & E. Ochs Keenan (Eds.), *Language socialization across cultures* (pp. 199–212). New York: Cambridge University Press.

Opie, I. A., & Opie, P. (1969). *Children's games in street and playground: Chasing, catching, seeking, hunting, racing, duelling, exerting, daring, guessing, acting, pretending.* Oxford, UK: Clarendon Press.

Paley, V. G. (1984). *Boys & girls: Superheros in the doll corner.* Chicago: University of Chicago Press.

Paley, V. G. (1992). *You can't say you can't play.* Cambridge, MA: Harvard University Press.

Paley, V. G. (2004a). *A child's work.* Chicago: University of Chicago Press.

Paley, V. G. (2004b). *A child's work: The importance of fantasy play.* Chicago: University of Chicago Press.

Sutton-Smith, B. (1976a). *A children's games anthology: Studies in folklore and anthropology.* New York: Arno Press.

Sutton-Smith, B. (1976b). *The psychology of play.* New York: Arno Press.

Sutton-Smith, B. (1979). *Play and learning.* New York: Gardner Press; distributed by Halsted Press.

Sutton-Smith, B. (1985). *Children's play: past, present & future.* Philadelphia: Please Touch Museum for Children.

Sutton-Smith, B. (1986). *Toys as culture.* New York: Gardner Press.

Sutton-Smith, B. (1997). *The ambiguity of play.* Cambridge, MA: Harvard University Press.

Sutton-Smith, B., & Kelly-Byrne, D. (1984). *The masks of play.* New York: Leisure Press.

Sutton-Smith, B., & Pellegrini, A. D. (1995). *The future of play theory: A multidisciplinary inquiry into the contributions of Brian Sutton-Smith.* Albany, NY: State University of New York Press.

Villanueva, S. (2009). Interview about the episode taped on October 16, 2006.

Vygotsky, L. S. (1930/2004b). Imagination and creativity in childhood. *Journal of Russian and Eastern European Psychology, 42*(1), 7–97.

Vygotsky, L. S. (1933/1976). Play and its role in the mental development of the child. In J. S. Bruner, A. Jolly, & K. Sylva (Eds.), *Play–Its role in development and evolution* (pp. 537–554). New York: Penguin Books.

Vygotsky, L. S. (1971). *The psychology of art.* Cambridge, MA: MIT Press.

Vygotsky, L. S. (1978). *Mind in society: The development of higher psychological processes.* Cambridge, MA: Harvard University Press.

Vygotsky, L. S. (1986). *Thought and language* (A. Kozulin, Trans. Rev. ed.). Cambridge, MA: MIT Press.

Vygotsky, L. S., & Luria, A. R. (1994). Tool and symbol in child development. In R. Van Der Veer & J. Valsiner (Eds.), *The Vygotsky reader* (pp. 73–98). Cambridge, MA: Blackwell Publishers.

Wolfenstein, M. (1954). *Children's humor, a psychological analysis.* Glencoe, IL: Free Press.

Dr. Marjanovic-Shane is very grateful to Dr. Eugene Matusov and "Mr. Steve" for sharing a part of the data, their own memories of the situation, and also for providing explanations and hints for interpretation of the event described in this chapter.

Part Two
Domains of Artistic Expression

Crossing Scripts and Swapping Riffs:
Preschoolers Make Musical Meaning

Patricia St. John

Surveying a rich array of rhythm instruments on the carpet, four-year-old
Elizabeth decided upon the wooden stir xylophone and a mallet. She
approached me and exclaimed, "I'm going to make something for you!"
Carefully choosing various colors of egg shakers, she filled the cylindrical in-
strument-now-turned-bowl and stirred vigorously. She deliberately mixed the
contents with the mallet-serving-as-spoon, listening carefully to the tone color
of wooden slats of varying length combined with plastic bead-filled egg shak-
ers. She proudly presented her soup concoction to me. As if anticipating an
objectionable response, she declared, "It's bug soup and you have to eat all of
it or you can't leave!"

Across the circle, Abigail created a spontaneous song to accompany her
"cooking." Keeping a steady beat on a small hand drum, she marched around
the circle while singing, "I love soup! Ah-ba-doo-ba-ya-ba-doo!" Elizabeth's ini-
tiation of soup-making had undoubtedly influenced Abigail's culinary im-
provisation, and the cooking theme now permeated the preschoolers'
instrument exploration time.

As each child spontaneously came in and out of the cooking circle, the ex-
changes evolved into a restaurant scene. Xavier watched intently as he freely
explored a variety of instruments; he examined sound production and mate-
rial, alternative uses and techniques. He observed my interactions with each
delivery of pretend food. When I declared, "Mmmm—delicious; my compli-
ments to the chef!" he jumped up and announced, "I'm the chef!" Suddenly,

he picked up one sand block and, handing it to me, said, "Your check, Ma'am."

Using Social Knowledge and Musical Understanding to Scaffold Experience

The scenario described above reveals the complexity of interactions in which children engage as they make sense of the world. This engagement reveals a sophisticated *activity system* (Cole & Engeström, 1993) that may be interpreted through the lens of Cultural-Historical Activity Theory (CHAT). Through these interactions, children formulate an intricate web of relationships, or what Bronfenbrenner (1974, 1976, 1977) terms "nested realities," which provide an ecological context to draw from and connect to as they actively construct knowledge. The continuous reciprocal interaction of personal and environmental determinants informs psychological functioning.

This chapter explores the inherent socializing force of collective music-making, particularly during preschoolers' free-play with instruments, and the power of socially shared cultural knowledge within a community of music learners. In their musical play, children revealed a complex system of interactions characterized by a division of labor, rules of engagement and the fundamental role of mediating artifacts to build on prior knowledge, scaffold experience and construct knowledge.

Analyzing social interactions and examining how social and cultural contexts influence development are not new. However, little research has been conducted to document socio-cultural theoretical implications with respect to early childhood practice, particularly in music-making settings. Using a microgenetic analysis that links theory with practice in early childhood music-making, my purpose is two-fold: 1) to investigate the trail of interactions in preschoolers' pretend play during musical instrument exploration and 2) to examine preschoolers' use of prior experience and *social scripts* (Nelson, 1983) to scaffold experience and to aid in concept discovery and musical understanding.

Through this analysis and with this dual purpose I hope to demonstrate what children's interactions during instrument free-play reveal about concept development and how children's connections from prior experience and across multiple social entities scaffold their learning and assist their musical understanding.

The Community of Learners

Community is at the heart of this dynamic interplay. As children grow in comfort and security in their learning environment, they form relationships and realize a sense of belonging. Dissanayake (2000) suggests that belonging is fundamentally connected to our ability to find meaning, develop competence, and realize elaboration. Drawing on these collective gifts of the learning community, children creatively collaborate to construct meaning, to elaborate on it, and to transform it. The unique subset of experiences that each participant brings to the learning community creates an environment rich in potential. As contributions are offered and received, the give and take of ideas evolve into a learning experience beyond individual possibility.

Vygotskian theory suggests that meaning making is accomplished in social context and that learning drives development through the acquisition of spontaneous concepts (through everyday interactions) and scientific concepts (through instruction) (See Panofsky, John-Steiner, & Blackwell, 1990). The mediation of cultural artifacts and the dynamic interplay between spontaneous/scientific concepts intersecting "nested realities" and combined with reciprocal collaborative efforts generate a vibrant, interactive, and powerful learning space called the *zone of proximal development* (Vygotsky, 1978). Sociocultural theorists (Cole & Engeström, 1993; Chang-Wells & Wells, 1993; John-Steiner, Panofsky, & Smith, 1994; and Rogoff, 1994) have expanded the concept of the ZPD to conceptualize learning. Terms such as, *distributed, interactive, contextual*, and the result of the *learners' participation in a community of practice* imply rich and "divergent environments" (Brown, Ash, Rutherford, Nakagawa, & Campione, 1993, p. 191). The community of learners scaffolds the emergent understanding of all the participants. Thus, the many and varied social and cultural contexts of the members in the learning community converge in the classroom, providing a wealth of multi-layered resources. It is the task of the classroom community to explore and discover these resources through creative collaboration, to expand and develop them, so that understanding and meaning emerge.

The social influences defining the classroom community play a fundamental role in children's music-making experiences. Observing interactions in the music classroom community provides a unique lens through which to view children's agency as they appropriate learning strategies for and with one another. Children integrate socio-cultural norms, rules, and *division of labor* within the community, while simultaneously displaying self-discovered musical understanding through free-play and instrument exploration. Like seasoned jazz musicians borrowing riffs and exchanging licks, they play off one another's

contributions as they actively engage in knowledge construction. Intensely absorbed in the task at hand, they seem to create their own *ZPD*, drawing upon cultural knowledge, the community of learners, and mediating artifacts in the environment to find what is most needed to scaffold their experience. Vygotsky (1978) suggests that, in play, children seem a head taller than themselves, acting above their age level and beyond their daily behavior (p. 102). Is this where self-scaffolding is realized? Children demonstrate agency by finding what they most need to know next through self-initiated problem-solving/finding and through implicitly drawn connections for self-discovered meaning making. Using found resources in the environment and through their interactions with persons and material, they self-scaffold learning, thereby defining their own learning space. Pretend-play enables them to realize roles and perform functions beyond their lived experience; *scripts* serve as an intermediary between that lived experience and scientific concepts.

Previous research exploring scaffolding strategies (e.g., Roberts & Barnes, 1992; Pratt, Green, McVicar, and Bountrogianni, 1992) demonstrates the adult charting a carefully crafted plan for the learner, based on what s/he can do and what s/he might be able to do with assistance. This research may be viewed from the adult perspective, evaluating what the learner needs next to achieve competence. Studies on mastery motivation (e.g., McCall, 1995) speak to the child's natural challenge-seeking propensity as s/he finds and makes meaning. From the learner's orientation, these studies reveal the need for competence and the desire to know. Research on flow experience in young children's music-making demonstrates their challenge-seeking and challenge-monitoring strategies (Custodero, 1998, 2002b, 2005; St. John, 2004; Sullivan, 2004). This research speaks to the learner's active engagement with the teacher-presented material and how s/he manipulates the music content, negotiating its simplicity or complexity in accord with perceived personal skill.

Awareness of others and how we relate to one another in the classroom environment provides a social framework which evolves into a community of learners. This sense of community empowers the child to co–construct knowledge. Social construction of knowledge calls forth the child's agency in the learning process as s/he engages in problem-solving *and* problem-finding strategies. Flow research on young children's music-making (e.g., Custodero, 1998, 2005; St. John, 2004, 2005) reveals that group and one-on-one experiences can facilitate flow for young children, depending upon the quality of adult and peer interaction. It seems that peers and adults need to be available to young children for modeling purposes to raise perceived skill level and to help sustain flow in shared experiences. The social influences help to free energy. The community, whether this is a dyad or a group of people, functions in

organizing consciousness; the collective experience and the *sense of belonging* free the individual's energy to be used toward the task.

The ability to appraise experience rather than outcomes in children's music-making seems not only desirable but necessary if teaching strategies are to acknowledge the child's creative responses, honor the child's emergent understanding, and foster the child's agency in the learning process. The flow model (Csikszentmihalyi, 1975, 1990, 1997) provides an appropriate framework for observing and evaluating both the learning *of* music and the encounter *with* music (Custodero, 2002b).

In this chapter, I examine preschoolers' instrument free-play, where the *child* leads the way and creates his/her own learning space. Implicit in this pedagogy is trust in the child's agency; the educator believes the child will find what is needed next to scaffold his/her experience and to facilitate learning. Freedom is given to explore possibilities and to discover alternatives. In this freedom, children find connections between self and object, mediating artifacts and community. Providing time for children to negotiate their engagement, to test their ideas, and to explore their expansions communicates value for their efforts and honors their contributions. This kind of learning community invites what Sawyer (2004) has called "improvisational performance" (p. 12). Because the children in this setting are given the freedom to follow their curiosity and to engage collaboratively in knowledge construction, they take ownership in it. Learning becomes not only effective but organically generated from their unique personal experiences.

I wondered how intersections of nested realities which children bring to the music setting facilitate musical growth. I wanted to examine interactions and how cultural knowledge, accompanying rules, division of labor, and mediating artifacts within the community assist children's learning. I was curious to explore how musical play might contribute to concept development. To address the methodological challenges posed in this inquiry, I employ a dynamic theoretical framework that incorporates the complementarity of Vygotskian Theory—specifically scaffolding strategies in the ZPD with Cultural-Historical Activity Theory, and the flow paradigm.

A Musical Menu

Guests and Venue

Eight children, ranging in age from 3.6 to 4.9 years, were enrolled in a preschool music class at an independent music school in the Northeastern

United States. Of the eight children, six were returning music students who had participated in the music center's programs since infancy.

Six[1] consecutive sessions of instrument exploration, the start of the 45-minute weekly music class, were videotaped across a 15-week semester in fall, 2004. Videotaped observations were coded using the Revised-Flow Indicators in Music Activities (R-FIMA) form, developed and refined by Custodero (1998, 2002b).

As the music teacher, I functioned as participant-observer in the data–gathering procedure. Glesne (1999) notes the value of active involvement in the social setting being observed, where the researcher learns firsthand how the actions of the research participants. In this case, the community of learners correspond to their words, patterns of behavior, and the unexpected as well as the expected. The teacher/researcher develops a quality of trust in the learning community that enables the participants to engage without reservation in the learning process.

Analysis

The unit of analysis was the single musical event, instrument exploration, and the accompanying *activity system* (Cole & Engeström, 1993), namely the music class and its evolving pretend play. Cole and Engeström suggest that using the activity system as a unit of analysis leads to important insights in that it provides a "conceptual map" leading to the location from which human cognition is distributed while also including the important component of others participating simultaneously within the system (p. 8). Analysis of each session, ranging from 8.5 to 12.5 minutes in duration, resulted in 50 hours of coding and yielded 35 R-FIMA forms for an average of seven children. The children determined when the instrument free-play time ended. As their teacher, I monitored their engagement, participated in their play when invited, and followed their prompts, verbal or non-verbal, to move onto something else. Detailed anecdotal notes, as well as informal parent telephone interviews complemented child-by-child coded observations.

The use of verbal and non-verbal exchange, reflective of the salience of language in Vygotskian theory, was recorded on the R-FIMA in narrative form under the comments section. Initially, these exchanges were noted to analyze how they might have facilitated and/or maintained flow. They were re-examined in light of CHAT to identify and categorize themes and trails of interactions, and to see how these may have contributed to or demonstrated concept development and distributed cognition. Videotapes of the selected

event were repeatedly reviewed and rewound; each tape was viewed a minimum of three times.

Noteworthy here is Katherine Nelson's (1983) developmental research. Nelson's work supplements Vygotsky's early work in that she relies upon observations of children's daily activities. Based on observation of everyday cognition, Nelson combines naturalistic settings of knowledge acquisition and more structured laboratory tasks. She identifies *script-based concepts*, i.e., generalized event representations from prior experiences, which children use to bridge learning, thereby aiding concept development. These contextualized venues draw upon spontaneous concepts derived from past experiences. Panofsky, John-Steiner, and Blackwell (1990) suggest that the *scripting* serves as an intermediary phase. "Scripting" facilitates the child's cognitive transition to scientific concepts, particularly along a developmental trajectory as events are *cross-scripted* and evolve from sequential structures, or syntagmatic relations, to paradigmatic relations where common elements are shared in similar contexts, but with different structures. Since the simplest paradigmatic relations require more abstraction from both the real world and the conceptual context than syntagmatic relations, the child's conceptual development is realized as these *cross-scripted* events evolve.

The "restaurant-script" is a typical example of how the sequence of events creates meaning. "Over time, concepts are derived from scripts by a process of analysis or partitioning" (Panofsky, John-Steiner, & Blackwell, 1990, p. 254). The collaborative efforts during the children's instrument free-play coupled with scaffolding strategies further drives development as participants play off each other's contributions. I aim to show how the complexity of this dynamic weaving of everyday concepts and scripted realities facilitates musical understanding and creates a rich texture of experience through the descriptive narrative gleaned from the videotaped sessions.

Gathering Ingredients; Making Connections

Analysis revealed the children's focused engagement with the instruments, moving seamlessly between musical explorations and extra-musical functions. The taped sessions showed the children finding multiple ways to engage in instrument-play, which included novel means of sound production as well as extra-musical uses. Because the activity was open-ended and the goal was clear and simple—to explore the instruments freely—the children were able to determine *for themselves* how they would use the instruments. They were not bound by an instructional protocol nor governed by an established systematic

introduction from one who understands the whole of musical skill development. This influenced their absorption in the self-determined task and the intensity of their engagement since every child could find a way to participate and all contributions were legitimate. The children's inventive possibilities resulted in high mean scores for flow indicators, *self-assignment* and *expansion*, and the quality of their gesture while exploring the many uses for the instruments translated into high mean scores for *deliberate gesture*. The presence of these three challenge indicators combined with perceived high skill in previous research (St. John, 2004) resulted in a factored dimension named *Flow*. Results from descriptive statistical analysis in the study being discussed here suggest that flow was operative in this setting. In addition to high correlations between the three indicators mentioned above, statistical analysis revealed high correlations between *peer awareness* and *skill level*, reflecting the salient role of others in the environment and how peers assist each other in the learning process.

As anticipated, flow was facilitated by the multi-sensory nature of the activity, the immediate feedback that it afforded, and the multiple opportunities for action and awareness to merge. A wide range of interpretations was observed as each child determined *how* to become part of the experience. For some their involvement was quite simple, focusing on one instrument in almost Zen-like fashion. One child, for example, played plastic castanets, with one in each hand, for almost an entire period of instrument exploration. He held them up to his ears as if intrigued by their tonal quality and explored various rhythms as he played them. Others increased the complexity of the task and expanded the open-ended activity by such means as making up spontaneous songs to accompany their improvisations, switching instruments to find new timbres for their pretend-play, and partnering with peers to create an ensemble. These adaptations revealed self-scaffolded efforts that moved from imitation to task mastery and even task transformation. Perception of one's individual skill improvement called forth increased challenge; children found ways to intensify their experience. This self-perpetuating cycle is intrinsically motivating as confidence increases and competency evolves.

What were not anticipated in the findings were the intensity of pretend-play and the *scripting* that permeated the children's instrument exploration and corresponding interactions. Embedded in this play was a sophisticated understanding of socio-cultural norms. "Soup-making" underscored each instrument free-play session. Serving as a mediating artifact, the stir xylophone became the "bowl." Each week children gathered around it, taking turns to spoon egg shakers carefully into the instrument-functioning-as-pot to create a

soup concoction. Intensely interacting between subject and object, they brought their creation to me with great care and anticipation. They admonished, "You have to eat it all!" or queried, "Do you want more?" as they watched while I pretended to "eat" the soup. Extending the improvised dialogue, they asked: "Would you like something to drink with that?" or "How 'bout some dessert?" While they watched, they accompanied their attending with instrument play, trying out various textures and timbres, exploring sounds and finding resonance. Were they knowingly creating background "dinner music?" As another child brought a new "serving," Abby, seemingly otherwise occupied, could be heard making up a spontaneous song about the soup's content while marching around the perimeter of the circle. She kept a steady beat with her feet as she marched and simultaneously improvised with Chinese bells. Was Abby tapping into another scripted reality, into what Nelson (1983) calls an *event representation*: "take out" or delivery?

The soup creations took on their own transformations as well; starting with bug soup, permutations included mud soup, scrambled eggs, ice cream, chicken noodle soup, and finally, bug stew served in a music restaurant. These alternative versions revealed yet another aspect of *cross-scripting*, where objects are transferred from original contexts and used in novel ways. Nelson (1983) suggests: "Creation of an object concept involves the establishment of a decontexted unit apart from its relationally contexted particulars" (p. 139).

The isolated act of "soup-making" evolved into a restaurant setting: a waiter presenting a pretend-check; making change and paying by credit card. Here the child-waiter used a sand block-turned-credit card receipt to authenticate the act with a mallet-functioning-as-pen to "sign" it. In each scenario, the children accompanied their fantasy play with instrument play, moving seamlessly from soup-making to music-making and back again. Other research has documented the seamless nature of children's musical play (e.g., Littleton, 1998; Custodero, 2002a). These studies reveal how children cross–pollinate content with other contexts, building on prior knowledge to scaffold experience.

Creating yet another social entity in the third session, Elizabeth made a pretend-parade as she high-stepped around the room, playing a steady drum beat. With that prompt, Raphaella placed a drum in front of me and explained that she was going to make some music for me. She placed the little rainbow drum flat on the floor, found two mallets, and improvised for two minutes. Alternating right- and left-hand mallets, she incorporated a variety of rhythmic patterns. Meanwhile, Xavier marched to his own drumming in Elizabeth's parade while Abigail was singing a made-up song about scrambled eggs which she had "served" to me previously. The whole group responded

enthusiastically to Elizabeth's invitation, "Let's make a parade!" Particular with formation, Elizabeth was clear with her instructions as she admonished her peers to stay behind her; she was the leader. Interestingly, everyone in the group initially reached for a drum to play! Was this a drum corps? Were the children referencing yet another social entity?

Consider each of these vignettes as examples of *cross-script* object relations, where common elements are shared in similar contexts but with different structures (Nelson, 1983, p. 138). These context-specific references within the music setting seem to enable the child to determine *what* object of her/his play will be conceptualized. That object is then analyzed around a dramatic narrative; the identifying characteristics of the object seem to facilitate connections outside of its original context but are ultimately applicable to musical understanding.

In the fifth session, a Sousa march gave way to the children's own improvised parade music which included three children playing to and reacting with one another much like drum circle dialogues. As the Sousa recording came to an end, Sarah exclaimed, "Let's do it again!" When given the choice of repeating the recorded march or making their own parade music, the children exclaimed, "Let's make our own!" Elizabeth challenged, "Let's do it backwards this time." I soon realized that she meant to reverse direction! As children marched counter-clockwise and switched instruments during their final parade rendition, it became apparent that they were setting up the next best thing, collaboratively scaffolding their own experience and re-inventing the activity to make it more complex.

During my informal telephone interviews with parents, I found out that seven of the eight children in this weekly music session attended preschool at least twice a week. I asked the parents if they thought their child's preschool setting was more structured or more exploratory; parents responded "highly structured." Furthermore, they added that they deliberately wanted an "academic" emphasis. I include this information here in light of the focus on academic "readiness" in preschools that often results in reduced or eliminated unstructured time and free-play. In play, children problem-solve and problem-find; they test hypotheses, drawing upon imagination and creativity to find and make meaning in their world. The value and importance of play in young children's knowledge construction, particularly in the early years, is well documented (e.g., Paley, 2005).

Master Chef or Music Conductor: Exchanging Roles

By engaging in the common household and, quite possibly, favorite pre-school task of cooking and calling forth a known experience, i.e., going out to eat, children used prior experience and *scripts* to find a way to participate in and make meaning from their learning. Defining *how* the instrument exploration would unfold, they set up the subject (cooking) and object (the stirxylophone) from which events would depart. Quite magically, a division of labor emerged. There were no committee meetings; there was neither discussion nor election of officers. Typifying childhood intuition, each child found his/her role and observed the implicit rules. Interestingly, I was assigned the role of customer: I received attentive service in a well-choreographed restaurant enterprise; multiple cooks gave me several variations on a "bowl of soup" and a shifting wait-staff attended to my needs.

While some aspects of this established activity system might appear unchanging, that is, there was always soup and some form of cooking, the transitions and reorganizations were astounding to observe. This made for a dynamic multi-layered experience that was both spontaneous and emergent as the children played off one another's contributions like jazz musicians jamming and improvising together. These exchanges may explain the high correlation between skill and peer awareness. Keenly aware of what the other was doing, participants drew upon social interactions and peer contributions to heighten their own experience.

Roles were exchanged as the pretend-play scene evolved, and the function of instruments moved from kitchen utensils to tools for musical expression. The complexity of this activity system was characterized by tensions and transformations, negotiations and novelty that kept equilibrium at bay. As some children negotiated the content of my repast, others produced lyrical accompaniments, moving in and out of created role of waiter and music-maker. In one example, Abby, who had initiated the soup making, moved away from the cooking circle. I suspect there may have been too many cooks in the kitchen for her! She found a small rainbow drum and began improvising on it as she marched around the room, perhaps borrowing from an alternate *script* to find another way to be engaged in the experience. As her culinary partners made scrambled-egg soup, she spontaneously made a song using scrambled eggs as the text. Using the common element of scrambled eggs, she swapped soup for song, exchanging a cooking ingredient for lyrical content. When others left the cooking circle, Abby re-established herself as chief cook. On another occasion, she found a drum partner and exchanged rhythmic dialogue, carefully

responding to her partner's improvisations and accompanying her reply with scat singing. Leaving behind *scripts*, now she was exchanging riffs!

This type of seamless cross-over from soup-making to music-making was complementary throughout the instrument exploration and indicative of paradigmatic relations. As children shared common elements with different structures, such as Abby's shift from scrambled-egg soup to scrambled-egg song, or the sand blocks functioning as credit card receipt and back to sound-maker, they demonstrated a level of abstraction with both the real world and conceptual contexts. Alternating instrument-function from cooking utensil to musical tool and borrowing *scripts* from "nested realities," they reveal social knowledge and musical understanding.

The vignettes described above demonstrate a salient aspect of children's play: they do not simply reproduce social structures. Their *cross-scripting* creates what is needed in-the-moment to assist learning. As Sawyer (1997) suggests, "...children appropriate [social] structures and use them to create new, improvised interactions" (p. 182). These interactions seem to scaffold their experience and to aid concept development.

The salient role of language, including *musical* language, in culturally mediated behavior is especially notable here. Luria (1981) writes:

> With the help of language, [human beings] can deal with things that they have not perceived even indirectly and with things which were part of the experience of earlier generations. Thus, the world adds another dimension to the world of humans (p. 35).

After observing Abby's drum exploration, Elizabeth reached for a drum and suggested the creation of a parade. "Follow me!" she exclaimed, "I'm the leader; be sure to stay in line!" As an example of another activity system, roles were assigned, positions assumed, and rules articulated. The primary role of drums in a parade was particularly noted as every child chose a drum through which to participate. The creation of a *quasi* drum-corps may communicate here distributed cognition across generations as well as culturally transmitted forms of festivity and genres of celebration. The accumulated knowledge from prior generations is present in the children's present day cultural environment and informs in-the-moment experience as they actively construct knowledge.

Novel Ingredients

Musical Instruments: Tools and Objects for Musical Expression and Play

Some children did not move from their instrument exploration. For example, Sean engaged in long, focused periods on individual instruments, exhibiting trance-like intrigue with timbre as he explored sound and sensation. Nonetheless, he was observed pausing at the "cooking circle," leaning into it to get a better look, and then resuming his improvisation. It should be noted that Sean came to this particular session clad in a paper hat he had made that morning in preschool. Was he providing ambiance, dressed up as "entertainer" and offering background music for dining pleasure? Is this an example of children making connections across play settings or as previously suggested, *cross-scripting*?

In previous research (St. John, 2004), instrument-play was the second most flow-producing activity in an early childhood music setting; movement activities generated the most flow. In their instrument-play, the children in this current study made implicit meta-cognitive adjustments as they self-corrected or found a peer to imitate. They used instruments in both novel and traditional ways, discovering alternative means to enhance their experience. The instrument free-play served as a backdrop to organize the children's experience, structuring consciousness and thereby facilitating flow. This "optimal experience" (Csikszentmihalyi & Csikszentmihalyi, 1988) is the result of a self-perpetuating cycle: as requisite skill is achieved for an activity, the challenge of the task must intensify. The balance between the two components is a dynamic interplay. Both skill and challenge must be high and equal to maintain the flow state. If skill is higher than the challenge presented, the individual experiences boredom; if the challenge is greater than the skill level, the individual experiences anxiety. The goal is to maintain a sense of harmony or well-being, also called psychic negentropy[2] or *flow experience*.

Csikszentmihalyi (1982) addresses the complexity of interpersonal relationships in the learning environment and how other people impact entropic and negentropic psychological states. The role of the community in maintaining *social* negentropy is documented in previous research (St. John, 2004). Interpersonal skills are necessary as they facilitate reciprocity of ideas, collaboration, and transformation of material among the community of learners. Analysis showed that the social strategy (*peer awareness*) was robust to influences of all types of musical activities, suggesting that *being with* each other is fundamental to young children's music-making. As participants found not only where to be in the environment but with whom to be, attention was re-

directed away from the negative state of entropy, characterized by internal conflict, toward negentropy, or the self in harmony. A sense of belonging facilitated subjective experiences associated with negentropy, i.e., fun, enjoyment, and joy. With the self in harmony, participants directed attention to the music material. Peers provided a context from which to draw; these interactions facilitated flow.

In this study, the children found ways to be *part of* the experience in the collective space. Being part of a community enabled them to direct attention toward their dramatic or instrument–play, sorting through cultural knowledge and making connections between and with one another to find something new. Conversely, by using the common entry point of cooking, children alleviated any anxiety over *how* to engage in the instrument play. The stirxylophone-as-bowl served as a mediating artifact to facilitate engagement. The dynamic interplay between making soup and making music produced its own flow-generating environment as children continually re-invented culinary delights using instruments both as cultural objects and musical tools.

In the above–mentioned study (St. John, 2004), children employed deliberate strategies to aid their learning. These scaffolding strategies revealed the learner's use of personal adjustments (personal strategies with component variables *self-correction* and *imitation*), music material (material strategies with component variables *anticipation* and *extension*), and awareness of others (social strategies with component variables *peer and adult awareness*), to find, maintain, or sustain flow experience. It is not surprising, then, that the children's instrument play evolved from a *music* restaurant into a parade, scaffolding one flow-generating activity to another as a means of intensifying their experience and increasing their musical skill. The interrelatedness of scaffolding strategies, *scripted concepts*, and flow experience is apparent here.

The dramatic inter-play of activity revealed many aspects of children's cognitive as well as musical development. From a cognitive perspective, the use of instruments-as-objects in their pretend cooking/restaurant play demonstrates the preschoolers' growing ability to separate thought (the meaning of a word) from object, and then to use the object across contexts as demonstrated in *cross-scripting*. Play facilitates this transitional stage. Vygotsky (1978) writes:

"In play thought is separated from objects and action arises from ideas rather than from things..." (p. 97). This is demonstrated in the children's use of the sand block, for example, as a credit card receipt and the mallet as a writing utensil. The child's relationship to the real, immediate, concrete situation is dramatically changed because the structure of her/his perceptions changes. Vygotsky used the ratio of object—as numerator, and meaning—as denominator, to express the structure of human perception (object/meaning). The object is dominant for the child and meaning is subordi-

nated to it; the ratio is inverted (meaning/object) when an object becomes the pivot for meaning-making in something else, such as the case with the sand block. "The child at play operates with meanings detached from their usual objects and actions..." (Vygotsky, 1978, p. 98).

As children create dramatic narrative to accompany their free-play with instruments, quite possibly *scripts* bridge the gap between spontaneous concepts and scientific concepts. Perhaps, as they move toward such conceptual music knowledge in their instrument exploration without the provision of explicit instruction, their meaning making is strengthened, predisposing them for success in future formal music instruction. Potentially, these early experiences may prepare them particularly well to make cognitive music connections in the ZPD, along the trajectory between spontaneous and scientific concepts.

Although the soup-making activity may be questionable as a *music* activity *per se*, the exploration of the stir–xylophone-turned-bowl provided opportunities to experiment with timbre, or sound quality, and tempo, as the stirring progressed from slow to rigorous. Cognitive connections were made, for example, as children discovered alterations in sound production dependent upon chosen tempo and material: stirring quickly vs. stirring slowly, or using a metal striker rather than a wooden mallet. Testing timbre and texture, they realized tonal differences between wooden, metal, and plastic instruments, and then made critical choices for participation.

Having discovered alternative solutions, the children found ways to expand and transform their experience. These expansions were observed in their spontaneous singing, connecting made-up songs to the cooking experience, for example, or adding vocal exploration to their instrument-play and discovering melodic contour. Children revealed self-corrective strategies as they adjusted their step to the recorded music or re-established the steady beat with their drum playing. They found alternative means to play instruments, expanding culturally accepted or traditional forms of performance. For example, one child discovered that striking a wooden mallet on the side of a small Chinese bell produced the preferred sound to the traditional use of two bells striking each other, or slapping the sand blocks together created a louder sound than rubbing them parallel, one against the other. Additional musical transformations included complex rhythmic exchanges with a collaborative partner. This collective music-making demonstrated an understanding of musical form vis-à-vis rhythmic patterning and phrase structure, as well as an astute awareness of ensemble and the power of exchange through musical dialogue.

Finally, the collective experience of soup-making evolved into a collaborative venture of improvised parade-making, a demonstration of coordi-

nated efforts in collective music-making. Complementing one another's musical skills, the community revealed a collective understanding of such musical concepts as sound production, steady beat, timbre, and tempo. They understood what it means to play *ensemble* and to communicate nonverbally through musical expression. They experienced this shared music-making as a powerful tool for personal as well as cultural articulation. Crossing and connecting "nested realities," the children demonstrated that collective music-making unites participants and facilitates community celebrations.

A Recipe for Success and an Improvised Score

Through play, the children established an integration of cultural knowledge with musical skills and concepts. Playing off contributions reciprocally and collaboratively, children scaffolded the experience for each other. The value of this collaborative activity has been explored previously (St. John, 2005, 2006a, 2006b). The common theme of cooking provided an entry point to become *part of* the social and musical experience for individuals looking for a way to belong in the community of learners. This permeating theme revealed understanding of such *social-scripting* as: culinary skills, dining out, and restaurant management. The assumed roles of cook, guest, waiter, and *maître d'* revealed a sophisticated understanding of *division of labor* in the community. Such comments as, "You have to eat it all or you can't leave" communicate their understanding of authority and expectations or the rules that govern unique family cultures and the *scripts* that identify them. Imitation led to parade-making, another collective, cultural phenomenon where children demonstrated social knowledge as they created roles of leader, participant, and spectator. Whether their formation of a *quasi* drum corps was conscious or not cannot be determined. Nonetheless, their understanding that drums play a fundamental role in parade organization was clear.

The children's dramatic play in the context of instrument-exploration reveals a dynamic dancing dialogue as they made connections between instruments and social behaviors, with music and cultural norms. Their carefully orchestrated choreography facilitated cognitive connections across nested realities as they drew upon *event representations through scripts*: from kitchen to music classroom, restaurant setting to civic venue and back again. Seamless in their play was the alternating use of instruments as objects to facilitate drama or as tools for musical expression.

The dynamic interplay of making music and making soup seems to have provided a background of order for the children. Without anxiety or bore-

dom, they could focus on the task at hand, whether that was soup-making or music-making, or a combination of both, to find flow! The instrument-play facilitated flow as they engaged in challenge-seeking and challenge- monitoring strategies (Custodero, 2005). Calling upon prior experience, both in social structures and musical endeavors, children revealed an understanding of spontaneous concepts and *scripted realities* in their play, crossing events and venues, borrowing *scripts* and swapping riffs. They demonstrated found musical skills through exploration and improvisation such as: keeping a beat, organizing rhythms, differentiating timbres, inventing songs, and playing together. The children moved seamlessly between these musical skills and carefully choreographed social skills, creating an elaborate activity system.

This chapter addressed the inherent socializing force of collective music-making, particularly during instrument free-play, and the power of *scripts* in socially shared cultural knowledge within a community of music learners. Through their interactions and pretend-play, children revealed a complex social system characterized by a division of labor, rules of engagement, and the fundamental role of mediating artifacts to build on prior knowledge, scaffold experience, and construct knowledge.

The community of learners, through their shared understanding of how relationships functioned in the music classroom, created what Bruner (1996) called a "mutual learning community," where each member's contribution was necessary and valued. Through this sophisticated *activity system*, children learned *about* music by *making* it. As they made music, they discovered musical skill and found music concepts. They found musical features by embodying them from the inside of musical experience. Nelson (1983) suggests, "...the experience of parts is a cognitive achievement, *not* a primitive building block" (p. 130). She calls this whole-making a *contextualized account of conceptual representation.*

We might learn from the children's demonstration of *division of labor*, from the way they exchanged roles and integrated knowledge from prior experience. Perhaps there is some insight to be gleaned from their cooperation and collaboration with one another, their negotiation of content and rules in pursuit of a common experience. Here the child realized basic music skills and understandings in addition to core principles of educational pursuit: to build community, to foster respect, and to value diversity.

References

Bronfenbrenner, U. (1974). Developmental research, public policy, and the ecology of childhood. *Child Development, 45*(1), 1–5.

Bronfenbrenner, U. (1976). The experimental ecology of education. *Teachers College Record, 78*(2), 157–204.

Bronfenbrenner, U. (1977). Toward an experimental ecology of human development. *American Psychology, 32,* 513–531.

Brown, A. L., Ash, D., Rutherford, M., Nakagawa, A., & Campione, J. C. (1993). Distributed expertise in the classroom. In G. Salomon (Ed.), *Distributed cognitions: Psychological and educational considerations* (pp. 188–228). New York: Cambridge University Press.

Bruner, J. (1996). *The culture of education.* Cambridge, MA: Harvard University Press.

Chang-Wells, G. L. M., & Wells, G. (1993). Dynamics of discourse: Literacy and the construction of knowledge. In E. A. Forman, N. Minick, & C. A. Stone (Eds.), *Contexts for learning: Sociocultural dynamics in children's development* (pp. 58–90). New York: Oxford University Press.

Cole, M., & Engeström, Y. (1993). A cultural-historical approach to distributed cognition. In G. Salomon (Ed.), *Distributed cognitions: Psychological and educational considerations* (pp. 1–46). New York: Cambridge University Press.

Csikszentmihalyi, M. (1975). *Beyond boredom and anxiety.* San Francisco: Jossey-Bass.

Csikszentmihalyi, M. (1982). Learning, "flow," and happiness. In R. Gross (Ed.), *Invitation to lifelong learning* (pp. 166–187). Chicago: Follett.

Csikszentmihalyi, M., & Csikszentmihalyi, I. S. (1988). *Optimal experience: Psychological studies of flow in consciousness.* Cambridge, New York: Cambridge University Press.

Csikszentmihalyi, M. (1990). *Flow: The psychology of optimal experience.* New York: Harper and Row.

Csikszentmihalyi, M. (1997). *Finding flow: The psychology of engagement in everyday life.* New York: Basic Books.

Custodero, L. A. (1998). Observing flow in young children's music learning. *General Music Today, 12*(1), 21–27.

Custodero, L. A. (2002a). *Connecting with the musical moment: Observations of flow experience in preschool-aged children.* Paper presented at the ISME Early Childhood Conference, Children's Musical Connections, Copenhagen, Denmark.

Custodero, L. A. (2002b, January/February). Seeking challenge, finding skill: Flow experience and music education. *Arts Education and Policy Review, 103*(3), 3–9.

Custodero, L. A. (2005). Observable indicators of flow experience: A developmental perspective on musical engagement in young children from infancy to school age. *Music Education Research, 7*(2), 185–209.

Dissanayake, E. (2000). *Art and intimacy: How the arts began.* Seattle: University of Washington Press.

Glesne, C. (1999). *Becoming qualitative researchers: An introduction* (2nd ed.). New York: Longman.

John-Steiner, V., Panofsky, C. P., & Smith, L. W. (1994). *Sociocultural approaches to language and literacy: An interactionist perspective.* New York: Cambridge University Press.

Littleton, D. (1998). Music learning and child's play. *General Music Today, 12*(1), 8–15.

Luria, A. R. (1981). *Language and cognition.* Washington, DC: Winston.

McCall, R. (1995). On definitions and measures of mastery motivation. In R. H. MacTurk & G. A. Morgan (Eds.), *Mastery motivation: Origins, conceptualizations, and applications* (pp. 273-292). Norwood, NJ: Ablex.

Nelson, K. (1983). The derivation of concepts and categories from event representations. In E. K. Scholnick (Ed.), *New trends in conceptual representation: Challenges to Piaget's theory?* Hillsdale, NJ: Erlbaum, pp. 129-149.

Paley, V. G. (2005). *A child's work: The importance of fantasy play.* Chicago: The University of Chicago Press.

Panofsky, C., John-Steiner, V., & Blackwell, P. (1990). Scientific concepts and discourse. In L. Moll (Ed.), *Vygotsky and education: Instructional implications and applications of sociohistorical psychology* (pp. 251-267). New York: Cambridge University Press.

Pratt, M., Green, D., MacVicar, J., & Bountrogianni, M. (1992). The mathematical parent: Parental scaffolding, parent style, and learning outcomes in long-division mathematics homework. *Journal of Applied Developmental Psychology, 13,* 17-34.

Roberts, R., & Barnes, M. (1992). "Let momma show you how": Maternal-child interactions and their effects on children's cognitive performance. *Journal of Applied Developmental Psychology, 13,* 363-376.

Rogoff, B. (1994). Developing understanding of the idea of communities of learners. *Mind, Culture and Activity, 1(4),* 209-229.

Sawyer, R. K. (1997). *Pretend play as improvisation: Conversations in the preschool classroom.* Mahwah, NJ: Lawrence Erlbaum Associates.

Sawyer, R. K. (2004). Creative teaching: Collaborative discussion as disciplined improvisation. *Education Researcher, 33(2),* 12-20.

St. John, P. A. (2004). *A community of learners: An investigation of the relationship between flow experience and the role of scaffolding in a Kindermusik classroom.* Unpublished doctoral dissertation, Teachers College/Columbia University, New York.

St. John, P. A. (2005). Developing community, defining context, discovering content: Young children's negotiation of skill and challenge. *Early Childhood Connections, 11(1),* 41-47.

St. John, P. A. (2006a). Finding and making meaning: Young children as musical collaborators. *Psychology of Music, 34(2),* 238-261.

St. John, P. A. (2006b). *"Let's dance!"–Inviting musical discovering through relationship.* Paper presented at the International Society of Music Education/Early Childhood Conference, Touched by Musical Discovery: Disciplinary and Cultural Perspectives, Taipei, Taiwan.

Sullivan, J. A. (2004). *Attention and flow in preschool children during music circle time and music choice time.* Unpublished doctoral dissertation in Music Education, University of Kentucky.

Vygotsky, L. (1978). *Mind in society: The development of higher psychological processes.* In M. Cole, V. John-Steiner, S. Scribner, & E. Souberman (Eds.). Cambridge, MA: Harvard University Press, pp. 84-104.

The Social Construction
of a Visual Language:
On Becoming a Painter

M. Cathrene Connery

This new art...is not about an original creation myth connected with the fertility and birth mysteries...it is about the mysteries of women's rebirth from the womb of historical darkness. Gloria Orenstein (1990)

THe guard shifted shifted nervously and cleared his throat. I looked up from the corner of the canvas and realized I had ventured a little too close. Pointing at the direction of the brush strokes frozen in oil just inches from my finger, I urged my companion, "Look. You can see her thinking." Stepping back from the painting, the shock of a white, sun-bleached pelvis slapped dry and hollow against a hard turquoise New Mexico sky. The canvas held visual secrets: inside a window framed by the bone, the soft sphere of a summer moon called out almost inaudibly, barely perceptible to the naked eye. The painting sang a song of the desert, of life and death, barrenness and fullness, grief and that which is left after loss.

It has often been said that a picture paints a thousand words. Indeed, I have always found the hushed galleries of art museums to be noisy places. Whether standing before a Renaissance crucifixion or a modern American still life like that of the great painter Georgia O'Keefe described above, sounds, words, and conversations rise from the canvas only to echo down polished halls. The average art viewer strives to understand significance lurking behind mute symbols that divide themselves and the painter. However, to the studio artist standing silently on the other side of the canvas, the development of a uniquely personal message worthy of public scrutiny presents the greatest chal-

lenge. How do painters decide what to paint? What is the process by which they begin to develop a personal body of work? O'Keefe once noted, "The meaning of a word to me is not as exact as the meaning of a color. Colors and shapes make a more definite statement than words." How do artists develop a visual language? As a painter, scholar, and educator, I sought to address these questions through a self-study of my own artwork generated in early childhood and adulthood.

Vygotsky's Cultural-historical Framework: A Semiotic Alternative

When I was in art school, an intense pressure existed among students in my painting program to visually 'come into their own' by the junior year. While I can't recall any of my professors specifically sharing how they originated and developed a corpus of coherent, stylized work, multiple theories abounded as to how to achieve this task. For example, in art history classes, the Impressionists' radical rejection of both the French Academy and Napoleon's politics was identified as the impetus for their lovely landscapes. A professor asserted everyday curiosity, as the origin of Picasso's great genius, noting the Spanish artist's penchant for holding crystal prisms to the light.

It was in vogue for the painting faculty to attribute Freudian conflicts and sexual desire as the wellspring from which all creative imagery was derived, thereby turning class critiques an exercise in academic voyeurism. The few followers on the teaching staff of the Swiss psychologist Gustav Jung challenged such views, but apparently had not considered the analyst's own shockingly sexist perspectives from the early 1900s. Still other professors engendered their own theories: a male German visiting artist once told me that *if* I continued to paint beyond my sixtieth birthday, as an *American female*, I might actually have something important to say. Wandering through the exhibition of yet another esteemed faculty member, I couldn't help but wonder at the soundness of this theory: the professor had executed a portrait of his wife sporting a toilet seat for her head in a comment on family life. This cacophony of amusing but questionable theories on artistic development was of little value to myself and my twenty-something friends as we developmentally struggled to discover who we were on canvas and in real life.

Later as doctoral student in a different place and time, an interest in semiotics—the ways cultures use signs and symbols to make meaning—led me to the work of L.S. Vygotsky. As an educator, Vygotskian, sociocultural or cultural-historical theory had informed my studies in language and literacy acquisition. Vygotsky's writings seemed to offer a conceptual framework to ponder

questions related to the creative effort. I wondered if cultural-historical theory could address how and why painters develop a visual language.

Vygotsky's framework has been distinguished by a focus on "the dynamic interdependence of social and individual processes" through themes of "development, co-construction, synthesis, knowledge transformation, and semiotic mediation" (John-Steiner, 1999, p. 2). Beyond the academic jargon, this spectrum of themes offered me a rich alternative psychological portrait of how the mind makes meaning. The premise that cultural practices are mediated or relayed, interpreted and processed through physical and psychological tools including sign systems (Vygotsky, 1978; 1986; 1987b) deeply resonated with my experience as a painter and student of art history. Further reading convinced me that cultural-historical theory offered both a theoretical framework and research methodology appropriate for a holistic, scientific assessment of the creative process. In particular, I was intrigued by Vygotsky's theories regarding semiotic mediation and sign acquisition.

Semiotic Mediation

My early readings of Vygotsky emphasized that semiotic mediation is a complex sociopsychological process. Literally, the mediation of meaning interweaves the ways we receive and relate information to make sense of our worlds. Historically, humans have developed a wide range of tools and practices to engage in semiotic mediation. These instruments and protocols allow us to adapt and manipulate the environment. However, as we use them to change nature, semiotic tools and practices transform *human* nature, or ourselves, at the same time (Cole, 1996). For example, the invention of the plow led to the development of agriculture and centralized, permanent communities. As a result of this shift, humans related to each other and to the land in a novel manner. In our time, we have acutely experienced how the internet has redefined our professional and personal lives as well as understandings about who we are and the planet on which we live.

Vygotsky helped me to understand that semiotic mediation employs both physical and psychological tools. Physical tools mediate actions aimed at nature and external objects (Kozulin, 1986). Paintbrushes, computers and telephones are physical tools that assist us in the mediation of cultural understandings. On the other hand, psychological tools are internally directed implements that assist us in controlling individual and collective thought, emotion, and behavior (Vygotsky, 1986; John-Steiner & Mahn, 1996). For example, Vygotsky's (1981a) list of psychological tools included "language; various systems for counting; mnemonic techniques; algebraic symbol systems;

works of art; writing; schemes; diagrams, maps, and mechanical drawings; all sorts of conventional signs" as psychological tools (p. 137). I remember being delighted to see art on his list and wondered how paintings, sculptures, dance, and poetry might guide what we do as individuals and groups.

The writings of John-Steiner & Mahn (1996) offered a partial answer. They note that "knowledge is not internalized directly, but through the use of psychological tools" (p. 193). The nuns of my youth had always emphasized the notion of the mind as a blank slate on which the worldly and divine invisibly impressed the fingerprint of knowledge. In contrast, Vygotsky (1986) asserted that psychological tools capture, shape, relate, and transform our thinking. As we learn to use or appropriate and employ psychological tools like the alphabet or decimal systems, higher thought processes are developed.

Young children and novice practitioners learn or acquire proficiency in physical and psychological tool use by "watching their elders and betters" (Wells and Caxton, 2002, p. 3). We develop expertise in using both types of tools gradually, over time, in successive approximations through a variety of learning contexts including scaffolding, joint productive activity, and guided practice (Echevarria, Short, and Vogt, 2004; Au, 1993). As we developmentally appropriate or learn to make meaning with combinations of physical and psychological tools such as the computer and software or pencils and algorithms, our perspectives and thoughts become enhanced. At the same time, we are welcomed or socialized into the larger, sociocultural, historical-political life of distinct communities and disciplines like the statistician's computer lab or painter's studio. Indeed, access to or denial of physical and psychological tools results in the diverse and differentiated conditions and nature of our interests, lives, and very existence (Cole, 1996).

Cognitive Pluralism in Semiotic Mediation

Vygotsky was especially interested in verbal and written language as forms of semiotic mediation. However, our human physiology allows for visual, aural, verbal, kinesthetic, tactile, and olfactory modes of meaning making. John-Steiner (1995) pointed out that our many perceptual abilities correspond to the many ways we re-present internal and external thought through the arts and other creative endeavors. She refers to these multi-modal ways of meaning making and their development as cognitive pluralism. John-Steiner's research into the thought processes of Native American children and mathematicians revealed that we each use specific preferred modalities and learning styles when problem solving derived from our personal and diverse approaches to

understanding and experiencing the world (John-Steiner & Osterreich, 1975; John-Steiner, 1995).

John-Steiner (1995) also found that distinct groups and communities accommodate, shape, retain, and promote particular forms of cognitive pluralism as favored systems of meaning making. For example, our highly scientific, mobile culture esteems the efficiency of verbal, written, and mathematical symbol systems easily packaged into fast–paced, electronic tools, practices, and processes. This form of cognitive pluralism can be contrasted with communities that esteem and rely on a common, kinesthetic understanding communicated in a face–to–face meeting or silent handshake.

When considering the transformative nature of semiotic means, and their capacity to shape our thinking, who we are, and how we experience our lives, I was struck by the powerful capacity of cultural-historical theory to account for the wide range of perspectives, personalities, and peoples in the world. Individually and collectively, the multiple tools we select to represent meaning "define who we are and assist us in the reconstruction of our identities and abilities" (Bruner, 1990, p. vii) as well as our culture.

Semiotic Signs: The Building Blocks of Meaning

The concept of cognitive pluralism validated the acutely visual manner in which I experience life. It helped me to identify how my own history shaped the personal manner in which I came to rely on sight and symbol to interpret and represent my external and internal worlds. If our diverse forms of cognitive pluralism are derived from the many ways we are raised and the multiple tools we use, I began to wonder what psychological structures or processes lie beneath the surface of meaning making. Was there a common link between the semiotic mediation of the poet, painter, and dancer? Vygotsky's ideas about signs provided the answer.

Like the atom in relationship to the universe, all forms of meaning making rely on the building blocks of signs (Vygotsky, 1987a). Vygotsky emphasized that signs serve as carriers of cultural thought. In fact, only the most primitive forms of communication are possible in their absence. However, Vygotsky's position differed from formal linguists because he emphasized, "It is the meaning that is important, not the sign. We can change the sign, but retain the meaning" (in Van Oers, 1999, p. 1).

Signs, including gestures, movements, words, and visual symbols, provide an efficient means of mediating generalizations. While their external forms may differ, their internal structures share common features and functions (Vygotsky, 1971). As I read further, I discovered Vygotsky (1997a; 1987b; 1978)

distinguished between first and second order signs or symbolism. He considered oral language as primary because speech is the fundamental means by which we mediate meaning with each other. Second order symbols serve as auxiliary sign systems for oral language. Mahn (1997) notes their development introduces "a new system of meanings...onto the existing system of developed meanings" (p. 361).

As building blocks of meaning, independent signs are organized into *codes* for easy conveyance. Semiotic codes are then interwoven into *systems* to produce cultural *texts*. The *way* in which these texts are mediated influences *how* we create understandings from them. Cultural knowledge that has been coded into multiple semiotic means, like documentaries or movies, holds the potential of being more successfully mediated to a broader audience. My distinct form of cognitive pluralism had led me to design studios where I had played with, experimented, and manipulated the building blocks of a visual language.

The Acquisition of Sign Systems

As a painter, I was fascinated to discover Vygotsky's assertion that all sign systems are acquired through the same basic process. Regardless of whether it is visual, verbal, aural, or gestural, thought and sign are unified through transformations occurring across four interdependent phases. His experiments led him to believe "speech development follows the same course and obeys the same laws as the development of all other mental operations involving the use of signs, such as counting and memorizing" (Vygotsky, 1986, p. 86). These stages do not conform to absolute or rigid categories but are better described as a functional continuum where the emerging meaning maker draws on features from previous stages. The evolving nature of young children's speech development provides a powerful example of this fluidity between stages. In the first phase of sign acquisition called the Primitive or Natural stage, the meaning maker's thought exists apart from sign (Vygotsky, 1986). For example, when a baby first begins to develop oral language as a sign system, her speech is considered to be "pre-intellectual" while her thoughts are "pre-linguistic" in nature. The infant cries, squeals, and makes verbal outbursts and utterances as physiological responses to express "feelings and emotions; they are devoid of objective meaning" (Vygotsky, 1986, p. 93).

However, babies are born into worlds where caregivers co-create meanings for them. We ascribe communicative intent or meaning to infants' speech, behaviors, and moods (Cole, 1996). In a process called prolepsis, we project meaning onto children and their abilities whereby we relate—and co-create—

their thoughts, emotions, and preferences. These ascribed intentions are the source of children's earliest meaning making.

Toward the end of the Primitive or Natural Stage, young children begin to adopt more powerful uses of speech. Daily routines and scripted events like bathing or diaper-changing provide a synchronicity between caregiver actions and language. Ultimately, the parallel of these experiential and linguistic patterns provides children's entry into language. In other words, young children acquire thought, language, and meaning within the highly repetitive and rhythmic patterns of their daily lives. Eventually, thought and sign use overlap, converging to create a series of new behaviors.

During the second or Naïve Psychology stage, meaning makers acquiring visual, verbal, aural, or gestural signs begin to "master the external structure of the sign" (Vygotsky, 1986, p. 93). During this period, novice sign users discover their abilities in relationship to physical and psychological tools of meaning making. This second phase is critical because the syntax of specific sign systems is acquired through activities requiring physical and communicative engagement. In fact, meaning makers use the syntactic forms of the signs they are acquiring long before they understand what such structures represent.

For example, in oral language development, young children are well known for engaging in word games. The repetition, control, and verbal play of early word games actually help young children develop a patterned, systematic presentation of verbal signs or words. Vygotsky (1986) asserted language learners actually master "the syntax of speech before the syntax of thought" (p. 87) because syntax provides the structure necessary for signs and their operations to exist in memory.

The third stage of External Signs and Operations serves as a mid-point for meaning makers when internalizing the semiotic means of signs and their systems. In this phase, meaning makers overtly employ signs and their systems to solve problems, like counting on one's fingers (Vygotsky, 1986). The external or public use of sign systems, such as finger-counting, provides an intermediary link to internal sign use including counting in one's head. However, during this stage, a shift occurs from external sign use "to the sphere of inner-personal psychic functions" (Vygotsky, 1986, p. 35).

For example, in oral language development, young children's audible "self-talk" transforms into inner speech or the internal voice many of us experience when thinking, reading, dreaming or problem solving. As an expression of our unique forms of cognitive pluralism, each of us comes to rely on distinct and diverse forms of internal sign use for planning purposes. Eventually, external sign use disappears, and we meaning makers rely on internal means to mediate our thoughts (Vygotsky, 1986).

Vygotsky (1986) called the final phase of sign acquisition the Ingrowth Stage because sign operations grow within the meaning maker, becoming internalized. These transformations have profound effects on our cognitive abilities, including the development of logical memory. I wondered, perhaps, this was why I didn't really "know" something until I drew or wrote about it.

In first language acquisition, inner, soundless speech first develops in this stage only to mature across the course of childhood. Interestingly, inner and external speech engage in a constant dialogue, moving from "one form effortlessly and frequently changing into the other and back again" (Vygotsky, 1986, p. 87). We have all experienced or observed this phenomenon when engaging in or watching children and adults talk aloud to themselves during difficult or emotional tasks. Once sign systems have been internalized, we meaning makers will spend our lifetimes benefiting from the interplay between external and internal features of sign use (John-Steiner, 1992).

A Qualitative Mixed Method Research Study

Against this background in cultural-historical theory, I decided to see if Vygotsky's theory of sign acquisition really applied to visual signs and their systems. I wanted to know how well his model applied to a visual process of development. To do so, I designed a research investigation integrating a qualitative, ethnographic self-study and semiotic analysis of my art work. My goal was to see if Vygotsky's theory of sign acquisition could explain the development of my own visual language across a twenty–year span from 1967 through 1987.

Empirical Materials and Data Collection

A vast array of empirical materials were used to collect data. In the ethnographic case study, I relied upon biographical sources and historical documents including cards, letters, school work, grades and standardized test reports, journal entries, and dream diary excerpts amassed over the years. Data from these sources were organized into a biographical chronology noting personal relationships, historical events, institutional influences, and ideological movements from the mid–sixties through the 1980s.

For the semiotic analysis, my empirical materials included multiple visual products including sketchbooks, notebooks, doodles, drawings and prints, photographs, slides, paintings, sculpture, and jewelry created between three and twenty-three years of age. All artwork was cataloged, analyzed, and coded according to the date it was executed, the age at which the work was constructed, the title of the piece, and a brief description of the work. Each arti-

fact was also analyzed to produce a list of significant formal elements (such as shape, tone, or line) with corresponding indices, icons, and symbols that relayed content or subject matter. The same process was employed with written artifacts including songs, poems, short stories, and prose from the same time period. I also conducted a review of imagery composed by other visual artists who were historically significant to me. A survey of symbols from other writers' poetry, prose, and songs was undertaken to establish imagery, themes, and influences from my youth. Data from this semiotic analysis were inserted into the chronology to easily cross-reference life events and artistic activity for further analysis.

Data Analysis

The analysis of this data conformed with principles and protocols Vygotsky outlined to be central to his microgenetic, "experimental-developmental" , or "experimental-genetic" method (1978, p. 61; Cole & Scribner, 1978, p. 12). In short, his research methodology calls for the analysis of psychological processes, including sign acquisition and meaning making, as active, dialectical processes instead of objects. Vygotsky's method requires "a reconstruction of each stage in the development of the process" (p. 62). Therefore, as an investigator, I hopscotched backwards through transformations in my life and artistic development to identify "the casual dynamic basis" or genetic origin(s) of my visual language.

I also reviewed the connections between external stimuli and internal responses from which my visual language emerged and formed. By investigating the dialectical dance between external (phenotypic) and internal (genotypic) features within the chronology, a holistic portrait of sign acquisition emerged.

In the last step of my analysis, the integrated chronology was read backwards to identify the dialectical processes of incorporation, negation, and transformation to identify the emergence and growth of my visual language. The emergence, practice, and appropriation of physical and psychological tools and processes were tracked forwards and backwards to reveal leaps and revolutions in my artistic development. Transactions between personal events and social processes were additionally monitored. In this manner, major transformations were identified amidst a larger dynamic account. The following four phases emerged from the data. These developmental phases were juxtaposed with Vygotsky's theory of sign acquisition. Like the discovery of an ancient galleon on the ocean floor, the outline of his framework hinted from the depths of my psyche, revealing the psychological craft of my artistic journey for over twenty years.

The Development of a Visual Language

First Phase: The Acquisition of Semiotic Means & Meanings

I was shocked to discover the drawings I produced between 3 and 7 years old reflected the same semiotic means and meanings of my best work some twenty years later. My first phase of artistic development directly corresponded to Vygotsky's Primitive or Natural Phase in sign acquisition. At the start of this period, my thoughts existed apart from the visual fields of rose and blue slathered across easel paper. My initial brush strokes and preliminary swatches, half circles, and pools of running color can be compared to the primary expressions and vocalizations of babies acquiring verbal language.

Early semiotic means. While my thoughts originally existed apart from the signs I would later make, these early attempts at mark-making eventually led to a period where I acquired enduring preferences for methodological approaches, design elements, and early symbolism. For example, my first paintings and drawings exhibited an additive, cumulative approach to working with two-dimensional media like pastels and paints. A collective review of work from this period also revealed a preference for vertical formats with a central focal point or one-point perspective. My earliest drawings displayed a penchant for shape with a sensitivity for relationships between componental parts as opposed to line. Many years later as an adult, I had written in a journal, "Line is secondary. I think in shape instead of line. I get confused when I have to reduce something in my external environment to black lines."

A consistent color scheme also resonated across my earliest works only to reappear in my later paintings. Despite growing up in a climate in which neutrals and grays dominated the visual and cultural landscape, vibrant hues sang out from these early drawings and paintings. Purple, red and turquoise clashed with blazing corals, warm yellows, and hot greens. In reflecting on the development of this color scheme, I realized its origin to be social in nature: my parents had dressed myself and my siblings in solid reds, bright blues and vibrant greens instead of flowered or patterned pastels. The color scheme also referenced the symbolic use of red, violet, and purple, silver and gold from the ritual of Catholic masses heavily emphasized in my childhood.

The investigation pointed out that the powerful manner in which I experience color, shape, and texture as a way of meaning making was initially appropriated from my mother. Despite a limited knowledge of art or science, my mother visually scaffolded an aesthetic sensibility by pointing out sunsets and the beauty of the natural world to me as a young child. From an appreciation of architecture to the glow of Christmas lights on snow, she mediated a

host of visual experiences shaping what I would later refer to as "a physical kind of knowing. What she provided for me was a sense of wonder. This is tied up in a sense of color...the two closely parallel" (personal journal).

Figure 1.
Momma in Curlers
Courtesy of the
artist)

First Semiotic Meanings. In addition to semiotic means, my mother's influence was also apparent in the meanings represented by the signs, icons, and symbols of this first stage in my artistic development. Artifacts from this period had been dated in her distinct script with notes about the content of each picture; comments composed in her spidery scrawl revealed the process of prolepsis. For example, an artifact with a stick-legged guppy represented my "first drawing from Mrs. Mahoney's play school" . This sign evolved into what she deemed early "self-portraits" . These signs I used to portray myself were additionally scaffolded by imagery from coloring books. On one page entitled "Mother's Helper" , I had carefully colored in the black outlines of a girl baking to look like myself. On the corner of the page, my mother recorded "Katie especially drew this for Mom so I wouldn't be lonesome while she was at [pre-] school." As cultural texts, these early artifacts demonstrate a distinct representation of the self using very specific signs from my Irish-Catholic culture of origin. The symbols I selected as a young child co-aligned with my mother's

expectations of who I was and would grow up to be with regard to birth order, sex, gender, and religion. As a result, the motifs of mothering, child care, and domestic work dominated the subject matter of my early artwork. For example, the drawing "Momma in Curlers" (see Figure 1), completed at the age of four, presents my mother breast-feeding my little sister. The signs of mother and child that first emerged during this phase would later take on special significance in my visual language.

These gender-related signs were complemented by imagery from the Catholic instruction I was receiving at home, school, and church. I recorded religious indices, icons, symbols and themes for assignments given by my teachers. For example, among my collection of early artifacts, I was shocked to discover I had formally illustrated my own personal version of the *Book of Genesis* as a first grader. Each page in the cultural text highlighted a completely developed illustration of some aspect of the creation of the universe derived from a biblical perspective. For example, the first drawing includes a giant black orb, looming sun, and cast of twinkling five-point stars to denote God's creation of the cosmos. On a subsequent page, crudely drawn giraffes, sheep, and lions smile up at the viewer from a hand-drawn earth. This seven–page book culminated with a picture of a male figure with long black hair and a short beard lying with his head on a pillow. Below the drawing, I had copied the letters "God rested."

Another book, entitled *My Stations of the Cross*, intimately detailed key events in the Easter story. Fifteen free-hand drawings account for Jesus' condemnation, crucifixion, and resurrection. Each page is accented by a two- or three–word dictation describing the plot such as "Jesus falls" "Jesus meets Simon"or "Jesus is taken down". I have a vague memory of struggling with the representation of Christ's face on the cloth Veronica used to wipe his sweat and blood on the road to Calgary. Interestingly, as a child, I was more fascinated with the appearance of this image on the shroud than that of the resurrection. These religious themes made a dramatic impression on my understanding of the connections between narrative, symbol, and the mystical dimensions of life that would surface later in my artwork. I would later turn to mythology as a means to articulate my visual language.

Perhaps the most interesting findings to emerge from this stage was the identification of symbols that would eventually develop into repetitive signs or leitmotifs. The image of a Nike first appeared during this phase in a drawing I had made of my infant brother and myself as angels when I was five years old. The drawing was recorded nine to twelve months prior to his death from Sudden Infant Death Syndrome. In later work, the separate icons of Nike and infant would reappear over and over again across a visual record of twenty

years. Curiously, all of these semiotic means and meanings re-emerged repeatedly in later paintings during my early adulthood without conscious planning.

Second Phase: Genesis of Essential Techniques, Signs and Motifs

A second phase of development was observable from artwork produced between 13and 21 years old. The careful reader will note that this second period skips artifacts created between 8 and 12 years of age. There is no doubt that, during my elementary years, I continued to acquire and refine the semiotic means and meanings from the first phase of my visual language development. The data also suggested that between the ages of 8 and 12, I was engaged in acquiring essential techniques, signs, and motifs from the second phase. However, the omission of evidence from ages 8 and 12 was important for two reasons: First, larger family issues kept me from consistently pursuing a love for the visual arts. Second, a limited number of artifacts prevented me from conducting a meaningful analysis. Changes in financial status and recreational opportunities eventually led to the production of a significant body of art work.

Within the larger development of my visual language, a distinct phase occurred in which essential techniques, signs, and motifs evolved across my adolescence and early adulthood. The two–dimensional, three–dimensional, and written artifacts analyzed from this period included drawings, paintings, sculpture, ceramics, music, photographs, poetry, and short stories. Interestingly, this stage paralleled Vygotsky's Naïve Psychology phase in sign acquisition.

Genesis of essential techniques. Across an eight–year period, I had unknowingly experimented with a wide array of media and formats, returning repeatedly to refine technical skills in acrylic and oil paint, poetry, songs, and short stories. I was fascinated to discover that the exploration, imitation, and play I had engaged in with multiple media and genres reflected my efforts to "master the external structure of the sign" (Vygotsky, 1986, p. 93). The opportunity to experiment with a diverse range of physical tools, from the potter's wheel to the printmaker's acid bath, resulted in the refinement of a personal methodological approach. During this period, I learned my personality would never lead me to become a painstaking, miniature, realistic watercolorist. However, stretching a six–foot by eight–foot canvas for a lyrical abstract oil painting made my heart sing. True to Vygotsky's theory of sign acquisition, a growing mastery of physical and psychological tools hallmarked this phase in my artistic development.

Art work from this period also included an assortment of solitary, distinct pieces that either imitated other artists or were conducted as explorative stud-

ies. These works held seemingly little or no connection to anything that I had produced before or after their execution. For example, one summer during an Edward Hopper kick, I photographed the pristine, geometric angles of hundreds of white wooden houses. I never used the imagery in my paintings but clearly recall an almost obsessive need to capture these structures in film. A highly realistic portrait of a Diné (Navajo) youth also distinguished itself from other paintings in this period. While the canvas showed great promise for a future in portraiture, I never returned to visual studies of the face. This portrait contrasted with the eerie surrealism of a water study in which a young girl observes a pool. The style of this painting proved to be much closer to what I would paint in the future, but the subject matter at the time was decidedly atypical.

A breadth of techniques was also used to execute similar imagery. In one canvas, a palette knife was used to vigorously capture a still life, while other object studies were conducted in shaded pencil and scumbled oil paint. Many years after the work from this second period had been completed, I would write:

> You kind of go through a phase when you don't know who you are visually. You paint and draw and paint, but each day is a different image, a different you. You have to go through a sorting process where you throw out all the images you have ever known and see what comes back to you. It wasn't unusual to have up to thirty or more paintings in your head in one day. They often painted themselves into series that were done by the time you went to sleep (personal diary).

In addition to imitation and experimentation, exposure to multiple psychological tools proved equally important during this period. In order to develop my own visual syntax, it was essential to be immersed in the written, musical, and visual genres of other artists. For example, I learned a great deal by studying the similarities and differences of landscapes by Cezanne, Wyeth, and Ansel Adams.

With the exception of my grandmother, during my childhood and early adolescence, I did not have access to any role models in the form of a teacher, practitioner, or older friend. However, as early as sixth grade, I began an intensive study of art history and the biographies of painters. Their lives, works, and written technical and ideological reflections provided answers to my own questions about art, the creative process, and human experience. As distant mentors, their pragmatic and philosophical guidance rose from the pages of the books I read and the works I studied on museum walls and shaded porticos. I felt welcomed into an artistic community from voices of the past. The visual languages of Caravaggio, Donatello, Calder, Newman, Nevelson,

Rothko, Betts, and O'Keefe echoed, resonated, and extended my own growing sense of self and symbol. Through their multiplicity of signs and genres, I discovered that the lives, purposes, and messages of artists across the generations were not so different from the musings of my own inner voice.

Gratefully, during this stage I met a camp counselor who was an accomplished ceramicist, song writer, and guitarist. While our contact was limited, Leslie acted as a mentor for a period of three years. I would later write:

> Leslie was the first individual within the art field to take notice of my work and my interest in painting, poetry, and some. She held a critical, yet supportive eye for my work and understood the painful, emotional process of trying to capture thought on paper and canvas at such a horribly self-conscious age (personal diary).

More importantly, Leslie's example as a young woman engaged in scholastic and creative accomplishments provided what I would later describe as a pathway from plastic geranium still lives, pooping sea gulls, and rotting barns, into the rigorous, colorful, intellectual domains of contemporary and modern art. The collective words of mentors helped me to articulate what is commonly referred to in the arts as "the hunger" or drive to capture or create that which is unspeakably conceived by the mind and heart. Their influence provided me with a sense of direction and purpose in my life—to be a painter and to pursue an advanced degree in doing so. I set out to develop a serious body of art work.

Genesis of essential signs & motifs. What I did not realize was that, in spite of the wide range of techniques, formats, and subject matter during this phase, my engagement in a variety of physical and communicative activities actually led to the development of a small, common set of essential signs. Hindsight allowed me to see that, while acquiring a visual syntax, the first words of my visual language were formed through these repeating symbols. For example, the same plant-like, anthromorphic form I blew up as a garbage-bag sculpture on the floor of the University of Illinois's Armory appeared as a symbol of growth in several paintings two and three years later. Water in the forms of lakes, oceans, and streams became a common feature of the many landscapes I sketched and painted to capture the power of the natural world. The sign of water was also integrated into the music and lyrics I wrote around the motifs of joy, healing, nurturing. Without consciously knowing it, the Nike symbol that first appeared in my drawings at five years old was replicated across multiple drawings and haiku. Despite my lack of intentional awareness, the sign became an omen of change and symbol of spirituality. Like the *Pietà*, the spiritual theme of mothering or nurturance took shape in a cloaked figure holding

an infant and through rolling, feminized landscapes. Desolate scarecrows blowing in the wind became a sign of modern crucifixion or a visual word for sacrifice. Through the dramatic values of an ebony pencil drawing, these signs allowed me to achieve catharsis surrounding my infant brother's death. Like a child learning to speak her first words, I had appropriated, internalized, and externalized the first words of an intimately personal visual language without conscious realization.

Third Phase: Establishment of a Core Visual Language

The analysis of the larger body of data continued to reveal insights into my development as a painter. A third phase noted the establishment of a core visual language I continue to draw on to the current day. The original artifacts used to analyze this stage included a series of approximately thirty sketches executed across three life-changing days in my mid–twenties. Reflective of Vygotsky's third phase in sign acquisition called the External Signs and Operations stage, the imagery constructed in the series hallmarked a pivotal midpoint in my artistic development.

At the time, a retrospective of my art work led to an epiphany in which I consciously discovered the existence of the recurrent signs that had unconsciously emerged in the first two stages. Up to that point in time, I had searched outside myself tapping external signs and public imagery in an attempt to express a personal cognitive-affective message. While individual paintings had been successful, many others were not and I could not explain why. The retrospective allowed me to identify that which I had been seeking for so long: my own visual language. I later described the experience:

> It was all right there...it felt like it hit me between the eyes. I looked at the imagery I had been painting [in art school] and it was as though a veil had been ripped from my head and my eyes and I was standing bareheaded and barefaced for the very first time. I knew my story for what would happen; I knew my death. I knew for a moment my entire life script for the remainder of my life (personal diary).

Ironically, what I so desperately sought was concentrated in a small, handful of visual leitmotifs. In music, a leitmotif is "a melodic phrase that accompanies the reappearance of an idea, person, or situation" or "a dominant, recurrent theme" (Merriam-Webster, 2003).

It is said that every piece of art is in some form a self portrait. Vygotsky (1986) noted that it is through the power of language that our identities are first developed as children. Standing back from my work for the first time on that fateful day, I was able to identify the small handful of recurring signs ac-

quired from my family, community, and institutions of my youth. Individually and collectively, the signs of the scarecrow, mother, mountain, and child represented who society had deemed I was as a person. At the time of my awakening, I realized that some of the signs, gleaned from the corpus of cultural texts, incorporated false and harmful dichotomies about myself. The very social myths and religious prejudices I had rallied so hard against as an adolescent and young adult stared at me on paper. I remember being shocked and frightened because the signs had come from my own hand.

It occurred to me that the isolated leitmotifs of mother and infant / child were not unlike the archetypes of Demeter and Persephone. In this ancient Greek myth, the daughter is abducted by the king of the Underworld and taken to his chamber to become his wife. In her grief, the goddess Demeter wanders in search of her child, withdrawing her warmth and sunlight. Her pain, sorrow, and anger cast an eternal freeze over the Earth until all its living things are threatened with death. This conflict eventually forces the other gods to reveal Persephone's location. The mother commences to rescue her child, however, because the marriage rite had already been performed, it is agreed that Persephone must return to her husband for a portion of each year. The daughter's annual return to Earth is marked by the season of spring and spiritual rebirth until the fruits of summer spoil, and she must reassume her throne as queen of the Underworld. During this time, Demeter walks into autumn and winter in memory of her beloved Persephone, awaiting her return.

Contemporary psychologists have observed that while symbols can define who we are, their generative properties also allow for the reconstruction of the self (see Baker-Miller, 1991; Ortner & Whitehead, 1981). Years later, I would read about this phenomenon in academic literature. Gestalt psychotherapy had also introduced the notion of integrating mother and daughter dimensions of myself into a core identity. At the moment, however, as a young artist, I was compelled to take pencil to paper and draw with a clarity, insight, and purpose I had never previously experienced.

Beginning with the two most prominent leitmotifs of the infant-child and scarecrow-mother, I worked rapidly to reduce them into their elemental design features on paper. Following a strong sense of intuition and the "inner voice" I often hear when engaged in the creative process, I then connected these dualistic signs by drawing a landscape that united them. Taking what felt to be a giant developmental leap as an artist and a person, I consciously pushed the drawing into the unknown by visually synthesizing both leitmotifs together (see Figure 2). Across the course of several sketches, the signs were subsumed in a whirl of image, color and movement. At the end of the series, a con-

sciously constructed, novel, sign for myself emerged from the drawings. This new leitmotif was a form of "visual protagonist" for my personal, symbolic language.

By visually reversing the myth of Persephone and Demeter and re-coding leitmotifs I had unconsciously used for myself, I had transitioned from a passive, reactionary use of symbols to an active, intentional approach whereby I used signs and their systems to solve problems and communicate intent. To use Vygotsky's words, a shift had occurred from external sign use "to the sphere of inner-personal psychic functions" (1986, p. 35). During this stage of External Signs and Operations, a distinct language was born. In subsequent paintings, I presented the novel symbol of myself within landscapes that consciously employed leitmotifs including the sun, moon, and mountains from previous stages. This basic visual vocabulary allowed me to present a cohesive, visual statement while articulating thought, opinion, and memory within a feminist visual narrative in the next stage.

Figure 2. Synthesis (Courtesy of the artist)

Fourth Phase: Development of a Visual Narrative

The fourth stage of my artistic development hallmarked the onset of a process that continues to this day. The three years immediately following the discovery of the leitmotifs and creation of my "visual protagonist" were characterized by

intense growth. Paralleling Vygotsky's fourth phase in sign development, I internalized, expanded, and elaborated a core visual language to present an ongoing, evolving visual narrative.

While the canvases I had previously visualized in my mind incorporated a wide variety of unrelated styles and subject matter, now a consistent, longitudinal series of paintings emerged from a common set of signs and themes. The ability to internally envisage and externally capture these visual dialogues on canvas sharpened my memory to an extent that felt like I thought in film. I was constantly engaged in a form of inner visual speech as art work took shape in my mind's eye.

Because preferences in technique, format, and design had been established in previous phases, it felt like I approached the construction of a new canvas on auto-pilot. My protocol was set: key decisions regarding

Figure 3.
American Pie
(Courtesy of the artist)

medium, brush selection, protocol, and perspective were not a consideration. I could begin a canvas or drawing knowing that I would adopt very specific shapes and colors to capture a specific emotion. Multi-modal and cross-genre sensibilities from the second phase of my development provided important insights into the creation of specific imagery or visual effects. For example, I manipulated shape and color in such a way that the two design elements might collectively elicit a musical quality similar to particular strands of guitar chords.

Because of the third phase in my development, I was able to immediately combine historical leitmotifs with novel symbols to express a wider range of characters, concepts, and contexts for each new piece of artwork. As I added these new words to my visual language, a playful tension emerged between abstractionism, representationalism, and realism in my paintings. Feedback from friends, studio mates, and instructors allowed me to gauge a certain level of specificity or clarity when conveying a visual message. For instance, I could directly comment about a person on canvas by painting a sign that purposely identified who they were, or I could allude to their presence by providing a vague symbol that hinted at their existence. This ability to adopt vocabulary and manipulate various levels of discourse is reminiscent of Vygotsky's In-growth stage. After linguistic sign systems have been internalized in this phase, inner and external speech engage in a constant dialogue, moving from "one form effortlessly and frequently changing into the other and back again" (Vygotsky (1986, p. 87). I was able to mentally visualize and physically articulate the integration of previous and new visual signs as my visual conversation grew broader.

The resulting narrative took on a variety of forms. Some paintings presented autobiographical accounts of my own personal experiences inside bright, semi-abstract intrapersonal landscapes of my life. For example, in "Playground of the Heart" (see front cover), I used color, landscape, and water to communicate the experience of relief, joy and rejuvenation as an expression of personal liberation. Coming full circle to the first phase of my sign development, many of these more intimate portraits recorded spiritual themes such as baptism and rebirth. However, in contrast to my early religious indoctrination, these concepts were presented within the context of my own personal narrative or myth.

Other complex visual compositions relayed interpersonal cultural scenes with a distinct, political and ideological commentary. For instance the canvas "American Pie" (see Figure 3) calls attention to the cheap desecration and pollution of sacred lands by our fast-food, throw-away, capitalistic culture. John-Steiner (1992) noted that once sign systems have been internalized dur-

ing the Ingrowth phase, meaning makers can spend their lifetimes benefitting from the interplay between external and internal features of sign use. Whether I am presenting a lecture on some abstract feature of psycholinguistics or moved to capture a fleeting emotion or sensitivity, today, all I have to do is close my eyes and pick up a brush or a pen to continue the visual conversation.

Conclusion: On Becoming a Painter

In the end, cultural-historical theory provided a framework to understand my own form of cognitive pluralism and the origins, means, and function of my creative process. In particular, Vygotsky's notions on the acquisition of first- and second-order signs offered a powerful explanation for my development as a painter. While more research needs to be conducted with other painters and two-dimensional artists, many of us dramatically experience the world through a heightened sense of sight and image. Unlike those of peers and family members, our eyes serve as the dominant means by which we ultimately make sense of the world when receiving, internalizing, and relating meaning. In becoming painters, we call on the first muse of oral speech to construct a second, visual language. Our personal journey through Vygotsky's stages of sign acquisition allow us to nurture a vision, identity and visual language with which we strive to co-create overlapping, personal narratives of a shared life.

To those of you standing on the other side of the canvas, it is definitely worth braving the wrath of museum security guards to break the silence between the self and canvas. For if you get as close as you can to peer intimately at our brushstrokes, you will not only see our thinking. You will hear us speaking. And sometimes you will even hear us sing.

References

Au, K. H. (1993). *Literacy instruction in multicultural settings.* Fort Worth, TX: Holt, Rinehart, & Winston.

Baker-Miller, J. (1991). The development of women's sense of self. In J. Jordan, A. Kaplan, J. Baker-Miller, I. Stiver, & J. Surrey (Eds.), *Women's growth in connection: Writings from the Stone Center* (pp. 11–26). New York: Guilford Press.

Bruner, J. (1990). *Acts of meaning.* Cambridge, MA: Harvard University Press.

Cole, M. (1996). *Cultural psychology: A once and future discipline.* Cambridge, MA: Harvard University Press.

Echevarria, J., Vogt, M., & Short, D. (2004). *Making content comprehensible for English learners: The SIOP model* (2nd ed.). Boston: Pearson.

John-Steiner, V. (1992). Cognitive pluralism: a Whorfian analysis. In Spolsky, B. & Cooper, R. (Eds.) (1992). *Festschrift in honor of Joshua Fishman's 65th Birthday.* (pp. 61 - 74). The Hague: Mouton.

John-Steiner, V. (1992). Private speech among adults. In R. M. Diaz & L. E. Berk (Eds.), *Private speech: From social interaction to self-regulation* (pp. 285–296). Hillsdale, NJ: Lawrence Erlbaum Associates.

John-Steiner, V. (1995, Winter). Cognitive pluralism: A sociocultural approach. *Mind, Culture, & Activity, 2*(1), 2–11.

John-Steiner, V. (1997). *Notebooks of the mind: Explorations of thinking* (Rev. ed.). New York: Oxford University Press.

John-Steiner, V. (1999). Sociocultural and feminist theory: Mutuality and relevance. In S. Chaiklin, M. Hedegaard, & U. J. Jensen (Eds.), *Activity theory and social practice: Cultural-historical approaches* (Chapter 11). Aarhus: Aarhus University Press.

John-Steiner, V., & Mahn, H. (1996). Sociohistorical approaches to learning and development: A Vygotskian framework. *Educational Psychologist, 31*(3/4), 191–206.

John-Steiner, V. & Osterreich, H. (1975). *Learning styles among Pueblo children.* NIE Research Grant, Final Report. Albuquerque: University of New Mexico, Department of Educational Foundations.

John-Steiner, V. & Souberman, E. (1978). Afterword. In L. S. Vygotsky, *Mind in society: The development of higher psychological processes* (pp. 121–133). Cambridge, MA: Harvard University Press.

Kozulin, A. (1986). Vygotsky in context. In L. S. Vygotsky (Ed.), *Thought and language.* Cambridge, MA: MIT Press. pp. xi–vi.]

Leitmotif, (2009). On-Line Merriam-Webster Dictionary. Retrieved August 25, 2009 from http://www.merriam-webster.com/dictionary/leitmotif

Mahn, H. (1997). *Dialogue journals: Perspectives of second language learners in a Vygotskian framework.* Doctoral dissertation, The University of New Mexico, Albuquerque.

Merriam–Webster. (2003). (11th Ed.). *Collegiate dictionary.* New York: Encyclopedia Brittanica.

Ortner, S., & Whitehead, H. (1981). Accounting for sexual meanings. *Sexual meanings: The cultural construction of gender and sexuality* (pp. 1–27). Cambridge, UK: Cambridge University Press.

Van Oers, B. (1999). *On the narrative nature of young children's iconic representations: Some evidence and implications.* Retrieved November 20, 2001 from http:/www.geocities.com/nschmolze/vanoers.html

Vygotsky, L. S. (1971). *The psychology of art.* Cambridge, MA: MIT Press.

Vygotsky, L. S. (1978). *Mind in society: The development of higher psychological processes.* London: Harvard University Press.

Vygotsky, L. S. (1981a). The genesis of higher mental functions. In J. V. Wertsch (Ed.), *The concept of activity in Soviet psychology* (pp. 144–188). Armonk, NY: Sharpe.

Vygotsky, L. S. (1981b). The problem of the cultural development of the child. In J. V. Wertsch (Ed.), *The concept of activity in Soviet psychology* (pp. 144–188). Armonk, NY: Sharpe.

Vygotsky, L. (1986). *Thought and language.* Cambridge, MA: MIT Press.

Vygotsky, L. S. (1934/1987a). *Thinking and speaking: The problem and the approach.* Retrieved April 29, 2003 from www.marxists.org/archive/vygotsky/works/words/lev1.htm

Vygotsky, L. S. (1934/1987b). *Thinking and speech: Written, inner, and oral speech.* Retrieved April 29, 2003 from www.marxists.org/archive/vygotsky/works/words/lev1.htm

Vygotsky, L. S. (1994). In R. Van Der Veer & J. Valsiner. (1994). *The Vygotsky reader.* Cambridge, MA: Blackwell Publishers.

Vygotsky, L. S. (1997a). The pre-history of the development of written language. In L. S. Vygotsky & R. W. Rieber (Ed.), *The collected works of L.S. Vygotsky. Volume IV: The history of the development of higher mental functions* (pp. 131–148). New York: Plenum Press.

Vygotsky, L. S. (1997b). The question of multilingual children. In L. S. Vygotsky & R. W. Rieber (Ed.), *The collected works of L.S. Vygotsky. The history of the development of higher mental functions.* (Vol. 4, pp. 253–259). New York: Plenum Press.

Wells, G. & Claxton, G. (Eds.). (2002). *Learning for life in the 21st century.* Oxford, UK: Blackwell Publishers.

Dance Dialogues:
Creating and Teaching in the Zone of Proximal Development

Barry Oreck

Jessica Nicoll

The first step, the Crone who scried the crystal said, *shall be to lose the way.*
Galway Kinnell from *The Book of Nightmares*

THe choreographer Bill T. Jones has described the way a dance can "arise" from an improvisation. "There are propositions," he said, "coming from both my mind and my muscles....I follow them and something comes out that makes me think, 'Whoa! Where did that come from?'" (as cited in Morgenroth, 2004, p. 144). Meredith Monk takes a different route. "I don't go into rehearsal where we're just going to do an improvisation. I never know how to use material generated like that" (p. 97). And yet she, too, surprises herself. "Part of the process is hanging out in the unknown....I'm excited that I don't know what the form is going to be when I start" (p. 91). Jawole Willa Jo Zollar urges her company members to collaborate in the choreographic process, sometimes asking them to problem solve with a phrase she has created. "It's really a question of listening and being open to where the creative process takes you" (as cited in Vellucci, 2009, p. 30). These choreographers, like many others we have studied, find—through different processes—ways to enter a dialogue with self. Their methods serve not as a formula but as an attitude: they step knowingly into unknown territory to make their art and discover its meanings.

We often inadvertently keep student choreographers from taking that important step. As teachers, we try to demystify the artistic process, breaking it

down into manageable parts, while designing intriguing problems for students to solve. In so doing, we may have overlooked an essential feature of creative play: the finding of those interesting problems.

By looking into the choreography class and reflecting on the words of professional choreographers, we will study the complex relationships involved in the development of dances and dance artists. We will also examine the role of play and physical activity in dance composition, the social nature of the experience, and the ways in which the language of dance is shaped through the interaction of the body and mind, cultural and historical contexts, word and image, and conscious and subconscious processes.

Artists and Teachers in the Zone of Proximal Development

Lev Vygotsky said, "The act of artistic creation cannot be taught" (1971, p. 256) and described the teacher's role as a cooperative one that would help students "organize the conscious processes in such a way that they generate subconscious processes" (p. 257). The visual artist and teacher Henry Schaefer-Simmern, in his groundbreaking work *The Unfolding of Artistic Activity* (1948), demonstrated how the teacher can help the artist open and maintain a dialogue between conscious and subconscious processes that he saw as key to the artist's progress through subsequent stages of artistic development. He maintained that a student arrives with inborn understandings about artistic form and that the teacher's job is to facilitate the individual's "awakening" to his or her inherent abilities.

As we examine the relationship of teacher or mentor to the developing artist it is useful to consider Vygotsky's theories concerning the zone of proximal development (Vygotsky, 1978). Vygotsky defined this zone as the distance between the problems a student can solve independently and his capabilities under the guidance of more competent teachers or peers. In the arts, where both the student's capabilities and the particular problems are indeterminable in advance, the zone itself, we suggest, cannot be determined. Vygotsky called it a "dynamic developmental state" (p. 87) that in the arts requires the artist to constantly move beyond the known, to push past his or her prior capabilities but that also, in most cases, requires support and collaboration with others to achieve. Even mature artists often look to mentors and collaborators for help in navigating this unknown place. Phyllis Lamhut, a choreographer and mentor to many contemporary choreographers, describes her role as "stabilizing the discomfort. I try to encourage artists to revisit their work—to not run away from their work quickly." Even masters, she says, need to "keep that edge of

freshness and challenge their risk-taking abilities" (personal communication, March 3, 2009).

Traditional views of the teacher-learner relationship that assume an individual of greater competence (teacher) and lesser competence (learner) focus on the student's zone of proximal development alone. In the arts, however, the teacher or mentor may possess greater experience but is not the expert in what the student has to express. If the student creates a product that is beyond the teacher's understanding or pushes the edge of socially accepted meaning, the frequent response from a teacher is to correct such thinking and behavior. It is an interesting dilemma: many art teachers bemoan the lack of original thought displayed by their students, and yet, by its nature, originality may flout the very structures or rules a teacher has imposed, perhaps even confounding the teacher's ability to recognize its value. A friend, for example, who teaches visual art stood before a painting at an outsider art exhibit, marveling at an unconventional, dynamic creation that featured a figure in one small corner of a large canvas. "If one of my students had turned that in," she said, "I'd have said he should use the whole page." She was shocked at the limits of her own perspective. The conventions of teaching through demonstration, modeling, and scaffolded instruction—often by breaking the whole into parts—offer structures to guide learning but may also reinforce a student's tendency to follow rather than initiate or innovate. Further, if the teacher has taken on the role of evaluator as well as instructor, both creative and evaluative processes remain only within the realm of the teacher's competence and zone of proximal development.

When a teacher/mentor recognizes and truly respects the seriousness and validity of a young artist's own vision, the relationship can more closely resemble a creative collaboration in which partners "create zones of proximal development for each other" (John-Steiner, 2000, p. 189). Their collaboration focuses not on the product, which is truly determined by the student artist, but on ways to support the student's own investigations and inner dialogue.

This stance, we recognize, is highly challenging for any teacher, whether situated in the culture of a school or of a professional studio. After all, the teacher is frequently judged by the quality of his or her students' work. Further, in academic settings, curriculum standards and assessments specify the elements considered necessary to demonstrate proficiency and artistic quality. Such a stance, however, is a logical expression of the underlying beliefs, proposed by Vygotsky, Schaefer-Simmern and many others, that artistic activity a) is a universal process of people and, b) stimulates consciousness of artistic form and is thus a process of internalization or dialogue between the self and the work of art.

Beginning the Dialogue

> Artistic activity cannot begin where educators impose on students externally formu-
> lated images and methods, concepts and cognition. A transaction between the indi-
> vidual and his or her physical, psychological, and social environments is necessary for
> true artistic activity....He or she needs, in short, *to become conscious of consciousness*
> within and emanating from the being. In doing so, the physical, affective, and cogni-
> tive domains of his or her being function in coordination with and in service to the
> artistic process (Schaefer-Simmern, 2003, p. xx).

While there is no evidence that Schaefer-Simmern, who died in 1978, had
read or was directly influenced by Vygotsky, his methods demonstrate how the
teacher/mentor can support the developing artist in his or her own zone of
proximal development, through a process of internalization that Wertsch
(2007) calls "implicit mediation" (p. 180). Schaefer-Simmern's role, as he saw
it, was to be sensitive to the student's developmental stages of visual conceiv-
ing (Schaefer-Simmern, 1948) and help students move their own work for-
ward. Rather than begin by instructing students in skills and form, he invited
them to create work based on their own personal imagery. He asked the stu-
dents to study what they had done and to identify what did or did not satisfy
their internal imagery. He then encouraged them, using a new page or fresh
materials, to revise their work. His guidance came not through an external
critique but through questions that promoted a student's self-evaluation of the
art product.

After students had arrived at a new stage of visual conceiving through this
process, new tools, materials, or processes and historical art works (related to
the forms students had discovered) might be introduced to reinforce students'
learning. Schaefer-Simmern believed that telling or showing students what to
draw and how to change their work actually served to inhibit their own crea-
tive development. The respect he paid to the students' internal vision as artists
altered their sense of themselves and of their own capabilities. The artistic
products they created, meticulously documented in Schaefer-Simmern's books
(1948, 2003), and through the work of his colleagues (Abrahamson, 1980;
Arnheim, 1972; Sarason, 1990, among others), attest to the often astonishing
abilities of children and adults previously considered "non-artists." Through
his analysis Schaefer-Simmern identified key developmental stages and specific
methods for both external and internal mediation to help students transform
perceptual images into unique and complete works of art.

Jessica Nicoll's study of Schaefer-Simmern's methods raised questions
about the ways she had been introducing choreography throughout her more
than 20 years of teaching. Though she felt a philosophical kinship with Schae-

fer-Simmern, having consistently focused on improvisational play as a starting place and included significant self-reflection in the creative process, she began to question whether she had gone far enough. Did she really let students determine the focus of their work and were they setting their own next steps through self-evaluation and revision rather than responding to external criteria or critique by either teacher or classmates? What was the effect on their creative process of introducing new forms that, though commonly used in choreographic craft, had not emerged for the students through their own internally mediated experience?

For modern dancers beginning to choreograph, looking at the work and therefore bringing form to consciousness is complex, for the product is not separate from self. Dancers often say the body is an instrument. The body is also the material; most choreographers begin by making up movement and performing it themselves or teaching it to others. This medium is shaped through physical training that depends in large part not on the student's vision as an artist but on tradition and on a teacher's perception of appropriate instruction for body and mind. Sound technical training has great value in developing a dancer's physical vocabulary, range of motion, and artistry as a dancer, but it also establishes habitual movement patterns that can be difficult to break.

In compositional training, the learning of analytic tools and traditional forms is often assumed necessary before students may begin to create out of their own imagery, concepts, or self-directed physical explorations. Often overlooked are the essential processes by which individuals make meaning and link conscious and subconscious thought through a dialogue with the work and themselves. Such a dialogue, central to both Vygotsky's and Schaefer-Simmern's work, occurs through action rather than calculation and is a vital source for a student's discovery of artistic form. "I never plan a dance," Anna Sokolow, an important modern dance pioneer, said. "I do it, look at it, and then say: 'Yes, I see what I am trying to do'" (cited in Cohen, 1965, p. 35).

Making Dances

Dance is a quintessentially communal activity and demonstrates an extraordinary depth of mostly non-verbal social discourse. Cultures in which dance is an integral part of daily life, and a vital element of community ritual, converse in a dance language that children learn as naturally as they would a spoken language. That dance exists in all cultures and demonstrates common structures related to time, space, and energy, is evidence that embodied artistic form is a human birthright (Hanna, 1987). While traditional dances follow

established structures, they continue to evolve as the people sharing them shape and extend the human vocabulary of communal action.

The founders of modern dance broke from tradition to express their own individual visions. Ironically, many of the training methods these pioneers developed have themselves become tradition-bound and offer students few opportunities to develop their own vision and style of movement (Lakes, 2005). Many of the most original choreographers in contemporary dance speak of breaking the rules of *these* traditions. In touch with their own curiosity about the world, they can find source material in anything. It can be as simple as an image. Kei Takei describes one such inspiration: "I saw a rainpool....It was the start of *Light, Part 3*. It was a shock, but somehow these things come out" (cited in Kreemer, 1987, p. 20).

Artists know that the questions formed and insights gained at such moments of discovery are key to their ability to create. They recognize that the interplay of word and thought, logic and feeling, mental and sensory processes must be "shaken up" or kept in a state of animation in order to make something truly novel and meaningful. To develop ideas beyond the initial inspiration they must discover a form integral to the problem they are trying to solve. By integrating the elements of form, including spatial arrangements of dancers, relationship of the movement to rhythm and music, use of light and darkness, integration of props and costumes, an artist strives to create a unity of vision, an indivisible merging of form and content: a gestalt.

Developing Choreographers

At the 92nd Street Y in New York City where pioneers of modern dance, Martha Graham, Doris Humphrey, and José Limón created and taught, Jessica Nicoll works with teenagers making their own dances. Nicoll's teaching approach has developed over 25 years, at the Y and other studios, and in artist residencies in the New York City public schools. In 2004 she began an experiment, attempting to apply Schaefer-Simmern's methods to dance-making. She wanted to see if the personal investment and artistic growth that Schaefer-Simmern engendered in children and adults would be more evident in her students if she did less "instructing" and used questioning and self-reflection in an even more intentional and disciplined way. She wanted students to find artistic problems as well as solve them and to develop their own ongoing processes of dialogue around their work, the work of their peers, and that of professional choreographers.

Thirteen teenage girls, ages 13–17, participated in the "Young Masters" choreography class during this period, with no more than six in any semester. They came to the Y with a range of dance backgrounds and three had studied dance technique and improvisation intensively with Nicoll previously. They attended a variety of public and private schools and all took at least one dance technique class per week, though some had neither improvised nor choreographed before. The program had been in existence for 10 years and Nicoll had directed or co-directed it for all but three of those years. The once-a-week class consisted of a warm-up, improvisation, individual or small group revision and rehearsal of previously developed material, showing and responding to choreography in progress, and, toward the end of each semester, preparing students' original work for public performance.

From 2004 until the final semester of the experiment, in the fall of 2007, Nicoll charted her own evolving process alongside the young choreographers. She observed an increasing willingness on her part to let go of teaching habits, such as presenting problems or assignments, that she had previously assumed necessary. Early on, both she and the students sometimes struggled with this new way of working. Space does not permit a full description of the process, but we will focus on some aspects that demonstrate how the artistic dialogue was cultivated in the choreography class and how it mirrored the processes of mature artists.

Finding a Personal Dance Language

"If I'm always the one to lead improvisations and present the assignments," Nicoll wondered, "how do the students take the step that artists must learn to take: giving themselves their *own* assignments?" As Alane Starko notes, "Rather than shielding students from the frustration of seeking ideas, teacher-structured problems rob students of the art making process: looking for ideas, choosing materials, tools, and forms, visualizing a variety of possibilities" (1995, p. 129). Where Nicoll previously designed thematic classes to guide exploratory improvisations out of which students would shape short studies, she now facilitated only a brief warm-up and asked students to initiate and determine the focus for improvisations and compositions. In composing, the students were encouraged to build dances using sources that interested them (e.g., an image, a rhythm, a piece of music, written text or story, or simply moving), but they were under no obligation to name or describe their ideas verbally to anyone.

Whatever the original source, the choreographer chose the movements, shaped them into phrases and sequences in space, defined the relationship of

movement to music, silence, words or other accompaniment, and set these elements on herself or another dancer or group of dancers. The choreographic mentor Phyllis Lamhut calls this process of finding and shaping movement to make a dance "creating a language for the idea" (personal communication, March 3, 2009). A central challenge for the choreographer is to keep creating new vocabulary, recognizing and resisting habitual patterns of movement. As Anna Sokolow recalled, "For me, *Lyric Suite* was a turning point. It was then that I began to find a language of movement for myself....The important thing is to stretch the personal vocabulary so that it does not remain static" (cited in Cohen 1965, p. 35).

Nicoll asked students to explore and be aware of their natural movement patterns: what felt good to their bodies, what they recognized as their "signature" movements, and how they related to the space and fellow dancers (see Figure 1). She neither identified students' tendencies for them nor suggested alterations; her intention was to raise self-awareness. Luisa, a former gymnast with little prior choreographic experience, explained:

Figure 1. Finding a Personal Dance (Courtesy of Markus Dennig)

I am really intrigued by how all dancers tend to revert to a particular type of movement or specific gesture when they "get stuck." I had such "default movements" that I would frequently incorporate into improvisations, phrases, and full pieces. However, I found that I was most satisfied with my choreography when I was able to transcend

the boundaries of my usual vocabulary and experiment with movement that was truly new for me.

Luisa's "default movements", which clearly reflected her gymnastic training, were evident to Nicoll. She took notes and tried to be alert to new stages of development that she could reinforce through guided reflection and by introducing relevant resources. She wondered, though, if she was failing Luisa by not directly pointing out her habits or offering solutions to the problems Nicoll perceived.

Several months into the process, the group discussed the humor and originality of a new solo by Luisa, a piece in which she'd layered elements of space and time with a witty and confident hand. It was clear that Luisa had uncovered a unique voice. Whether that voice would have emerged (or been silenced) with the specific intervention of a teacher can't be known. What stands out in Luisa's later reflection, however, is her own discovery: an awareness that pushing beyond her own boundaries was the most satisfying aspect of her artistic growth.

Improvisation and Play

Improvisation, alone and in groups, was allotted considerable time in class. Whether used to develop an existing idea, or pursued for its own ends, improvisation provides a means of listening directly to the physical impulse, restimulating a playful attitude of discovery, and reconnecting with the subconscious. The choreographer Mel Wong said, "I don't necessarily set up a problem and try to resolve it, but I focus on an idea which is a mystery to me and start from there....I try to put myself in a state of awareness on a subconscious level, where the subconscious level becomes conscious through my movements" (cited in Kreemer, 1987, p. 75). While common for dance makers, improvisation is not the only way to play. As Paul Taylor puts it:

> The aim is to do the most magical work you can—to permit the chain reaction of movement ideas, which spring from the original concept. The mind tends to think in a logical way, but magic is not logical. If dance is too logical, it becomes expected and predictable; then it can lose its life (cited in Cohen, 1965, p. 101).

Directed physical play helps artists resist the tendency and pressure to intellectualize the process. The teacher's role in this can be critical. As Nicoll's student Julia put it, "[Jessica] always told us to not think so much, just act. Not to worry about what looked pretty or what was the best technical method. She wanted you to dance through your heart, not your feet."

The students began to identify the processes they found intriguing and to design their own "what if" structures for play during both improvisational and compositional exploration (see Figure 2). These included experiments with spatial and rhythmic elements, dynamics, and sound, including vocalization, and often played with the relationship of content to form. During one episode the dancers took turns observing and improvising in the midst of a shifting arrangement of chairs set up by one student choreographer who wanted to explore the theme of claustrophobia. Alex, a 15 year-old who'd not choreographed before, shared a "what if" list in her second class, "What if someone else danced my phrase at the same time but reversed? Huge? Small? Slow? While making sounds? Wearing a rainbow?", and then looked at the group with surprise. "What does that mean?" she asked, laughing.

Tools for Self-Reflection

Journals were important tools for self-reflection and evaluation. Nicoll had urged the use of journals throughout her years of teaching but struggled to get teenagers to follow through. During this process, however, students fully embraced the use of journals. One student, Stella, later wrote, "I often found myself using my journal to jot down instantaneous bursts of inspiration when I was in class, on the train, or about to go to bed." The choreographers used their journals to communicate with their dancers, record others' responses to their work as well as their responses to others, and document the development of the class and art work throughout the semester.

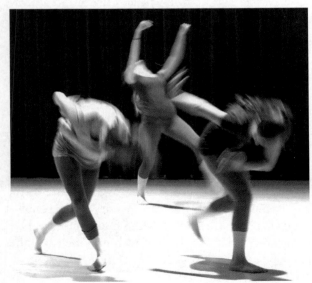

Figure 2. Improvisation and Play (Courtesy of Markus

Work in progress was often videotaped, giving students the ability to study and evaluate their work at home. Julia observed, "I could step back from the choreography process and just watch my progress, and see what else I needed to work on." Not all students found video equally useful but it was particularly helpful when the choreographer was dancing in her own piece. Nicoll also shared videotapes of other dances and performers and arranged for students to attend dance concerts. She selected these experiences based on the students' work and particular problems with which they were grappling.

Teacher as Guide

Shifting away from teacher-generated assignments did not mean Nicoll abandoned her role as a guide. In some ways it intensified the challenge and caused her to revisit her own practice as an artistic mentor. While students worked independently, she used her own journal to slow herself down and avoid inserting herself in their process prematurely. It was important that the students know she was available but that she not set herself up as judge or the solver of their problems.

Roy Abrahamson, a student of Schaefer-Simmern, points out that even if a teacher says nothing, his or her value systems will be evident (Abrahamson, 1980). This is a critical point in understanding this approach to arts teaching. It is not, Abrahamson writes, "a matter of influencing or not influencing students. Rather, what should concern us is the kind of influence—where it leads" (p. 43). Nor is this process a hands-off method focused on "self-expression" in which students would erupt in what John Dewey called a "gush" (Schaefer-Simmern, 1948, p. x), unguided by either teacher or self. The work is focused and rigorous, and yet the goal is not to make students achieve a desired result. The questions a teacher poses and the self-evaluation a student practices, are part of a delicate balancing act intended to support the student's own process of becoming an artist. At the same time, the teacher is shaping his or her own teaching, a practice we would also identify as artistic. The goal of students' full independence in perception, thought and concept, as well as self-motivation, self-confidence, and trust in intuition within a social context, requires all participants to work as collaborators.

Nicoll used questions to help students explore and evaluate their own work and also urged students to develop their own questions. While drawing attention to specific aspects of the work or opening possibilities for play, she herself offered no critique of the students' process or product. Constructing questions also helped Nicoll negotiate her own relationship to the material students wanted to explore. She watched from the studio's perimeter, video

camera and journal in hand, with the goal of informing herself. The students alerted her when they wanted to show or videotape work in progress. They also came to talk with her when they wanted help. As one student, Lydia, put it:

> [We] would show Jessica our work and anticipate comments and suggestions. But we almost never received these and instead were presented with questions such as, "What do you want to develop about this phrase?" and, "What would you like to fix?" Sometimes we would answer out loud to Jessica, but more often she would quickly add, "You don't need to tell me; just think about these things and keep working."...We were encouraged to reflect on what we had created, what we had not yet created, what we wanted to achieve, and what we could ultimately achieve.

Phyllis Lamhut, has described a similar process with established choreographers, "Everything I do is dialogue, just to get them to focus on that section, not to do what I say....I have to call attention to something, which is different, in a way, than making a suggestion" (personal communication, March 3, 2009).

Challenges and New Perspectives

Regardless of the choreographer's stage of development, the underlying principle is the same: to help artists look at their work from a new perspective and generate their own questions to move the process forward. One of the young choreographers, Anna, reflected on her own sense of that challenge:

> I think it was just challenging to step outside the easy. I remember Jessica once asking me, "What are you doing with this piece? What is new, what is your own?" That was not a question I wanted to hear. But I do think about it each time I start conceptualizing a new piece.

Developing work beyond the initial inspiration is one of the most difficult tasks for any artist. Stella, who worked with Nicoll over several years, spoke of this as a continuing struggle.

Several months into the process, the group discussed the humor and originality of a new solo by Luisa, a piece in which she'd layered elements of space and time with a witty and confident hand. It was clear that Luisa had uncovered a unique voice. Whether that voice would have emerged (or been silenced) with the specific intervention of a teacher can't be known. What stands out in Luisa's later reflection, however, is her own discovery: an awareness that pushing beyond her own boundaries was the most satisfying aspect of her artistic growth.

Every year, the most challenging aspect of the choreography process...remained the same: completing a piece. I often get bursts of inspiration in which I can create a one to two minute phrase that I am satisfied with on its own, but once I set about developing these ideas, I frequently run into roadblocks.

Luisa went on to describe the way questions helped her move beyond those roadblocks. She also applied her discoveries to later work in a painting course and describes the satisfaction of finding completion while remaining open to the unexpected: "I now view the development of a piece, culminating in its completion, as a process that is anything but stagnant: everything can always be pushed around, added to, removed or manipulated."

Helping to shape group discussions was also a significant part of Nicoll's role as a mentor. She urged the students to ask each other for the kind of feedback they needed and to pose specific questions to direct the group's attention. She encouraged the students to find the aspects of each other's work that excited, surprised, intrigued, or puzzled them, and this established a positive yet honest framework. Nicoll avoided speaking first or serving as a gatekeeper during group discussions. She wanted to take herself out of the role of expert and to foster a collaborative spirit among the dancer/choreographers themselves. Stella recalls:

These discussions were some of the most revealing aspects in my own process of development, since they brought my attention to various themes I could play with that had not occurred to me. Even listening to observations of other works, I was able to relate them to my own and thereby get new ideas.

Results of the "Experiment"

One of the clearest outcomes was the level of students' commitment to their artistic process. The parent of one 14 year-old who had been working with Nicoll at the Y since she was eight, asked Nicoll at the end of the first experimental year, "What did you do differently? Something changed; they owned this in a whole new way." Anna said later, "It really felt like it was ours, that it had emerged from something we already had inside of us—not that it had been 'taught.'" Nicoll had noticed changes immediately; the choreographers were using the tools for reflecting and moving the work forward in a new way and began to function as a true artists' collaborative. They needed no reminders to keep up with their journals or develop choreography between classes. They communicated with each other during the week and found spaces outside of the Y, from family living rooms to apartment building playrooms, to rehearse independently. They watched their videotaped dances at home and arrived at

the studio, notes in hand. Possibly most striking, given the difficulty many teenagers have revising and editing, they continued to revise even "finished" dances up to and after their public showings. This self-regulation and focus on the work were clearly on display at a student dance festival where a number of their pieces were performed. They were the only performers who, without prompting, requested time onstage before and between the two shows to re-hearse themselves: making changes, working out spacing problems, and fixing what hadn't worked well in the first show, while Nicoll looked on from the side.

What of the quality of the artwork itself? Our interest, beyond the integ-rity of each student's artistic process, focused on the extent to which the works, at the developmental level of each choreographer, showed a complete-ness of vision and demonstrated growth over time. In terms of dance composi-tion, Nicoll hoped to see that each choreographer pursued her own interests to make dances that went beyond simply stringing together favorite moves. She examined whether they had applied formal structures as integral elements of the work; discovered a language for their ideas; and developed movement vocabulary and craft that, while informed by training and personal inclination, did not remain the same for each new piece. Had they achieved a unity of vi-sion that served the meanings they brought to the work and that allowed for discovery of new meanings? One would have to see their choreography over a period of time to judge whether the works overall demonstrated the sort of integrity a Gestalt formation suggests. The observations of audience members, the dance center director, and parents corroborated our perception that these students' choreography, as well as their discussion and analysis of composi-tion, reflected a sophisticated application of these artistic principles and was both varied and distinctive.

The concert at the end of the first year of the experiment, in spring 2005, featured seven original works by four choreographers. Indira's quartet, "Pre-paring to Promenade" explored the link between ballet vocabulary, performed at a ballet barre onstage, and a teenager's sense of imperfection. In rehearsal Indira had asked her dancers to improvise off set phrases by imagining "All the audience sees is you casting a shadow that becomes a mirror image and then reveals the imperfections of a person near you." The dance featured spo-ken text, written by Indira and performed on tape by the dancers, directed and recorded by Indira.

On the same program, Anna and Lydia performed a co–choreographed duet, "Versation.con" that had grown out of a playful improvisation in which they "took time to move together and create a relationship,...testing limits, how hard can we pull...can I jump onto you from the ground...surprised at

where we could land." Anna had also created a new piece in the final week before the performance, "Cross Sensitization," and recruited more than a dozen dancers from another performing group to learn a structured improvisation during dress rehearsal and performed that night in a bustling exploration of pedestrian motion and stillness accompanied by a percussion score. Each dance, and the four others on the program, made a unique artistic statement and used both the qualities of the individual dancers and elements of form to express a wholeness of vision. Nicoll was consistently surprised by the fullness of the work. In her journal she wrote, "I'm delighted with their choreography, partly because I have no responsibility for it. I have a sense of not knowing where it came from."

Applications to Other Settings

This rare opportunity to explore the nature of art-making with a small, highly motivated group of young women may not immediately seem applicable to other circumstances. And yet, by examining the key features of the culture that grew up around the process, we recognize ways in which such artistic activity can apply to different settings. Nicoll's on-going work with younger students (ages 7–12) in much larger groupings (classes of 25–30 students) in the New York City public schools has given her an opportunity to explore these principles of stepping back and trusting both the individual artistic impulse of every child and how social learning can extend the artistic possibilities of choreographic play.

Though Nicoll's public school classes are not focused specifically on choreography, they do include improvisation and collaborative composition. Informed by her experiment at the Y, she challenged herself to open up the more structured processes she has developed in public school residencies. We can summarize the key features of the approach as follows:

1. Encourage students to offer ideas to adapt exercises or structures.
2. Give students leadership roles as early and as often as possible.
3. Establish and practice methods for self-directed group work.
4. Provide open structures in which students can find their own problems and pose their own questions.
5. Integrate reflection and focused observation and discussion throughout each class.

While these processes are difficult to implement fully in a school gym, auditorium or classroom, the results of Nicoll's shift toward a more collaborative model have been obvious, both to her and to the classroom teachers with

whom she works. Students demonstrate greater motivation and commitment; they show improved collaborative skills and reveal enhanced awareness of their own processes and what interests them in the world. Encouraging students to use their imaginations, make works of art based on their own ideas, and collaborate with peers stands in stark contrast to the increasing standardization and rigidity now dominating many American schools and classrooms.

Off the Cliff

Changing internalized teaching models is extraordinarily difficult. Nicoll left almost every class during the experiment wondering whether she was shirking her responsibilities, withholding help and expertise from her students. In retrospect she recognized that not only was she working just as hard, though in different ways, but she was seeing a different result both in the students' level of commitment and in the quality of their art. After 25 years of teaching with what she felt was a student-directed, constructivist approach she had asked herself, "How did I come to the conclusion that certain things had to be taught in a certain sequence? How do these results change my assumptions?" We hope the description of this process stimulates similar self-reflection in teachers and mentors about the correspondence between philosophies and practices, between *our* aesthetic values and the task of helping students recognize their own, and between the need to fulfill external expectations and the goal of developing internally-directed artists.

Conclusion

We recognize that some dancers and dance educators may dispute some of our basic premises concerning the development of choreographers and the teacher/mentor's role in the process. Even for those who accept them, the ramifications of these ideas may be difficult to fully grasp. The underlying principles can be restated as:

1. Everyone has the capacity for artistic creation in dance.
2. Children and adults move through developmental stages of artistic activity through social interaction and internal dialogue.
3. Teachers and mentors must be open to the possibility that they cannot imagine what and how their students and mentees are about to create.

If we believe the artistic processes of all individuals, from children to beginner adults to professional artists, do not fundamentally differ and that the tools of choreography are in service of expression and meaning making, rather

than prerequisites for it, we must respect and nurture the internal processes that allow meaning to emerge. Further if we believe that the most productive learning occurs through the discoveries we make for ourselves at the upper edges of our ability, then the teacher must be prepared to offer aid and instruction but cannot make assumptions about the individual's capacities or predict the trajectory of the artistic creation. Artistic activity changes what the artist is capable of.

In *The Psychology of Art* (1971) Vygotsky wrote, "[Art] is a requirement that may never be fulfilled but that forces us to strive beyond our life toward all that lies beyond it" (p. 253). His description of artistic striving seems a profound recognition of the zone of proximal development, though he would not articulate the theory for several years. For artists to move into the unknown, to extend and reinvigorate their stay in the zone of proximal development, they must establish processes that keep open the dialogue between the conscious and subconscious. The powerful intellect prompts us to name, explain, and analyze, trying to return us to a safer and more known reality. But the choreographer Kei Takei reminds us, "I should not be safe in my creativity" (cited in Kreemer, 1987, p.18). When working with young artists the temptation is strong to offer solutions and comfort by having them follow set procedures. The safety nets we provide, however, may keep our students from exploring the imaginative realms we most desire for them. Perhaps holding less tightly, joining them in the unknown space, will bring them closer to the heart of their artistry. In dance, the journey involves one's own body, along with the companionship of other dancers, teachers and mentors. Beyond this, we are accompanied by the cultural and historical influences that shape our ideas and understandings. Original, meaningful creation in dance occurs through the integration and deepening of the dialogue among all these sources. As Julia, now 15, puts it:

> Dance, although you may practice it solely for yourself, is not a private practice at all. Dance is a community with your teacher, your classmates, your audience and especially yourself. If you string all of these people together, and include them into your thought process, your movement will be heard.

References

Abrahamson, R. E. (1980). The teaching approach of Henry Schaefer-Simmern. *Studies in Art Education, 22*(1), 42–50.

Arnheim, R. (1972). *Toward a psychology of art: Collected essays.* Berkeley, CA: University of California Press.

Cohen, S. J. (Ed.) (1965). *The modern dance: Seven statements of belief*. Middletown, CT: Wesleyan University Press.

Hanna, J. L. (1987). *To dance is human: A theory of nonverbal communication*. Chicago: University of Chicago Press.

John-Steiner, V. (2000). *Creative collaboration*. New York: Oxford University Press.

Kinnell, G. (1971). *The book of nightmares*. Boston: Houghton Mifflin.

Kreemer, C. (Ed.) (1987). *Further steps: Fifteen choreographers on modern dance*. New York: Harper & Row.

Lakes, R. (2005, May–June). The messages behind the methods: The authoritarian pedagogical legacy in western concert dance technique training and rehearsals. *Arts Education Policy Review, 106*(5), 3–18.

Morgenroth, J. (2004). *Speaking of dance: Twelve contemporary choreographers on their craft*. New York: Routledge.

Sarason, S. (1990). *The challenge of art to psychology*. New Haven, CT: Yale University Press.

Schaefer-Simmern, H. (1948). *The unfolding of artistic activity*. Berkeley: University of California Press.

Schaefer-Simmern, H. (2003). *Consciousness of artistic form*. Carbondale, IL: The Gertrude Schaefer-Simmern Trust.

Starko, A. J. (1995). *Creativity in the classroom: Schools of curious delight*. White Plains, NY: Longman.

Vellucci, M. (2009, March). Phenomenal women. *Dance Teacher, 31*(3), 26–34.

Vygotsky, L. S. (1925; 1971). *The psychology of art*. Cambridge, MA: MIT Press.

Vygotsky, L. S. (1978). *Mind in society*. Cambridge, MA: Harvard University Press.

Wertsch, J. V. (2007). Mediation. In H. Daniels, M. Cole, & J. V. Wertsch (Eds.), *The Cambridge companion to Vygotsky* (pp. 178–192). New York: Cambridge University Press.

The Inscription of Self in Graphic Texts in School

Peter Smagorinsky

I n this chapter I focus on a small set of U.S. high school seniors to reveal the ways in which they wrote themselves into graphic texts that they designed and produced. All students attended the same high school in the Southwestern U.S., and most had struggled with school in the past. Indeed, of the four students featured in these three case studies, only one graduated on time with her class, and she did so with assistance from a medication prescribed for her Attention Deficit Disorder. Among the others, one dropped out of school altogether; one had insufficient credits to graduate on time and his graduation status remains unknown, and the third completed high school well after his scheduled date of graduation.

Even given their general lack of affiliation with the institution of school, they nonetheless demonstrated a deeply engaged commitment to tasks that involved a provocative stimulus, life experiences that mapped well onto the assignment's requirements, and an artistic or graphic medium through which to express themselves. Although art and other graphic expressions are considered of lesser importance in the logocentric and analytic sphere of school (Gardner, 1983), these students not only immersed themselves in these tasks, but produced work of impressive insight.

This degree of involvement and learning was abetted in each case by the opportunity to inscribe their own experiences and worldviews in the texts they produced. While the connection between personal lives and educational material has long been lauded in much educational writing going back at least to Dewey (e.g., Dewey, 1902), it is still considered frivolous by many involved in making educational policy (see, e.g., Rowan & Correnti, 2009; and Smagorinsky, 2009, for a rebuttal). The affordances provided by both the application of

personal knowledge to school knowledge, and the possibilities in nonverbal expression as a means of assessment, thus appear to have great potential for educators who seek to engage and retain students who otherwise find school to be a tedious and dispensable experience.

The three case studies that I highlight illuminate the potential available when teachers open interpretive and expressive possibilities to students by expanding their interpretive and expressive tool kits to include artistic and graphic media in which they can inscribe their own experiences as they engage with the curriculum. Each case study features students producing texts in response to assignments that involve varying degrees of availability for personal connection:

- A mask produced in a senior British Literature class as part of a unit on identity, taught by Cindy O'Donnell-Allen; in this assignment, the inscription of self was a deliberate and obligatory dimension of the students' work (see Smagorinsky, Zoss, & O'Donnell-Allen, 2005; Zoss, Smagorinsky, & O'Donnell-Allen, 2007).
- In the same British Literature class, a graphic interpretation of John Keats' "When I have fears that I may cease to be," in response to an assignment with no specific cue for students to relate the poem to their personal experiences (see Smagorinsky, Cameron, & O'Donnell-Allen, 2007).
- A set of architectural plans for a house that the student envisioned inhabiting one day; this assignment implied an inscription of self, one requiring indirect expression in the layout of a home designed to support a particular, self-determined lifestyle (see Smagorinsky, Cook, & Reed, 2005).

In the sections that follow, I detail each of these productions by introducing the students and their task and then providing an account of their inscription of self in the texts. The data reported are from the studies referenced above but do not represent the whole of the findings. Readers are directed to the referenced publications for a broader understanding of the students' situated design of these graphic texts.

Individual Composition of an Identity Mask

Zoss et al. (2007) report on three students who created masks in their senior British Literature class; in this chapter, we focus on one of those students, Peta (a pseudonym, as are all student names in this chapter; cf. Smagorinsky, Cook, & Reed, 2005). Peta was a male who counted a variety of nationalities in his ethnic heritage: the Native American tribes of the Cherokee, Delaware, Kiowa,

Sioux, Cheyenne, and Arapaho; and the European nationalities of the English, Irish, Scottish, and French. His primary identity was as a Native American, and he maintained an active role in the local Native American community. In contrast, he found school to be largely irrelevant and dropped out shortly after he completed his mask in mid-October of his senior year of high school, well short of the minimum requirement for credits.

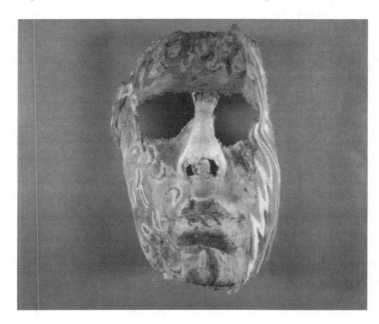

Figure 1.
Peta's Mask
(Courtesy of the artist)

The mask activity took place as part of a unit on identity that included literature and other media through which authors and speakers considered their unique places in society and personal life trajectories. As part of the assignment, students were told that "masks serve as identities because when you put on a mask you become what the mask represents. We become our mask." Students dedicated several days of class on a block schedule to constructing the mask forms in relation to their facial contours, allowing them to dry, and producing images on the exterior that indicated the identities they hoped to present to the world. The interior of the mask was available for the side of themselves that they kept more private.

Peta was absent during the decoration of the masks, but took his form home, where he spent considerable time inscribing his identity on the exterior. When he returned to class, he provided a retrospective protocol about his process of composition; that is, he sat with me, and I recorded him as he ex-

plained his process of composition on the mask exterior. His dedication to this task, which only briefly preceded his decision to leave school altogether, suggests that it provided an unusually stimulating activity for him in what he regarded as the dull and dispiriting environment of school. Figure 1 presents the product of his work; what follows is the portion of his protocol in which he explains how he inscribed himself in his design.

In the context of this assignment, Peta revealed himself to be a serious, thoughtful, and committed young man in relation to issues that concerned him. These issues were outside the scope of the abstract curriculum provided by the school in general. The mask allowed Peta to express emotions that the disembodied school curriculum generally discouraged from arising in student work. In the following exchange, for instance, Peta discussed his use of color to represent deep feelings of anger:

Peter: Why is your nose yellow with a kind of a red triangle or pinkish?

Peta: Because that is how I was wanting to represent the inner rage.

Peter: The yellow is rage?

Peta: It's coming from, you know, sometimes when you get mad, you have pressure that's like right here...I put it around the brow.

Peter: Uh huh. Is that why the nose is yellow?

Peta: Uh huh.

Peter: So that's where you feel it coming...is it coming out or is that just where...or does it stay there?

Peta: It seems to like...it kind of feels everything else. It's, I guess maybe...yeah, it just kind of feels everything else. It kind of...it sets things in motion. Of course, by thinking about it and expressing it and all that stuff, it cools it down.

Peta's comments illustrate what Gee (2003) calls a *projective identity*, which employs two senses of the work "project," as both verb and noun: "to project one's values and desires onto the virtual character" [in a video game and to see] "the virtual character as one's own project in the making." Gee's observations come in the context of how video game players imbue their avatars with personifications of their own identities but are appropriate for considering Peta's work on his mask. From a gamer's perspective, argues Gee, this virtual character is "imbue[d] with a certain trajectory through time defined by my aspirations for what I want that character to be and become" (p. 55). Through this graphic text, Peta depicted his identity as a person whose experiences had caused him to develop a "rage from deep inside." In this instance he used his

mask design as what we called an *emotional mediator*, as a tool for exploring or representing his emotions in relation to his identity.

In addition, Peta's mask served as a *spiritual mediator*: as a way to express his broader connection to the earth, an orientation that Jacobs and Jacobs-Spencer (2001) maintain is central to a Native American outlook. In describing the vine on the mask, for instance, he discussed how it enabled him to illustrate his view of the interconnectedness of his life's activities:

Peta: It's just, I guess, the way I write and stuff. I bring it out, it's kind of entwined...and fluid and it just seems natural...the vine. And I've got the leaf as my lips.

Peter: As I look at it, I'm wondering, it doesn't look as though the leaf is, say, covering up to keep you silent. Is that...or is it intended as something you can open?

Peta: That's kind of how it looks, but that's not really how I intended it. I just made the vine red because, and it's like a life that was kind of entwined through it all.

He depicted his spiritual connection with the earth through a variety of images. In describing his choice of background for the mask, for instance, he said that he chose brown "because it's earth tones. And it just happened to be the color of my skin, but it's, it has nothing to do with my skin." His decisions about how to depict his identity on the mask, then, were designed to simultaneously convey emotions (e.g., rage) and manage those emotions (to cool the rage). He further represented his spiritual connection with the earth and the whole of life in ways that were absent the adversarial emotions that followed from his interactions with his (mostly White) schoolmates and teachers whose fragmented curriculum, and ways and values he abandoned when he left school for more important things.

The previous examples show how Peta employed symbols to express himself in his mask design. He used color (e.g., brown to represent the earth) and symbols from nature (e.g., the vine to represent the interconnectedness he saw in life) to depict central aspects of his Native American identity. Other aspects of his design similarly used iconography, such as when he described the blue drops of water on the forehead of his mask:

I wanted that to look like a rain image and I wanted the purple—since I had already used blue for the rain, I wanted the purple to give it sort of a mellow [mood] because the way I think. The way I actually *think* is pretty calm. The way I *feel* is very, I guess, sort of, I wouldn't want to say violent, but it's kind of that degree. [emphasis added]

Peta also used what we termed a curvilinear element throughout his mask design to symbolize his relationship with nature. When I noted that his mask

included "a lot of swirls...a lot of circular motion," Peta replied, "Chaos is very circular. And randomness is very circular. So it's just kind of—I guess nature is kind of chaotic." This curvilinear element was also evident in Peta's use of the vine as an interconnective element in his design.

The images that Peta selected were designed to depict narratives he constructed from his life experiences. When asked about his use of bright yellow, red, and green, and a less lustrous green in the background, he said:

Peta: It's kind of the, it's like the sorrow and the envy and the pain that, I mean we all go through certain things, and I feel that I have experienced many things to give me insight on a lot of, and it kind of reflects on how I write. And I've always noticed that, you know, you get that sort of ache when you hurt? And I've always noticed that it's been stronger like on my left side.

Peter: Interesting. Is that what the sharp images are?

Peta: Yep. I guess that it could be it. Yeah. It's sort of the pain and emotion. It's always very, like I said, I was, the way it, is always strong. I guess I always go to extremes on how I feel like being extremely happy or extremely angry.

Peter: Uh huh. Is that all on the inside, because you told me that you have kind of mellow outer appearance and that's mostly what I see.

Peta: Yeah.

Peter: But inside, there's a lot more going on than you show?

Peta: Yeah. But it doesn't bother me because I can write about it.

Peta's last remark reveals his employment of multimodal means of expression; his mask project was accompanied by a poem that he wrote in addition to what he'd been assigned. On the whole, his work on the mask illustrates how a graphic text may involve a great deal more thoughtfulness and consideration than might be attributed to nonverbal productions in school. Unlike most of what was asked of him at school, the mask project stimulated him to draw on his personal and cultural background to express his understanding of his world through a provocative creation. His decision to leave school appeared to follow from the absence of such opportunities through assignments across the curriculum and the lack of seriousness with which he believed the majority of his classmates took life and its social investments.

Collaborative Graphic Interpretation of a Poem

Roughly two weeks after the mask activity, Cindy followed through with an assignment in which students analyzed poems within the theme of identity by

using colored markers to draw their interpretations on large sheets of butcher paper. Each group then presented their interpretation to the class and led a brief discussion on the meaning of the text. We focus on two students who collaborated on an interpretation of John Keats's "When I have fears that I may cease to be." provided below. The interpretation by Rita and Dirk is presented in Figure 2.

When I have fears that I may cease to be
Before my pen has glean'd my teeming brain,
Before high-piled books, in charactery,
Hold like rich garners the full ripen'd grain;
When I behold, upon the night's starr'd face,
Huge cloudy symbols of a high romance,
And think that I may never live to trace
Their shadows, with the magic hand of chance;
And when I feel, fair creature of an hour,
That I shall never look upon thee more,
Never have relish in the faery power
Of unreflecting love; then on the shore
Of the wide world I stand alone, and think
Till love and fame to nothingness do sink.
John Keats (1818)

John Keats's "When I have fears that I may cease to be."

Rita was a European American female who had experienced difficulty with her academic learning, a problem that improved dramatically during her junior year of high school when she was tested for learning disabilities and was found to have Attention Deficit Disorder, for which she was prescribed Ritalin. She received a grade of B in Cindy's class for both semesters of her senior year. Dirk was a very personable, soft-spoken, and friendly African American male. Like Rita, Dirk experienced problems with concentration, although he had no formal diagnosis and treatment upon which to base an assessment of his mental state. Dirk passed the first semester with a low D and was the only student in all of Cindy's five senior English classes who failed the second semester because of his grades (other students failed because of excessive absences). Because he failed English, Dirk did not graduate with his class.

The Keats poem potentially provides a number of interpretive obstacles for readers who have difficulty focusing on schoolwork, in that it requires great concentration to sort through the 18th-century British language and literary conventions to arrive at a construction of meaning. The analysis suggests that the students' reading of the poem was heavily influenced by recent ex-

periences they had had with death, the fear of which is the focus of Keats's poem; and indeed, Keats died at age 25 within a short time after writing the poem, a victim of tuberculosis, which had recently taken the life of his brother.

Dirk's pastor had died three years previously, an event that led to his withdrawal from church; and just before the assignment, Mary, the 24-year-old sister of Rita's best friend, committed suicide. This latter event emerged in their discussion as the more significant influence on their interpretation and will be the focus of the following analysis.

The chronology of Mary's death is important in understanding Rita's reading of the Keats poem. Mary was a soldier in the U.S. Army and on Tuesday, October 10, committed suicide during a period of clinical depression. On Wednesday, October 11, Rita was at school but did not attend Cindy's class. In her absence, Cindy assigned a set of readings, including "When I have fears that I may cease to be," for the next class meeting on Friday of the block schedule. On Friday, October 13, Cindy provided butcher paper and colored markers for the students to use in small group artistic interpretations of the various literary works assigned for homework, with each group selecting a different poem. On Friday, Rita and Dirk interpreted the Keats poem, and on Saturday Rita attended Mary's funeral. The following Tuesday, each group presented its artistic interpretation to the class. On Thursday, Rita and Dirk provided a retrospective protocol for the research in which they reconstructed their process of composition, using their completed drawing as a stimulus.

Rita's close relationship with a family that had experienced a terrible loss was a powerful influence on their reading of "When I have fears that I may cease to be." We next illustrate the relation between Rita's experiences with death in a family with whom she was very close and Rita and Dirk's collaborative reading of a poem centered on fears of death by a member of a family seemingly cursed by tuberculosis.

With a strong personality and heartfelt beliefs about the intersection of her experiences with death and her reading of the poem, Rita was the dominant interpreter of the poem. She drew a number of parallels between Mary's outlook and that of the poem's narrator, in particular their negativity toward life, the degree to which their actions were amenable to choice, and the possibility of an afterlife. Rita described her feelings toward the speaker, saying:

> It is real negative of this guy not to think that once he dies things will be better. And he is thinking of all this bad stuff that is going on right now, and after he dies, and why he was put on the earth, and thinks of the positive things that he has done with his life....But I still think he should be afraid to die. But I don't think he should bring out all this sadness and this feeling sorry for himself, and I don't think that is right. I

think he should be scared of what is going to happen to him, but not to a point that he is so negative towards everything.

Figure 2.
Dirk and Rita's Interpretive
Drawing
(Courtesy of the artists &
their parents)

Her view of Mary was similar to her view of the speaker. Both, she felt, capitulated to overly pessimistic views of their lives:

> She shouldn't have been so negative, and this guy [the poem's speaker] shouldn't have been so negative. This guy didn't have a choice if he would die or not. But he should not have been negative. And she did have a choice....She wasn't dying of [an illness]....She was dying because of depression. I guess that is an illness, but she was so negative towards everything....It [the interpretation] was a way for me to say how scared I was of dying, and how I think everybody should fear death, and it hit so close to home for me that week.

Their presentation to the class repeated these themes. It invited a discussion among the class of how to understand and respond to death. What follows is an account of the discussion, reconstructed from the field notes and so generally if not specifically accurate:

Rita: What does it mean, When I have fears that I may cease to be? Billy?

Billy: (tries to hide behind his hand)

James: (attempts answer but does not complete it)

Rita: When you cease to be, you're dead. Why should he be afraid to die?

Jenny: Because maybe he hadn't accomplished everything he wanted.

Cindy: (points students to the biographical passage that accompanied the poem explaining that both Keats and his brother died young)

Rita: This is a hard one. The guy is afraid to die because his brother has just died young. He uses a lot of metaphors. The first line is about, he's trying to take all that he has in his brain and use a pen to get it out, so he's using a pen to get all this crap out of his head. What does he want to do after he gets the ideas out of his head, into books?

Alan: Why should everyone be afraid of death?

Rita: I've never been around death till this weekend when one of my friends killed herself. I think everyone should be scared of it. Nobody knows what death is, so you should be afraid of it.

Shondell: I'm not scared, but if I knew I was dying, I'd be upset because of how young I am. But I'm not scared of what happens after that.

Lucy: A lot of people are curious, not really scared.

Rita: I think you'd be scared. Even if you have a really strong [religious] faith like I do, you'd be scared.

Shondell: No.

Billy: Say if you're an old man and you've did your purpose on earth, then you're not gonna be scared.

Alan: Maybe that's all you're meant to accomplish. What if you're 24 years old and going to die? Maybe that's all you're meant to live.

Shondell: You might be upset but not necessarily scared.

Rita: (addressing two students who were talking quietly about fears of death) I gave you my attention [during your presentation], now give me yours. It pisses me off when people don't look at me when I'm talking.

Rita & Dirk: (explain the symbols in their drawing)

Shondell: That's a good poem, Rita.

Rita took the occasion quite seriously, snapping at students whom she believed were not paying attention. During the retrospective protocol Rita described the gravity of this moment, saying, "I have never had a grandparent die. I have never had anybody that I have known [die]. I have never been to a funeral in my life. And until this past...I really, I kind of got upset with the people who weren't listening to my viewpoint out there."

Rita's own personal connection to the speaker's introspection about death was explicit in her remarks as discussion leader. Both these comments and her questions to the class prompted other students to ponder the ways in which they might face death at different life stages. The discussion that we have reconstructed reveals the students talking less about Keats's language and more about their own feelings about profound issues: the degree to which one's death is fated, the role of religion in confronting death, the purpose of human

life on earth, the possibilities of an afterlife, and other questions raised in light of Keats's speaker's facing his own mortality.

This discussion, facilitated by Rita's connection of her recent experience with her friend's death, continued during the retrospective protocol. While reflecting on the presentation, Rita said:

> All the religion that has been piled into me by my parents, and by my church, I do have a strong [Catholic] faith. But I have no idea what is going to happen to me after I die. Nobody can say that they know what is going to happen after they die. And it is just like, one of the girls [during our presentation to the class] was not afraid to die. But I think that if it came down to it, I think she would be scared half to death, because she has no idea what is going to happen to her.

Rita and Dirk sustained their focus on the topics raised in the poem across a period of over a week. Stimulated by the speaker's ruminations and the death of a friend, they moved from a concern that both Mary and the narrator were too negative about their lives to a more complex consideration of how a person most appropriately faces death. This attention came in response to a poem that, as Rita said at the beginning of their presentation, is a "hard one." Through their multiple iterations of the initial reading, their effort to represent the poem graphically, their presentation and discussion with the class, and their reconstruction of their interpretive process and search for meaning for the research, Rita and Dirk had the opportunity to develop their ideas across multiple interpretive discussions and experiences, particularly the intense emotions surrounding the death of Rita's friend. As Rita said, in addition to attending to the language of the poem, their graphic interpretation provided her with "a way for me to express also my feelings about this girl's death."

Individual Architectural Design

The third text I will review was produced for a class in Architectural Design at the same high school. The student was Rick, a white male who had dropped out of a Vocational-Technical school during his senior year, only to re-enroll the following year at age nineteen in his community high school's architectural design class. Rick's most immediate plan following school was to rebuild a car with a friend and perhaps become, like his father, an auto mechanic. He was also considering the possibility of returning to the Vocational-Technical school he had dropped out of previously. When contacted several years after the research, he was working as a carpenter in a different city in the same state.

Rick's teacher, Bill, described the task as being "to design a house from 1,250 square feet to 1,800 square feet. There are restrictions: single story, must have two car garage, must have at least one full bath, does not have to have a formal dining room, but must have a kitchenette, like a breakfast nook. Must have a minimum of two bedrooms, 3/4 brick veneer." This style matched the designs produced by Bill's brother, a local contractor and so fit in with residential designs currently being marketed in a community that had recently suffered from a major housing depression. Bill further encouraged each student to enter his or her design in a state competition in which their drawings were read by architects and university architecture professors who evaluated their full set of house plans. Bill's assessment of the students' work explicitly anticipated the standards used by these judges. (See Figure 3 for Rick's design.)

Figure 3. Rick's Architectural Drawing (Courtesy of the artist & his parents)

Rick inscribed several aspects of his personality in his design. One overarching quality he described repeatedly was his need to be different, a dimension of his makeup that often placed him at odds with Bill's preferences for his design. Much of the design work that Rick saw going on in his classes relied on norms and conventions that he wanted to break:

> I wanted to do something that just didn't look average. You know, you can drive through some of the nicer neighborhoods here, and there's the same basic shape to all the houses. And I just, I wanted to do something different inside, and if you look at [my house] plan...there are three rooms that are the shape of stop signs. There are three octagons in the house. And [my teacher and my girlfriend's father, an architect] didn't like that.

The octagons were a continuing source of tension between Rick and Bill, who viewed such a design as unmarketable and out of place in the sort of

neighborhood he envisioned for the houses. In spite of this difference, Rick's design placed fourth in the state competition, suggesting a broader view of housing options among the judges, one less driven by marketability and other practical considerations.

In addition to this independent streak that Rick drew into his plans, he infused his text with narratives of how he intended to live. He designed his kitchen, for example, to accommodate his love for rollerblading:

> As far as the kitchen goes, I wanted a breakfast nook in the bar with another small round type of table, which is just an extension that goes all the way around. Just for an easy...half the time, if I go in my house and I want something to eat, I'm not going to fix something to eat and sit down at the table in the dining room, because that's just not me. And we've got new white carpet in our house, so we're not allowed to take it in the living room. So, I'll just pick it up and just eat in the kitchen. We don't have a bar, so I can't actually sit down. If I've been out rollerblading all day I can't sit down, so I've got to stand there and eat. And so, you know, that was something that played a part in it. I wanted something just so I could sit there.

Although static in appearance, then, Rick's design was infused with all of the movement and traffic flow that he envisioned as the inhabitant of the premises. This movement was articulated in the narratives that provided the "story of the house" and thus its layout. Rick's design of the foyer, for instance, was informed by the following narrative:

Rick: The teacher wanted to put some coat closets in there, and I didn't... I couldn't think of a place to put it without taking away from the overall...he was talking about, okay, let's cut this wall down like this, and we'll make this a closet. The door will be right there. Well, at, really to me, that just wouldn't be right. To have that study, then, like that. It just doesn't look right.

Q: Wouldn't it be symmetrical like that?

Rick: Yeah. It would, it would make it, the plan, easier. But yet not what I was shooting for. I was shooting for something just totally different. I wanted something nice and open, but at the same time I wanted some closed off areas. I used to have a...there was a door coming out here. And there was actually a patio, like a garden that you could go out in the morning and drink coffee or whatever, and it was, there was a four-foot brick wall going all the way around it. So that, you know, you had a little bit of privacy, but not too much. Which kind of fit in with the rest of the theme of, you know, your dining room, you've got a little bit of privacy, that wall there, that had no shade. But at the same time, you could still get, you could still see into the living room.

Rick's design ideas did not meet Bill's cultural schema for a home entry, one in which a resident or visitor was immediately met by a coat closet upon entering the house for convenient uncloaking and storage. This feature did

not, however, meet with Rick's need for openness and symmetry, as evidenced through his narrative of how he envisioned using this living space. Yet Bill composed a different reading for this foyer, one that envisioned visitors who had no place to hang their coats and hats upon entering the house.

Rick's need for an open design was a consequence of his belief that "I didn't want everything tight, compact....A lot of the houses, and even the houses that won state, looked tight and uncomfortable to me...I don't like feeling cramped in. I am extremely claustrophobic and I don't, I wanted something large." This need for open space operated alongside Rick's need to be different and live a specific sort of life within his design. He could not produce a conventional home of the sort anticipated by Bill; he said, "Everybody's got this real basic shape. You see a lot of squares. And I wanted to stray away from that." Rick's open design with octagonal rooms and unconventional layout reflected his inscription of a preferred way of living in the home, one suited to life as he envisioned it. Even as his plans departed from local convention, they worked within the broader cultural requirements of architectural design sufficiently to earn him a high ranking in the state competition.

Discussion

These three cases illustrate the inscription of self in very different sorts of graphic texts in school. The two produced in the British Literature class were unusual in that general setting because of the canonical nature of such courses, both in terms of what is read and how readings are allowed to be interpreted. The third was highly conventional for an architectural design class but rarely considered in research on literacy practices. As a whole they suggest the ways in which issues of identity can become more central in mainstream teaching and learning and how the production of nonverbal texts across the curriculum may enable students with access to learning that is not available through the conventional analytic and logocentric curriculum.

Brockmeier (2001) views individual identity as emplotted within a larger cultural identity. One's identity is mediated by society's teleological goals and the cultural practices that they suggest so as to provide "some of the fundamental trajectories of our existence (p. 216)...it is the individuals who 'suture themselves into the story'" (p. 221). People's identities are bound in broader cultural narratives, "creating a narrative 'emplotment,' a synthesis of heterogeneous elements" (p. 225; cf. Ricoeur, 1984). Drawing on their prior narratives from personal experience, readers and authors may emplot each new textual experience, situating each in dialogue with and in extension of other texts.

These processes appear to have been at work in the case studies reviewed in this chapter. The students wrote themselves into their texts in ways that involved their personal experiences as mediated by cultural phenomena such as Native American concepts and related imagery, conceptions of fear and death drawn from religion and other sources, and conventions for producing architectural drawings. Both the inscription of self in academic texts and the availability of graphic media for expression and interpretation lie outside the norms for public education and its emphasis on detached abstract linguistic analysis of curricular material. Given that the affordances of these tasks engaged students who in general had little interest or investment in school, to the point where their work occupied them extensively outside class, the inclusion of graphic means of textual expression and interpretation appear to have considerable potential for providing access to academic interest and success for students whose prospects for graduation are dim. Although the current climate of educational accountability appears to diminish the prospects for such possibilities yet further, these studies demonstrate that opportunities for the inscription of self in graphic texts in school may help provide the bridge that some marginalized students need to find the curriculum worth staying around for.

References

Brockmeier, J. (2001). Texts and other symbolic spaces. *Mind, Culture, and Activity, 8,* 215–230.

Dewey, J. (1902). *The child and the curriculum.* Chicago: University of Chicago Press.

Gardner, H. E. (1983). *Frames of mind: The theory of multiple intelligences.* New York: Basic Books.

Gee, J. P. (2003). *What video games have to teach us about learning and literacy.* New York: Palgrave/Macmillan.

Jacobs, D. T., & Jacobs-Spencer, J. (2001). *Teaching virtues: Building character across the curriculum.* Lanham, MD: Scarecrow Press.

Ricoeur, P. (1984). *Time and narrative* (K. McLaughlin & D. Pellauer, Trans., Vol. 1). Chicago: University of Chicago Press.

Rowan, B., & Correnti, R. (2009). Studying reading instruction with teacher logs: Lessons from A Study of Instructional Improvement. *Educational Researcher, 38*(2), 120–131.

Smagorinsky, P. (2009). The cultural practice of reading and the standardized assessment of reading instruction: When incommensurate worlds collide. *Educational Researcher, 38* (7), pp. 522–527

Smagorinsky, P., Cameron, T., & O'Donnell-Allen, C. (2007). *Achtung* maybe: A case study of the role of personal connection and art in the literary engagement of students with attentional difficulties. *Reading & Writing Quarterly, 23* (4), pp. 333–358.

Smagorinsky, P., Cook, L. S., & Reed, P. M. (2005). The construction of meaning and identity in the composition and reading of an architectural text. *Reading Research Quarterly, 40,* 70–88.

Smagorinsky, P., Zoss, M., & O'Donnell-Allen, C. (2005). Mask-making as identity project in a high school English class: A case study. *English in Education, 39*(2), 58–73.

Zoss, M., Smagorinsky, P., & O'Donnell-Allen, C. (2007). Mask-making as representational process: The situated composition of an identity project in a senior English class. *International Journal of Education & the Arts, 8*(10), 1–41. Retrieved November 7, 2009 from http://www.ijea.org/v8n10/v8n10.pdf.

Commitment and Creativity:
Transforming Experience into Art

Seana Moran

The central fact of our pyschology is the fact of mediation...
Culture creates special forms of behavior.
L.S. Vygotsky, The Problem of Consciousness–

This chapter describes Vygotsky's theory of creativity as cultural meaning making through social interaction. It links these ideas to similar systems models of creativity and explains the results of a study of commitment and creativity in 20th-century American poets and fiction writers through a Vygotskian lens: How are differences in creativity related to the ways writers commit themselves and externalize to the literature domain and culture?

In examining creativity and how artworks come into being, I am particularly interested in the individual's intentional contribution to the environment—what he or she wants to effect and how he or she "stays on course" despite fluctuations in or antagonisms from the environment (see Moran, 2010, in press). Commitment addresses the personal force that keeps a person pursuing a goal or staying within a social position or identity over long periods of time. Better understanding of commitment provides insight into how a person turns experiences into personal resources, then uses those resources, in turn, to add to the social and cultural environment for others to experience.

Art as Social Meaning Making

Vygotsky's ideas about creativity were scattered across his many writings, sandwiched between two arts-focused publications: his dissertation, which became *The Psychology of Art* (1925/1971), and a short paper on actors (Vygotsky,

1999). These writings have been summarized and contextualized in several chapters (Moran & John-Steiner, 2003; F. Smolucha, 1992; L. W. Smolucha & F. C. Smolucha, 1986). Vygotsky argued that creativity is the construction and synthesis of experience-based meanings and cognitive symbols embodied in cultural artifacts (i.e., creative products) that endure over time to be appropriated by future generations (see Moran & John-Steiner, 2003).

An artwork is a cultural artifact produced by an individual and shared with others in his or her culture. Like other cultural artifacts, its social significance and meaning are intersubjectively agreed upon among cultural members. This meaning-making entails three interacting processes: *appropriation* of understandings from prior generations, elaboration of understandings through idiosyncratic senses of the artwork based on personal *experience*, and *externalization* or sharing of those personal senses to be understood and negotiated by other cultural members (Moran & John-Steiner, 2003). Based on the individualized sense that a person makes of cultural resources he or she has appropriated and experienced, a person's externalizations can vary in their effect on a culture—from relatively conforming to transformational.

Art is important for individuals to connect with their communities. It is a mediator and organizer of the interaction between the individual and the social, between one person and his or her community. Art provides "the social technique of emotion, a tool of society which brings the most intimate and personal aspects of our being into the circle of social life" (Vygotsky, 1925/1971, p. 249). Through art, we come to understand ourselves and each other better. Furthermore, art helps perpetuate culture by affecting individual's minds and hearts to make use of, to transform, and to carry forward the ideas and emotions embedded in the materials of everyday life. For example, Vygotsky (1925/1971) discussed how Shakespeare's creativity selects and combines elements within the socially accepted aesthetic and cultural standards of his time to create new emotional and ideological understandings that transcend his time.

Creativity as Contribution to the Culture

> Every symbolic activity...was at one time a social form of cooperation.
> L.S. Vygotsky, *Tool and Sign in the Development of the Child*

Vygotsky's theory of creativity elaborates his notion of the zone of proximal development (ZPD). This zone is a space where people learn their cultures through social mediation (Vygotsky, 1978). The zone initially was understood primarily as the setting where a novice learns from a more expert individual

how to accomplish a cultural task. Thus, the ZPD concept was embraced by the educational community as a pedagogical tool. Within the zone, the individual internalizes or appropriates from the culture—he or she learns the correct ways to conduct behavior and use cultural resources.

Although Vygotsky focused the ZPD on children, the concept can be elaborated throughout adulthood. Throughout the lifespan, people understand cultural resources in different ways. "Carbon copies" of cultural ideas are not imprinted on our minds. Rather we absorb and make sense of cultural ideas through experience. We subjectively live through events, what Vygotsky (1994) called *perezhivanie*. This subjectivity serves as both a filter and a prism for information from the environment. Thus each of us will feel or understand the same event in different ways.

Because our internalization of existing cultural resources does not create exact replicas of information in each person's mind, considerable variation in understandings entails. This variation leads to the potential of widening the repertoire of possibilities for both individuals and cultures to develop. We perpetuate our culture when we share our understandings with others through conversation, teaching, and creating cultural artifacts such as artworks, books, or inventions. As mentioned above, this process is called externalization. Through externalization, the zone also becomes a setting for the culture to learn from the individual.

Depending on an externalization's impact on others, it may be labeled "creative." Creativity arises when the culturally agreed-upon meaning, or conventional wisdom, or central tendency of those in power, changes because of a new externalization. Experts consider and teach the cultural resources differently after the creative artifact is accepted. Thus, creative artifacts are those externalizations that are both novel and deemed appropriate in a social venue (Amabile, 1996).

Think of a continuum. At one end is exact reproduction of a product or idea to preconceived specification: for example, exact replication from a blueprint. The person's sense is very close to the already accepted, socially agreed-upon meaning. That is, it matches "conventional wisdom." This is conformity. What the person externalizes is usually considered uncreative, or little-c creative, even if it is valuable expertise. People consider it relatively standard fare and easily accept it as "normal."

At the other end is originality: putting one's unique fingerprint on a contribution to the world. The emphasis is on idiosyncratic sense making. It is conceived of as spawning new possibilities that emerge from existing materials. These new, realized possibilities could be rejected by cultural members as "error," and they disappear from or are marginalized in the culture's historical

record. Or they could be accepted as "creative" and eventually become the new norm, a renegotiated socially agreed-upon meaning (see also Stacey, 1996). For a work to be big-C creative, enough other people must come to understand the artwork or other cultural resource in the same sense as the creator so that the idiosyncratic sense becomes universalized meaning (see also Feldman, 1994, for a similar theory).

The Interplay of the Social and the Symbolic to Effect Change

> The application of psychological tools enhances...the possibilities of behavior by making the results of the work of geniuses available to everyone.
>
> L.S. Vygotsky, *The Instrumental Method in Psychology*

For Vygotsky, then, development is internalization of cultural meanings into individual senses based on experiences of artifacts. Creativity is externalization of idiosyncratic senses that are socially negotiated by others as worthy and transformative.

Vygotsky's model of creativity is similar to Csikszentmihalyi's (1988) individual-field-domain systems model (see Moran, 2009a). Csikszentmihalyi's (1988) systems model aggregates Vygotsky's model. Csikszentmihalyi's model involves not an expert-novice dyad but rather a field of many experts and novices, with special "gatekeeper" privileges given to some experts. These gatekeepers, more than others in the field, have power to determine which sense making becomes accepted cultural meaning. Furthermore, Csikszentmihalyi's model expands from a single symbolic task to a domain of many related symbols and tasks. An *individual* develops an artifact and makes it public to the *field* or a socially connected group. These groups are often organized into institutions that practice, control, and standardize tasks related to a particular *domain*, or organized body of knowledge and symbol systems. When the field accepts the artifact as a novelty worthy to use and to perpetuate to future generations of practitioners, creativity has occurred.

Both Vygotsky's and Csikszentmihalyi's models of creativity emphasize the interaction of the social and symbolic dimensions of a task or role. A role is an aggregate of tasks that involves the interaction of a person's interests and skills with the environment's performance standards and relational connections (Biddle, 1986; Passy & Guigini, 2000). The social dimension of a role involves power, institutions, status, and network connections. The symbolic dimension involves psychological tools and mental processes used to accomplish tasks. Most studies and theories involving work roles promote "fit" or "alignment" between the individual and the role (e.g., Gardner, Csikszentmihalyi, &

Damon, 2001), which tends to emphasize standardized job positions and performances.

This emphasis on alignment is similar to the focus on Vygotsky's ZPD as a space for novices to learn the culture's "right way" from experts. This focus privileges cultural and social stability over cultural transformation and progress. Creativity, as a temporary misalignment, tends to be viewed as deviance from a standard, an aberration from the socially agreed-upon meaning. Instead of seeing creativity as a natural aspect of both individual and cultural development, as Vygotsky did (see Moran & John-Steiner, 2003), many thinkers, leaders and educators consider creativity something to be contained and controlled (Moran, 2009b, 2009c). Misalignment is not seen as fruitful but as dangerous. Thus, cultural possibilities are often inhibited.

However, art is one of the few fields where creativity is held as the standard. Creativity is encouraged, sought, and cherished. In addition, art is a particularly useful venue for the complex interplay of the social and the symbolic dimensions of work. Vygotsky (1925;1971) theorized that emotion becomes "social or generalized" through symbolic works of art (p. 243). Subjective sense making and physical materials interact to affect both human feelings and concrete media. This interaction results in collective meaning making, symbolic change and, in some cases, social change. Vygotsky called this process "catharsis."

Catharsis recognizes the usefulness of misalignment. It involves emotional contradiction and conflict that transform the pains or lessons of everyday life into the pleasures of an aesthetic experience. Despite the tragedies and struggles of an artwork's subject matter or content, the person's interaction with the art form makes it possible for these negativities to be transformed and appropriated. Through this catharsis, both the people and the art are different after a creative or aesthetic experience than they were before. Art brings what was formerly only possible into the realm of reality through emotion and imagination. Just as the original meaning of the Greek word catharsis was clarification, art's catharsis brings a "clarification" of meaning that revitalizes the culture.

Commitment: The Lubricant of Social and Symbolic Mediation

> Intention is a type of process of controlling one's own behavior by creating appropriate situations and connections.
>
> L.S. Vygotsky, Self Control

Vygotsky's theory of creativity is complex because it incorporates various levels of dialectics, or interactions among seemingly contradictory or antagonistic entities. There is the dialectic between (1) the individual and the social through the relational aspects of a role, (2) the individual and the symbolic through the cultural aspects of a role, and (3) the individual and the future through the transformative aspects of creativity and art that contribute to a historical progression. Especially with art, externalizations produce aesthetic effects that outlive their original social and symbolic historical contexts to reach new audiences (Lima, 1995).

These dialectics create tension. As Vygotsky insisted, internalization and externalization do not create replicas; the interaction is not perfect. Thus, rarely do the individual's characteristics and environmental affordances "jive" perfectly in the zone of proximal development within a work role (Dawis & Lofquist, 1984). Friction arises and adjustment occurs. The environment contributes to this adjustment through support. The individual contributes to this adjustment through commitment.

Commitment involves how the person invests resources over time into a role. Before an externalization or artifact is put to the field for evaluation, the person must invest emotional, cognitive, social/reputational, material, physical and psychological effort, and time resources at his or her disposal to bring that artifact into being. Commitment is particularly important with creative endeavors, which may not receive much support from the environment because other people do not understand them at first. Individuals aiming to realize new possibilities often have to "run on their own resources" until after the field can judge that the new artifact is worthy.

Once made, commitments serve as biases; they are part of the personal filter of sense making. They organize how a person perceives environmental information and how a person behaves in commitment-relevant contexts. Commitments tend to be self-reinforcing: a person interprets incoming commitment-congruent information more favorably than incongruent information (Janis & Mann, 1977). Thus, commitment involves how a person processes experiences. Vygotsky's theory of creativity is one of the few theories that recognizes experience as key. Thus, it is a particularly fruitful framework for examining commitment.

At its most basic, commitment encompasses two aspects: the resources a person invests (*assets*) and the role dimensions to which he or she commits (*targets*). However, as Vygotsky (1978) emphasized, the person and environment compose each other through development. Similarly, commitments interact with *supports/obstacles* and with *gains/losses*. Supports and obstacles describe the resources (or lack thereof) that the social and cultural environ-

ment invests in the role. Gains and losses measure the additional or diminished resources that the person receives as feedback over time from the process of investing in a particular target.

These three relationships, asset–target, asset–support/obstacle, asset–gain/loss, can be analyzed to understand the structure and focus of a person's work-related commitments. A person contributes to the role through commitment and consumes the benefits of supports and gains that the environment contributes to the role. Commitment usually provides more purpose, more self-direction, than just being at the whim of the environment. By examining commitment, we can better understand how the person *intends* to make a mark on his or her culture and society, not just how he or she responds to environmental stimuli.

Sampling the Literary Field

> ...art...forces us to strive beyond our life toward all that lies beyond it.
> L.S. Vygotsky, *The Psychology of Art*

To make Vygotsky's ideas more concrete, I present findings of a study on writers. Like Vygotsky did in *The Psychology of Art*, I studied literature. My research question was: How are differences in creativity related to the ways writers commit themselves and externalize to the literature domain and culture? That is, are there differences in the commitment patterns of writers who wrote fairly standard works versus those who transformed the literature domain?

My sample comprised 36 20th century American poets and novelists born before 1945 who were interviewed as part of *The Paris Review*'s Writers at Work series (see Moran, 2009d, for methodological details). To conduct my sampling, which used Csikszentmihalyi's notion of field gatekeepers to distinguish writers based on their creative impact on the literature domain, I reconstructed the aggregated meaning-making process of the American literary field during the early and middle 20th century. That is, to determine what Vygotsky would call the socially agreed-upon meaning of a writer's body of literary work in the context of other writers' works, I surveyed critics' assessments, award citations, college and high school English syllabi, and current literature professors using a web survey.

These field mechanisms separated writers into genre conformers, experimentalists, and domain transformers. Genre conformers were successful and garnered a reader following, but their work was often viewed as formulaic. Experimentalists' work tried new approaches that were not widely adopted by others (at the time the interviews were conducted), although they may have

spawned subgroups (e.g., the beatniks or postmodernists). Domain transformers' work was recognized for opening new opportunities for others. These three groups displayed different prototypical patterns of commitments. Twelve writers were selected in each creativity status for analysis of their interviews. My sample consisted of:

Genre Conformers

- Louis Auchincloss, lawyer and writer of "novels of manners" of the New York City upper class.

- Hortense Calisher, fiction writer whose multicultural family and parents born 22 years apart contributed to her reputation as a "luminous language" literary artist of wide range.

- Joan Didion, shy yet enduring and bestselling novelist and essayist, known for her portrayals of "vacant" heroines, such as in the popular *Run River*.

- William Goyen, reclusive Texan novelist whose works focusing on struggling against alienation, such as *House of Breath*, did not sell well nor find wide critical acclaim.

- Donald Hall, former *Paris Review* poetry editor and poet who seems famed as much for whom he interviewed (e.g., T.S. Eliot and Ezra Pound) and his literary criticism as for his own prolific production of formal and impressionistic poems.

- Carolyn Kizer, feminist poet associated with the Pacific Northwest school of Ted Roethke who also dabbled in public service at the State Department and National Endowment for the Arts.

- James Laughlin, publisher of the influential *New Directions*, the distinguished literary magazine that launched many foreign writers' American careers, who focused on his own poetry only later in life.

- Archibald MacLeish, Lost Generation poet and playwright whose move into public service made him an outsider of the literary field, despite his *Collected Poems* winning numerous awards.

- Walker Percy, medically trained philosopher and Southern novelist who depicted the "malaise" of the modern world, such as in his best-known novel, *The Moviegoer*, which won the National Book Award.

- William Stafford, Northwest poet more known for leading writing workshops, although he won numerous smaller awards and became Poet Laureate of Oregon.

- William Styron, popular Southern novelist whose works examining various forms of incarceration, such as *Sophie's Choice* and *The Confessions of Nat Turner*, made the bestseller lists and have been turned into movies or spawned popular controversy.

- John Edgar Wideman, African–American novelist known for spanning the black working class and the upper class of white academia in his novels, such as *Homewood Trilogy*.

Experimentalists

- Maya Angelou, poet and autobiographer most famous for *I Know Why the Caged Bird Sings* about rejuvenation following personal traumas.

- John Barth, postmodern novelist of philosophical, satirical, humorous works widely acclaimed by the literary establishment and influential on other literary innovators, but also criticized as being difficult.

- Donald Barthelme, experimental short story writer and novelist considered the "archetypal postmodernist" for his ironic, precise, yet oblique "verbal objects."

- William Burroughs, Beat Generation novelist whose experimental portrayals of drugs, homosexuality, and police persecution in *Junky* and *The Naked Lunch* earned him a cult following.

- Raymond Carver, short story writer known for depicting ordinariness, the working class, and downtrodden themes based on his real life as an alcoholic and struggling working man.

- John Dos Passos, realistic novelist associated with the Lost Generation expatriates of Paris and known for integrating cinematic techniques into his *U.S.A. Trilogy* and other novels.

- William Gaddis, novelist of complex commentaries regarding spiritual bankruptcy, such as *The Recognitions* and *JR*, who is credited with launching postmodernism.

- William Gass, philosophy professor and novelist whose novels, such as *The Tunnel*, and essays on language and literature have attracted critical controversy for their complexity of style and metafictional quality.

- Jack Kerouac, stream-of-consciousness novelist who coined the term "Beat Generation."

- James Merrill, lyric poet whose most famous works were supposedly based on communications with spirits using a ouija board.

- Henry Miller, bohemian novelist known primarily for his sexually explicit autobiographical novels of the 1920s and 1930s, which were banned from publication in the United States until the 1960s.

- Marianne Moore, eclectic poet and editor of *The Dial* magazine, who initially was considered peripheral but has become considered central to the early 20th-century modernist movement.

Domain Transformers

- John Ashbery, modernist poet whose talents were recognized early in his career, eventually winning numerous awards for his works' noted musical and ambiguous qualities.

- Elizabeth Bishop, modernist poet known for her brilliance with form and description who was revered by her contemporaries despite her small body of work.

- T.S. Eliot, poet, playwright, and literary critic whose poem, *The Waste Land,* is considered the pinnacle of modernism and whose influence on the literary canon earned him the Nobel Prize in 1948.

- Ralph Ellison, African–American novelist whose one book published in his lifetime, *Invisible Man,* influenced communities of various races as well as the literary community through its psychologically realistic portrayal of an ambiguous protagonist reaching for self-discovery.

- William Faulkner, novelist and short-story writer considered a great innovator of narrative technique, who won the Nobel Prize in 1949, and whose works are some of the most widely read on high school and college syllabi in America.

- Robert Frost, poet who achieved both popularity and critical acclaim in his lifetime through his accessible yet richly meaningful blank verse poems such as "The Road Not Taken".

- Allen Ginsberg, whose confessional epic poems, *Howl* and *Kaddish,* became the anthem of alienation for the Beat Generation and were influential within the youth counterculture since the 1960s.

- Ernest Hemingway, novelist and short-story writer whose influence on later generations of writers is unparalleled because of his clear, straightforward style. He received the Nobel Prize in 1954.

- Robert Lowell, poet born to a literati family, whose confessional poems influenced later generations of poets to write more autobiographically and earned him the Bollingen Prize.

- Toni Morrison, African–American novelist noted for her depiction of and reflection on the experiences of African–Americans and women, who in 1993 became the first African–American and the second woman to win the Nobel Prize.

- Ezra Pound, modernist poet and critic who helped edit and promote the top writers of the early 20th century, and whose masterpiece, *The Cantos,*

which interweaves personal and historical narrative with lyric poetry, continues to be discussed and debated in colleges.

- Philip Roth, novelist known for his satirical depiction of sexuality and Jewish middle class family life. His wide range and willingness to experiment have earned him continued popular success and critical acclaim since the 1960s.

Commitments among Writers

Genre Conformers

> ...what a great part belongs to the collective creative work of unknown inventors.
> L.S. Vygotsky, "Imagination and Creativity in Childhood"

Genre conformers represented the traditional Vygotskian expert-novice interaction in the zone of proximal development. They mostly represent how the culture is internalized. Staying in sync with others and with socially agreed-upon meaning was very important to them. As poet Archibald MacLeish explained: "What you really have to know is one: yourself. And the only way you can know that one is in the mirror of the others." Similarly, novelist Hortense Calisher emphasized the interaction of individuals over time in the composition of identity and creative work: "The family history, all the places we came from. The generation gaps. The enormous diversity of my home town—New York. I come from the admixture we set ourselves up to be." The writer's persona and purpose were composed through interaction with others.

The genre conformers were master internalizers. The dominant literary culture decided which symbolic media and tools would be rewarded. Genre conformers were sensitive to such rewards. They invested their resources attending schools and workshops to learn the proper techniques, honing their craft, gaining confidence through feedback from others, and enticing others to help them so they could satisfy the expectations set by teachers, editors, critics, and others in power. They aimed to be accurate and be part of the wider community of writers. As writers, they contributed literary works that were well-accepted and successful, but these works, according to literary gatekeepers, added little new to the culture. The gain for their commitment was higher standing within the literary community, the field.

Genre conformers' emotional tenor was one of contentment. They wanted their lives to stay on an "even keel" with their social-cultural environment over time. As a result, their commitments focused on compensation.

They committed when they knew they would be compensated with money or prestige. They compensated among competing commitment demands among work projects—such as writing and editing or between work and family or personal obligations. And they compensated with effort for a perceived lack of talent, preparation, or pedigree. They were often in awe of literary "greats" who came before them, trying hard to live up to these prior writers' standards and expectations rather than focusing on their own idiosyncratic understandings.

Novelist Louis Auchincloss, a lawyer/writer most well known for the novel, *Rector of Justin*, epitomized the genre conformer. He did not stray far from his wealthy roots in New York. He wrote based on detailed outlines, almost like legal briefs, that realistically chronicled the relationships of New York's upper class and legal profession: "In a lot of my books I take great events in my own lifetime that I've been in a position to view fairly closely...I wanted to get the facts exactly right."

Auchincloss was sensitive to criticism and sales, which affected his perceived standing in the literary community. He was so devastated when a publisher rejected his first novel, written in college, that he quit Yale and went to the University of Virginia Law School. When his book fictionalizing Groton Academy caused problems with the institution, it was important to Auchincloss that things were set aright. He tended not to argue with, but rather accept, judgments others made of his work: "Plot is very important to the kind of novel that I write. I've sometimes overdone it. I'll never forget [critic] Elizabeth Janeway saying a lot of plot 'rumbles around.'" The literary field passed him by on major awards despite nominations for both the Pulitzer Prize and the National Book Award.

Experimentalists

> It is for oneself, in the mind, that poems and novels are produced, dramas and tragedies are acted out, and elegies and sonnets are composed.
> L.S. Vygotsky, "Imagination and Creativity in the Adolescent"

Experimentalists represented the traditional Vygotskian ZPD interaction gone awry. Most of the experimentalists' works were only moderately accepted by the literary field or garnered a "splash" in a small subgroup. Examples include the Beatniks' depictions of drug culture, or postmodernist novelists' portrayals of fragmented minds, or protest poetry, or self-absorbed autobiographical fiction.

They did not want to internalize the culture but rather emphasized their own subjectivity. Their idiosyncratic sense took precedence over the socially agreed-upon meaning of the phenomena. The experimentalists were master externalizers. They saw *themselves* as primary and dominant and wanted to assert themselves directly into the culture through symbolic means. They resisted the conventional teachings. Novelist Henry Miller quipped: "It was a deliberate conscious effort to turn the tables upside down, to show the absolute insanity of our present-day life, the worthlessness of all our values....Whenever a taboo is broken, something good happens, something vitalizing." Experimentalists did not want to become part of some larger external entity but rather to enlarge their selves.

Their emotional tenor was one of anger. Novelist Donald Barthelme described: "Cursing what is is a splendid ground for a writer....I believe that my every sentence trembles with morality in that each attempts to engage the problematic rather than to present a proposition to which all reasonable men must agree." Experimentalists defied. Their commitments functioned to resist established ways. They resisted authorities whom they believed constrained their self-exploration. Experimentalists twisted traditions to yield personal meanings through pastiche, satire, metaphor, and abstraction.

The dominant society in charge of the culture, in turn, tended to resist their symbolic creations. Commitment functioned as a protective device from perceived obstacles and as a "backup battery" to provide resources that were not forthcoming as supports from the environment. Because the literary field's gatekeepers often were antagonistic to experimentalists' "deviant" perspectives, experimentalists tended to receive little environmental support. Their own investments sustained their efforts to gain reader allies, courage, and control. Their commitment's gain was self-perceived authenticity.

Novelist William Gass typifies the experimentalist. He conveyed this position-at-odds-with-society not only through what he said, but how he said it. For example, he interjected socially objectionable words throughout the interview in defiance of propriety. He did not want retribution, but rather "to rise so high that when I shit I won't miss anybody." His work was not rejected, but he could not even get "a colorful fart" published.

Strong negative emotion drove him: "I write because I hate. A lot. Hard. And if someone asks me the inevitable next dumb question, 'Why do you write the way you do?' I must answer that I wish to make my hatred acceptable because my hatred is much of me, if not the best part." His interest was not to communicate with or persuade other people, but rather to "write sentences out of context." Gass fumed against writers who produced easy-to-read works that "stand to literature as fast-food to food."

Gass was alienated primarily by his own choosing: "I simply rejected my background entirely....I just had to make myself anew—or rather, *seem* to." This rejection motivated him to write for the purpose: "To cancel the consequences of the past." His writing provided a venue for him to become a self that was not trapped by connections.

Domain Transformers

> Every inventor, even a genius, is always the outgrowth of his time and environment. His creativity stems from those needs that were created before him, and rests upon those possibilities that, again, exist outside him.
> L.S. Vygotsky, "Imagination and Creativity in Childhood"

Those writers whom the literary field attributed the highest creativity, the domain transformers, talked about their commitments with the strongest sense of affecting others emotionally. Through their works, they aimed to surprise the reader and change the reader's mind to a *wider* emotional experience and *broadened* culture beyond the current norm or standard.

This drive to change minds corresponds to what Vygotsky (1925;1971) said was the "combination of aesthetic symbols aimed at arousing emotion in people...to organize future behavior" (p. 253). Domain transformers wanted to change the future outlook and options of those readers who would emotionally involve themselves with the writers' works. Novelist Ralph Ellison conveyed: "I feel that with my decision to devote myself to the novel I took on one of the responsibilities inherited by those who practice the craft in the U.S....the possibility of contributing not only to the growth of the literature but to the shaping of the culture as I should like it to be."

Domain transformers invested mostly in the domain. The domain comprises the symbols themselves, such as the ideas, knowledge, and values related to the literary work process. Their commitments were made to share and perpetuate some beloved aspect of literature with new minds. They fell in love with rhythm, grammar, form, meaning, characters, or imagery. They questioned and made associations until their beloved aspect of literature, the symbolic work itself, put forth an idea or image catalyst to gather momentum in the work and provide some cognitive scaffolding for these writers to continue (see also Bruner, 1962). Their gain was making their ideas, stories, and symbols understandable and moving to readers.

Domain transformers' emotional tenor was passion. Their statements seemed most in line with Vygotsky's theory of art as catharsis, of the interplay of conflicting emotions toward an unexpected but satisfying end. Domain transformers were impassioned, both in terms of admiration and suffering, for

their beloved aspect of literature. They idealized some aspect of literature and saw themselves as serving it. By connecting this beloved to new minds, helping other people come to adore it, domain transformers created additional momentum for the domain to gain influence within the wider culture. Yet, they tended to struggle with realizing the possibilities they saw in the domain, suffering about whether their work lived up to their visionary expectations. Thus, even within themselves and the creation of the literary artwork, these writers exemplified catharsis.

Domain transformers also highlighted how important the symbolic dimension of art is. They often did not feel that the symbolic was socially mediated. Rather, the symbolic was mediated through *them* to become social. They, as writers, were the medium through which important emotions and ideas could be shared intersubjectively. In his 1949 Nobel Prize speech, William Faulkner explained the writer's role: "It is his privilege to help man endure by lifting his heart, by reminding him of the courage and honor and hope and pride and compassion and pity and sacrifice which have been the glory of his past." Thus, domain transformers best realized how roles or ZPDs represent the interplay of two minds-in-action. The social is not an abstract aggregation; rather, it is the dynamic between two or more individuals trying to create and share meaning.

Faulkner exemplifies the domain transformer's emphasis: "The writer's only responsibility is to his art." He believed that the writer "has a dream. It anguishes him so much he must get rid of it. He has no peace until then." Faulkner was at the mercy of where the writing wanted to take him: "*The Sound and the Fury*. I wrote it five separate times, trying to tell the story, to rid myself of the dream which would continue to anguish me until I did."

He did not assume the standard social position of writer that the literary field put forth. "I am not a literary man but only a writer," Faulkner claimed. His relationship was to the act of writing. He did not focus on field members or mechanisms because such attention took away precious time from writing: "The artist doesn't have time to listen to the critics. The ones who want to be writers read the reviews, the ones who want to write don't have the time to read reviews....The artist is of no importance. Only what he creates is important." The scaffold he needed and used was not others' standards, nor his own subjective preferences, but rather the developing needs and possibilities of the story and the characters. He was not alone while writing, "[b]ecause with me there is always a point in the book where the characters themselves rise up and take charge and finish the job—say somewhere about page 275. Of course I don't know what would happen if I finished the book on page 274."

Conclusion

> Creativity exists not only where it creates great historical works, but also everywhere human imagination combines, changes, and creates anything new.
> L.S. Vygotsky, "Imagination and Creativity in Childhood"

"I was a fierce advocate of the contemporary, with huge dislikes and admirations, and I wanted to impose my taste. That's why I did the *Advocate* at Harvard, why I did *The Paris Review*, why I did anthologies," genre conformer poet Donald Hall shared. "When I was young, critics helped teach me to read poems."

"All of my work is directed against those who are bent, through stupidity or design, on blowing up the planet or rendering it uninhabitable," experimentalist novelist William S. Burroughs countered.

"I don't think good poetry can be produced in a kind of political attempt to overthrow some existing form," domain transforming poet T.S. Eliot suggested. "I think it just supersedes. People find a way in which they can say something....Obviously you wouldn't be satisfied if the poem didn't mean something to other people afterward."

This conversation among these three writers never actually occurred. But the juxtaposition of their statements shows the differences in their commitments. Their comments hint at how they kept themselves motivated and guided their work. To summarize the results of the writers' commitments in Vygotskian terms, the genre conformers were master internalizers. They emphasized the appropriateness aspect of creativity. The dominant culture decided which symbolic media and tools to support, and these media and tools were taught to persons through institutionalized social means. A person could contribute symbolic media or tools, but they probably did not add significant novelty to the culture.

As a genre conformer, Hall was successful, made a name for himself, and earned a following among readers or the literati, but his work has not generated a change in poetry. A genre conformer stays within the bounds of current conventions, helping to solidify the power of the current state of the genre. In the statements above, Hall's focus is on garnering support from other writers or critics to stay in line with and maintain the contemporary norms and expectations of the literary field.

The experimentalists were master externalizers. They emphasized the novelty aspect of creativity with little care for appropriateness. They saw themselves as primary and dominant, and wanted to assert themselves directly into the culture through symbolic means, without intervention from the social

field. They resisted the social teachings of the field experts, and the dominant society in charge of the culture tended to resist their symbolic creations.

As an experimentalist, Burroughs eschewed current conventions, preferred to go off on his own tangents and techniques, and often aimed to use those new techniques to undermine literati, politicians, or others in power. An experimentalist aims for self-expression, often against the establishment. In the statements above, Burroughs' focus is on self-protection and fighting current ideas.

The domain transformers integrated internalization and externalization. They combined novelty and appropriateness. They saw themselves in service to the culture through symbolic media. Thus, the symbolic dimension of the role dominated the social dimension, but domain transformers did not lose sight of the social dimension. They valued their audience, whose minds were needed to perpetuate their beloved domain. They did not resist or antagonize institutionalized social means, but they did not limit themselves to those pathways either. They felt they had a direct relationship with the symbolic tools to help others make meaning.

As a domain transformer, Eliot used and developed techniques, subject matter, forms, genres, and other aspects of the literature domain in such a way that readers and other writers could relate to and appropriate the novelty. Through this influence, the domain transformer's work changes what is acceptable to be included in the domain. The work expands or deepens what literature entails. In the statements above, Eliot's focus is on the English language, what it can do, and how to communicate with the reader.

Two implications arise from this study. First, creativity is not "lone genius" born of isolation or disengagement. As Vygotsky said a century ago, creativity is symbolically mediated engagement with other minds. If there were no social networks through which ideas could be shared, culture would die. If there were no symbolic media through which individuals' externalizations arise, society would be silent and inert. We need both the social and the symbolic, as individuals and as social-cultural groups, to stabilize, perpetuate, and elaborate our ways of life.

Second, commitment focuses on how people are not consumers or pawns in society or culture; they *contribute*, often purposefully. Differences in externalizations support and/or antagonize cultural stability and progress. That is what Vygotsky (1925;1971) was referring to when he talked about contradictions in art, juxtaposing "order and harmony" with the "explosive." A work of art is "a combination of aesthetic symbols aimed at arousing emotion in people" (p. 5). Art is a process of transformation. Culture is not staid; it also develops. Art "introduces the effects of passion, violates inner equilibrium,

changes will in a new sense, and stirs feelings, emotions, passions and vices without which society would remain in an inert and motionless state" (p. 249). Without such movement, momentum, and perhaps volatility within the symbolic dimension of culture, civilization would stagnate. With and through art, we stay connected in communities of both realized and possible meanings.

> Development never ends its creative work.
>
> L.S. Vygotsky, "The Problem of Age"

References

Amabile, T. (1996). *Creativity in context: Update to the social psychology of creativity.* Boulder, CO: Westview Press.

Biddle, B. J. (1986). Recent developments in role theory. *Annual Review of Sociology, 12,* 67–92.

Bruner, J. S. (1962). The conditions of creativity. In J. S. Bruner (Ed.), *On knowing: Essays for the left hand.* (pp. 17–30). Cambridge, MA: Harvard University Press.

Csikszentmihalyi, M. (1988). Society, culture, and person: A systems view of creativity. In R. J. Sternberg (Ed.), *The nature of creativity* (pp. 325–339). New York: Cambridge University Press.

Dawis, R. V., & Lofquist, L. H. (1984). *A psychological theory of work adjustment.* Minneapolis: University of Minnesota Press.

Feldman, D. H. (1994). *Beyond universals in cognitive development* (2nd ed.). Norwood, NJ: Ablex.

Gardner, H., Csikszentmihalyi, M., & Damon, W. (2001). *Good work: When excellence and ethics meet.* New York: Basic Books.

Janis, I. L., & Mann, L. (1977). *Decision making: A psychological analysis of conflict, choice, and commitment.* New York: Free Press.

Lima, M. G. (1995). From aesthetics to psychology: Notes on Vygotsky's "Psychology of Art." *Anthropology & Education Quarterly, 26*(4), 410–424.

Moran, S. (2008). Creativity: A systems perspective. In T. Richards, M. A. Runco, & S. Moger (Eds.), *The Routledge companion to creativity* (pp. 292–301). London: Routledge.

Moran, S. (2010, in press). Creativity in school. In K. S. Littleton, C. Wood, & J. K. Staarman (Eds.), *Elsevier handbook of educational psychology: New perspectives on learning and teaching.* Oxford, UK: Elsevier. Moran, S. (2009a). Metaphor foundations in creativity research: Boundary vs. organism. *Journal of Creative Behavior, 43*(1), 1–22.

Moran, S. (2009b). What role does commitment play among writers with different levels of creativity? *Creativity Research Journal, 21*(2/3), 243–257.

Moran, S., & John-Steiner, V. (2003). Creativity in the making. In R. K. Sawyer, V. John-Steiner, S. Moran, R. J. Sternberg, D. H. Feldman, J. Nakamura, et al. (Eds.), *Creativity and development* (1st ed., pp. 61–90). New York: Oxford University Press.

Passy, F., & Guigini, M. (2000). Life-spheres, networks, and sustained participation in social movements: A phenomenological approach to political commitment. *Sociological Forum, 15*(1), 117–144.

Smolucha, F. (1992). A reconstruction of Vygotsky's theory of creativity. *Creativity Research Journal, 5*(1), 49–67.

Smolucha, L. W., & Smolucha, F. C. (1986). L.S. Vygotsky's theory of creative imagination. *SPIEL*, 5, 299–308.

Stacey, R. D. (1996). *Complexity and creativity in organizations.* San Francisco: Berrett-Koehler.

Vygotsky, L. S. (1925/1971). *The psychology of art.* Cambridge, MA: MIT Press.

Vygotsky, L. S. (1978). *Mind in society: The development of higher psychological processes.* Cambridge, MA: Harvard University Press.

Vygotsky, L. S. (1994). The problem of the environment. In R. van der Veer & J. Valsiner (Eds.), *The Vygotsky reader* (pp. 338–354). Oxford, UK: Blackwell.

Vygotsky, L. S. (1997). Consciousness as a problem for the psychology of behavior (M. J. Hall, Trans.). *The collected works of L. S. Vygotsky* (Vol. 3, pp. 63–80). New York: Plenum Press.

Vygotsky, L. S. (1997). Self control (M. J. Hall, Trans.). In R. W. Rieber & J. Wollock (Eds.), *The collected works of L. S. Vygotsky* (Vol. 4, pp. 207–219). New York: Plenum Press.

Vygotsky, L. S. (1998a). Imagination and creativity in the adolescent (M. J. Hall, Trans.). In R. W. Rieber & J. Wollock (Eds.), *The collected works of L. S. Vygotsky* (Vol. 5, pp. 151–166). New York: Plenum Press.

Vygotsky, L. S. (1998b). Imagination and creativity in childhood. *Soviet Psychology, 28*(10), 84–96.

Vygotsky, L. S. (1998c). The problem of age (M. J. Hall, Trans.). In R. W. Rieber & J. Wollock (Eds.), *The collected works of L. S. Vygotsky* (Vol. 5, pp. 187–205). New York: Plenum Press.

Vygotsky, L. S. (1999). On the problem of the psychology of the actor's creative work (M. J. Hall, Trans.). In R. W. Rieber & J. Wollock (Eds.), *The collected works of L. S. Vygotsky* (Vol. 6, pp. 237–244). New York: Kluwer Academic/Plenum Press.

Vygotsky, L. S. (1999). Tool and sign in the development of the child. (M.J. Hall, Trans.). In R. W. Rieber (Ed.), *The collected works of L. S. Vygotsky* (Vol. 6, pp. 3–68). New York: Kluwer Academic/ Plenum Press.

Acknowledgments

Dr. Moran acknowledges the original writing study presented in this chapter was funded in part by the American Association of University Women, the Spencer Foundation, and the Harvard Graduate School of Education. She also expresses her thanks to *The Paris Review* and to all of the writers for sharing their thoughts and feelings publicly.

Part Three

Connections Between Creative Expression, Learning, and Development

A Synthetic-Analytic Method for the Study of Perezhivanie:

Vygotsky's Literary Analysis Applied to Playworlds

Beth Ferholt

Few understand why it is imperative not only to have the effect of art take shape and excite the reader or spectator but also to explain art, *and to explain it in such a way that the explanation does not kill the emotion* (Vygotsky, 1971, p. 254).

The students' discussion about their play has been difficult and long. The floor is littered with the bodies of the younger children, heads in arms, picking at noses and shoelaces. But one child named Pearl[1] sits on a table and speaks with great eloquence; she tells us, "Everyone in this class is my best friend."

As if they have been physically lifted by Pearl's words, several of the children on the other side of the argument and the room, children who have not budged all afternoon, simply stand up and walk over to Pearl's side of the room. The most outspoken advocate for the opposing camp, Nancy, crosses the room and sits down right next to Pearl, and then rests her head on Pearl's knee. Another child from the opposite side of the room, Alice, finds a way to satisfy the demands of the children on each side of the room and her unexpected solution is greeted by children on both sides of the room with huge smiles and exclamations of, "Oh!"

In celebration the children's teacher, Michael, takes the class outside for a run in the field. One child, Rachel, says as she runs, "I feel like I'm flying." Pearl looks up at the sky as she runs and says, "I look up and I go faster." Andrea, Pearl's younger sister, runs backwards and asks, "Why am I walking backwards?" She answers herself, "I don't have to look. I know where I'm going." Michael and I still look at each other in amazement when we watch the

film of this event together. How did Rachel, Pearl, and Andrea know then, what it took us three years to understand about *both* perezhivanie and our own means of representing this perezhivanie for analysis?

Introduction

In this chapter, I argue that the elusive phenomenon of *perezhivanie* (or "intensely-emotional-lived-through-experience") can be made available for analysis in its full, dynamic complexity in part through the use of synthetic-analytic methods of representation that themselves evoke and manifest perezhivanie. I describe an application of Vygotsky's method of analysis of literary works to play that makes perezhivanie an empirically researchable phenomenon. I focus on one example of this application in which a team of researchers, including the author, made maximum use of our roles as participant-observers by enhancing our own and others' emotional re-engagement in adult-child joint play using the art form of film and play. My claim is that this process did not show us perezhivanie that was less 'real' than the perezhivanie we had experienced firsthand but instead revealed qualities of the perezhivanie we had experienced that we could not see without our "*film-play*"[2].

This method derived directly from the unique form of play we were studying, in which children and adults combined their respective modes of creative imagining: play and art. This method of film-play merged with several stages of our research including the design of the project, collection and analysis of data, and presentation of findings. Concretely, through joint scripted and improvisational acting, costume and set design, and multi-modal rehearsal and reflection, adults and children together brought a work of literature to life (Lindqvist, 1995, p. 72), transforming a classroom into a world inspired by a book. Adult play through film then allowed the creativity of play to be "captured alive," so that we could better study the impact of such vivid experiences on development.

In this chapter, I will first describe this unique form of play: *playworlds* (Lindqvist, 1995). I will then describe our new method for the study of perezivanie: film-play. I will focus on a particular episode in a study of playworlds that demonstrates the usefulness of this method and conclude with a discussion of this method.

Playworlds

The ideal of modern Western childhood with its emphasis on the innocence and malleability of children (Aries, 1962; Fass, 2007) has combined with various social conditions to promote adults' direction of children's play toward adult-determined developmental goals and adults' protection of children's play from adult interference. However, new forms of play in which adults actively enter into the fantasy play of young children as a means of promoting the development and quality of life of both adults and children, have recently emerged in several countries. This new form of activity, called playworlds, holds special potential for making complex dynamic relations between such key psychological processes as cognition, emotion, imagination, and creativity visible, and hence available for research (Ferholt, 2009). According to some researchers who study playworlds, it appears playworlds also promote the development of these processes in child and adult participants (personal communication with Marjanovic-Shane, Nilsson, Rainio, and Miyazaki on May 22, 2009).

In playworlds, adults and children enter and exit a common fantasy together. They do this through a combination of adult forms of creative imagining, which require extensive experience, and children's forms of creative imagining, which require embodiment of ideas in the material world or "a pivot" (Vygotsky, 1978) through a combination of the disciplines of art and science, and play. Playworlds promote the development and quality of life of both children and adults by creating the possibility for children to strongly encourage adults to participate with children in play at the same time as these adults are engaged in the more familiar project of strongly encouraging children to participate in art and science.

Playworlds are now taking place in Japan, Sweden, Finland, Serbia and the United States[3]. As one would expect, playworlds differ greatly across these five countries. A folk tale or classic work of children's literature is often used as a key organizing artifact in playworlds, and dramatic enactments are often the central adult-child joint activities. This practice characterizes playworlds in the United States, which are primarily inspired by Gunilla Lindqvist's (1995) founding work on playworlds and by Pentti Hakkarainen's (2004) work on narrative Learning, but is not universal.

Playworlds take place in and out of schools. Adult participants include teachers, teachers in training, researchers, and/or professional visual artists, actors, and musicians. Child participants range in age from two through adolescence. Furthermore, while in some playworlds neither traumas nor hardships of participants are particularly apparent, in other playworlds, participants

incorporate their experiences of large-scale trauma such as war. In other play-worlds, participants incorporate their experience of hardships related to race, ethnicity, religion, sexuality, gender or disability.

In the United States, four playworlds have been staged over the past six years. One of these playworlds took place at a private preschool and the other three were located in public elementary schools on a military base. While re-searcher participation is rare in playworlds outside of Serbia and the U.S., a strong emphasis of U.S. playworlds is teacher involvement and teacher devel-opment. An important tool for promoting this involvement and development has been the cultivation of researcher-teacher collaboration through the inclu-sion of researchers and teachers in playworld implementation and teachers as well as researchers in playworld analysis.

Film-Play

Although we know that playworlds can make visible complex dynamic rela-tions between such key psychological processes as cognition, emotion, imagi-nation, and creativity (Ferholt, 2009), the question of how to make these relations the subject of empirical investigation (i.e., how to observe them for analysis) remains. This challenge can be understood using the metaphor of a golem. A golem is a clay giant that is brought to life by inserting a piece of written text into its mouth. When it is turned back into clay, when its soul is taken from it, it becomes not only inert but also weightless. We can accept that "we murder to dissect," but when we murder a phenomenon such as perezhivanie, we may find that we have created not a corpse for study but, in-stead, an emptiness. One response to this methodological dilemma is film-play: a form of adult-adult interaction that incorporates the playful creation and appreciation of ethnographic films that are both social-scientific docu-ments and also works of filmic art.

In *The Psychology of Art* (1925;1971) Vygotsky describes a simultaneously classical and romantic process of analysis[4] that allows one to "witness how a lifeless construction is transformed into a living organism" (1971, p. 150). Vy-gotsky writes of this process of analysis: "It is useful to distinguish (as many authors do) the static scheme of the construction of the narrative, which we may call its anatomy, from the dynamic scheme, which we may call its physiol-ogy" (1971, p. 149–150). Vygotsky argues that it is only anatomy, components visible after murder and dissection, that the structure of the material or the poetic technique, taken on their own, can reveal. The process of analysis that Vygotsky proposes makes physiology available for study by juxtaposing material

and poetry and then asking the function of the technique in relation to a whole.

A limitation of conventional social science methods is that they often make the anatomy but not the physiology of a subject available for study. However, it is only possible to increase our understanding of several phenomena that playworlds make visible when the physiology of a playworld is made available for study. As Vygotsky prescribes the juxtaposition of material and poetry to reveal the melody of a short story, in the episode of a playworld study that is the focus of this paper, we juxtaposed the material of a playworld with poetic representations of this playworld to make perezhivanie visible for analysis. These poetic representations included films, drawings, paintings, collages, and mapped representations of the playworld that were created by child and adult participants. These poetic representations also included various songs, films, photographs, and books that adult participants perceived to be representations of this playworld even though these works of art were written, performed, and published long before the playworld was created. We combined these methods with more traditional approaches, which I will mention as I provide a brief description of this playworld study, before focusing on one specific episode of this study.

A Playworld Study

Site and Participants

In this playworld, the class we worked with was a kindergarten and first grade classroom located within a public elementary school on a military base in the United States. The participants included the 20 students of the class (12 kindergarteners and eight first graders), their teacher, myself, and three other researchers. The book the playworld was based on was C. S. Lewis's *The Lion, the Witch, and the Wardrobe* (1950).

Implementation of the Playworld

Over the single academic year during which the playworld took place, the first half of the novel was read aloud to the children. The second half of the novel was never read to the children. Instead, the children became more and more active participants in the acting of the story, until they collectively wrote and directed their own resolution to the novel's central conflicts. Playworld sessions occurred weekly, lasted approximately two hours, and included reflection

upon the enactments in the form of discussion and then free play or art activities.

Most of these sessions included all four researchers, who played the child heroes of the playworld. The teacher joined halfway through the sessions, playing the evil White Witch, and the children joined during the sessions following the arrival of the White Witch acting as themselves. For the final session, the children were the primary planners of the adult-child joint play.

All of these playworld sessions involved set pieces and props created by both the adults and children, including some props that were designed to appeal to the participants' senses of touch, smell, and sound. By the time half of these sessions were completed, the teacher, who had been moving the set pieces to the side of the classroom at the end of each playworld session, began to leave the set pieces in place throughout the week. The classroom was filled with large, colorful structures, and the teacher conducted all of his classroom activities in and around a cardboard dam, cave, castle, etc.

After the final session of adult-child joint acting, the children decided to present a play of the playworld to their families. This initiated a series of child-conceived sessions which were unanticipated by the adults. Their teacher, with some input from one of the researchers, helped the children design, direct, and rehearse this play. The time the class spent on this process continued to grow until it was taking whole days and crowding out other scheduled activities. The children presented the play to their parents in the final week of the school year. After the school year was complete, the adults continued the playworld through many different forms of playful analysis, including adult-adult interaction that incorporated filming, drawing, and painting.

Ethnographic Data

We recorded all classroom activities related to the playworld project as well as adult rehearsals, adult planning meetings, and individual interviews with adult and child participants. In addition to collecting written or recorded field notes from all the adult participants and the many e-mail correspondences among adult participants, we recorded audio and audio-video footage with high quality equipment using two or more cameras at a time and often took still digital photographs. At times, the children also videotaped the proceedings. On two occasions, professional filmmakers videotaped the proceedings, and both child and adult cinematographers were encouraged to avoid using the traditional stationary tripod and wide-angle lens.

Data Analysis

Data analysis (Baumer et al., 2005; Ferholt, 2009) has included two types of analysis: analysis of discourse and communicative exchanges using transcriptions from the video and audio recordings and the juxtaposition of the material of a playworld with poetic representations of this playworld. As I will explain through a description and discussion of the creation and effects of one of our "poetic" films, these second methods of analysis have merged with the design of the research project, collection and analysis of the data, and presentation of the findings. Furthermore, in so far as collaboration with the teacher included ongoing researcher-teacher joint analysis in a form that mimics the playworld, the playworld itself can be described as still in progress through this second method of analysis.

While engaged in this second type of analysis, we did not randomly select children's artwork to analyze but chose drawings, paintings, and maps that allowed us to re-experience moments in the playworld that were particularly emotionally charged. We did the same with our audio and video footage and our still photographs and also viewed or listened to our "favorite" audio or video clips, photographs or artwork, those works that brought us the most pleasure in multiple sessions both individually and jointly. We sought art about the playworld that captured the quality of its emotional intensity from our individual perspectives, drawing on a variety of sources outside the playworld. We shared these representations with each other throughout the year of the playworld project and during data analysis. These representations included songs, films, photographs, and audio-visual collages that made us "re-feel" the playworld from a different perspective. And we reread favorite novels and children's picture books that reminded us, in the emotions they aroused as well as in their form and content, of the playworld.

The method of this type that took the most time, and was arguably most successful, involved manipulating our video footage to create ethnographic films of the playworld that were not necessarily polished for an outside audience but used filmic techniques to synthesize the events that they depicted. Some of these films were created not only for the purpose of guiding our analysis but also for a variety of audiences including the child participants, an outside audience of amateur artists, and professional scholars. Several of these films, in the form of short, experimental segment tapes, were re-edited many times to serve these different audiences.

With these ethnographic films, we attempted to enhance our own and others' emotional re-engagement in the playworld using a specific technique we had learned from our play with children. In children's play, the imaginary

is often intertwined with the real through investing inanimate objects with an emotional life and with agency. We also invested our video footage with an emotional life and agency by freeing our footage from the category of "data" and by pushing it to become "film," thus imparting to our footage that quality of film Vivian Sobchack calls "lived momentum" (1992, 2004).

This particular method, therefore, constitutes a critique of conventional social science, in which the explicit goal is to see that which one studies objectively ("without being influenced by personal feelings or opinions; in an impartial or detached manner," *Oxford English Dictionary*, 2007). This method also constitutes an argument that filmic representation can be a form of play and that this "film-play" can be of use to scholars. This claim allows for the use of ethnographic film not only as a means of documentation but also as an object of study. In this way this claim contributes to a discussion concerning the uses of ethnographic film in the social sciences.

This method holds the potential to "bridge segregated and differently valued knowledges, drawing together legitimated as well as subjugated modes of inquiry" (Conquergood, 2002, p. 151–152). Because this method is derived from our play with children, it shows that adults can learn about more than play, children, childhood, and human development from the creative activity of children's play. As we adults continued our joint play/work with children, we discovered some of what can be accomplished when we include in the social sciences the excluded knowledge, knowers, and means of knowing in childhood.

A Case Study of Film-Play

In order to demonstrate the usefulness of this method of film-play, I will now turn to the following example. In response to the session in the playworld when the teacher joined the acting as the White Witch, a discrepancy arose between adult and child understandings of the playworld. The adult participants unanimously agreed that the children were not engaged in this day's playworld session. In fact, we were all concerned that we had jeopardized the success of the playworld with this failed performance. The teacher, Michael, was initially quite distressed by his performance and its reception. Then, on the Monday after Michael's Friday performance, the children told Michael that he was indeed the White Witch and that they could not wait for the White Witch to arrive in the playworld again.

Apparently the children *were* engaged and the White Witch's appearance was a success, not a failure. How can we understand this divergence of inter-

pretations? The answer to this question was essential to the success of the playworld, which depended upon coordination between the adults and children and also upon Michael's conviction that he was the White Witch.

In the process of resolving the discrepancy between adult and child understandings of the playworld, we discovered that film-play was a powerful tool for making the perezhivanie visible in playworlds available for analysis. In assessing why this was so, we concluded that film-play recreates perezhivanie in filmmakers and the audience. The following analysis of the film allows us to better understand the perezhivanie of one child named Milo.

Resolving the Discrepancy between Adult and Child Understandings

The video footage of this performance was filmed with an excellent camera by a professional cinematographer whose lyrical and gripping autobiographical documentary works I like. We asked this cinematographer not to shoot footage reserved for analysis but to shoot footage for a stand-alone ethnographic film of the playworld we were planning to make. We also encouraged her to enjoy the process of filming and to experiment with various angles, frames, movements, lighting, and camera settings. Before the filming began, we presented previous playworld footage and described the playworld project to this cinematographer and also pointed out positions from which she might want to film and children on whom she might want to focus.

When the researchers viewed the footage of Michael's first appearance as the White Witch we were shocked. The children were, very obviously, intently engaged with Michael's arrival as the White Witch. The researchers were now convinced that Michael had correctly understood the children when they told him that he was the White Witch and that they could not wait for the White Witch to arrive in the playworld.

We could not understand how we had been in the same room with these children, some of us even observing the children through a video camera lens, and had not seen what this footage showed us. For Michael, viewing this video footage was one of the most important turning points in the playworld. In his own words, he felt "relief (and joy) that I was able to be the White Witch...especially juxtaposed with the fact that just prior to seeing the tape...I had felt as though I had failed my students (i.e., I had not become the White Witch)" (Michael, personal communication, July 28, 2008).

Once Michael felt sure that he was "able to be the White Witch," we could proceed with planning the acting sessions much differently than we would have if the researchers or Michael had not felt that the White Witch had arrived in the classroom. Furthermore, this footage has had an interesting

trajectory through the presentation of our findings and back to analysis. This film-play began with the interactions between researchers and cinematographer that led to the production of the footage. This film-play continues through the present moment, as the reader reads this chapter and views the selected film stills, and perhaps also the film itself. [11]

The Film

This instance of film-play immediately changed our approach toward data collection. After this event, we paid even more attention to the quality of our equipment, the skill and quality of engagement of the people filming, and our interactions with these people. We also manipulated this footage over a period of several years for a series of audiences and for a variety of purposes: to use as we discussed perezhivanie with other playworld scholars and as we presented our work at academic conferences; to show Michael in an interview setting, to elicit his description of the significance of the footage for him, and to show a group of scholars who were sharing their amateur and professional art to each other.

For this last audience, and to satisfy our own need for artistic catharsis (Vygotsky, 1925;1971), one of the other researchers and myself spent many hours selecting and editing together moments of the footage that would literally bring tears to our eyes when we viewed them in extreme slow motion. After the formal presentation of our "finished" product, we placed the film in a public location where it could be viewed by others with any of a few songs, each carefully chosen because the music further enhanced our own emotional responses when we viewed the film. This incarnation of the footage turned out to be the most useful to us as researchers as we found, after the process was completed, that we had "captured" an instance of perezhivanie. We had managed to represent perezhivanie in the playworld in such a way that the emotional content of the event remained intact and also legible to those who were not participants in the event.

The following is a description of the film with one selection of music, followed by several still images from the film. The film has two scenes in color, and is two minutes and twenty-three seconds long. It may be useful to remember that in the dramatic system of Konstantin Stanislavsky (1949), perezhivanie is a tool that enables actors to create characters from their own re-lived, past lived-through experiences: Actors create a character by revitalizing their autobiographical emotional memories. As emotions are aroused by physical action, it is by imitating another's or a past self's physical actions that these emotional memories are relived.

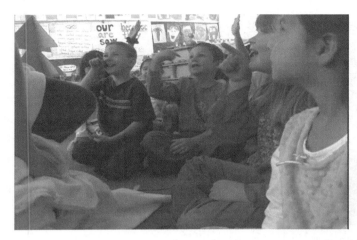

Figure 1.
After pointing at
Michael, Milo (center)
points at himself.
(Courtesy of Fifth
Dimension)

While Michael is moving his gloved hands on the side of the frame, one child, Milo, is holding his own right arm. He holds his arm while his finger points to Michael, joining his classmates in response to Michael's questions: "So, who do you think is the White Witch?" Then, all of a sudden, Milo's right arm breaks free and starts to point back to himself (see Figure 1). At this point in the film, Milo's face moves from bored wariness to pride, and Michael, who is still out of the frame, moves toward Milo in such a way that it appears he may fall fully into the frame.

A second child who is sitting next to Milo, named Luke, then takes Milo's arm himself and moves it down, ending the pointing. He falls into Milo from the side, embracing him, while another child who is next to Luke, Maya, also leans in. Heads touching, faces turned upward, the three children turn to look to Michael. Then Milo, who now has an exhausted, ecstatic look on his face, raises his arm slightly and, with Luke still holding his arm, knocks his chest with his fist, thumb up.

In the second scene of the film, Michael reaches down for his coat, which Luke is holding. Milo mirrors the large white hands and arms, his own small hands and arms reaching up, as if he was a much younger child who was asking to be lifted (see Figure 2). Then Milo's hands are opening and falling to his lap, palms up. And Milo looks to be at great peace.

In the soundtrack, a Japanese singer sings in English with a heavy accent. The vocals are therefore choppy, highlighting the visual effect of extreme slow motion in which the frames follow each other so slowly, that they almost appear as a series of still frames. The lyrics of this song can be interpreted as describing aspects of perezhivanie: "Why don't we sing this song all together—open our minds let the pictures come—and if we close all our eyes together—then we will see where we all come from."

Figure 2. Milo (at right) mirrors the White Witch's hands and arms, extending his own upward. (Courtesy of Fifth Dimension)

A Discussion of Film-Play: Lived Momentum

Michael, the teacher participant in the playworld of this study, has described playworlds thus:

> I [when not in a playworld] imagine the things I cannot be. I do not BE the things I cannot be. In the PW [playworld] I can BE a witch. A kid has to act because he cannot imagine. I have to act like the things that I know that I cannot actually be...A PW [is] kids and adults HAVING to act. Adults [are] acting things they cannot be. Kids [are] act[ing] things they cannot internally imagine (Michael, personal communication, January 25, 2009).

In other words, the children are playing because they cannot yet imagine without play. And the adults are not joining in play only to promote and guide the development of the children's ability to imagine. They are also joining in play because this allows them to experience things they are not able to experience through imagination alone, things which appear too far from the possible to be experienced through imagination without play. In a playworld the great need or the imperative of children to learn adult forms of imagining (the art

and science they traditionally learn in school) is coupled with the adults' desire to "BE" that which they cannot "BE" through imagination without play.

Richard Schechner explains this phenomenon when he writes that performance "offers to both individuals and groups the chance to re-become what they once were, or even, and most often, to re-become what they never were, but wish to have been or wish to become" (1985, p. 38). And Schechner also writes of "(a) special empathy/sympathy (that) vibrates between performers and spectators," a "special absorption (that) the stage engenders in those who step into it or gather around it" (1985, p. 113). This occurs when we "do not 'willingly suspend belief.' (We) believe and disbelieve at the same time. (And) (t)his is theater's chief delight. The show is real and not real at the same time" (1985, p. 113).

Michael adds to his playworld definition that, while children in a playworld benefit from adult expertise and experience in the arts and sciences, adults in a playworld benefit from playing with children. This is because children do not simply request that adults play with this "special absorption" and demonstrate for adults the skills and confidence that allow one to reach this state. Children also encourage adults to play "with belief and disbelief at the same time" by refusing to play with adults if these adults do not simultaneously believe and disbelieve (Michael, personal communication, January 25, 2009). Michael states, "(H)ere is an analogy...I have on my football helmet...and everyone else is playing basketball. The kids are playing basketball...and if we want to play, we need to get rid of the helmet" (Michael, personal communication, January 25, 2009).

Throughout our editing, viewing and presenting the above-discussed film, and even during the initial filming of the footage[5], we were engaged in film-play because we were keeping our helmets off. We were continuing that "special absorption" which is "belief and disbelief at the same time." For Bateson (1972), play is a paradox because it both is and is not what it appears to be. The quality of film that we were striving for in our filming and editing is the illusion of time flowing that we, the audience, fall into, even as we are aware of, in fact because we are aware of, the disjointed still photographs that film actually is. Sobchack calls this quality of film "lived momentum" (1992, 2004).

Sobchack's argument is that film shows us the frame through which it is created. She claims that the paradox of film is that our knowledge of this frame—our knowledge that the movement we experience is just an illusion—is what makes this illusion convincing. Film designates a space, by drawing attention to the frame of this space, and we, the viewers, then fall into this space and, in falling, glimpse the future.

Furthermore, because it has momentum, which is the ability to develop towards a future, film is alive. Sobchack (1992) claims that film has an active life of its own: You can live in film, but film also lives within you. Vygotsky describes this same quality of the novel through a quote from Pushkin (via Tolstoy): "My heroes and heroines sometimes do things against my wishes" (2004, p. 19).

As ethnographers harnessing the "lived momentum" of film, we are most directly influenced by the "direct cinema" of Jean Rouch (1978)[6] . Our method of film-play makes perezhivanie the subject of empirical investigation both because it keeps perezhivanie "alive" for study, and because it is, itself, a form of perezhivanie. Rouch's ethnography, like our own, mirrors his topic of study, so that increased understanding of one leads to increased understanding of the other.

Furthermore, in both our own and Rouch's work the "filmmaker-observer" (Rouch, 1978) both modifies what she films and is changed by what she films. When the filmmaker-observer shows the film to the subjects of the film, "a strange dialogue takes place in which the film's "truth" rejoins its mythic representation" (Rouch, 1978, p. 58). It is for these reasons that I took the term "film-play" directly from Rouch, who draws a detailed parallel between his ethnographic filming and the possession dance, magic, and sorcery he filmed, writing: "It is the "film-trance" (ciné-trance) of one filming the "real trance" of the other" (1978, p. 64).

In our video ethnography of the playworld, we did not only re-experience the playworld through viewing the playworld. This process itself reflected the processes that interested us in the playworld. And, to continue this spiral, while this doubleness was a result of our "ciné-play," it was also this act of re-framing (Bateson, 1972) that made our film playful. The reason that our films give us access to the physiology of perezhivanie is that they "allow us to confront the intersecting of the worlds they describe" (MacDougall, 2006, p. 348), and generate new perceptions. David MacDougall celebrates our ciné-play when he asserts that when we cross cultural realities with our ethnographic films, we are "on the verge of the surreal," and that we should take from surrealism the lesson that the "experience of paradox is in itself significant and must be grasped to generate new perceptions" (2006, p. 348).

Moreover, as described above, when we engaged in the playworld we agreed to learn from the children about play. In so far as our analysis is a continuation of the playworld, any marginalization of the "play" in our use of film is a breach of this contract and an affront to the children who agreed to join us as equal contributors in the playworld. The question of whose story the film tells is a question of both moral and ontological import: The dignity of

the subjects is at stake (Rouch, 1974)[7] when the film is "inside someone else's story" and this is why we ask ourselves, "Whose story is it?" (MacDougall, 1991).

Just as the children, through their play, taught us how to film, our film-play, in turn, helped us to play in the playworld: our ciné-play merged with our creation of a playworld. Our filming became a means of "creating the circumstances in which new knowledge (could) take us by surprise" (MacDougall, 2006, p. 355), and when this occurred, our films became ongoing research processes in themselves. The divide between adult and child perceptions of this event might not have been bridged if filming the children had not created a shared space in which adults and children could meet with more ease than they could elsewhere[8].

It is the movement between or double existence in immersion and detachment that is both the content of our short experimental segment tapes that interest us: perezhivanie and also the quality that film-play brings to our endeavor to represent this content: "lived momentum," or that "strange and intensive mode of access to the world, both more immersed and more detached" (MacDougall, 2006, p. 91). This movement between or double existence is also what we adults needed to achieve if we were to create a playworld with children, as the children refused to play with us if we did not simultaneously believe and disbelieve. Playworld participants experience the playworld not as a pale shadow of reality but, to use Michael's words, as "more real" (Michael, personal communication, May 6, 2009) not only when, but because, they are creating the frame that brings the playworld into existence.

Because this understanding allows for film-play, it is this understanding that makes perezhivanie an empirically researchable phenomenon. By using various ensembles of methods of representation, some of which themselves evoke and manifest perezhivanie so that they constitute examples of the perezhivanie that they are to intended to represent, this elusive phenomenon is made available for analysis in its full, dynamic complexity. In this way, this understanding also contributes toward the larger methodological project of challenging the divide between method and object in conventional social science.

In play, children are lifted above their current potential, achieving that which they could not achieve outside of play, while briefly inhabiting what we could call their future selves. Film can also allow us to glimpse a future of potential and a future self, can make a "brief flight into life, out of the fixed frames and inexorable logic of the fated narrative" (Lupton, 2005, p. 93). And in play, children push themselves to the limit, placing themselves right next to their greatest fears, and right by those demons that truly threaten their physi-

cal and emotional selves. Children enter a designated space in which they are at risk because they are challenging themselves, and in which they could not challenge themselves without risk. Within the frame of film, the ability to glimpse a future coexists with the whirling sensation of vertigo, as we fall into a film time somehow more our own than the "real" time unmediated by film (Alter, 2006).

Perezhivanie in a playworld and the 'lived momentum' of film-play are both the fall that becomes a flight and the flight that becomes a fall. In Rachel's words: "I feel like I'm flying." Concerning the creation of circumstances in which new knowledge can take us by surprise, both in play and in live representation of play, Pearl and Andrea tell us: "I look up and I go faster," and "Why am I walking backwards? I don't have to look. I know where I'm going."

References

Alter, N. M. (2006). *Chris Marker*. Urbana, IL: University of Illinois Press.
Aries, P. (1962). *Centuries of childhood*. New York: Knopf.
Bateson, G. (1972). *Steps to an ecology of mind: Collected essays in anthropology, psychiatry, evolution, and epistemology*. San Francisco: Chandler.
Baumer, S., Ferholt, B., & Lecusay, R. (2005). Promoting narrative competence through adult-child joint pretense: Lessons from the Scandinavian educational practice of playworld. *Cognitive Development, 20,* 576–590.
Cole, M., Levitin, K., & Luria, A. (2006). *The autobiography of Alexander Luria: A dialogue with the making of mind*. Mahwah, NJ: Lawrence Erlbaum Associates.
Conquergood, D. (2002). Performance studies: Interventions and radical research. *The Drama Review, 46*(2), 145–156.
Dagis-TV:s utbildningsprogram om Ett lekpedagogiskt arbetssätt från Hybelejens daghem i Karlstad med Gunilla och Jan Lindqvist. TV-producent: Birgitta Sohlman, UR, 2006-93517-1.
Fass, P. S. (2007). *Children of a new world: Society, culture, and globalization*. New York: New York University Press.
Ferholt, B. (2009). *Adult and child development in adult-child joint play: The development of cognition, emotion, imagination and creativity in playworlds*. Unpublished doctoral dissertation, University of California, San Diego.
Hakkarainen, P. (2004). Narrative learning in the fifth dimension. *Outlines: Critical Social Studies, 6*(1), 5–20.
Lewis, C. S. (1950). *The lion, the witch, and the wardrobe*. New York: Macmillan.
Lindqvist, G. (1995). *The aesthetics of play: A didactic study of play and culture in preschools*. Uppsala, Sweden: Uppsala University.
Lindqvist, G. (2001). When small children play: How adults dramatize and children create meaning. *Early Years, 21*(1), 7–14.
Lupton, C. (2005). *Chris Marker: Memories of the future*. London: Reaktion Books.
MacDougall, D. (1991). Whose story is it? *Visual Anthropology Review, 7*(2), 2–10.

MacDougall, D. (2006). *The corporeal image: Film, ethnography, and the senses*. Princeton, NJ: Princeton University Press.

Miyazaki, K. (2007). *Teacher as the imaginative learner: Egan, Saitou and Bakhtin*. Paper presented at the 2nd Annual Research Symposium on Imagination and Education, Vancouver, Canada.

Nilsson, M. (2008). *Development of voice through the creative process and multimodal tools in digital storytelling*. Paper presented at the Second Congress of the International Society for Cultural and Activity Research, September 9–13, 2008, San Diego, CA.

Objectively. (n.d.) In *Oxford English Dictionary online*. Retrieved May 1, 2007, from http://www.oed.com.

Rainio, A. P. (2005). Emergence of a playworld. The formation of subjects of learning in interaction between children and adults. *Working Papers 32. Center for Activity Theory and Developmental Work Research*, University of Helsinki, Finland.

Rainio, A. P. (2008a). Developing the classroom as a figured world. *Journal of Educational Change, 9*(4), 357–364.

Rainio, A. P. (2008b). From resistance to involvement: Examining agency and control in a playworld activity. *Mind, Culture and Activity, 15*(2), 115–140.

Rouch, J. (1974). The camera and man. *Studies in the Anthropology of Visual Communication, 1*(1), 37–44.

Rouch, J. (1978). On the vicissitudes of the self: The possessed dancer, the magician, the sorcerer, the filmmaker, and the ethnographer. *Studies in the Anthropology of Visual Communication, 5*(1), 2–8.

Schechner, R. (1985). *Between theater and anthropology*. Philadelphia: University of Pennsylvania Press.

Sobchack, V. C. (1992). *The address of the eye: A phenomenology of film experience*. Princeton, NJ: Princeton University Press.

Sobchack, V. C. (2004). *Carnal thoughts*. Berkeley: University of California Press.

Stanislavsky, K. (1949). *Building a character*. New York: Theatre Arts Books.

Tobin, J., & Hsueh, Y. (2007). The poetics and pleasures of video ethnography of education. In R. Goldman (Ed.), *Video research in the learning sciences* (pp. 77–92). New York: Lawrence Erlbaum Associates.

Vygotsky, L. S. (1971). *The psychology of art*. Cambridge, MA: MIT Press.

Vygotsky, L. S. (1978). *Mind in society: The development of higher psychological processes*. Cambridge, MA: Harvard University Press.

Vygotsky, L. S. (2004). Imagination and creativity in childhood. *Journal of Russian and East European Psychology, 42*(1), 797.

Acknowledgments

Dr. Ferholt would like to thank, with great warmth, her collaborators and mentors in this project: the children of "Michael"'s class and "Michael"; Sonja Baumer, Robert Lecusay and Lars Rossen; Michael Cole, Patrick Anderson and Bennetta Jules-Rosette; Ana Marjanovic-Shane, Monica Nilsson, Kiyotaka Miyazaki, Pentti Hakkarainen and Anna Rainio.

Keeping Ideas and Language in Play:
Teaching, Drawing, Writing, and Aesthetics in a Secondary Literacy Class

Michelle Zoss

I n the *Psychology of Art*, Vygotsky (1925/1971) argues that while art is composed from experiences, art infuses more meaning into these experiences than could have been constructed without the art. A drawing is a situated work of art invested with emotion that is constructed in a social space. The artist has the opportunity to render an image woven with both personal reactions, such as emotions and material information, including details of an idea, object, or person from experiences. Working toward a final product, the artist works to integrate her personal experiences within the objects she creates.

In modern U.S. schools students are taught to do their work in disjointed pieces, with work in English class disconnected from work in Math, Science, and Art. Even within an English class, activities can be isolated into solitary units: begin the class with a short grammar activity, read a short story, then complete a series of writing exercises. Each of these activities may be part of a textbook or textbook series of lessons that are also disconnected with the personal lives of the students. In this chapter, I present a teacher working in an English language arts class who sought to make connections within her curriculum and with the experiences of the students by bringing visual art into the lessons. Specifically, I investigate a literacy teacher who is interested in teaching students how to use drawing and writing together to compose responses to literature, to play with language to help describe and redefine the objects in the classroom and those they carry with them to school each day. Within the curriculum play with language and image, the teacher helps create opportunities for students to weave their personal experiences into materials used in the classroom.

Vygotsky's (1925/1971) discussion of aesthetics and art considers the role of emotions, the body, and the work of art in relation to the perceiver of the work of art. He argues that "art is based upon the union of feeling and imagination" (p. 215), a statement that creates a lens for viewing the work of students and teachers in a classroom as being opportunities for bringing personal stories, experiences, and emotions into the curriculum. To further illustrate the connection between emotion and thinking, Vygotsky's (1994) concept *perezhivanie* provides a frame for thinking in which a person is in a dialectical relationship with her environment and her thinking-emotions (Connery, 2006). As Connery (2006) explains, the meanings a person makes include "awareness, understanding, interpretation, emphasis or attitude, and emotional state toward the current context at hand" (p. 49). In other words, to view the work of the teacher and students in this study, it is useful to see the meaning-making activity involved in the lessons as being multidimensional, inclusive of emotions, and situated within the specific environment of the classroom. I understand the activity in this classroom as a complex set of relationships among the students, the teacher, the materials they use and make, and the meanings they attach to these relationships as evidenced in their talk in class and the products they compose.

As a participant observer in the classroom that is the focus of this chapter, I watched and listened as drawings, costumes, writing, and storytelling revealed student ideas about the curriculum. In order to sift through what I could view and hear in this school space, I turned to Suhor's (1984, 1992) semiotics-based curriculum to frame the action. A semiotics-based curriculum is one in which the multiple sign systems that humans use to communicate are valued as potential sites for exploration. This view of curriculum frames communication and expression as a complex activity that goes beyond language. That is, communication is seen as something that can occur separately and simultaneously through the use of signs in language, image, gesture, construction, and others. John-Steiner's (1995) research in cognitive pluralism highlights the multiple means for communication through multiple sign systems. Working with adults and children, John-Steiner illuminates the ways in which thinking is multidimensional and is not limited to language. In the lessons highlighted here, students use a number of different sign systems: linguistic signs in oral and written language; gestural signs in acting, costuming; and, pictorial signs in drawings. Having multiple modes for communication facilitates multiple modes for thinking in this space, a space in which students perform and play with ideas visually, linguistically and spatially. Vygotsky (1925/1971) posits that "art performs with our bodies and through our bod-

ies" (p. 253). Indeed in this classroom, as I aim to show in this chapter, student bodies and emotions are very much a part of the activity of learning.

This chapter illustrates one teacher's path toward building a curriculum for teaching literacy that embraced multiple means for expression. The works students produced in language, image, and gesture are extensions of the curriculum (Eisner, 2002) that opened the door for emotions to be included in the curriculum. In this semiotically and emotionally rich environment, the teacher invited students to connect their schoolwork with their lived experiences both in school and beyond.

The literacy teacher in this study is Sherelle, a teacher working in a rural area of the Southeastern United States. Her sixth grade classes met with her for 80 minutes each day as she taught English language arts and reading. The curriculum for the classes was in large part governed by the state performance standards for sixth grade students. The curriculum in Sherelle's classroom, however, was not a mere recapitulation of students identifying parts of speech or composing persuasive essays or technical writing. Rather, she developed lessons to invite students to use vocabulary words to identify relationships between terms found in their literature text with objects found in the room and to use drawings as tools to explore their experiences with literature and their own personal experiences with attending school.

In this chapter, I write about how Sherelle uses three lessons for vocabulary, literature response and personal narrative to discuss how a teacher can keep language and composition visual and constantly in play in a classroom. Sherelle worked to teach students that language was part of the visual landscape of the classroom. Words were not simply parts of books or posters but could be used to describe and redefine the physical space of the classroom. So, Sherelle taught students how to attend to the visual space of their room while pairing that attention to a linguistic detail. Likewise, she asked students to attend to details in a piece of literature in order to visualize the circumstances characters were involved in and to do this visualizing using props to dress up a classmate, then draw a portrait of a character from the short story, and finally, to write about that character from a perspective informed by reading, costuming and acting and drawing. In another lesson, Sherelle invited the students to consider the physical and mental weight of the bags they carried with them to school for the whole of their sixth grade experience. Students drew large images of their bags and wrote about the tangible and intangible things they carried. The lesson drew heavily on the students' personal experiences with school. These three lessons illustrate how Sherelle took the state-provided curriculum for students to perform a set list of tasks in language arts and reading and shaped that curriculum to create opportunities for students to play with

language, image and their own experiences with reading, writing, and attending school. I turn now to a discussion of each of the three lessons.

Figure 1. The Word Web Spider (Courtesy of Sherelle Patisaul)

Vocabulary Lessons, Play, and the Visual Space in a Classroom

Sherelle taught vocabulary as a multi-faceted set of activities in which students used language, image, and physical space to define specific words tied to the curriculum. In teaching vocabulary, Sherelle focused on personal connections with the students. Sherelle asked the students to perceive the physical space and objects of their classroom in a way that fostered new connections among both vocabulary terms and the environment. Every teacher in the school was required to have a visual display of vocabulary words in each classroom. Many teachers had a "Word Wall" that occupied the space of a bulletin board and listed words the classes encountered while using textbooks, novels, work-books, and other materials used in the curriculum. In Sherelle's classroom, a giant black spider fashioned from butcher paper loomed over her "Word Web." (See Figure 1). Each week, over the course of several weeks, Sherelle chose five or six words to add to the spider's web. These words came from short stories and poems she and the students were reading from their literature anthology text. The words appeared in the web on Mondays and the students completed typical vocabulary activities with these handfuls of words: On sheets of paper, the students defined each word using a glossary or dictionary; they identified the part of speech to which each word belonged; they wrote a sentence using the word. One less than typical activity that Sherelle also required of the students was to include with this definitional writing a sketch of a scene that described the word. For instance, one week the words included

lurk, and several students drew pictures of caves with eyes looming in the darkness or of a wolf's head peering from around a tree or bush. The term lurk came from a short story about a wolf and the students used information found in the story to help them illustrate their vocabulary drawing requirement.

During the week in which a set of vocabulary words appeared in the spider's word web, Sherelle gave students time during class to complete their definitional linguistic and pictorial work and directed the students to study their writing and drawings to prepare for a quiz on Friday. During the quiz, students matched terms with definitions, identified the parts of speech for each word, wrote sentences to define the words, and finally, chose one word to illustrate. In the illustration, students could show any of the words from that week in action; the sketch could use the entire side of an 8 ½ x 11 inch sheet of paper and was paired with a short verbal description. Sherelle explained that the drawing of a scene in which the vocabulary word was being imaged required a verbal description to ensure that she could understand the intent of the artist/writer.

With the quiz complete, Sherelle introduced the last act for the words that had spent the week in the spider's web: a new life of meaning outside the clutches of the spider. Sherelle told the students that the spider was really a vegetarian and not interested in eating the words caught up in his web. The students, she suggested, could then offer the words an opportunity to live new lives in the classroom space. The words needed to be "freed" from the web to continue their lives in new homes. The students' responsibility was to find the words a new location to call home that would help the students to remember what the words meant. Working in small groups, each group was given one word and time to write the word boldly on a card with an adhesive backing and then decide where the word should live for the remainder of its life. Each group then placed their word on the thing in the room that they wanted to use to remember what the word might mean. Within Sherelle's teaching load, she taught three sections of English language arts/reading, and each class had one set of words to release into the classroom space. Thus, three cards for the words *lair, vast, perturb, hinder,* and others were placed throughout the space. Once secured to the objects, each group reported to the class what word they were given, the new home location of the word and their reasoning for the placement.

The vocabulary words were attached to objects and other words found throughout the room. The television sported the word *hinder,* as did the small poster of rules governing behavior on Sherelle's sixth grade team. The students

with the TV *hinder* explained that television was something that, at home, could hinder their performance in completing homework; meanwhile, the group that put *hinder* on the team rules explained that the rules in place could hinder their socializing at school and perhaps impede the relationships they wanted to build with their peers. These two examples of the word *hinder* showed how the students saw the classroom space as connecting to their lives outside of school (the television) while at the same time tied to their academic performance (hindering the completion of homework); and yet, the classroom space also served as a reminder of both their own expectations of behavior in school (developing relationships with peers) and the expectations of the teachers for that behavior (team rules about respect and responsibility).

The spider itself was also subject to the vocabulary word placement by students (see Figure 1). Two groups labeled the spider with *vast*, another labeled it *ludicrous*, both citing the relative size of the spider as reasons for the labels. Another group described the emotions of the spider, using *perturb* to describe how the spider felt about having words in its web that it could not eat. One group opted to use the spider as a means to locate a personal connection: This group attached the word *cringe* to the spider with the explanation that one of the group members had a deep fear of spiders, and this spider was a reminder of how the student responded to the sight of a real spider. Like the placement of the word *hinder*, this spider illustrates a site for students' developing ideas about how language can be used flexibly to describe their environment. Certainly the spider could have been labeled as vast and nothing else. But, the students opted to expand their ideas about the spider by further describing the girth of the arachnid as ludicrous, by ascribing a human emotion of perturbation as part of their understanding of why they were spreading these words across the room, and by connecting their own feelings about spiders in general to this almost comically-large paper representation.

As a researcher working in this classroom, I see this redefining of vocabulary terms creating flexible and purposeful relationships for students between language and visual environment. That is, this set of vocabulary activities Sherelle used allowed students to work with the linguistic terms using writing, drawing, and perception in order to create multiple and varied meanings for words. The act of "freeing" the vocabulary terms from the spider's word web gave time for students to play with their perceptions of words and the potential relationships of those words to the larger physical space in which they spent at least 80 minutes a day.

Siegesmund (1999) posits that the perception of relationships is concerned with aesthetics, citing the origin of aesthetics with Baumgarten's

(1750/1961) coining of the term from the ancient Greek word *aisthanesthai*, which means "to perceive." Perception in this case is a relationship between the perceiver and the thing being perceived; both work on the other. In Sherelle's classroom, the freeing of the vocabulary lesson was a means for students to work on the visual space they encountered each day using specific vocabulary words and, later, allowing the labeled space to work on them as reminders of what these words can mean in a specific context. She provided a handful of words to work with and the students interacted with the space. Thus, the physical space of the classroom was not wholly constructed by the teacher for students to consume as needed; rather, the physical space was a work in progress, a space defined and redefined as students played with their own developing meaning making. Drawing from Vygotsky's work on sense and articulation as key nodes in the development of concepts, Smagorinsky (2001) argues that students composing provisional texts can use those texts as markers for their current understanding of a concept and simultaneously use the same text as a mediator for ongoing development of that concept. In Sherelle's classroom, the locations of vocabulary words were provisional texts for what a word could mean. The multiplicity of locations of a given word, like *hinder*, points students to the notion that the meaning of a word (or concept) can be transient, that context in which a word/concept is located matters, and that there is room for multiple meanings.

Though not necessarily articulated to students through words, Sherelle's actions in this vocabulary lesson illustrate how the work of developing an understanding of a word can also mediate the development of concepts, like the idea that a word's function in language can be mutable, played with, and changed based on context and relationships within that context that the perceiver (student) identifies. Ultimately, the placement of the words around the room helped them shape their own meanings of the words and the potential meanings that their classmates might have of the same words. Smagorinsky (2001) explains the development of concepts through mediated activity using Vygotsky's notions of *sense* and *meaning*. As the students learn that words and word meanings are mutable and can change, they develop their ongoing sense of the words. Sense in this case is like a cloud of meaning filled with potential raindrops and the raindrops are the articulations of meaning. Put another way, a student's sense of the meaning of cringe begins to form with her experiences with real spiders and develops further as she reads the word in the context of a short story and continues to expand as she looks at the giant spider on the classroom wall. Her articulation of what cringe can mean in this specific context, the classroom with its vocabulary spider, is the pinning of the word cringe to the spider with the explanation that spiders make her body

react in this way. The meaning of cringe is not limited to this particular articulation raindrop because her sense cloud includes a number of other experiences that can allow her to articulate multiple meanings for different contexts. The freeing vocabulary activity is an example of how Sherelle taught students to articulate both visually and linguistically their concept developments and personal connections with the vocabulary words. While not a drawing in a traditional sense, the composition of words placed all round the room is a visual composition of student perceptions of their classroom environment.

Visualizing Characters through Reading, Gesture, Drawing and Writing

Sherelle used a short story unit to teach students how to use drawings to compose their ideas about reading a text. The students read three short stories; I focus here on one story that involved gesture as part of the composing process. The students read Kurt Vonnegut's (1961) short story "Harrison Bergeron," a tale of a utopian society in which all the people of the world are made equal through what Vonnegut describes as a "handicapping" process. That is, beautiful people are made more ordinary looking through the shaving off of their eyebrows, the wearing of hideous masks; smart people are forced to wear inner ear implants that make horrific sounds of crashes and bangs at random intervals in order to quell the streaming of coherent thoughts. Harrison Bergeron, the main character of the story, is the handsomest, strongest, most brilliant man to have walked the planet. As a result, the handicaps he bears are severe and multiple. After the students read the entire story, Sherelle asked them to attend to the details of Harrison Bergeron the character and to consider what it means to "handicap" someone with desirable qualities. Students formed groups of three-to-four members and were given a card with a list of qualities such as beautiful, agile, and intelligent. Each group had a different set of qualities to attend to, with the goal to use common objects to dress up one of the group members in order to subdue those qualities. The common objects Sherelle brought to class for the costumes included scarves, sweaters, shirts, hats, cooking utensils, gloves, belts, and sunglasses. Students could also use any other objects they could find in the room; dictionaries became weights to pull down and hinder the agile and strong characteristics; papers were fashioned as masks to alter beauty, and pencils and pens were tied on as antennae for radio transmitters to prevent intelligent thought.

The costuming process to "Harrison Bergeronize" the classmate involved preparing for performance as well. One quality that students had to perform that did not involve a costume was "humorous." Students had to figure out

how to show not being funny whilst being encumbered with all of the other hindrances their classmates had put on them. These students opted to tell a really bad joke. Laughter punctuated the dressing–up process and practice performances. The sense of play in the classroom was palpable as one student in each group was transformed. As the one student became the focus of multiple costuming ideas, the students creating the costumes tried out possibilities on their own bodies: for example, one non-Harrison student pulled a hat over his eyes to test out the merits of the object's potential to create blindness before putting the hat on the designated Harrison in the group. Students used spatulas and spoons to squeeze heads and hands, arms and legs, in order to determine which body part would be best hindered by this tool or another. Through whispers, shouts and giggles, students spoke aloud ideas and tried others by adding a scarf tied to a dictionary around the waist of another Harrison student. This was an activity in which the students laughed and moved and talked with each other about how to solve the problem at hand. They sought Sherelle out as a consultant only when a group couldn't find an object they needed and asked for help to find an alternative. Sherelle moved from group to group to ask questions about how the students were solving the problem qualities they were given and asked how the different parts of the costumes accounted for the qualities in their problem solving. After the "Harrison Bergeronizing" costumes were completed, each group performed in the middle of the room to show how they had transformed a classmate into a character like those found in the short story.

With the costuming and performing complete, Sherelle asked students to return to their regular seats and reread the descriptions in the short story that describe Harrison Bergeron's physical characteristics. Then, students composed a portrait drawing of Harrison, using these linguistic details to visually show what they saw in Vonnegut's prose. With pencils and markers, students drew on pieces of paper measuring 8½ inches by 5½ inches. Once completed, students composed a written description of Harrison Bergeron and the life that he leads in the story. Both the drawing and the writing were later displayed in the classroom as a single composition to show what the students had learned from reading this short story.

As a lesson providing opportunities for play, this dramatic, drawing/writing composition for reading "Harrison Bergeron" is an excellent example of how students could play with the language of the story. By playing with the language, I mean that the students could play with costumes to think about how to reverse qualities of beauty, intelligence and strength and then play with the language that Vonnegut used to create their own vision of Harrison both in drawing and writing. One student, Avery, wrote:

My drawing shows a handsome man. Or he used to be. In the future Harrison is forced to look like everybody around him, where everybody is the same. He is forced to wear huge earpieces that shock him over and over. He's wearing scrap metal, huge glasses, and has flaming red eyes. What a future to look forward to.

In this paragraph, Avery's comment shows that he could imagine the future society Vonnegut envisioned. The sense of sarcasm in the final sentence illustrates how Avery problematized the value of a society based on sameness. These statements, though, were made possible because Avery had time and materials to work with in class that allowed him to explore a number of nuances related to making people more the same. "Students moved between linguistic, gestural, and visual sign systems (Suhor, 1984) throughout the entire lesson to be able to perform Harrison Bergeron as a character classmate, to draw Harrison as a literary character and to describe Harrison with language. The learning possibilities in this space were not keyed in to a "heritage model" of schooling (Smagorinsky & Taxel, 2005) in which a teacher is the one knowledgeable person in the room and students look to her for the answers; rather, the learning was located among the students and Sherelle as they solved the problems of understanding physical and social qualities that are admired, finding ways to deter or "handicap" those qualities, and then use this socially constructed knowledge to independently draw and write about a fictional character.

The learning was simultaneously and successively based in multiple sign systems that allowed for a multiplicity of responses (Eisner, 2002; Suhor, 1984). The lesson began in the linguistic system with reading the short story. Next, students used props to communicate about their Harrison's qualities via visual costumes and gestures. Finally, students composed multimedia texts of drawings and writing, again using the pictorial and linguistic sign systems. Eisner (2002) argues that work in multiple media, such as drawing, writing and acting, allows students to compose rich responses that are not duplicated in the representation in each individual medium. In other words, students drawing, drawing, and acting are creating three visions of an idea. In this lesson alone, students render multiple images of their understandings about the short story "Harrison Bergeron", and each rendering is an additional opportunity to play with the ideas, characters, and meanings of the story.

Connections to Students' Lived Experiences in School

In the third set of lessons, Sherelle taught her students to consider the material details of the backpacks they brought to school each day. The lesson re-

quired students to draw a backpack, listen to excerpts from a short story, then compose an essay about the things they carried with them to school. The lesson also illustrates Vygotsky's (1925/1971) notion of infusing content within a creative piece. That is, the content of the drawing/essay composition was a rendering of the backpack itself as well as the emotions and memories of carrying the bag throughout the school year. Unlike the vocabulary lesson which began with words found in literature or the dramatic drawing lesson which began with reading a short story, Sherelle located this activity in the image first, and the language second. In theorizing this activity of drawing a backpack, listening to a short story and writing an essay about things carried in that backpack, Siegesmund (2005) points out that this is a lesson focused on qualities: lines, shapes, patterns as well as emotions. Unlike the vocabulary lesson that keys students into the symbols of words, this backpack lesson centers on perceiving non-symbolic details as the drawings are composed. In this perception of bulges and valleys in the bag, the student can attend to the weight of the bag and consider the emotional and physical ties to those shapes and patterns. They can imagine what was held in the bags as they shouldered them to school for 180 days or more; they can feel how rough or smooth the fabric has become over time. Recalling that "art is based upon the union of feeling and imagination" (Vygotsky, 1925/1971, p. 215), this lesson illustrates how Vygotsky's position on art sees the human as engaged with both mind and emotion. The progression of the lesson allows for time to be spent considering the object of the bag with the hand, the mind, and the feeling of carrying it.

As a set of activities Sherelle learned while enrolled in her teacher education program, the backpack lesson required students to draw the bags they carried with them to school every day, to think about the tangible and intangible things carried in those bags and then write about these things by contemplating the bulk and measure of them after they completed the drawings. Sherelle began the three-day lesson with a drawing on the board modeled after a Shel Silverstein (1974) illustration and poem called "What's in the Sack?" The drawing depicts a man stooped by the weight of the very large sack on his back; students made guesses about what might be in the bag. Next, Sherelle read the poem associated with the drawing and then told the students they would be considering their own backpacks and school bags and what they carried inside those bags. The students were given large drawing paper and vine charcoal. The paper was large enough (18" x 24") that it filled the surface area of their desks. With their bags resting on their chairs, the students stood next to their desks and drew nearly life-size renderings of their bags.

The students were given a mini-lesson in drawing with an emphasis on practicing drawing the lines and curves of their bags in the air first and then

on paper. Sherelle used a mantra throughout the lesson: "Draw what you see, not what you think you see." Students practiced outlining the contours of their bags with their drawing hands in the air, moving their arms and hands with the shape of the bags, then returned to the paper to make similar gestures with the vine charcoal. Given the size of the drawings, which were nearly three times as large as the sheets of paper they usually used for drawing in class, the students needed two class periods to complete their images. Once the outline of their bags were complete, they moved on to the details—adding in zippers, pockets, folds, bulges, valleys, straps, and folds, as well as shadows.

During the second day of class, as students added the last details, Sherelle read excerpts from Tim O'Brien's (1992) short story, "The Things They Carried." A story about American soldiers traversing jungles during the Vietnam War, the characters are developed through the listing and description of all the personal and impersonal accoutrements they carried on their bodies. O'Brien specifically writes about the weight of the tangible and intangible things carried by the soldiers, pointing out that though a radio was heavy to lug, fear sometimes weighed even more. To transition the students from drawing to writing, Sherelle asked the students to talk as a whole group about the tangibles and intangibles the soldiers carried and to consider what they carried in their own bags to school every day. The students talked about how the notes from their friends were light pieces of paper that did not weigh much physically but as intangibles held significant weight because they represented their relationships and reputations with people important to them in school. As the second day of the lesson came to the end, all of the students had finished their drawings and were sitting at their desks drafting a written essay about their bags and the things they carried. The third 80-minute lesson was devoted to writing. The students finished their essay drafts, shared them with classmates and some with Sherelle, then revised and rewrote the essays in a final draft format. Sherelle displayed the compositions as dual writing/drawing pieces. Images and essays filled the walls of the room.

Two students in the class declared to Sherelle that their drawings and essays were the best things they had ever done in school. Rachel's essay made specific connections among the tangible and intangible things she carried:

In this purse I carry my pencils, pens, money, keys, make up, and notes. The purse itself is a little old, but it looks really new. There's candy wrappers and little pieces of papers. I try to keep a lot of stuff out of it, but every day I get new pencils and stuff to fill my purse with. I also keep memories, ideas, and thoughts of the past and hopes. For every pencil I have a memory of my class and how much fun I had. I have notes of the past and soon to be the future. My hopes and dreams are locked and waiting for the keys. Each day I come to school with my purse. It is like my diary.

In Rachel's essay, she showed how she connected the concrete objects of pencils with memories of her experiences in school. Like a commonplace collection (Sumara, 1996), Rachel's bag acted as a location to collect both physical objects and metaphorical ideas. By including these specific connections in her essay, Rachel showed how she understood the connections between the tangibles and intangibles that she carried with her as part of her school experiences.

The second student who declared her emphatic enjoyment of the backpack lesson was Madison. In her essay, Madison wrote about how her social experiences in school were part of the intangible things she carried:

> In my purse I carry a lot of things. I carry pens, pencils, erasers and [other personal items]. I also carry things that make me look nice and smell nice. These things are hair bows, deodorant, lipstick, baby lotion, and Chapstick. I also carry love notes, notes from friends, and money in my Tinkerbell wallet. Another thing I carry is very important to me. This thing is my cell phone that sits in my pocket, inside my purse.
>
> In this purse I also carry dreams that become memories. Some dreams have come true, and now they can't be considered a dream any more. Now it's a memory that I can cherish for the [rest] of my life. I also carry questions about who's going to act like my friend or what's going to happen in class. I also carry my success and my reputation. I carry my success of being at school every day of the year and making good grades. I also carry my hope with me everywhere I go, inside my purse. I carry all these tangible and intangible things in my purse that means so much to me.

In Madison's words there is a social quality to the emotions tied to the objects she described. That is, her notes and cell phone join her memories, questions, success, and reputation. She "cherish[ed]" her memories and dreams, and she valued the vessel that carried these dreams as the "purse that means so much to me." With both Rachel's and Madison's essays, I see these students showing the social relationships among the personal items they held in their bags and the school and friendships they had in the classroom. These students located their emotions within the bags as well as the experiences they had in school as they cherished the memories and the "fun I had." The emotions were not simply positioned within the heads of these students; rather, emotions were part of larger social circles of people they knew both in and out of school and along a continuum of time in which they had experiences with other people. The backpack activity thus provided students with means to express their emotions and memories in both image and language. The acts of drawing and writing and later displaying the work in the room provided a social means for expressing those emotions and memories (Vygotsky, 1925/1971).

In this activity, Sherelle used drawing as a means to teach students how to blend image and emotion into compositions attendant to the literacy content of the class. That is, she taught the students to look closely at the text at hand: the backpack. She also invited them to first consider their own emotional connections to the text by means of exploring the physical weight of their bags and, then, secondly, the bag's psychological weight. Siegesmund (1999, 2005) argues that this lesson encourages students to consider visual and emotional qualities in a specific and focused way that allows students to make connections that might not be possible if they were not given time to look, to draw, and to write. In other words, if students were simply to read the O'Brien (1992) short story and write an essay about the things they carried, they may not make the emotional connection with the intangibles. Vygotsky (1925/1971) posits that art is a social expression of emotion. Sherelle's goal for the backpack activity was to teach explicitly how to attend to both visual and emotional details in a familiar object. The resulting compositions of drawing and writing were a public expression of what students could see, feel, and describe in language and image. These image/essay compositions connected physical, concrete objects with emotional, abstract sensations that the students encountered during their sixth grade school experience. As a culminating activity, the backpack lesson was a rendering of what the students brought with them and, possibly, learned during their 180 days of life as sixth graders.

Learning from a Teacher Building Relationships among Images and Language

The three lessons I present in this chapter illustrate one teacher's path toward building a curriculum for teaching literacy that embraced visual art. Rather than being duplicative work, the drawings produced in Sherelle's class and the attention given to perceiving the visual space of the classroom represented extensions to the curriculum (Eisner, 2002) and opened the door for students to include their emotions in their schoolwork. This was not a sterile classroom in which literature and writing were divorced from the rich, emotional, and creative lives of the students who filled the desks and chairs each day. Rather, this was a classroom in which perceiving was valued, feeling was embraced, and writing became more than simply putting words on paper.

Skeptics who may worry and trouble the intrusion of emotion and drawings in a language-based literacy classroom may find difficulty in accepting the value of the work by Sherelle and her students. Sherelle herself worried about this same issue. What might happen if someone, like a principal or a parent or

a veteran teacher, were to come into the room and observe the students using markers and crayons as tools for their compositions? This question was one that she brought up on several occasions as she worked through her first years of teaching. The solutions she came up with were to carefully document the connections between her lessons and the state standards for performance in sixth grade and to anticipate potential skeptics with rationales written into her lesson plans and in her mind. She told me that as a teacher making these kind of moves, she needed to be sure that she could explain to anyone walking into her classroom that she knew the value of the lessons, that these lessons represented a mindful approach to teaching literacy, and that these lessons were necessary for the success of her students. By mindful approach, I mean that students in Sherelle's classroom were given multiple opportunities and multiple means for expressing their ideas, questions and solutions to problems. In this way, a mindful approach to curriculum is a semiotics-based approach that values communication with and beyond language in ways that are fruitful for the development of thoughtful adolescents.

Sherelle did not teach her class in a vacuum, nor did she seek to isolate herself as a rogue teacher trying to change the world from behind a closed door. Rather, she sought the advice and support of other teachers both in and outside of the school as consultants for her ideas about teaching reading and writing with drawings. With the help of an art teacher she knew, she developed several lessons that had originally been designed for middle school visual arts classes. Sherelle's twist on these lessons was to connect the drawings with readings from literature. Instead of simply teaching students the details of self-portraits, she taught the students to transform images of themselves into the imagined faces of characters in novels. In this move of transforming a visual art lesson into an arts-based literacy lesson, I see Sherelle's creativity of thinking at work.

In Sherelle's classroom, in which thoughtful composition is fostered, creativity was valued for both student work and teacher work. That is, vocabulary was not taught simply as a language lesson to be replicated in sentences and essays, on tests and in homework. Rather, vocabulary became part of the spatial defining of the classroom space. Students could name and describe the objects and ideas surrounding them in their environment. Sherelle's inclusion of the Word Web Spider in her curriculum prompted students to play with the multiplicity of definitions that a word can have as well as the multiplicity of meanings that an object can have. The spider was not simply a spider on the wall, it was vast, ludicrously so, and it was anthropomorphized to feel perturbed at having inedible words in its web, and it evoked emotions of fear, or a cringe, in the students who looked upon it.

Emotions of students were valued in this classroom alongside their multiple attempts to figure out how to solve problems of language, of ways of describing something or someone. When the students "Harrison Bergeronized" their classmates and drew portraits of Harrison, they expressed their solutions through gesture, image, and language. They played with costumes, colors, shapes, and words to come up with their developing understandings of what a handicap is, could be, and was portrayed as in the Vonnegut short story. There was no single solution to find, no magic answer to tease out of the teacher; students in this classroom worked together and independently to come up with their own solutions and then shared them publicly with each other.

At the end of the year, when Sherelle presented the backpack lesson, they reflected on the course of their experiences. Sherelle directed their attention to a physical object to spend time perceiving an object that had traveled them as they communicated in multiple sign systems in her class. The contents of their drawings and essays were entirely of their own experiences in school. Their stories of what they carried mattered as the source for writing, just as their understandings of the vocabulary words placed around the room and their interpretations of Harrison mattered in lessons earlier. Moreover, in this space in which multiple modes of thinking through language, image, and gesture were valued, both the students' and Sherelle's emotional engagement with the curriculum were important components of the cognitive plurality in the curriculum (John-Steiner, 1995). In this classroom, emotions and writing, and literature were given time to play in the thinking of the students and the teacher. Ideas and language were in play in this space, and the result was a rich classroom environment in which expression brought together imagination and feeling.

References

Baumgarten, A. (1961). *Aesthetica*. Hildesheim: G. Olms. (Original work published 1750)

Connery, M. C. (2006). *The sociocultural-semiotic texts of five and six year old emergent biliterates in non-academic settings*. Unpublished doctoral dissertation, University of New Mexico.

Eisner, E. W. (2002). *The arts and the creation of mind*. New Haven, CT: Yale University Press.

John-Steiner, V. (1995). Cognitive pluralism: A sociocultural approach. *Mind, Culture, & Activity*, 2(1), pp. 2-11.

O'Brien, T. (1992). The things they carried. In J. C. Oates (Ed.), *The Oxford book of American short stories* (pp. xiv, 768). New York: Oxford University Press.

Siegesmund, R. (1999). Reasoned perception: Aesthetic knowing in pedagogy and learning. In L. Bresler & N. C. Ellis (Eds.), *Arts and Learning Research, 1998-1999. The Journal of the*

Arts and Learning Special Interest Group of the American Educational Research Association (Vol. 15, pp. 35-51). Washington, DC: American Educational Research Association.

Siegesmund, R. (2005). Teaching qualitative reasoning: Portraits of practice. *Phi Delta Kappan,* 87(1), 18-23.

Silverstein, S. (1974). *Where the sidewalk ends: The poems & drawings of Shel Silverstein* (1st ed.). New York: Harper & Row.

Smagorinsky, P. (2001). If meaning is constructed, what's it made from? Toward a cultural theory of reading. *Review of Educational Research, 71*(1), 133-169.

Smagorinsky, P., & Taxel, J. (2005). *The discourse of character education: Culture wars in the classroom.* Mahwah, NJ: Lawrence Erlbaum.

Suhor, C. (1984). Towards a semiotics-based curriculum. *Journal of Curriculum Studies, 16,* 247-257.

Suhor, C. (1992). Semiotics and the English language arts. *Language Arts, 69,* 228-230.

Sumara, D. J. (1996). *Private readings in public: Schooling the literary imagination.* New York: Peter Lang.

Vonnegut, K. J. (1961). Harrison Bergeron. [Short story]. *Magazine of Fantasy & Science Fiction* (October), 5-10.

Vygotsky, L. S. (1971). *The psychology of art* (Scripta Technica, Trans.). Cambridge, MA: The M.I.T. Press. (Original work published 1925)

Creating Developmental Moments:
Teaching and Learning as Creative Activities

Carrie Lobman

The most valuable learning occurs when people are engaged creatively—in activities that allow them to use their imaginations intellectually, socially, artistically, and culturally (Egan, 2005; Eisner, 1999, 2005; Greene, 1988; Holzman, 2009). Learning in the absence of creative engagement can be said to more closely resemble what animals in a lab are able to accomplish than the rich meaning-making activity of which human beings are capable. Most current educational theories recognize this and focus in one way or another on the importance of preparing children to be critical, flexible thinkers who are able to act creatively in the face of a rapidly changing world (Bruner, 1990; Dewey, 1938, Eisner, 1999, 2005; Greene, 1988; Vygotsky, 1978).

The recognition of the importance of creativity has led many educators to advocate for including the arts in education (Eisner, 1999, Hoffman–Davis, 2005). According to Eisner (1999):

> [Schools] ought to include significant opportunities for students to experience the arts and to learn to use them to create a life worth living. Indeed, providing a decent place for the arts in our schools may be one of the most important first steps we can take to bring about genuine school reform (p. 86).

From this perspective the arts are thought to provide an antidote to the narrow educational priorities of current policies that focus primarily on an understanding of human learning as the accumulation of knowledge and on a definition of cognition as separate from aesthetics and emotionality. Despite strong evidence that the arts support rather than hinder learning (Catterall, 2002; Deasy, 2002; Herbert, 2004; Murfhee, 1995), creative programs are al-

ways vulnerable to being cut for economic reasons or because of low test scores in what are considered the academic subjects. Creative arts programs are also far more likely to be found in schools that serve middle and upper class students, while their urban counterparts are engaged in memorization and "drill and kill" test preparation (Kozol, 2005). Overall, programs that relate to creativity as a push-in or supplemental activity have failed to transform the day-to-day experience of learning for the vast majority of American school children. As we enter the second decade of the 21ˢᵗ century, most children, particularly poor children and children of color, are essentially being taught the same way today as they would have been a hundred years ago.

There are, however, those who advocate for a larger shift in our understanding of the relationship between creativity and learning (Lobman & Lundquist, 2007; Newman & Holzman, 1993; Holzman 1997, 2009) and therefore a larger shift in what creativity might look like in schools. Rather than creativity and imagination being something to bring into teaching and learning (thus bringing the arts into schools), educators are urged to look at teaching and learning themselves as creative and imaginative activities that children and teachers need to be engaged in together.

A Word About Creative

A deconstruction of the word *creative* can be helpful in understanding the difference between supplementing the curriculum with the arts and creating a cultural, artistic methodology of teaching and learning. According to the *American Heritage Dictionary* (2009) creative has two definitions:

1. Having the ability or power to create: *Human beings are creative animals.*
2. Characterized by originality and expressiveness; imaginative: *creative writing.*

When people advocate for bringing the arts into schools it is the second definition, that of originality and expressiveness, that is usually invoked. However, from the perspective of teaching and learning themselves being creative arts, it is the first definition of having the ability or power to create that is most important. Originality and expressiveness can be wonderful characterizations of some of the things human beings can create, but it is the human ability to make things, to build, to develop—especially in its most mundane forms—to create a conversation, a picnic, or a lesson about angles that is missing in most schools. Whether what is created is original or completely ordi-

nary is secondary to the importance of teachers and students being the crea-tors of the environments that they share.

What can it possibly mean for ordinary creativity to be missing from schools? On the one hand, teachers and students are obviously creating to-gether all the time. What else could they be doing? On the other hand, at this point in human history most people have become alienated from their creative abilities. It is possible to go through life as if one is playing out a script in an already written play rather than engaged in the task of continuously using the materials available to collectively create with other people. There is a tendency to relate to environments as if they were fixed or pre-determined, and to see people as *being in*, rather than *creating* the environment.

In schools, an institution that is determined by centuries of beliefs about what teaching and learning should look like, the alienation from our creative ability can be particularly strong. This alienation means that in many cases teachers and students are unaware that they are creating anything together, and, when they are aware, they often do not have the tools to break out of stagnant and unhelpful scripts to create new ways of relating to each other and to what is to be learned.

In fields other than education, for example, in business, there has been recognition in recent years that people who are active builders and creators of the work environment are the best learners and therefore better at their jobs (Barrett, 1998; Hosking, 1988). In youth development and outside of school learning programs, people have recognized that young people who are actively involved in building or creating their own programs are more likely to grow and develop (Farmer, 2008; Feldman & Silverman, 2004; Heath, 2000; Gordon, 2002; Gordon, Bowman, & Mejia, 2003). In these cases, there is a focus on the first definition of creativity—having the ability or power to cre-ate—and this supports people to be the producers and creators of their work and lives and not just the passive consumers of scripted performances.

In education, as was stated previously, to the extent that creativity is part of the conversation at all, the focus has been on creativity in the sense of originality and expressiveness as something special and unique. One of the by-products of the emphasis on expressiveness is that creativity has been vulner-able to being set up as being in opposition to learning. We are either learning which is about acquiring knowledge and skills and is not a creative activity. Or, we are being creative which is about producing something unique or spe-cial, but is not necessarily about learning.

So how can we understand the relationship between creativity and learn-ing if it is not an oppositional one? One option is to understand the relation-ship as dialectical. Learning is inseparable from the activity of *creating* the

environment for learning. From this perspective creativity does not reside in the products of learning, but in the dialectical relationship between the process of creating the environment for learning and what is created.

A Postmodern Vygotskian Perspective

A dialectical perspective on the relationship between creativity and learning is deeply rooted in Vygotsky's (1978) understanding of the relationship between learning and development. According to Vygotsky, "learning and development are interrelated from the child's first day of life" (1978, p. 84), and are part of a dialectical, emergent process where learning leads, supports, and is inseparable from overall human development. One of Vygotsky's greatest contributions to educators was to demonstrate that development, rather than being the unfolding of a series of maturational stages, is an activity that human beings *create* socially and culturally: "Human learning presupposes a specific social nature and a process by which children grow into the intellectual life of those around him" (p. 88). His work reveals learning as a continuously emergent social activity that is dialectically tied to development, quite different from the standard dualistic model of an individual learner acquiring objective knowledge.

Vygotsky is perhaps best known for introducing the zone of proximal development (ZPD), a concept that helps us to understand the learning-leading-development activity. While there are multiple characterizations of the ZPD in Vygotsky's writings (Newman and Holzman, 1997; Holzman, 2009), most contemporary educators have defined it as an instructional tool whereby a more developed adult or peer provides just enough support for a less developed child to do something they could not do independently (Bodrova & Leong, 1996; Rogoff, 1984; Wood, Bruner & Ross, 1976). Newman and Holzman (1993, 1997) move beyond an instrumental definition of the ZPD. They see the ZPD as a creative, improvisational activity. It is the activity of people creating environments where children (and adults) can take risks, make mistakes, and support each other to do what they do not yet know how to do. Rather than being a tool for learning discrete pieces of information, "the ZPD is the ever–emergent and continuously changing 'distance' between being and becoming. It is human activity that gives birth to and nurtures the ZPD and, with its creation, human learning and development" (Holzman, 2000, p. 5).

From Newman and Holzman's (1993) perspective the ZPD is not a technique or even a distance. It is an activity that people engage in collectively. By participating in creating environments where development can occur, people

develop. This view of the zone of proximal development shifts the focus away from the learning that is occurring *in* the ZPD and toward the active creation *of* the ZPD. The ZPD is not an instrumental tool for learning particular things but is more a "tool and result" activity (Newman and Holzman, 1993, pp. 86–89). The activity of creating the ZPD, of creating the environment for development, is inseparable from the development that occurs.

In some ways this is very simple, but in a society where learning is seen as a commodity to be acquired, it can be difficult to imagine what a creative ZPD might look like. Vygotsky (1978) provided an example when he described the pretend play of young children as a ZPD.

> Though the play-development relationship can be compared to the instruction-development relationship, play provides a much wider background for changes in needs and consciousness. Action in the imaginative sphere, in an imaginary situation, the creation of voluntary intentions, and the formation of real-life plans and volitional motives—all appear in play and make it the highest level of preschool development (pp. 102–103).

According to Vygotsky, while all play contains both rules and an imaginary situation, the relationship between the two in pretend play is the reverse of what it is in other, more rule-governed types of games. The rules in pretend play are not imposed from the outside, nor are they preconditions for the play to occur. Instead the rules are in the service of the imaginary situation, and the imaginary situation brings into existence the need for rules. In play children are the active creators of both the rules and the imaginary situation. This is important because, as Vygotsky pointed out, children are able to follow the rules they create in play long before they are able to follow the rules created for them in the rest of their lives. As active creators and rule-makers, children are able to go beyond their current level of development. According to Newman and Holzman (1993), children in play are both who they are and who they are becoming.

This brings us back to the distinction between the two definitions of the word "creative". Anyone who has played house or superheroes with a four-year-old recognizes that pretend play is not necessarily creative in the sense of being unique or distinctive. Children often play the same thing over and over again, or they copy stories or characters from TV or books. The play of young children is creative because the children who are engaging in it are actively creating it, not because the content or the product of the play is particularly original. In play, children are not alienated from their creative abilities. Rather than being passive recipients of knowledge, they are the active creators of the very activity that produces opportunities for learning and development. While

Vygotsky did not say that pretend play should be a model for how people learn and develop throughout the lifespan, others have documented the value of this kind of active, creative, environment-building in many areas of life, including learning that takes place outside of school (Farmer, 2008; Gordon, Bowman, & Melija, 2000), therapy (Holzman, 2009; Newman, 2009), and professional development (Holzman, 2006; Salit, 2003).

One way to understand what is happening when ZPDs are created is that people are performing. Performance obviously has many meanings, but one way to understand it is as our human ability to be who we are and who we are not simultaneously. Similar to Vygotsky's (1978) description of when young children play, when older children and adults perform, they do not stop being who they are but are neither constrained by who they are. Newman and Holzman (Newman, 2003; Newman & Holzman, 1993; Holzman, 1997, 2009) argue that our ability to perform is too valuable a tool to only be used on the stage. From their perspective, human beings are active creators of their development by virtue of the capacity to perform, that is, to be simultaneously who we are and who we are not. In this understanding of performance, pretending, playing, and imagining are essential to emotional, social, moral, and cognitive development.

If we see the ZPD as a collective life activity, then it has the potential to change how we see teaching. If learning itself is seen as a creative activity, meaning human beings actively create it, then what is needed to reinitiate learning and development is not remediation, but to engage students and teachers in the playful activity of creating environments for learning and development to occur. The focus shifts from the products of those environments to the dialectical relationship between what is to be learned and the creating of the environment for learning and development.

Creating Developmental Moments in the Classroom

Almost a century after Vygotsky developed his theory, schools still remain committed to a view of learning that separates it from development. Rather than supporting the totality of the emotional, cognitive, cultural, and social development of young people, schools are overly fixated on children acquiring (or failing to acquire) knowledge and skills. Most schools are not places where children (or teachers) are rule or environment creators. Rather than being places where young people are actively engaged in the developmental activity of creating the environment for learning, in school many children become

alienated from their ability to create (an activity that most of them engaged in as preschoolers) and therefore to learn.

A major shift in educational policy would have to occur for schools to transform into environments where young people are fully engaged in the activity of creating development. While there are changes taking place in many places (i.e., through charter schools and arts-based learning initiatives), system wide change does not seem imminent. This has led many people who care about the development of young people to turn to outside-of-school learning environments. These informal learning programs have more freedom to provide young people with opportunities to be active creators (Gordon, 2002; Heath, 2000). However, teachers and students still spend the vast majority of their day in schools, and it is important to find ways to infuse some development into those environments as well.

Even though the culture of schools is rarely creative, it is possible for teachers to seize or create developmental moments even in the midst of traditional learning environments. These are moments when children and teachers can go beyond the scripted curriculum or proscribed objectives and create opportunities for everyone to be active creators of their learning and development. This requires stepping out of the script of schooling or creating something new with the script which gives children a sense of themselves as creators.

Becoming Developmentalist Educators

I had a teacher friend who once described to me how, after the tenth time of reprimanding a child for disrupting a math lesson, he launched into the exact same tirade in gibberish and then went right back to what he was teaching. The child and the class stared at him for a few seconds, but according to him it created a more creative environment in the class (at least for a few moments). I do not think moments like these are that unusual. While schools are not particularly developmental environments, they are filled with human beings who find ways to have and create moments of ordinary creativity even under constraining conditions. These moments of shared creativity can be developmental for everyone involved because they give people the experience of being connected to themselves as creators.

While moments like these can occur spontaneously, it is also possible for teachers to learn to look for such moments and to capitalize on them when they occur. The remainder of this chapter will describe the work of myself and two other educators who have been trained in the social therapeutic approach of Newman and Holzman (Newman, 2003; Newman & Holzman,1993;

Holzman & Mendez, 2003) at the East Side Institute (ESI) in New York City. The ESI is an independent non-profit that has been developing non-traditional approaches to learning since the late 1970s. Over the years, the ESI has developed its understanding and practice called social therapeutics through a number of programs including a therapeutic approach, an independent elementary school, and through its close relationship with several outside-of-school youth development programs (for more on these programs see Holzman, 2009). All of these programs receive no support or payment from the schools; they are independently supported by private donations and volunteer labor.

For many years, the ESI trained teachers in social therapeutics through a combination of one-time workshops, short-term classes, ongoing supervisory groups, and informal mentoring. In 2006, during an attempt to widen the influence of the approach, the director of the Institute asked me to launch the Developing Teachers Fellowship Program, a year-long training for New York City area teachers who are already certified and are currently working in public schools. All of these teacher training programs are based on the understanding that learning leads development, and that the human ability to perform (to be who we are and who we are becoming) is what makes qualitative transformation possible. The teachers whose stories are included in this chapter have learned to seize and create developmental moments in the midst of institutional and curricular constraints. These moments can be mundane or they can be heightened moments of emotionality. What they have in common is that, at least momentarily, the teachers and students are using their human ability to create.

Creating a Chess Learning Environment

I taught preschool for many years. The children in my class ranged from 3½ to 5 years of age. After I had been teaching for several years, I had a child in my class who was gifted in many ways. At four years of age he had a well-developed understanding of numbers (he could add, subtract and do simple multiplication in his head) and he could play chess. While he was not what you would call a prodigy, he knew how to play the game with some level of sophistication. He knew how all the pieces moved, could play a complete game, and had some understanding of strategy and how to see the whole board. He was, not surprisingly, the only child in the class who could play chess, and while I knew how the different pieces moved, he was well in advance of my co-teacher and me.

This raised an interesting question for me. In the past when I had a child who was unusually good at something, I had tended to relate to the talent as located within and belonging to the child. Robert's skill at math and chess was what made him unique, and my job as a child-centered preschool teacher was to find the appropriate way to teach him given who he was. I would provide Robert with special activities that would challenge him to go further in his area of strength, or I would admire his chess playing as an isolated skill and work on teaching him about the things that he was less good at (in this case social skills). I tended to look at these strengths individually, as something that was special about that particular child, but did not have much to do with the rest of the class or the learning environment as a whole.

At the point at which Robert was in my class, I had come to feel the limitations of the child-centered teaching approach. While I could not easily identify what was frustrating, I felt that the children and I had more to offer each other than was possible while I was trying to meet the needs of 23 individuals. I later came to describe it as feeling like a waitress at a crowded restaurant. I was trying to provide all of the children with appropriate experiences, and in the course of this challenge, I was teaching them to be consumers of learning, not producers or creators.

When Robert was in my class I had just started taking improv theatre classes as part of my training in social therapeutics at the East Side Institute, and this led me to begin to see the class and teaching in a new way. Improv, like you might see on TV or in a comedy club, is a performance art where an ensemble collectively creates scenes or stories without a script. The ESI uses improv to help people develop as environment creators because it focuses on the ensemble and draws attention to our human ability to create without being overly focused on the products of that creation (Lobman & Lundquist, 2007).

One of the most important changes was that I began to see the class as an improvisational ensemble rather than as a collection of individuals. While most preschool teachers are concerned with helping children learn to work and play together, as an improviser I had come to understand that task in a particular way. In improv the job of each performer is to make the ensemble look good. From this perspective, individual talent, ideas, and even mistakes are the material by which the ensemble creates the show. Creativity in improv is the process by which the collective uses everything available to create something new. While individuals may appear funny or talented, it's the effort of the ensemble that is understood as paramount. In improv classes, teachers stress the skills of listening and supporting, rather than being able to produce the funny comment or gag.

As I came to see the class as an improv ensemble and myself as one of the performers, I began looking for offers the children were making that could be useful to the development of the class. In that context, Robert's chess playing appeared as an opportunity. I decided to see if we could use Robert's skills to support the development of the class as a whole and to create an environment for everyone to develop, not just as chess players, but also as learners and teachers. In this context I was less interested in whether the children learned chess and more interested in having the children participate in creating an environment where Robert could teach us to play chess. The focus was not on the end product but on the relationship between playing chess and playing at being learners of chess.

Over the course of several conversations, I asked Robert if he would help the class learn chess and he agreed. His mother sent in a Beginner's Chess set where all the pieces were marked with a diagram that showed how the pieces moved. Robert set up a chess center at the "table toy" table in the middle of the room, and children and teachers who wanted to learn could ask Robert to set aside time to teach them.

As in any ensemble, the members of the class brought different skills to the learning of chess. Some children were obviously not ready to learn anything resembling traditional chess. Robert and these children had to grapple with that fact. Within a few weeks, a small group of boys had created what they called Power Ranger Chess, where the pieces could "morph" into Power Rangers at any time. While Robert found this disconcerting, he was able to go along with it, and over time he actually became a fan of this kind of play. His mother even reported that he had taught his grandfather (who was his original chess teacher) this new version, and they now both enjoyed it as an alternative to the "more serious" game. There were other people, including me, who were eager to learn the more standard game. Robert, it turned out, was a very patient teacher, and by the end of the year I could even occasionally beat him at a game.

So what does this story have to do with creativity? The children, Robert included, and I had to figure out how to create the environment where he could teach us to play chess. In other words we had to create the ZPD together, and it was a social, improvised play zone, not a tool for learning a particular skill. While this was one moment in my long preschool teaching career, I think of it often. If we see learning as a commodity, then one of the things that children learn to do with what they have learned is to hold on to it and keep it for themselves. When children are particularly talented at something, this can be especially strong. Adults and other children admire their skill, but it can also lead to them being isolated from the group. However, if we see

learning and teaching as a creative process by which groups of people create the environment for development and learning to occur, then skills and knowledge get transformed into materials for the group to use and children learn to be builders and creators. Rather than being a star or a geek, Robert learned that he was a teacher and a leader and that he was capable of creating with other people.

Creating the School Script

Play is still considered a legitimate activity in most preschools, but once children graduate to elementary school, it virtually disappears as an activity teachers and children engage in together. Some stage theorists (Piaget, 1962), including Vygotsky (1978) in some respects, see pretend play as giving way to the rule-governed games of older children and adults. Additionally, some scholars argue that the pretend play of early childhood gets internalized and becomes the imagination of older children and adults (Gajdamaschko, 2005). It is the case that through pretend play children develop many of the skills they need to follow rules and play games. There does appear to be a relationship between imagination and play. However, if one understands creativity as the activity of building and creating, and the ZPD as the social creation of environments for development, then older children and adults would also benefit from being able to keep playing in the ways of young children. That is in being able to not only follow the rules but to collectively create the rules.

Jim Martinez had been trained in social therapeutics as a volunteer at a youth development program that utilized the approach. When he became a public school teacher after a career in technology and found that the environment of school was less than developmental for him and his students, he turned to the East Side Institute for further training and support. In the following vignette, Jim was teaching from a scripted curriculum, but he found a way to create with his students without abandoning the objectives that he was mandated to meet:

> I was teaching third grade in the South Bronx and I was in the middle of a unit that had us working on reading and writing scripts for plays. Ironically, this unit was on writing scripts and it was part of a scripted curriculum. I was supposed to follow the script. One day I was working on the overhead with a prepared transparency and the kids were reading along. It was in the middle of the spring semester and I remember that I was tired and bored and so were the kids. Johnny, one of my "bad" boys, started acting up in the back of the room and disrupting everything. I got really annoyed but I decided to do something other than yelling at him. I removed the scripted transparency and replaced it with a blank one and wrote:

Teacher: Sit down Johnny!

Johnny: I asked my students, "What is Johnny supposed to say." All of sudden hands started going up all over the room and Johnny's hand was up also. I picked a student and she said, "Johnny says, No!" So I wrote that down and asked what the next line would be for the teacher. Hands went up all over the room, and they told me what the next line was for teacher. We went on like that for a few more lines and I realized that they all knew this script. They knew what I would say and they knew what Johnny would say. They became very enthusiastic and we took turns writing the lines.

After we wrote the play together for a few minutes I tried to see if I could get some kids to improvise some new lines for Johnny. I asked for volunteers. I picked a "good kid" and I tried some new teacher lines on him, but he wanted to perform the "bad kid." I chose a couple of other kids and I got similar results. They were all having a good time telling the teacher off and being "bad."

If creativity involves the activity of building and making, and what we have to create with is the material of our lives, then one of the things school children and teachers can play with is school. Jim's job, from the perspective of his principal and the curriculum, was to teach the children about scripts and playwriting. Ironically, while scripts and playwriting are the stuff of traditional views of creativity, there appears to be very little that is creative about how Jim had been asked to teach them. However, Jim was also focused on his students' development as creators and builders. From this perspective he was looking for opportunities to support his students to go beyond learning skills and information and to come to see themselves as the active builders and creators of their lives.

In this vignette, Jim seized a moment of frustration to draw attention to the fact that he and the class had been creating, among other things, a script together. It appears obvious from the students' responses that they were aware of the script even if they would not have articulated it as such. By making the script public Jim posed a challenge to the children; rather than automatically playing out this conflict, they could play with it. Instead of everyone playing out their individual parts, they could create a collective performance. They could use Johnny's "bad behavior" and Jim's annoyance as material to create something new together. At the end of the vignette, Jim appeared to want the children to try and improve the script, to create a less combative situation or to get Johnny to see he doesn't have to be a "bad boy." However, the children did not want to go in that direction, and Jim did not relate to this as a failure. Instead, in this moment, the "new" script they created looks just like the old script, but it is also completely different by virtue of being played with and consciously created.

Improvising New Performances

Often there is very little creativity in adult–child relationships in school. Students do things that push teachers' buttons, and teachers react to students based on an abstract notion of discipline, rather than creatively in the moment. In general, the relationship between students and teachers (particularly as children enter the middle grades) is often scripted: the roles of teacher and student are clear and the range of responses allowed to either role is quite limited.

Rachel Farmer is a graduate of the East Side Institute's Developing Teachers Fellowship Program. Some of the tools the program makes use of are the improv games that performers use to warm-up before a show and to practice the skills of identifying and creating with others. In the following example from her 4th grade class, Rachel used the Relationship Game to support her students to be powerful rather than victimized when they felt that teachers were treating them unfairly. In the Relationship Game, two participants are given a relationship (i.e., sisters, doctor/patient, teacher/student) and a first line (i.e. "You stole my wallet," "I hate pistachios"). The participants then perform the scene over and over again, each time starting with the same first line, but improvising many different conversations in response to that line. The repetitiveness of the activity often helps participants discover responses they did not know were possible and to go beyond their ordinary reactions to create something new:

One particular afternoon a student named Ariana came into class very upset with another teacher in the school. She was upset because she felt that the teacher does not listen to her, is unfair, and doesn't let her use the restroom. The list went on. I decided on the spot (which has been something I had been learning to do more often) to play the Relationship Game with her and to use the relationship of teacher-student as the premise of the game. She chose someone to do the performance with her and we selected the first line of, "I need to go to the bathroom." Ariana performed the scene three times and every time we discussed it. The class pointed out that every time she performed it the words she used were different but the anger was the same throughout. The class said that, "The feeling in all performances was similar." Natalie, the girl who performed with Ariana, attempted to change the tone of the performance but it was obvious that Ariana couldn't go with it.

This was fascinating to discuss with the [class]. We decided collectively to ask two different people to perform the same scene. The scene was performed three times very differently which led to more discussion on the power of performance in our lives. After we played the game, Ariana was still under the impression that her teacher would not be able to respond to any new performance she came up with. The class suggested that Ariana could try out new performances of herself without waiting for the teacher to change (Lobman, 2009, personal notes).

Rachel related to her students as performers and creators of their lives. In this vignette, she created an environment where the class could play with some new ways of relating in challenging situations. While Ariana may have felt that she was incapable of providing leadership to an authority figure, Rachel provided her and her classmates with an opportunity to see how they could take more responsibility for their relationships with teachers. Emotions are often related to as unchangeable or reactive, not creative. However, in this vignette, Rachel and her students played with emotions in a way that related to them as fluid and changeable rather than fixed. She taught the children that they had the option of being creative in situations where they are feeling reactive and where the circumstances appear to be beyond their control.

Conclusion

Inner city schools often relate to children and teachers as consumers of knowledge, and the evidence is that many children fail to learn under these conditions. However, from the Vygotskian perspective presented in this chapter, human beings are not primarily consumers or even knowers; we are creators, producers, and performers. We are the creators of our lives, our learning, and our development. The teachers in this chapter work in a large urban school system that is not known for its creativity, and yet they have managed to seize moments where they are able to create with their students in some small but significant ways. Through their training in social therapeutics, these teachers have learned to see themselves and their students as creative beings. These creative moments are not a negation of the school environment or the mandated curriculum but involve the teachers making use of the materials from those environments to create something new and hopefully more developmental for themselves and their students.

I am a fan of the products of creativity—of an extraordinary piece of music, a beautiful dance, and a hilarious comedy. And I believe schools would be much more humane places if students were given plenty of opportunities to practice these art forms and others. However, I also have a passion for the ordinary, everyday forms of creativity such as creating conversation, cooking a meal, or learning to spell. As a teacher and teacher educator, I strive to teach people that they do not have to wait for creativity to be inserted into the curriculum, that they can relate to all of life, including teaching and learning, as creative activities. They can provide their students with the developmental experience of creating in mundane and ordinary ways with the materials available to them. While the examples presented in this chapter can be seen as the

products of these creations, I also hope that the readers of this book will choose to relate to what is written as material for an ongoing creative process of their own.

References

Barrett, F. (1998). Creativity and improvisation in jazz and organizations. *Organization Science*, 9(5), 605–622.

Bodrova, E., & Leong, D. J. (1996). *Tools of the mind: The Vygotskian approach to early childhood education.* Englewood Cliffs, NJ: Merrill/Prentice Hall.

Bruner, J. (1990). Acts of meaning. Cambridge, MA: Harvard University Press.

Catterall, J. (2002), Involvement in the arts and success in secondary school. In R. Deasy (Ed.), *Critical links: Learning in the arts and student achievement and social development.* Washington, DC: AEP.

Creative. (2009). *The American Heritage® Dictionary of the English Language, Fourth Edition.* Retrieved June 9, 2009, from Dictionary.com.website: http://dictionary.reference.com/browse/creative

Deasy, R. (Ed.) (2002). *Critical links: Learning in the arts and student achievement and social development.* Washington, DC: AEP.

Dewey, J. (1933/1998). *How we think* (Rev. ed.). Boston, MA: Houghton Mifflin Company.

Dewey, J. (1938). *Experience and education.* (The Kappa Delta Pi lecture series, n. 10). New York: Simon & Schuster.

Egan, K. (2005). *An imaginative approach to teaching.* San Francisco: Jossey-Bass.

Eisner, E. (1999). *The kinds of schools we need: Personal essays.* Portsmouth, NH: Heinemann.

Eisner, E. (2005). *Re-imagining schools: The selected works of Eliot Eisner.* London: Routledge.

Farmer, E. (2008). From passive objects to active subjects: Young people, performance and possibility. *Journal of the Community Development Society, 39*(2), pp. 60–74.

Feldman, N., & Silverman, B. (2004). The let's talk about it model: Engaging young people as partners in creating their own mental health program. In K. E. Robinson (Ed.), *Advances in school-based mental health, best practices and program models.* New Jersey: Civic Research Institute.

Gajdamaschko, N. (2005) Vygotsky on imagination: Why an understanding of the imagination is an important issue for schoolteachers. *Teaching Education, 16*(1), 13–22.

Gordon, E. (2002, March). The idea of supplementary education. *Pedagogical Inquiry and Praxis: Informing the Development of High Academic Ability in Minority Students, 3,* 1–3.New York: Teachers College, Columbia University, Institute for Urban and Minority Education.

Gordon, E., Bowman, C., & Mejia, B. (2003). *Changing the script for youth development: An evaluation of the All Stars Talent Show Network and the Joseph A. Forgione Development School for Youth.* New York: Institute for Urban and Minority Education, Teachers College, Columbia University.

Greene, M. (1988). *The dialectic of freedom.* New York: Teachers College Press.

Heath, S. (2000). Making learning work. *Afterschool Matters, 1*(1), 33–45.

Herbert, D. (2004). Finding the will and the way to make the arts a core subject: Thirty years of mixed progress. *The State Education Standard, 4*(4), Washington, DC: National Association of State Boards of Education.

Hoffman-Davis, J. (2005). *Framing education as art: The octopus has a good day.* New York: Teachers College Press.

Holzman, L. (1997). *Schools for growth: Radical alternatives to current educational models.* London: Lawrence Erlbaum Associates.

Holzman, L. (2000). Performative psychology: An untapped resource for educators. *Educational and Child Psychology, 17*(3), 86–103.

Holzman, L. (2006). Lev Vygotsky and the new performative psychology: Implications for business and organizations. In D. M. Hosking and S. McNamee (Eds.), *Organisational behaviour: Social constructionist approaches.* Oslo, Norway: CBS Press.

Holzman, L. (2009). *Vygotsky at work and play.* London: Routledge.

Holzman, L., & Mendez, R. (2003). *Psychological investigations: A clinician's guide to social therapy.* London: Routledge.

Hosking, D. (1988). Organizing, leadership and skilful process. *Journal of Management Studies, 25*(2), 147–166.

Hosking, D., Dachler P., & Gergen, K. (1995). *Management and organization: Relational alternatives to individualism.* Aldershot, UK: Avebury.

Kozol, J. (2005). *The shame of the nation: The restoration of apartheid schooling in America.* New York: Three Rivers Press.

Lobman, C., & Lundquist, M. (2007). *Unscripted learning: Using improv activities across the K-8 curriculum.* New York; London: Teachers College Press.

Murfee, E. (1995). *Eloquent evidence: Arts at the core of learning.* Washington, DC: National Assembly of State Arts Agencies.

Newman, F. (2003). *Performance of a lifetime.* New York: Castillo International.

Newman, F. (2009). Where is the magic in cognitive therapy? (A philo/psychological investigation). In R. House & L. Lowenthal (Eds.), *Against and for CBT towards a constructive dialogue?.* Ross-on-Wye, UK: PCCS Books.

Newman, F., & Holzman, L. (1993). *Lev Vygotsky: Revolutionary scientist.* New York: Routledge.

Piaget, J. (1962). *Play, dreams and imitation in childhood.* New York: W.W. Norton.

Rogoff, B., & Gardner, W. P. (1984). Guidance in cognitive development: An examination of mother-child instruction. In B. Rogoff & J. Lave (Eds.), *Everyday cognition: Its development in social context* (pp. 95–116). Cambridge, MA: Harvard University Press.

Salit, C. R. (2003). The coach as theater director. *Journal of Excellence, 8*, 20–41.

Vygotsky, L. (1978). *Mind in society.* Cambridge, MA: Harvard University Press.

Wood, D. J., Bruner, J., & Ross, G. (1976). The role of tutoring in problem solving. *Journal of Child Psychology and Psychiatry, 17*(2), 89–100.

A Cultural-historical Approach to Creative Education

Ana Marjanovic–Shane
M. Cathrene Connery
Vera John-Steiner

Ana Marjanovic–Shane
M. Cathrene Connery
Vera John-Steiner

A t the start of this book, we posed the question of why the arts have been neglected by those interested in human development. This inquiry is of significant importance to educators, administrators, and policy makers responsible for the future of our society. If our country is to produce innovative and critical thinkers, creativity cannot be viewed as a luxury or an easily eliminated curricular add-on. We argue that, in order for reform and progress to occur in all educational ventures, we must expand our definitions of learning.

We assert that the very nature of learning is creative. In order for authentic, long-lasting, and meaningful learning to take place, we must understand education as a cultural, systemic form of meaning making. In many schools today, learning and creativity are dichotomized. Ironically, creativity among students and teachers is often suppressed. What we teach and how we teach it are frequently divorced from learning because we do not consider our instructional and curricular engagements as the socializing or cultural practices they prove to be.

We claim that when children are actively involved in meaning making the "not here" and "not now" abstractions of history, humanities, and the social sciences and when students are engaged in imagining novel conceptual relationships in mathematics and the physical and natural sciences, they are participating in creative activities. Creative educational practices mobilize children's whole beings and lived experiences to lead, lift, and inspire their development.

The poet Ralph Waldo Emerson once advised to hitch our wagons to a star. Toward this end, creativity must become the central quality of all educational endeavors. Therefore, we introduced our readers to the thinking of L.S. Vygotsky, a scholar whose work originated in and investigated the creative life of the mind. In the twelve chapters that followed, researchers, artists, and practitioners use his framework to illustrate the innovative, integrated nature of thought and emotion as well as the indivisibility of multimodal meaning making or learning realized in play, imaginative processes, and the arts.

In this chapter, we discuss popular myths surrounding creativity that conflict with the merit of arts-based programs. We explore creative projects seeking to promote the learning, development, and well–being of children and adults based on Vygotskian theory. We additionally offer a cultural-historical approach to creative education derived from the work of Vygotsky and our authors, to emphasize teaching and learning as creative, collaborative processes. We highlight that these reciprocal processes originate within, are sustained by, and simultaneously generate novel purposes in human relationships. Finally, we argue that creativity and the arts play a fundamental, if not pivotal role, in education and society.

Popular Myths of Creativity

When Albert Einstein stated that imagination was more important than knowledge, the great scientist targeted one of the many pervasive, popular myths regarding creativity. Our greatest private and public accomplishments— whether small everyday achievements attributed to creativity with a lower case "c" or the great works of art and innovation representative of Creativity with a capital "C"—require a balance between and among multiple forms of knowledge and imaginative processes. Unfortunately, fictitious dichotomies in our larger conversations serve to separate these thought processes from the totality of human experience, preventing us from understanding them as integrated and holistic phenomena. In this book, Carrie Lobman indentified the false dichotomy between learning and creativity as distinctly cognitive or affective activities. Lois Holzman further recognized the currently accepted distinction between learning and play. While multiple factors can be identified as the source of these popular myths, Rabkin & Redmond (2004) attribute these false dichotomies to the "historic tension between education and the arts" (p. 2). As Wakeford (2004) observes, "the figure of the scientist has held claim to the mantle of empirical inquiry, reason, and cognition, [while] the artist has

stood as the embodiment of subjectivity, spontaneity, and imagination" (p. 81).

As a result, schools have been traditionally seen as institutions that nurture the intellect, effort, and reason as opposed to the emotions, play, and imagination. The deep rift between science and mathematics, on one hand, and the arts and humanities, on the other, is founded on faulty thinking that polarizes logic and intuition, truth and relativity, as well as practical and theoretical activities. In our technological, materialistic culture, negative values have been assigned to creativity. Tragically, the development of the imagination and creative expression are often seen as unworthy, expensive, or frivolous goals in education. Despite over two centuries of psychological and educational research to the contrary, play, exploration, and inquiry have been demoted and rendered inconsequential and unimportant within current educational legislation. In our view, a radical shift is needed to place creativity as the central principle and unifying goal at the heart of our educational system, where teaching and learning are esteemed as engaged, complementary, and transformative genres of meaning making.

The Effects of Creativity and Arts-Based Programs in Education

Traditionally, creativity in education has been gauged by the number of arts programs available to children. This practice reveals another false assumption that creativity is solely the domain of the arts, ignoring that math and science programs can be best implemented through imaginative and innovative means. Nevertheless, a significant body of literature underscores the benefits of in-school and after-school art and science programs (Brice Heath & Roach, 1999; Brice Heath & Robinson, 2004; Brice Heath, Soep, & Roach, 1998; Burton, Horowitz, & Abeles, 1999; Catterall, Chapleau, & Iwanga, 1999; Catterall & Waldorf, 1999; Deasy, 2002; McArthur & Law, 1996; Oreck, Baum, & McCartney, 1999; Rabkin, 2004; Stevenson & Deasy, 2005; Wakeford, 2004). Research on the impact of these programs establishes that student engagement in the arts is associated with multiple positive effects (Catterall, et al. 1999). As authors of a national longitudinal study including over 25,000 students, Catterall and colleagues concluded that sustained involvement in art programs strongly correlated with positive academic development. For example, Catterall et al. (1999) found a significant connection between participation in secondary music classes and high levels of mathematic proficiency in twelfth grade. Long-term engagement in the theater arts directly corresponded with enhanced academic and personal development in the areas of

reading proficiency, positive self-concept, motivation, empathy, and tolerance for others.

Brice–Heath and Roach's (1999) investigation of after-school, secondary programs found that arts-based curriculums had a stronger impact than community service or athletic programs in fostering positive academic and personal outcomes. It should be noted that art education programs have an especially positive impact for "at-risk" , low income, and linguistically and culturally diverse children as well as individuals suffering the effects of trauma, immigration, prejudice, or war. In fact, Rabkin (2004) found that "low-income students who were high arts participators did better in school and life than peers" by earning higher grades and exhibiting leadership skills (p. 7). Brice–Heath and Robinson's (2004) research noted that engagement in arts–based programs was significant, especially for youth growing up amidst poverty and war stating, "Young people see the arts—personally and for their societies—[as] playing a unique social and educational role, and they view their work as real, vital and necessary" (p. 108). As once participant explained, "It changes your perception of the world" (Brice–Heath and Roach, 1999, p. 24).

Despite research establishing the value of arts-based programs, a national survey conducted by the Arts Education Partnership (Ruppert, 2008) reported significant decreases in these programs. In some instances, this reduction included the complete withdrawal of state funding. Moreover, the group especially observed the absence of arts-based programs in low-income and urban communities serving culturally and linguistically diverse children. Rabkin (2004) also pointed to the "comprehensive erosion" of arts education, particularly in financially challenged districts. As a consequence of the No Child Left Behind Act, Ruppert (2008) reported a series of factors leading to the decimation of arts-based programs including a focus on standardized test scores, bare-bones, narrowed, and remedial curriculum, insufficient numbers of qualified teachers, vague state laws, and the lack of graduation or college entrance requirements for art classes. Despite previous legislative support, the implementation of state art education policies is left to local control with little or no accountability (Ruppert, 2008).

In our view, the American public educational system suffers from a serious lack of vision and action when it comes to the development of creativity. The very structure and practices of our K-12 system restrict, retard, or prevent imagination, play and creative ingenuity across the disciplines. While retaining or implementing arts-based programs would be a worthy beginning, incorporating more music, drawing, sculpture, drama and writing classes is not an antidote. As our authors attest, teaching and learning in all domains need to be instituted as creative processes. Children's powerful propensity to make

meaning or learn is inseparable from the creative construction of original arti-facts and innovative solutions. If these abilities are not nurtured and extended in children's formative years, how can our society expect these proficiencies to be present after thirteen years of schooling? Indeed, our negligence in fostering creativity represents the critical difference between achievement and failure for both individuals and communities. With cultural-historical theory, we can dance with the muses, hitch our wagons to a star, *and* place creativity at the hub of wheels that drive our schools and society.

Contemporary Initiatives Inspired by Cultural Historical Theory

Vygotsky's ideas regarding play, creativity, and art have inspired a variety of international educational and psychological research initiatives. Investigations based on cultural-historical theory first appeared in the former Soviet Union in the wake of the Stalinist era (see Elkonin, 1978/1981). The Soviet effort was followed by studies on play and creativity in the former Yugoslavia that first emerged during the late 1960s (see the works of Ivić, 1981; A. Marjanovic, 1982, 1983; S. Marjanović, 1972, 1977, 1979; Ognjenović, 1986/87 and many more.). His writings also prompted the work of Swedish, Finnish, American, and Japanese scholars in the late 1980s–1990s (see Hakkarainen, 1999, 2004, 2006; Lindqvist, 1995a; Miyazaki, 2005, 2007, 2008). In the latter part of the 1990s, significant changes in the structure of American public schools motivated researchers to re-examine play, meaning making, creativity, and the arts during the traditional academic day and in after-school programs designed for children and youth (Baumer, Ferholt, & Lecusay, 2005; Cole & Consortium, 2006; Holzman, 1997, 2009).

To date, several creative and arts-based educational programs have drawn on this research. Cultural-historical scholars have implemented playworlds, computer programs, and performance opportunities for children and adults. As Beth Ferholt relates in her chapter, playworlds involve the joint construc-tion of imaginary worlds by children and adults who enter and exit a common fantasy together. In the former Yugoslavia, creativity was placed at the fore-front of education by Sanda Marjanović as well as her students and colleagues in day care centers, schools, and after–school institutions (S. Marjanović, 1973, 1975, 1977, 1987b, 1990). These innovations became a foundation for national reform in educational programs and teacher training. In Sweden, Gunilla Lindqvist pioneered the use of playworlds in day care centers, kinder-gartens and schools (Lindqvist, 1995b, 2001a, 2001b, 2003). Her educational approach was informed by Vygotsky's emphasis on the centrality of aesthetics

in emotional, cognitive and social development. In Lindqvist's playworlds, adults and children engage in dramatizations based on traditional and culturally significant literary works.

Playworlds in Finland (Hakkarainen, 1999, 2004, 2006) are founded on a variety of themes planned to prepare children for school and facilitate emergent literacy. Instead of focusing on formal skills or the traditional curriculum, Finnish playworlds follow Lindqvist's (1995b) play pedagogy, motivating learners through the creation of narratives (Hakkarainen, 2004; Rainio, 2005). Studies on playworlds conducted in the United States suggest such programs promote narrative competence (Baumer et al., 2005). In Japan, playworlds blend Vygotskian theory and traditional Japanese educational philosophy called Kyouzai-Kaishaku. During these year-long experiences, imaginative teachers emotionally re-interpret subject matter in a novel and surprising manner for all members of the educational community, including art activities with professional artists (Miyazaki, 2007).

American educators and psychologists like Michael Cole have also created computer-mediated play programs for after-school institutions in the United States. Known as the Fifth Dimension, these unique initiatives involve collaborations between children, after-school teachers and university students from local university communication or education departments. Cole & Consortium (2006) report the design elements and interactional norms of the Fifth Dimension programs embody principles and ideas derived from John Dewey, G.H. Mead, L.S. Vygotsky, A. Luria and A.N. Leontev.

Vygotsky's theories have also been at the core of creative arts programs for children and youth developed by psychologists, therapists, and researchers. For example, arts-based programs supported children, youth and young adults suffering from the effects and aftermath of the war in Yugoslavia during the 1990s (Ognjenović & Skorc, 2003). Programs at the East Side Institute for Group and Short Term Psychotherapy in New York City are based on the concepts of creative imitation, completion, and performance. Vygotsky and Wittgenstein's ideas have guided their educational initiatives including the experimental Barbara Taylor School (Holzman, 2009, p.53–54), the All Stars Talent Show, Youth on Stage project (YO!), and several other after-school programs for youth (Holzman, 2009).

A Cultural-Historical Approach to Creative Education

Vygotsky emphasized that the source and substance of all development lie within human relationships. Through the use of culturally constructed symbol

systems, we learn and grow by actively engaging in social practices. Such involvement entails individuals' full cognitive-affective participation in personal and public activities. This principle serves as a cornerstone for postmodern, constructivist approaches to learning and development (see Stetsenko & Arievitch, 1997). In this book, we individually and collectively call attention to the central role that play, imagination, creativity, and art occupy in learning and development.

A cultural-historical approach to creative education calls us to reconstruct all aspects of the PreK-12 system. Educational environments, programs, and models need to be founded and designed on a vision that affirms and supports the creative nature of the developmental process, placing innovative and imaginative structures, goals, and practices at the heart of our educational practice. Regrettably, in our capitalistic, positivistic society, teaching has been conceptualized as the transmission of ready-made, prescribed knowledge. Tragically, learning is often reduced to the basic processes of recognition, retention, and the structured application of information. For example, the sequence of thought processes in Bloom's Taxonomy of Educational Objectives portrays learning as a linear progression moving from basic or lower cognitive processes including memorization, understanding, and application to complex or higher order thinking reflected in analysis, evaluation, and creation (Pickard, 2007). Time and time again, research has noted that children engage in lower level cognitive activities for the majority of their school day. Analysis, evaluation and creation are allocated much less time and attention. Shamefully, this practice is especially true for our youngest learners, linguistically and culturally diverse children, and students growing up in the shadow of poverty. Indeed, current textbooks used to educate pre- and in-service teachers and administrators contain little or no information on creativity, imagination, play, or art. It is not surprising that such books engender stances that afford limited space to multi-modal meaning making in both teaching and learning.

We assert that reform begins with the redefinition of teaching and learning as complementary, collaborative, and creative processes occurring at all ages and developmental levels. Learning environments need to be understood as mutually overlapping zones of proximal development (ZPDs). Creative education calls for the mindful, deliberate, and active construction of these zones. As a result of this book, our own understanding of the ZPD has transcended narrower definitions that espouse a one-way direction between that which novices can attain independently and those activities achieved through interaction with a more capable partner. Instead, we now view the ZPD as a multidirectional, collaborative construction that simultaneously coordinates conditions for meaning making, builds new layers of knowledge and

reflection, and mediates critical aspects related to the self. In this manner, the ZPD is reconceptualized as a dynamic, multi-dimensional and evolving process that facilitates both evolution and revolution in the course of individual and social transformations.

Placing creativity at the heart of all teaching and learning activities holds implications for all aspects of education including the learning environment, curriculum, instruction, and assessment. We address these educational implications in the following discussion of a cultural-historical approach to creative education.

Creativity and Human Relationships

A cultural-historical approach to creative education identifies the deep roots of learning in human relationships. For example, Ana Marjanovic-Shane captured the impact that creativity and playfulness bring to social interactions. She demonstrated how play transforms relationships by converting tensions, fears and hopes into sources of reflection and understanding. Lois Holzman also stressed that individuals shape and reshape their relationships to themselves, each other, and to the material world through creative imitation, completion, and play.

Vygotsky's contention that "imagination operates not freely, but directed by someone else's experience, as if according to someone else's instructions" (1930/2004, p. 17) is clearly observable in Patricia St. John's accounts of children's free play with musical instruments. Similarly, Beth Ferholt's description of a child's revelation experienced during a dramatic moment of play also relates this psychological phenomenon.

Seana Moran additionally noted that writers transform personal experiences into resources for their work. These internal resources are then externalized in relationship to larger literary norms and traditions. By representing meaning through artistic forms, artists then contribute these assets to others, enriching the socio-cultural milieu. The social nature of the creative process is best captured in the metaphor employed in our first chapter's title: holding hands, we participate in a dance of meaning as co-creators in relationship to each other. Within the creative circle of community, we are the dancers *and* the muses. Relationships that are mediated by joint play or that involve co-participation in arts-based or other creative projects are strengthened within the collaborative partnership. John-Steiner (2000) highlights the benefits of these creative collaborations, noting that "In the course of intense partnerships, new skills are acquired...through collaboration we can transcend the constraints of biol-

ogy, of time, of habit, and achieve a fuller self, beyond the limitations and the talents of the isolated individual" (p. 187–188).

As a collaborative process, a cultural-historical approach to creative education redefines the roles and relationships of teachers and students. It is not enough for teachers to be knowledgeable about their subject matter or the processes they seek to facilitate or extend. Teachers do not didactically "teach" topics or strategies. Instead, they assist *children* in their attempts to learn by becoming familiar and addressing the unique needs of their students while creating environments that facilitate creative meaning making.

As S. Marjanovic (1987a) observed, "Cultivating creativity in education demands that the education be transformed into an open system of exchange of knowledge and experience between the students and the teachers and between the students themselves" (p. 100). Instead of one-way, transmission, or banking approaches (Freire, 1970), a cultural-historical approach to creative education views teaching and learning as complementary forms of meaning making where all participants share and build funds of knowledge (Moll, 2001).

Matusov (1999) described his first encounter teaching in an innovative school in Utah, where he witnessed the "teachers tried to find creative questions to support discussion with the children" (p. 162). This practice contrasted with the more traditional approach he used at the time where he "could only communicate either with one student at a time or with a whole class, treating it as one individual" (p. 162). Moreover, he "tried to control fully the interaction; any student's contribution that was not sanctioned a priori by me was considered an interruption...[instead of] children freely contribut[ing] to the discussion" (p. 162). He soon realized this kind of power relationship stifles learning, undercutting potential conceptual flight. Without creating opportunities for and inviting students to actively and freely participate in the creation of knowledge, teachers restrict student understanding and growth.

Like an improvisational performance, learning and development often take place through spontaneous interactions between community members. Authentic, meaningful interaction between participants needs to become a mindful, deliberate instructional goal. Teaching methods need to support the role of teachers as expert guides who are "first among learners" (Miyazaki, 2007). Such postures allow children to observe and interact with experienced problem solvers and evolving models of creativity, multi-modal meaning making, and learning. When learning and teaching are viewed as forms of joint meaning making, curricular standards are enhanced. Children, youth, and adults utilize the curriculum as a springboard to engage in the critical con-

struction of novel ideas, events, and artifacts. As a result, teaching is recast as the highly professional, developmental, and artistic process it is, while learning takes on a motivated, dynamic, and invigorating quality.

Thought and Affect as Unified Processes

A cultural-historical approach to creative education affirms that thought and affect exist as complementary, integrated processes. In fact, emotions are woven into learning and teaching in at least three distinct ways. First, affect is a catalyst that brings children and curriculum together in a personal manner. Second, affect exists as an essential dimension in the quality of teaching-learning relationships. Third, emotions form a crucial aspect of both the personal and group identities that make up a class.

Vygotsky's seminal work on catharsis and perezhivanie highlights the equal importance of thought and affect, placing emotion, interwoven with cognition, at the heart of the creative process (Vygotsky, 1925/1971, 1930/2004, 1933/1976). He established that play, art making and aesthetic response allow us to experience, explore, and resolve powerful feelings and meanings. Cathrene Connery illustrated how art's potential for catharsis affords us the opportunity to regain psychic balance and generate new ways of understanding our lives and ourselves. Vygotsky further observed the inherent unity of cognition and emotion when he expressed "every construct of the imagination has an effect on our feelings, and if this construct does not in itself correspond to reality, nonetheless the feelings it evokes are real feelings, feelings a person truly experiences" (1930/2004, p. 19–20). Both Peter Smagorinsky and Michelle Zoss described how emotional aspects of creative engagement facilitate a greater understanding and connection to the curriculum.

It is essential that we rewrite affect and emotional literacy back into the curriculum. Vygotsky wrote when "emotions...take hold of us from the artistic images on the pages of books or from the stage, [they] are completely real and we experience them truly, seriously and deeply"(1930/2004, p. 20). In other words, emotions serve as muses to provide reality, significance and importance to our understanding and development. Similarly, he reflected "the internal logic of feeling [will] represent the most subjective, most internal form of imagination" (1930/2004, p. 19). Topics that are deeply personal are exciting for children. Imaginative processes, initiated by teachers and students, provide an active menu to make meaning about the curriculum. Without the emotional engagement of subject matter, the potentially vibrant nature of curricular concepts and topics can be rendered lifeless, insignificant, and inconsequential.

Emotional safety and respect are essential conditions for creative education. Students and teachers best express themselves, recount lived experiences, explore their identities, and forge trusting relationships when they feel esteemed and protected. The manner in which learning environments are organized fosters or dissuades the emotional and relational conditions for creativity. Toward this end, several scholars have drawn on cultural-historical theory to identify the characteristics inherent in communities of practice (Lave & Wenger, 1991; Rogoff & Gardner, 1984; Rogoff & Lave, 1984; Rogoff, Turkanis, & Bartlett, 2001; Wenger, 1998). According to this research, communities of practice actively incorporate four key components including feelings of trust and belonging to community; development of self and personal identity; learning as experiencing and meaning making; and learning as performing and engagement in relevant activities (see Wenger, 1998, p. 4–5). In communities of practice, participants have the freedom to express opinions and feelings, knowing their diverse personal interests and passions will be respected and valued. Teachers and students alike can trust their opinions and positions will be carefully listened to, considered, and taken into account in communal decision making.

In a cultural-historical approach to creative education, teachers, students, parents, and administrators do their unique parts in the conscious construction and maintenance of environments built on mutual trust and respect. Indeed, such actions are essential to the educational process. Positive relationships fuel risk-taking and creative engagement, resulting in novel insights and achievements for all members of the teaching-learning community. John-Steiner (2000) wrote "to achieve such bonding, partners need to learn to listen carefully to each other, to hear their words echoed through those of the collaborator, and to hear the words of the other with a special attentiveness born of joint purpose...living in the other's mind requires trust and confidence" (p. 190).

Toward this end, creative education reconsiders the rationales, structures, and consequences of specific forms of evaluation and assessment. Currently, student assessment is performed for the purpose of comparing and sorting individual students and ethnic or socioeconomic groups into preconceived and de-contextualized continua of alleged competency. Despite the plethora of literature that contests the validity of this perspective, this practice presupposes the existence of quantifiable knowledge and capabilities easily measured by "scientific" means.

However, assessment is currently conducted without consideration for the emotional, cultural, linguistic, and socio-psychological dimensions of teaching and learning. Authentic evaluation enhances children's self-worth, identities,

and learning processes while enriching classroom dynamics. Evaluation that promotes disengagement, silence, and alienation is contrary, harmful, and, in our view, a form of academic violence. Both students and teachers have a right to the creative process where developmental transitions serve as points of future growth.

When creativity is placed at the hub of the educational wheel, the purpose of assessment and evaluation is changed. Instead of faulty assessments implemented for the benefit of government, business and the military at taxpayer's expense, accountability and assessment respectfully and sensitively inform the teaching and learning process. A cultural-historical approach to creative education embraces intelligent, accurate, innovative assessment and evaluation practices based on the developmental, generative, and contextualized means associated with authentic assessment. A cultural-historical approach to creative assessment is motivated by a genuine educational posture instead of political or profitable measures. Such measures might include instruments and protocols in which the community of learners including students, parents, educators, and other stakeholders, evaluates processes and projects that guide decision-making. Active self-assessment on the part of students provides a powerful tool to shape and refine one's self and future.

Multi-modal Meaning Making

In addition to social and emotional dimensions, a cultural-historical view of creative education recognizes that creativity involves both internal and external forms of multi-modal meaning making. In our text, several authors noted that creativity needs to be nurtured and recognized through multiple forms and modalities. Drama, drawing, and dance represent only a few of the many ways symbolic systems allow humans to mediate, internalize, externalize, and co-construct meaning. Sources and elements of art making are derived from the social scripts and *perezhivanie* of childhood and, as Barry Oreck and Jessica Nicoll have related, are enriched by free play, innovative experimentation, imitation, and joint discovery with peers, elders, and experts.

Words, paint, music, and dance provide diverse ways to weave rich, symbolic texts. The power of these semiotic means lies in their ability to engage our multi-modalities in the co-construction of new understandings. For example, metaphors allow us to relate the most vivid qualities to the most abstract notions. Similarly, the organization of multimodal patterns provides opportunities for joint, novel experiences. The multi-modal meaning making embodied in and aroused by the arts offers us powerful, symbolic ways to connect and reconnect in creative education.

Creative educational programs recognize, validate, supplement and extend the cognitive pluralism of students and their teachers. Sufficient time, planning, and quantities of physical tools and materials need to be afforded to ensure that multi-modal learning takes place. The entire palette of psychological tools offered by the arts is integrated in creative education. In this manner, higher order thinking becomes the origin, focus, and end product of the curriculum. The development of higher order thinking is additionally achieved by enhancing content area meanings and strategies with critical thinking developed in group discussions and collaborative efforts.

Instructional goals in a cultural-historical approach to creative education include the development of both common and unique knowledge, skills, strategies, and dispositions. Students are not considered or required to become multiple replicas of one and the same learner with predetermined abilities, knowledge, interests and manners of expressing themselves. The enhancement of children's cognitive pluralism, multiculturalism, and bilingual-biliterate proficiencies is facilitated through active engagement in a variety of teaching-learning formats including debate, role play, experimentation, inquiry, art making, and performance.

The Transformative Potential of Creativity

Finally, each of the chapters in this book highlights the transformational quality of creative expression. Such creative transformations forge authentic opportunities for learning and development. In all of its manifestations, the creative process allows both young and old to construct cognitive-affective connections across our nested realities, so we might imagine the possible, new, and profound. Within this educational dance, novices, apprentices, and experts are admitted to the cultural circle to continually redefine its nature. As we individually and collectively make sense of our roles and values and perform actions beyond our lived experiences, the creative process allows us to gain an enhanced understanding of ourselves, our relationships, and our cultural-historical moment. Most importantly, the dance enables us to develop a sense of significance and belonging.

In a cultural-historical approach to creative education, both what and how we teach or learn is made to be personally and collectively relevant. The curriculum is redefined as an evolving, flexible and emergent project. What is to be learned, as well as when and how it will be learned is authored by all members of the learning community. Partnerships and collaborations are constructed across ages, homes, schools, and communities, uniting experts and novices. Such networks hold the potential to create multiple opportunities for

novel relationships and growth experiences. In this manner, parents are not estranged or marginalized from the education of their own children. Rather, they are actively engaged in directing, assisting, and achieving desired outcomes. Similarly, teachers and students generate curricular topics to explore while administrators are responsible for fostering and sustaining conditions for creativity. Teachers research, explore, and invent novel instructional means as students pose questions, address challenges, and realize dreams. The curriculum is contextualized to represent the personal meanings and cultural experiences of students, their communities, as well as multicultural and critical perspectives so often absent from everyday, political, and educational conversations. Because lessons, discussions, field trips, and other activities address how standards, subject areas, or topics relate to students' place in the world, children develop a sense of self and relevance within the larger world. Such creative transformations hold the potential for a stunning impact: Teachers rediscover students as they themselves become re-engaged in the learning process and subject disciplines. Conversely, students build competencies, develop interests, and nurture passions for the future. As participants in a community of practice, all stakeholders are accountable to cultivate and sustain responsibility, commitment, and creativity.

Education and the Cathartic Moment

We conclude this text by coming full circle to the start of our book and Vygotsky's original work on catharsis as a form of cognitive-affective transformation. Catharsis occurs when the creative juxtaposition of conflicting emotions implodes to produce something novel that has not existed before. In the cathartic moment, individuals and groups overcome the past, transforming perceptions of themselves, others, and the world. In this manner, the creative process touches the future.

A cultural-historical approach to creative education provides ample opportunities for cathartic moments including the sudden "a-ha" one feels when grasping a new concept, the breakthrough insight a team experiences working on a science project, a brilliant solution crafted by novice and mentor to a complex social-historical puzzle. An exhilarating new dance movement, the overwhelming sense of unity experienced in a choir performance, and the irresistible urge to cheer on the school team are all educational experiences that can be described as variants of the cathartic moment. Individually and collectively, such moments facilitate emotional release, lead to new understandings, and strengthen our identities. Catharsis engenders growth. The sense of joy,

accomplishment, or wonder escorts us into the human community ensuring the development of our species. The pristine beauty of a mathematical proof can lift us to the sky. An ancient political intrigue can transport us from dusty library shelves to the sights, smell, and sounds of the past events. In all its intricacy and splendor, the natural world can shock us from beneath a microscope.

Strings sing at the touch of a violinist's bow. Light and shadow are cast across a stage like a river of silk, while bodies move to the heartbeat of a wild drum. Sunflowers burst into bloom on canvas, as clay rises on the wheel into a cylindrical dome. Schooling devoid of such moments, in our opinion, cannot be considered education. Such practice is better described as an unrecognized form of child labor. As children and adults, we are all inspired to play, make meaning, and engage in the creative process. Across time and space, politics, and religion, we are united in our collective roles as muses and dancers, teachers and learners. Education, in the truest sense of the word, can only be measured by its social, emotional, and transformative impact on our individual and collective growth.

References

Baumer, S., Ferholt, B., & Lecusay, R. (2005). Promoting narrative competence through adult–child joint pretense: Lessons from the Scandinavian educational practice of playworld. *Cognitive Development, 20*, 576-590.

Brice–Heath, S., & Roach, A. (1999). Imaginative actuality: Learning in the arts during the nonschool hours. In E. B. Fiske (Ed.), *Champions of change* (pp. 19-34). Washington, DC: Arts Education Partnership.

Brice–Heath, S., & Robinson, S. K. (2004). Making a way: Youth arts and learning in international perspective. In N. Rabkin & R. Redmond (Eds.), *Putting arts in the picture* (pp. 107-125). Chicago: Columbia College.

Brice–Heath, S., Soep, E., & Roach, A. (1998). *Living the arts through language and learning: A report on community-based youth organizations.* Washington, DC: Americans for the Arts.

Burton, J., Horowitz, R., & Abeles, H. (1999). Learning in and through the arts: Curriculum implications. In E. B. Fiske (Ed.), *Champions of change: The impact of the arts on learning.* Washington, DC: The Arts Education Partnership.

Catterall, J. S., Chapleau, R., & Iwanga, J. (1999). Involvement in the arts and human development: General involvement and intensive involvements in music and theater arts. In E. B. Fiske (Ed.), *Champions of change* (pp. 1-18). Washington, DC: Arts Education Partnership.

Catterall, J. S., & Waldorf, L. (1999). Chicago arts partnership in education: Summary evaluation. In E. B. Fiske (Ed.), *Champtions of change.* Washington, DC: Arts Education Partnership.

Cole, M., & Consortium, D. L. (2006). *The Fifth Dimension: An after-school program built on diversity.* New York: Russell Sage.

Deasy, R. (Ed.). (2002). *Critical links: Learning in the arts and student academic and social development*. Washington, DC: Arts Education Partnership.

Elkonin, D. B. (1978/1981). *Psihologija Decje Igre* [Psychology of child's play]. Beograd: Zavod za Udžbenike i Nastavna Sredstva.

Freire, P. (1970). *Pedagogy of the oppressed*. New York: Herder and Herder.

Hakkarainen, P. (1999). Play and motivation. In Y. Engeström, R. Miettinen, & E.-L. Punamäki (Eds.), *Perspectives on activity theory* (pp. 231–249). New York: Cambridge University Press.

Hakkarainen, P. (2004). *Narrative learning in the Kajaani fifth dimension*. Paper presented at the American Educational Research Association 2004 Annual Meeting, San Diego.

Hakkarainen, P. (2006). Learning and development in play. In J. Einarsdottir & J. T. Wagner (Eds.), *Nordic childhoods and early education* (pp. 183–222). Greenwich, CT: Information Age.

Holzman, L. (1997). *Schools for growth: Radical alternatives to current educational models*. Mahwah, NJ: Lawrence Erlbaum Associates.

Holzman, L. (2009). *Vygotsky at work and play*. New York: Routledge.

Ivić, I. (1981). *Igra deteta i njena uloga u razvoju*. Beograd: PA za obrazovanje vaspitaca predskolskih ustanova.

John-Steiner, V. (2000). *Creative collaboration*. Oxford, NY: Oxford University Press.

Lave, J., & Wenger, E. (1991). *Situated learning: Legitimate peripheral participation*. Cambridge, UK; New York: Cambridge University Press.

Lindqvist, G. (1995a). *Lekens estetik, en didaktisk studie om lek och kultur i förskolan*. Karlstad: Högskolan i Karlstad.

Lindqvist, G. (1995b). *The aesthetics of play: A didactic study of play and culture in preschool* (Vol. 62). Uppsala, Sweden: Acta Universitatis Upsalensis.

Lindqvist, G. (2001a). The relationship between play and dance. *Research in Dance Education, 2*(1), 41–53.

Lindqvist, G. (2001b). When small children play: How adults dramatize and children create meaning. *Early Years, 21*(1), 7–14.

Lindqvist, G. (2003). Vygotsky's theory of creativity. *Creativity Research Journal, 15*(4), 245–251.

Marjanović, A. (1982). Šta je novo u metafori? [What is new in metaphor?]. *Psihologija, XV*(4), 63–79.

Marjanović, A. (1983). Criteria of metaphoricity of children's utterances. *Metaphor Research Newsletter, 3*(1), 8–9.

Marjanović, S. (1972). Savremena shvatanja o stvaralaštvu (Contemporary understanding of creativity). *Kreativnost Mladih i Slobodno Vreme (Creativity of Youth and Free Time)* (pp. 20–41). Zagreb: Nasa Djeca.

Marjanović, S. (1973). Govor u igri predškolskog deteta [Speech in play of the pre-school child]. *Zbornik* (Vol. 6). Beograd: Naučna Knjiga.

Marjanović, S. (1975). Jezičke igre predškolskog deteta [Speech play of the pre-school child]. *Predskolsko Dete, 5* (2), 11-32

Marjanović, S. (1977). *Dečja igra i stvaralaštvo* [Children's play and creativity] (Vol. 70). Belgrade: Prosvetni Pregled.

Marjanović, S. (1979). Stvaralaštvo, igra i vaspitanje [Creativity, play and education]. *Predškolsko Dete* (1–2), 1–15.

Marjanović, S. (1987a). Dečja igra i stvaralaštvo [Child play and creativity]. *Predskolsko Dete, 17*(1–4), 85–101.

Marjanović, S. (1987b). Tematsko programiranje: Izvori, konceptualizacija, pedagoška razrada i primena, effekti [Thematic programming: sources, conceptualization, pedagogical development and applications, effects]. *Predskolsko Dete, 17*(1-4), 39-55.

Marjanović, S. (1990). Igra kao forma uvodjenja deteta u jezik i govor [Play as a form of introducing a child to the language and speech]. In S. Marjanović, R. Ivanović, S. Janković, & S. Gašić-Pavišić (Eds.), *Dečje Jezičke Igre* [Children's language games]. Beograd: Zavid za udžbenike i nastavna sredstva.

Matusov, E. (1999). How does a community of learners maintain itself? Ecology of an innovative school. *Anthropology & Education Quarterly, 30*(2), 161-186.

McArthur, D., & Law, S. A. (1996). *The arts and prosocial impact study: A review of current programs and literature.* Los Angeles, CA: Rand Corporation.

Miyazaki, K. (2005). *Drama play project in Ibi kindergarten summer 2004: First report of a Japanese practice relating to LCHC 5D Drama play project.* Paper presented at the AERA Annual Meeting, Montreal, Canada.

Miyazaki, K. (2007). *Teacher as the imaginative learner: Egan, Saitou and Bakhtin.* Paper presented at the 2nd Annual Research Symposium on Imagination and Education. Vancouver, Canada.

Miyazaki, K. (2008). *Imagination as collaborative exploration: Art education in Saitou pedagogy.* Paper presented at the 3rd Annual Research Symposium on Imagination and Education. Vancouver: Canada/

Moll, L. C. (2001). The diversity of schooling: A cultural-historical approach. In M. de la Luz Reyes & J. Halcón (Eds.), *The best for our children: Critical perspectives on literacy for Latino students* (pp. 13-28). New York: Teachers College Press.

Ognjenović, V. (1986/87). O emocionalnim aspektima dečje igre [On emotional aspects of children's play]. *Zbornik Pedagoske Akademije za Vaspitače.*

Ognjenović, V., & Skorc, B. (2003). *Hi neighbour: Evaluation of the program.* Beograd: Akademska Stampa.

Oreck, B., Baum, S., & McCartney, H. (1999). Artistic talent development for urban youth: The promise and the challenge. In E. B. Fiske (Ed.), *Champions of change* (pp. 63-70). Washington, DC: Arts Education Partnership.

Pickard, M. J. (2007). The new Bloom's Taxonomy: An overview for family and consumer sciences. *Journal of Family and Consumer Sciences Education, 25*(1), pp. 45-55.

Rabkin, N. (2004). Learning and the arts. In N. Rabkin & R. Redmond (Eds.), *Putting the arts in the picture: Reframing education in the 21st century.* Chicago: Columbia College, pp. 5-15.

Rabkin, N., & Redmond, R. (Eds.). (2004). *Putting the arts in the picture: Reframing education in the 21st century.* Chicago: Columbia College.

Rainio, P. (2005). *Emergence of a playworld. The formation of subjects of learning in interaction between children and adults* (Working Papers 32). Helsinki, Finland: Center for Activity Theory and Developmental Work Research.

Rogoff, B., & Gardner, W. (1984). Guidance in cognitive development: An examination of mother-child instruction. In B. Rogoff & J. Lave (Eds.), *Everyday cognition: Its development in social context* (pp. 95-116). Cambridge, MA: Harvard University Press.

Rogoff, B., & Lave, J. (1984). *Everyday cognition: Its development in social context.* Cambridge, MA: Harvard University Press.

Rogoff, B., Turkanis, C. G., & Bartlett, L. (2001). *Learning together: Children and adults in a school community.* Oxford; New York: Oxford University Press.

Ruppert, S. S. (2008). State of the states: Results of the 2007-2008 AEP Arts Education State Policy Survey. 1-19. Retrieved July 5, 2009 from www.aep-arts.org.

Stetsenko, A., & Arievitch, I. (1997). Constructing and deconstructing the self: Comparing post-Vygotskian and discourse-based versions of social constructivism. *Mind, Culture, and Activity, 4*(3), 159–172.

Stevenson, L. M., & Deasy, R. J. (2005). *Third space.* Washington, DC: Arts Education Partnership.

Vygotsky, L. S. (1925/1971). *The psychology of art.* Cambridge, MA: MIT Press.

Vygotsky, L. S. (1930/2004). Imagination and creativity in childhood. *Journal of Russian and East European Psychology, 42*(1), 7–97.

Vygotsky, L. S. (1933/1976). Play and its role in the mental development of the child. In J. S. Bruner, A. Jolly, & K. Sylva (Eds.), *Play–Its role in development and evolution* (pp. 537–554). New York: Penguin Books.

Wakeford, M. (2004). A short look at a long past. In N. Rabkin & R. Redmond (Eds.), *Putting the arts in the picture: Reframing education in the 21st century* (pp. 81–107). Chicago: Columbia College.

Wenger, E. (1998). *Communities of practice: Learning, meaning and identity.* Cambridge, UK: Cambridge University Press.

Notes

Chapter 3: Without Creating ZPDs There Is No Creativity

1 Vygotsky used the Russian word "obuchenie," which refer to both teaching and learning. It is usually translated as "learning."

2 Lantolf and Thorne (2006) note this misunderstanding and make a worthwhile distinction between scaffolding and development in the ZPD.

3 What I am describing as completion would be identified in language acquisition and linguistics literature by other terms, such as expansion or contingency, which are located within a cognitive framework. My expansion/liberal interpretation of Vygotsky's terms is not.

4 Reports on the advantages of culturally-based outside–of–school programs, including arguments that they can help close the achievement gap" are many. See for example, Arts Education Partnership, 1999; Bodilly and Beckett, 2005; Childress, 1998; Heath, 2000; Heath, Soep and Roach, 1998; Carnegie Council on Adolescent Development, 1992; Gordon, Bridglall and Meroe, 2005; and Mahoney, Larson and Eccles, 2005.

Chapter 4: From Yes and No to Me and You

1 For instance instance traditional games with defined formats like "peek-a-boo" played with infants, "tag" and other chasing games, guessing games, risk games, and acting games among pre-school and school children (Opie & Opie, 1969), as well as plays and games that adults play with children or other adults.

2 This outlook on play is explored more thoroughly in other chapters in this book.

3 The meaning of "postupak" in Serbian [pronounced: po-stoo-pahk] is most approximate to the English word "deed" . Postupaks are acts of ethical and responsible transactions between the participants. They are deeds judged and measured both in terms of achieving or not achieving their objects and, more importantly, in terms of their compliance or resistance to values, expectations, rules and norms that people hold within the chronotopes in which they operate. According to Bakhtin, they are acts "within the unitary and unique event of being...directed toward the actual modification of the event and of the other as a moment in that event; such actions are purely ethical actions or deeds" (Bakhtin, Holquist, & Liapunov, 1990, p. 24).

4 All the names in this story are changed to protect the privacy of the participants.

5 Personal communication, June 10, 2009.

6 As stated above Mr. Steve and most of the children in the Center belong to the American Latino community.

7 Matusov, E., Personal Communication, June 10, 2009.
8 The word "real" is used here for chronotopes characterized as "serious" , "actual" and "binding" . Although not less "existing" , a play chronotope, in contrast, is not "actual" , but a construction of an imaginary, fictive and even fantastic situation.
9 What might happen with an uninvited player was described in another place (Marjanovic-Shane, 1989) and would be beyond the scope of this paper.
10 Martin Buber described the relationship between "I" and "Thou" as having something [going on] *between* them (Buber & Kaufmann, 1970).

Chapter 5: Crossing Scripts and Swapping Riffs

1 The sixth session was not included in analysis because of problems with the video-taping equipment.
2 When conflict interrupts intention or interferes with goals, disorder in consciousness is produced. Disorder in consciousness claims attention and focus is diverted; psychic energy is unable to be directed positively toward goals. Consciousness can become disordered in many ways such as fear, worry, anxiety, to name a few. This negative use of energy is called psychic entropy. The opposite state of psychic entropy is order in consciousness, or psychic negentropy which Csikszentmihalyi named optimal experience. Information relayed back to consciousness is in harmony with goals and "psychic energy flows effortlessly" (Csikszentmihalyi, 1990, p. 39). People experience psychic negentropy, or *flow experience*, by controlling consciousness and focusing attention.

Chapter 7: Dance Dialogues

1 Quotes from the choreography students were collected via email in March 2009 in response to a set of open-ended questions one to three years after the end of the experience. Other student comments were taken verbatim from Jessica Nicoll's notes at the time.

Chapter 10: A Synthetic-Analytic Method for the Study of Perezhivanie

1 All names have been changed to protect the privacy of the participants.
2 Although it is generally understood that there are differences between film and video, they will not be discussed in this chapter. Discussion of video as concerning the real and film as concerning the imaginary is of relevance to my argument but not necessary for my argument, so I will use the words 'video' and 'film' interchangeably throughout.
3 For descriptions and analyses of these playworlds, see: Baumer et al., 2005; Hakkarainen, 2004; Lindqvist, 1995, 2006; Miyazaki, 2007; Nilsson, 2008; Rainio, 2005, Rainio, 2008a & 2008b.
4 Alexander Luria states: "When done properly, observation accomplishes the classical aim of explaining facts, while not loosing sight of the romantic aim of preserving the manifold richness of the subject" (2006, p. 178).
5 The film itself could not be included but can be viewed upon request of the author.
6 We carried our playworld mode of interacting into the initial filming of the footage in several ways, including having our cinematographer adjust her camera to create footage

that appeared to be film footage, not video footage, and thus footage that was more readily imbued with "lived momentum".

7 Joseph Tobin and Yeh Hsueh (2007) are other academic scholars of children's play who create films, for use in their analysis, that are both social-scientific documents and works of art. However, it is the dialogue that the films stimulate, not the films themselves, that constitute their data.

8 Rouch (1974) makes this assertion in his advocacy of "shared anthropology".

9 Rouch writes of the ciné-trance: "It is a strange kind of choreography, which, if inspired, makes the cameraman and soundman no longer invisible, but participants in the ongoing event" (1978, 63–64).

Contributors

M. Cathrene Connery, Ph.D. is Assistant Professor of Education at Ithaca College. A bilingual educator, professor and advocate, she has drawn on her visual arts education as a painter and sculptor to inform her research and professional activities in language, literacy, and sociocultural studies. Dr. Connery has presented on theoretical, pedagogic, and programmatic concerns surrounding the education of culturally and linguistically diverse children in the United States for the past 25 years. She holds a B.F.A. in Painting with several works in private collections.

Beth Ferholt, Ph.D. is Assistant Professor of Education at Brooklyn College, New York. Her current study of adult-child joint constructions of imaginary worlds and of the merging of artistic media with children's play, began during her decade as a preschool, reading and after-school teacher in New York City. Dr. Ferholt enjoys storytelling and has created several ethnographic videos over the past 15 years.

Lois Holzman, Ph.D. is director of the East Side Institute for Group and Short Term Psychotherapy. This international research and training center is engaged in the development of a new psychology that explores the human ability to perform through pretending, play, and improvisation as a key to emotional, social and intellectual growth and well-being. She has recently published the text *Vygotsky at Work and Play* (2009, Routledge). Dr. Holzman has been engaged in performance and performative psychology for over 20 years.

Vera John-Steiner, Ph.D. is Emeritus Regents' Professor of Linguistics and Education at the University of New Mexico. She is regarded as an international authority on creativity, collaboration, and cultural-historical activity theory. As a renowned scholar of psycholinguistics, cognitive psychology, and cross-cultural education, Dr. John-Steiner has presented at the world's leading research institutions and conferences for the past 35 years. She has

authored over 100 articles and book chapters, 14 book reviews, and written and co-edited 10 books including *Notebooks of the Mind* which received the American Psychological Association's William James Award. Dr. John-Steiner has a lifelong interest in dance.

Carrie Lobman, Ed.D., is associate professor of education at the Graduate School of Education, Rutgers, the State University of New Jersey. Her research interests include performance, play, teacher education, and early childhood education. A former early childhood educator, Dr. Loban holds a background in improvisation and theatre.

Ana Marjanovic-Shane, Ph.D. is assistant professor of education at Chestnut Hill College. She has assisted children and their families of the former Yugoslavia as president and program director of the Cultural Education Center ZMAJ in New York City for the past six years. An expert in the areas of metaphor, play, and creativity, Dr. Marjanovic-Shane has lectured extensively at the invitation of professional organizations and international institutions. She has a background in the performing arts.

Seana Moran, Ed.D. is Research Manager of the Youth Purpose Project at the Center on Adolescence, Stanford University. She earned her doctorate in human development and psychology from Harvard University. Dr. Moran studies creativity, commitment, wisdom, and purpose.

Jessica Nicoll, B.A. has been a working artist, writer, and teacher for more than 25 years. She additionally consults with arts-in-education organizations including ArtsConnection, the Metropolitan Opera Guild, and the NY City Center. The recipient of several awards, Ms. Nicoll currently teaches children and adults in the NYC Public Schools and at the 92nd Street Y Harkness Dance Center.

Barry Oreck, Ph.D., is adjunct professor of Education at Long Island University, Brooklyn, and Buffalo State University. He serves as director of professional development for New York City in the Schoolwide Enrichment Model. His research focuses on artistic talent, self-regulation, arts assessment, and the professional development of classroom teachers and teaching artists. Dr. Oreck has engaged in theater, music, dance, writing as well as performance and visual art activities throughout his lifetime.

Peter Smagorinsky, Ph.D. teaches in the English Education program in the Department of Language & Literacy Education at the University of Georgia. He is the recipient of multiple awards from the Association of Teacher Educators, the American Educational Research Association, and the National Council of Teachers of English. Dr. Smagorinsky's research focuses on the semiotic implications of Vygotsky's theory and the role of nonverbal text construction in meaning making. He has worked at the art of landscape architecture for 10 years.

Patricia St. John, Ed.D. is an adjunct Assistant Professor of Music and Music Education at Teachers College. She is affiliated with the Carondelet Music Center. Dr. St. John has been a pianist and music educator for over 30 years. Her area of specialty includes early childhood music education.

Michelle Zoss, Ph.D., is assistant professor of English Education at Georgia State University. Her interest in bridging literacy and the visual arts is derived from experiences teaching art and English in elementary and high school classrooms in the United States. Dr. Zoss has expressed herself though drawing and painting since childhood.

Index

•A•

acquisition, 65, 90
 knowledge, 27, 69
 language, 7, 84, 90
 literacy, 84
 sign, 85, 88, 90, 92, 95, 98, 103
activity
 artistic, 91, 108–110, 121–123
 collective, 30
 creative, 31, 37, 172, 201, 204
 human, 5, 202
 joint, 14, 29, 86
 play, 35, 42
 systems, 56–57, 64, 68, 73–74, 79
 transformative, 12
aesthetics, 17–18, 181, 186, 199, 219
 response 17–19, 23–25, 224
after-school programs, 43, 219–220
Amabile, T., 143
appropriation, 8, 12, 91, 142
art, 3, 13–14, 17–19, 20, 22, 24–25, 43, 58, 86, 123, 144–147, 159, 165, 182, 192, 194, 199, 216–219, 227–228
 history, 85
 origins of, 20–21
 Psychology of Art, 5, 13–14, 17–18, 21, 24, 123, , 139, 141, 147, 166, 181
 programs, 200, 205, 216–220
 works, 141–144, 156, 168–169
artifacts, 3, 5, 12, 64, 66–68, 79, 91, 98, 142–144, 219
artist, 10, 17–20, 23–25, 83, 108–110, 122, 156, 165, 185
artistic
 content, 23, 145
 creation, 108, 123
 knowledge, 13

form, 23, 121, 212, 224
function, 23
interpretation, 132
mentor, 117
problems, 112
process, 107, 110, 112–113, 116, 118, 120, 123, 223
product, 7, 9, 19, 84, 91, 110, 224
audience, 3, 6, 17–18, 20–25, 54, 88, 120, 123, 146, 158, 169–175

•B•

Bakhtin, M., 52–53, 57
Brice-Heath, 201–202, 205, 217–218
Brockmeier, J., 138
Brofenbrenner, U., 64
Bruner, J., 79, 87,155, 199, 202

•C•

catharsis, 17–18, 21–24, 43, 57, 98, 145, 155–156, 172, 224, 228
choreography, 78, 108, 110, 113, 117–122
chronotope, 53–57, 233–234
cognition, 7, 13, 42, 69, 110, 165, 200, 216, 224
 distributed, 68, 74
cognitive-affective processes, 18–19
cognitive pluralism, 7, 86–89, 103, 182, 227
Cole, M., 5, 64–65, 68, 85, 86, 88, 91, 219, 220
collaboration, 14, 29–32, 55–56, 65, 77–79, 108–109, 222
commitment, 122, 125, 141–148, 152–158
community
 of learners, 65–68, 78–79, 226
 of practice, 65, 228

completion, 33, 36, 57–58, 119, 186, 220, 222, 233
Connery, C., 3, 8, 17, 83, 215
consciousness, 9, 30, 79, 142
creative, 32, 33, 36, 144, 200, 203, 205, 215
 abilities, 201
 artifact, 19
 object, 19
 process, 23, 85, 96, 100, 103, 107, 111, 209, 213, 218, 221–228, 230
 products, 18–19, 23, 142
 production, 23
creativity, 3–4, 12–14, 17, 27, 30, 72, 123, 142–147, 155–158, 165, 197, 199–201, 205–207, 209–213, 216–219, 221–228
closure, 47–48
Csikszentmihalyi, M., 67, 75, 144, 147
cultural–historical theory, 3–4, 6, 43, 64–68, 84–85, 87, 90, 103, 216, 219–220, 225
culture, 4, 8, 37, 109, 121, 141–143, 147–148, 152–158
 cultural meaning, 141, 144
curriculum, 109, 126, 128–130, 138–139, 181–184, 194–195, 197, 200, 205, 211–212, 218–219, 222, 224–225, 227–228
 scripted, 205, 210
Custodero, L., 66–68, 71, 79

• D •

dance, 3, 9, 14, 20–21, 29, 36–38, 86–87, 91, 107-1-8, 111–123, 176, 212, 219, 222, 226–229
development, 4, 9, 11, 28–29, 31–32, 37–38, 42, 64–65, 69, 74, 87–88, 110, 144, 146, 159, 165, 202–206, 215–216, 220–229
 artistic, 84–85, 90–92, 103, 108, 110, 119, 122
 cultural, 29, 145
 human, 3, 8, 28, 30, 41, 171, 202
 imagination, 217
 language, 7, 32, 42, 90
 learning-leads-development, 28–29, 31, 38, 202
 musical, 76
 psychological, 10
 social sources, 6, 9, 220
 thought, 7, 67–69, 88, 90, 187–188, 204, 227

Dewey, 117, 126, 199, 220
dialectics, 18, 146
dialogue, 36, 42, 57, 71–73, 77–78, 90, 101–103, 114, 118, 123, 138, 188
domain, 14, 97, 144, 147–148, 150, 155–158, 217–218
 domain transformers, 147–148, 155–158
drama, 3, 5, 9, 17, 21, 23–24, 42, 72, 76–78, 94, 98, 103, 131, 153, 165, 172, 189, 191, 218, 220, 222, 226
drawing, 3, 65–66, 72, 86, 90–102, 117, 132–139, 167–170, 175, 181–196, 218, 226, 239

• E •

education, 200–201, 215–219, 222–223, 228–229
 art, 218
 creative, 216, 220–227
 public, 139
Educational Psychology, 5
Einstein, A., 216
Eisner, E., 183, 190, 194, 199
Engestrom, Y., 64–65, 68
emotions, 13, 22–25, 42–43, 58, 89, 128–129, 135, 142, 155–156, 159, 172, 182–183, 193–197, 212, 217, 224, 229
environment 9, 13, 21–22, 29–37, 65–66, 70, 74, 76, 86, 141–143, 146–147, 152, 154–155, 182–186, 195, 201–205, 208–209
 cultural, 4
 classroom, 66, 188, 196
 learning, 65, 75, 222
 The Problem of the Environment 8
 school, 212
epistemology, 30, 42
ethnography, 176
 ethnographic, 43, 90, 166, 169–170, 176
 ethnographic film, 166, 170–171, 176
 video, 176
experiment, 49, 77, 88, 112, 116, 119–122
 experimental, 169, 227
 experimentation, 96, 227
experimentalists, 148–149, 153–154, 157–158
externalization, 142–144, 146, 158

• F •

Ferholt, B., 8, 163
field, 144, 146–147, 152
film, 8 44, 96, 101, 164, 166–178
flow, 22, 25, 66–70, 75–76, 79, 136, 175
Freud, S., 21
Fundamentals of Defectology, 30

• G •

Gardner, H., 125, 144, 225
Gee, J.P., 128
genre–conformers, 147–148, 152, 157
gesture, 52, 57, 70, 182–183, 188, 196
grounded theory, 43

• H •

higher level thinking, 57–58
Historical Meaning of Crisis in Psychology, 5
Holzman, L., 9, 27, 199, 200–206, 216, 219, 220, 222

• I •

imagery, 7, 84, 91, 93–94, 96, 98, 102, 110–111, 139, 155
imagination, 6–14, 23–24, 43, 72, 145, 157, 165, 174–175, 182, 191, 196, 200, 209, 216–218, 221–224
Imagination and Creativity in Childhood, 13, 152, 155, 157
imitation, 31–34, 36–37, 70, 76, 79, 95–96, 220, 222, 226
improvisation, 14, 63, 75, 79, 107, 113, 115, 121
informal learning programs, 37, 205
instruction, 6, 28, 35, 37, 65, 77, 109, 111, 123, 203, 215, 222–223, 227–228
instruments, 63, 65, 69–73, 75–78, 85, 222, 226
internalization, 7, 109–110, 143–146, 158
interpsychological, 42, 50, 55, 75, 102
intrapsychological, 6, 29

• J •

John–Steiner, V., 3, 5, 7, 85–87, 102, 109, 182, 196, 215, 220, 225

Notebooks of the Mind, 13
journal, 90, 92–93, 96, 98, 116–121

• K •

Keats, J., 131–135
Kozulin, A., 85

• L •

learning, 3, 6–7, 11–12, 18, 28–29, 36–37, 64–67, 73, 77, 110, 123, 183, 190, 199–204, 206–209. 216–217, 221, 223, 225
informal, 36–37
language, 7, 33–35
leads–development, 28–29, 31, 38, 202
multi–modal, 227
rote, 30, 36
leitmotif, 94, 98–102
Leontev, A., 220
Lindqvist, G., 164–165, 219–220
literacy, 3, 4, 85, 138, 181, 183, 194–195, 220
Lobman, C., 199
Luria, A., 6, 220

• M •

Mahn, H., 9, 85–86, 88
mask, 8, 126–130, 188
Marjanovic–Shane, A., 3, 8, 41, 215
meaning, 7, 11–12, 19, 21, 23, 28, 31, 35, 41–44, 48, 50, 63, 65–69, 73, 76–77, 84–85, 87–89, 92, 95, 103, 107, 109, 120–123, 131–132, 135, 142, 144–145, 152, 154–159, 181–182, 185–188, 190, 195, 204, 219, 221, 223–229
social construction of, 66, 83
meaning making, 3–4, 6, 10–14, 35, 41–43, 65–66, 77, 86–89, 91–92, 122, 141–142, 145, 147, 182, 187, 199, 215, 217–218, 221, 223–226
mediation, 6–7, 65, 110, 141, 145
semiotic, 85, 87, 88
social, 142
symbolic, 145
mentor, 13, 96–97, 108–110, 114, 117, 119, 122–123, 206, 228
Mind in Society, 5
Moran, S., 9, 141
motivation, 66, 122, 218

self, 118
movement, 9–10, 20–21, 33, 75, 87, 111–115, 120, 123, 137, 177
music, 3, 7, 9, 21–22, 67, 78, 96, 98, 172, 226
music making, 64–67, 71, 74–75, 77–79

• N •

narrative, 94, 013, 130, 137–138, 165–166, 220
 competence, 220
 cultural, 138
 dramatic, 72, 77
 historical, 152
 personal, 184
 visual, 100–101
negotiation, 73, 79
Nelson, K., 69, 71–72, 79
nested realities, 64–67, 74, 78, 227
Nicoll, J., 9, 107
No Child Left Behind Act, 218

• O •

O'Keefe, G., 83–84, 97
Oreck, B., 9, 107

• P •

painter, 19, 83–88, 96–98, 103
Paris Review, 147–148, 157, 160
Piaget, J., 4, 209
play, 3–4, 6, 10–13, 27, 31, 34, 35–38, 41–43, 48, 51–57, 64–67, 69–79, 88–89, 96, 108, 111, 115–116, 121, 164–166, 168–170, 177–178, 181–186, 189, 195–196, 201, 203–204, 207–209, 212, 216–219, 221–222, 224–226, 229
playworld, 163–178, 219–220
perezhivanie, 143, 163–164, 166–167, 171, 173–177, 182, 224, 227
performance, 3, 37–38, 77, 144, 170–171, 175, 186, 188, 201,, 204, 207, 210211, 219–220, 227
 academic, 186
 assisted, 9
 improvisational, 67, 224
postpak, 43, 234
Problem of the Environment, 8

prolepsis, 88, 93
psychobiological, 17, 20–22
Psychology of Art, 5, 13–14, 17–18, 21, 24, 123, , 139, 141, 147, 166, 181

• R •

rhythm, 20, 23, 47, 63, 112–113, 155
Rogoff, B., 37, 202, 225

• S •

Sawyer, R. K., 67, 74
scaffolding, 13, 29, 66–67, 69, 72, 76, 86, 156
Schaefer–Simmern, 108–110, 112, 117
scientific concepts, 65–66, 69, 77
Scribner, S., 5, 91
script, 63–63, 66, 69, 70–79, 89, 164, 201–202, 205, 207
 cross–script, 63, 72, 74–75
 school script, 209–211
self–regulation, 120
semiotic
 analysis, 90–91
 codes, 88
 means, 7, 87–89, 92, 95, 226
 mediation, 85–86
 signs, 87
semiotics, 84
 curriculum, 182, 195
sign, 7, 10, 12, 17, 20, 71, 84, 86–90, 92, 96–97
 acquisition, 85, 88, 90–91, 94–98, 104
 first order, 88
 gestural, 89
 leitmotif, 94
 multimodal, 21
 operation, 8, 90
 second order, 88
 systems, 85, 88–90, 102, 182, 190, 196
 verbal, 90
Smagorinsky, P., 8, 125–126, 187, 190, 224
Smolucha, F., 142
social processes, 14, 91
social sources, 3, 6
social units, 27, 30–31, 181
Souberman, E., 5

space, 3, 30, 33, 44, 53, 65–67, 76, 111, 113–115, 118, 123, 138, 142, 145, 175, 177–178, 181–187, 190, 194–196, 221, 229
spontaneous concepts, 65, 69, 77, 79
St. John, P., 8, 63
Stanislavsky, K., 8, 172
Stetsenko, A., 221
successive approximation, 86
Suhor, C., 182, 190
Sutton-Smith, 41

•T•

teacher, 4, 10, 30, 44, 66, 68, 96, 108–1111, 115, 117–118, 122–123, 136–137, 163, 166–170, 174, 181–187, 190–191, 194–196, 205–212, 219
Thinking and Speech, 33
thought, 3, 7, 12, 17, 22, 85–86, 88–89, 109, 111, 117, 188, 216, 221
and affect, 224
and language, 34, 76, 89, 112
communities, 12
cultural, 87
development of, 7, 89, 123
higher thought processes, 86
Thought and Language, 5, 10
tools, 3, 7–8, 12, 25, 73, 75, 78, 87, 111, 113, 116, 120, 153, 157, 184, 195, 201, 211
analytical, 111
choreographic, 122
musical, 76
physical, 85, 89, 91, 95, 227
psychological, 31, 85–86, 89, 91, 96, 144, 227
symbolic, 158
Tool and Symbol in Child Development, 5
triadic relationship, 17–18
transformation, 24, 44, 57, 75
cultural, 145
knowledge, 85, 91
qualitative, 12, 28, 30, 206

•U•

unity, 9, 28–29, 33, 53, 112, 120, 229

•V•

Vygotskian theory (or cultural–historical theory), 3–4, 6, 43, 64–68, 84–85, 87, 90, 103, 216, 219–220, 225
Vygotsky, L. S.
biography, 4–6
framework, 6–9, 11–14
Fundamentals of Defectology, 30
Historical Meaning of Crisis in Psychology, 5
Imagination and Creativity in Childhood, 13, 152, 155, 157
Educational Psychology, 5
Method, 10
Mind in Society, 5
Problem of the Environment, 8
Psychology of Art, 5, 13–14, 17–18, 21, 24, 123, , 139, 141, 147, 166, 181
Thinking and Speech, 33
theory, 3–4
Thought and Language, 5, 10
Tool and Symbol in Child Development, 5
vocabulary, 9, 32–33, 100, 102, 111–112, 114–115, 120, 183–188, 191, 195–196
voice, 21, 89, 96–99, 115, 118

•W•

Wells, G., 9, 86
Wertsch, J., 7, 29, 37, 110
Writing, 7–8, 76, 86, 132, 153, 156, 181–188, 190, 193–196

•Z•

Zone of proximal development, 6, 9, 11, 28–29, 32, 42, 65, 107–110, 123, 146, 152, 202–203
Zoss, M., 8, 181
ZPD, 9, 12–13, 27–36, 65–67, 77, 142–145, 154, 202–204, 208–209, 221

Critical Pedagogical Perspectives

Greg S. Goodman, *General Editor*

Educational Psychology: Critical Pedagogical Perspectives is a series of relevant and dynamic works by scholars and practitioners of critical pedagogy, critical constructivism, and educational psychology. Reflecting a multitude of social, political, and intellectual developments prompted by the mentor Paulo Freire, books in the series enliven the educator's process with theory and practice that promote personal agency, social justice, and academic achievement. Often countering the dominant discourse with provocative and yet practical alternatives, *Educational Psychology: Critical Pedagogical Perspectives* speaks to educators on the forefront of social change and those who champion social justice.

For further information about the series and submitting manuscripts, please contact:

Dr. Greg S. Goodman
Department of Education
Clarion University
Clarion, Pennsylvania
ggoodman@clarion.edu

To order other books in this series, please contact our Customer Service Department at:

(800) 770-LANG (within the U.S.)
(212) 647-7706 (outside the U.S.)
(212) 647-7707 FAX

Or browse online by series at:

www.peterlang.com